The Shaping of Art History examines art history's formation in the German academy in the late nineteenth century. Focusing on the work of Wilhelm Vöge and Adolph Goldschmidt, two influential scholars of medieval art, Kathryn Brush analyzes their methods and particularly those scholarly projects that were critical to the development of their approaches. Her work combines intellectual and institutional history with the study of artistic monuments and biography. It is the first to consider how the study of the pioneering scholarship in the field of medieval art is critical to an understanding of the formulation of art historical method as a whole. Drawing on a range of published and unpublished sources, this study also demonstrates how a variety of factors, such as nationalism, scientific paradigms and personality, helped to shape the discipline, and how many of the investigative procedures developed in turn-of-the-century Germany were only selectively understood when later transmitted to Europe and America.

The Shaping of Art History

The Shaping of
Art History

Wilhelm Vöge, Adolph Goldschmidt, and the Study of Medieval Art

KATHRYN BRUSH

University of Western Ontario

CAMBRIDGE
UNIVERSITY PRESS

Published by the Press Syndicate of the University of Cambridge
The Pitt Building, Trumpington Street, Cambridge CB2 1RP
40 West 20th Street, New York, NY 10011-4211, USA
10 Stamford Road, Oakleigh, Melbourne 3166, Australia

First published 1996

Printed in the United States of America

Library of Congress Cataloging-in-Publication Data
Brush, Kathryn.
The shaping of art history : Wilhelm Vöge, Adolph Goldschmidt, and
the study of medieval art / Kathryn Brush.
p. cm.
Includes bibliographical references.
ISBN 0–521–47541–4 (hc)
1. Art, Medieval. 2. Art – Historiography. 3. Vöge, Wilhelm,
1868–1952 – Criticism and interpretation. 4. Goldschmidt, Adolph,
1863–1944 – Criticism and interpretation. I. Title.
N5970.B78 1996
709'.02'0722 – dc20 95–9680
 CIP

A catalog record for this book is available from the British Library

ISBN 0–521–47541–4 Hardback

For my parents

Contents

CONTENTS

Illustrations

Acknowledgments

I<small>N WRITING THIS BOOK</small>, I have benefited from the help and support of many institutions and individuals whom I now wish to thank.

Preliminary research in European libraries and archives during the summers of 1989, 1990 and 1991 was supported by grants from the Deutscher Akademischer Austauschdienst (DAAD), the University of Western Ontario and also from the Social Sciences and Humanities Research Council of Canada. An Andrew W. Mellon Faculty Fellowship in the Humanities at Harvard University provided me with the ideal circumstances in which to complete my research and undertake the task of writing. A research grant and research time stipend from the Social Sciences and Humanities Research Council of Canada enabled me to conduct further work in Europe and to continue writing at Harvard as a Visiting Scholar in Fine Arts during 1992–93.

I am very grateful to the staffs of the following archives for facilitating access to the unpublished materials on which this study is based: Archives Départementales du Bas-Rhin, Strasbourg; Historisches Archiv der Stadt Köln; Rheinisches Amt für Denkmalpflege, Abtei Brauweiler; Staatsarchiv Hamburg; Staatsbibliothek Preussischer Kulturbesitz, Berlin, Autographenabteilung; Universitätsarchiv der Rheinischen Friedrich-Wilhelms-Universität, Bonn; Universitätsbibliothek Bonn, Handschriftenabteilung;

Universitätsbibliothek Basel, Handschriftenabteilung; Universitätsarchiv der Albert-Ludwigs-Universität, Freiburg im Breisgau; and the Warburg Institute, University of London.

A number of individuals who provided assistance with other archival resources deserve special mention. Wilhelm Schlink, Director of the Kunstgeschichtliches Institut at the Albert-Ludwigs-Universität, Freiburg im Breisgau – the art history institute founded by Wilhelm Vöge – was extremely generous in his support of this project. He enabled me to examine the extensive documentation pertaining to Vöge in the institute archives, arranged for photographs and responded to my innumerable questions with exemplary speed. I am equally indebted to Hans-Joachim Krause, Chief Conservator, Landesamt für Denkmalpflege Sachsen-Anhalt, Halle, who accommodated my research by recalling the papers of Wilhelm Vöge from long-term storage at a particularly busy moment in the history of the Landesamt. Dr. Krause and his colleagues kindly assisted with photographs as well. I am very grateful to Marie Roosen-Runge-Mollwo for making unpublished materials relating to Adolph Goldschmidt available to me. The great-nephews and great-nieces of Wilhelm Vöge, especially Klaus Dziobek and Ursula Hausen, followed this project with great interest and graciously gave me access to family letters and photographs. Thanks are also due to Günter Hess who reviewed my transcriptions from documents.

The staffs of the Zentralinstitut für Kunstgeschichte and the Fine Arts and Widener libraries at Harvard University are to be commended for much efficient and sympathetic assistance. Roger Gardiner and the other staff members of the D. B. Weldon Library, University of Western Ontario, also provided valuable help on numerous occasions.

Many colleagues in North America and Europe significantly aided my research. I acknowledge with gratitude the suggestions of Heinrich Dilly, William Heckscher, Willibald Sauerländer, John Shearman and the late Kurt Weitzmann, with whom I discussed specific aspects of my project. I also wish to thank Jaynie Anderson, Roger Chickering, Robert Deshman, Richard Hunt and Bryce Lyon for answering the queries I directed to them. Liliane Châtelet-Lange and Amata Niedner provided special aid with photographs. Peter Nisbet and Emilie Norris of the Busch-Reisinger Museum also helped with photographs and shared my enthusiasm for research on German art and culture during my stay at Harvard. My friends

in Germany, especially Holly and Markus Richardson-Streese and Editha and Joachim Deeters, helped track down elusive citations and assisted in countless other practical ways.

I am particularly indebted to Pamela M. Jones and Joanna Ziegler, who read the text in draft and responded with challenging suggestions. They acted as important sounding boards for many of the ideas contained in this book. Thanks are also due to Corine Schleif and Elizabeth Sears for their constructive suggestions as readers of my manuscript. During the writing stage Elisabeth Dunn carefully text-edited the manuscript. Her professional sensitivity to matters of form and content helped me to refine the text. It was also a great pleasure to work with Beatrice Rehl, Fine Arts Editor, Cambridge University Press, who oversaw the publication with dedication and dispatch. Other members of the Cambridge University Press production staff, especially Holly Johnson, Christie Lerch and Alan Gold, offered valuable assistance as well.

I owe a fundamental debt to Kermit Champa of Brown University. Some years ago he suggested that my work on medieval art could be enriched and extended by studying the nineteenth- and twentieth-century historiography of art history. The present project has profited immeasurably from his scholarly generosity, extraordinary conceptual range and unfailing encouragement.

Finally, I owe my oldest and deepest debt to my parents, who have always been unwavering in their support of my work.

London, Canada
July 1994

Introduction

T HIS STUDY examines some of the intellectual and historical circum-
stances that helped define the academic study of art history. It does
so by tracing and contextualizing the ways in which the first generation of
professional interpreters of art in Germany shaped discourse on medieval
art. The investigation focuses on the decades of the 1880s and 1890s, when
art history was first established as an academic discipline at German, Aus-
trian and Swiss universities. In conjunction with the study of published
texts, an analysis of archival materials affords new insights into the com-
plex (and often contradictory) movements of thought that helped shape
humanities scholarship generally, and art historical scholarship specifically,
in late nineteenth-century Germany.

In view of the wave of theoretical and critical self-examination that has
swept recently through many disciplines, including art history, it may come
as a surprise to many scholars that the intellectual and methodological
foundations of art history have been only partially explored to date. This
applies to the historiography of art history as a whole – for example, a
comprehensive analysis of the institutionalization of the discipline at Ger-
man universities during the late nineteenth century has yet to be under-
taken[1] – as well as to the historiography of scholarship treating the various
historical eras embraced by the discipline since its founding. The majority

of recent chroniclers of art history have regarded scholarship on the Renaissance or post-Renaissance periods as the primary intellectual barometer of the growth and development of the discipline. The widespread assumption that the most important methodological experiments took place in the investigation of Italian Renaissance art has meant that short shrift has been given to 1880s and 1890s scholarship examining artistic monuments of other periods. This is especially true of the early study of medieval art.

But chroniclers of the discipline are not the only scholars who have neglected to explore the pioneering discourse on medieval art. Even historians of medieval art, including native speakers of English, German and French, have been slow to investigate and contextualize the writings that form the foundations of their now largely discrete subdiscipline. As a result, nineteenth-century scholarship on medieval art (and especially the ground-breaking writings of German-speaking scholars) remains *terra incognita* to scholars of our day on both sides of the Atlantic.[2]

Why, one might ask, does historiography occupy the margins of art historical inquiry on the Middle Ages? At least part of the neglect stems from a widespread belief that the dusty, often disintegrating tomes in our libraries are essentially "old hat," and that they present information that has long since been improved upon or corrected. Another common misconception is that the discourse of the pioneering scholars was fundamentally unilinear and therefore has little to offer to a multidimensional present. Recent debates concerning the aims, nature and methods of art history by a new generation of critical historians of art, though highly provocative for the field as a whole, have frequently conveyed the impression that the first-generation scholars were positivists concerned almost exclusively with formal categorization.[3] This impression has acquired the force of virtually unquestioned truth, because many students and scholars of medieval art, whether in Germany, France, Britain or America, no longer possess first-hand knowledge of the now century-old founding texts – texts that demonstrate that much of the early scholarship was remarkably varied in method.

Furthermore, recent scholars outside of Germany have neglected early medieval scholarship written in German, for a variety of political, ideological or chauvinistic reasons. Medievalists in France, for instance, have traditionally confined their research to monuments located within the borders

of France.[4] British scholarship, although somewhat less insular, likewise does not tend to look farther east than France.[5] To cross the Atlantic, Erwin Panofsky's optimistic vision (1953) of American art history as operating free of the national borders of Europe has not had any long-term validity for the scope of research on medieval monuments by North American scholars.[6] Despite the presence of Panofsky and other German-trained émigré scholars at American universities from the 1930s to the present, the scholarship of American-born medievalists during the past forty or fifty years has been primarily Francocentric, and secondarily Anglocentric, in orientation.[7] The bias inherent in this dominance of an Anglo-French axis outside of Germany is self-perpetuating, for it has severely limited the acquisition of fluency in foreign languages (not just German) by many art historians.[8] Whatever the priorities among these and other conditioning factors, the neglect of German scholarship has made a balanced historiographical analysis of medieval art historical scholarship virtually impossible, especially as it relates to the study of the Middle Ages in northern Europe.

The neglect of these early studies has broad implications for our understanding of how the discipline of art history was formed. In late nineteenth-century Germany, study of the medieval era achieved important status within art history – a status comparable to that granted to the study of the Italian Renaissance and classical antiquity. Indeed in its early years, the field of art history was far less specialized in orientation and practice than it is today. For the small group of men who formed the fledgling art historical community in Germany during the 1880s and 1890s,[9] the study of art history denoted critical engagement with the entire history of art, rather than with the largely independent subdisciplines (e.g., Renaissance art history, modern art history) so familiar to scholars of our day, especially in countries outside of Germany. The relatively unpartitioned state of the young discipline was conditioned in part by its extremely small size. No more than several dozen professors and students populated the field in Germany in the 1880s and 1890s,[10] making "specialist" directions in art history fluid in definition. Often those scholars who concentrated their work on the Middle Ages also published or taught on the art of other eras.[11] The division of art history into professional subcategories, most notably outside of Germany, occurred only later, following World War I, with the institutional and geographic expansion of the field.

Thus critical study of early scholarship on medieval art can help us understand broader intellectual currents in the developing discipline.

These writings also reflect the centrality accorded to the study of the Middle Ages in German academic and political culture during the late nineteenth century. It is well known that the Middle Ages attracted much scholarly and popular attention all over Europe from the late eighteenth century onward. But the founding of the German empire in 1871 acted as a powerful catalyst for German scholars.[12] The medieval period was championed as an era that anticipated the formation of the European nation-states – and the German empire specifically. Nationalist sentiment sparked interest in Germany's own history, and not surprisingly, much post-1871 research on the Middle Ages (including art historical writings) focused on the medieval empires of the Carolingian, Ottonian, Salian and Hohenstaufen eras.

Although consideration of the specific nationalist agendas and academic politics that helped shape the study of the Middle Ages in Wilhelmine Germany is beyond the scope of the present study, it is important to point out that this heightening of scholarly interest in the Middle Ages more or less coincided with the formation of the discipline of art history. This situation, and the virtually immediate integration of the study of medieval art into the new discipline, must be factored into any attempt to analyze the formulation of art historical method as a whole. By neglecting to consider early scholarship on medieval art, we have severely limited our understanding of the development of the entire discipline of art history.

It is not my aim here to construct a panoramic view of the scholarship on medieval art published in late nineteenth-century Germany nor to determine whether specific arguments put forward in that scholarship were right or wrong. Rather, my goal is to begin sorting out and identifying some of the criteria that provided intellectual support for the pioneers of art history as they structured discourse on medieval art during the 1880s and 1890s. In other words, I am interested in gauging the kinds and range of issues and methodological stimuli that gave direction to the study of medieval monuments at a moment when interpretative norms for the fledgling discipline of art history had not yet been established.

I have chosen to emphasize art historical pioneers less well known than canonical figures like Alois Riegl (1858–1905) and Heinrich Wölfflin (1864–1945), who have received the lion's share of scholarly attention to

date.[13] Instead, in order to contribute to a more complete picture of the formation of art history, my study centers on two crucial figures whose work has been inadequately studied: Wilhelm Vöge (1868–1952) and Adolph Goldschmidt (1863–1944), two of the most prominent scholars of medieval art in German academic and museum circles during the 1890s and later (Figs. 1, 2). My investigation takes the general form of a case study of the thought and work of these two men, who received their university educations during the 1880s and embarked on their professional careers around 1890. Along with Austrian, Swiss, German and French scholars such as Franz Wickhoff (1853–1909), Riegl, Julius von Schlosser (1866–1938), Wölfflin, Max J. Friedländer (1867–1958), Aby Warburg (1866–1929) and Émile Mâle (1862–1954), Vöge and Goldschmidt belonged to the pioneering generation of art historians born in the 1860s or just slightly earlier. Within German art history, Vöge and Goldschmidt stand out because they represented fresh blood, conceptually speaking, for the study of medieval art during the 1890s.[14]

When Vöge and Goldschmidt began their university studies in the mid-1880s, the discipline of art history was in its infancy, and medieval art was just becoming a subject of intensive study in universities and museums.[15] Goldschmidt, who is much better known today than Vöge, studied at the university between 1884 and 1889.[16] In his Leipzig dissertation of 1889, Goldschmidt presented the first systematic study of late medieval painting and sculpture in the Hanseatic city of Lübeck.[17] Although late medieval art always remained an area of special interest for Goldschmidt, many of his subsequent publications of the 1890s concentrated on Carolingian and Romanesque manuscripts, as well as on twelfth- and thirteenth-century sculpture in Germany, all topics that had received little attention until then. His work during these years was not restricted to medieval art, for he also published and taught on subjects that included Michelangelo and Dutch and Flemish painting.

In 1892 Goldschmidt became the first art historian with a medievalist orientation to teach at the University of Berlin. In 1895 he published his *Habilitationsschrift*, or postdoctoral thesis, on the twelfth-century Albani Psalter.[18] In 1904 he became professor of art history at the University of Halle, a post he held until 1912. Although Goldschmidt had served in an important advisory capacity during the late 1890s for dissertations on medieval illuminated manuscripts by Arthur Haseloff and Georg Swarzen-

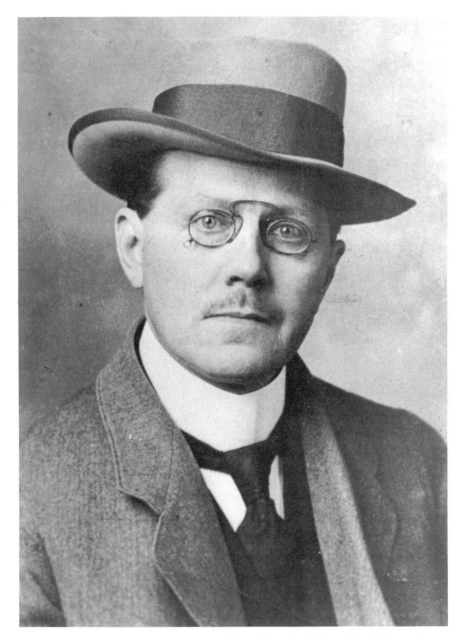

Figure 1. Wilhelm Vöge, before 1915. (Photo: Klaus Dziobek and Ursula Hausen)

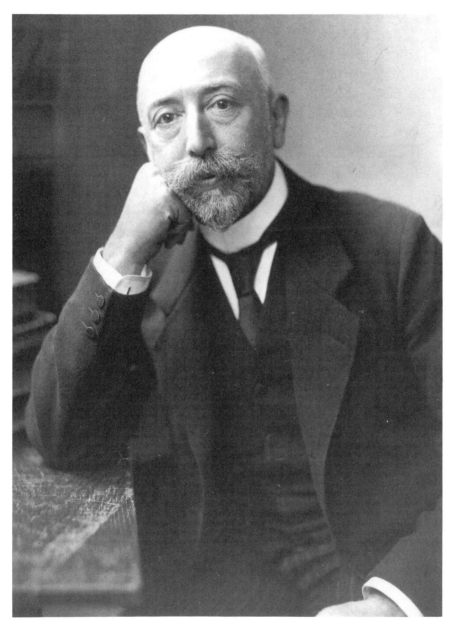

Figure 2. Adolph Goldschmidt, ca. 1912. (Photo: Staatsarchiv Hamburg, Bestand 622-1 Goldschmidt)

ski,[19] it was in Halle that he established his reputation as a teacher. Indeed Goldschmidt's pivotal role in shaping the field of art history, and medieval art history specifically, stemmed equally from his publications and from his accomplishments as a teacher. During the years he spent in Halle and at the University of Berlin (to which he returned in 1912) Goldschmidt supervised almost one hundred doctoral dissertations in many different areas of art history. His doctoral students included Hans Jantzen, Ernst Gall, Alexander Dorner, Rudolf Wittkower, Ulrich Middeldorf and Kurt Weitzmann, all of whom became distinguished scholars in their own right.[20]

Shortly after 1900 Goldschmidt published his first article on medieval ivory carvings.[21] Between 1914 and 1926 he published his monumental four-volume corpus of Carolingian, Ottonian and Romanesque ivories, which was supplemented in 1930 and 1934 by a two-volume corpus of Byzantine ivories, produced in collaboration with his student Kurt Weitzmann.[22] Although Goldschmidt's name tends today to be associated most closely with his pathfinding corpus of medieval ivory carvings, *Die Elfenbeinskulpturen*, he also published dozens of important articles and books on medieval manuscripts, bronze doors, and Romanesque and Gothic sculpture during the same years.

Unlike many of his German-speaking contemporaries (for example Riegl and Wölfflin), Goldschmidt achieved an international reputation on both sides of the Atlantic during his lifetime. American medievalists maintained regular contact with Goldschmidt from the early 1920s onward. He made three trips to the United States (in 1927–28, 1930–31 and 1936–37), where he lectured widely, in addition to teaching at Harvard University and at the Institute of Fine Arts in New York. Following a long and immensely productive scholarly career, Goldschmidt was forced to leave Nazi Germany in 1939 and died in Basel in 1944.

WILHELM VÖGE, like Goldschmidt, was one of the first major German art historians to concentrate on the Middle Ages.[23] After commencing his university studies at Leipzig in 1886, Vöge spent his academic *Wanderjahre* at the universities of Bonn, Munich and Strasbourg. In his Strasbourg dissertation, published in 1891 and still considered fundamental today,

Vöge established many of the identifying characteristics of the Ottonian group of manuscripts now associated with the scriptorium at Reichenau.[24] Between 1892 and 1894 Vöge traveled to France to study at first hand French monuments of medieval architecture and sculpture. His second book, *Die Anfänge des monumentalen Stiles im Mittelalter* (The Beginnings of the Monumental Style in the Middle Ages), was published in 1894.[25] In this highly influential study Vöge presented the first critical account of the genesis of Gothic sculpture in France. In 1895 Vöge became a *Privatdozent*, or lecturer, under Georg Dehio (1850–1932) at the University of Strasbourg, and he taught there until 1897. After making a foray into the Renaissance by publishing a book on Raphael and Donatello in 1896,[26] Vöge devoted the rest of his brief public career to the study of medieval sculpture. Between 1898 and 1908 he worked under Wilhelm Bode (1845–1929) in the sculpture department of the Berlin Museums. There he published two influential catalogues on medieval ivories and monumental sculpture, as well as numerous essays.[27]

In 1908 Vöge returned to academia and established the art history institute at the University of Freiburg im Breisgau. During the eight years he spent in Freiburg Vöge supervised fourteen doctoral dissertations, including Erwin Panofsky's study of Dürer's theory of art (1914).[28] Kurt Badt, Friedrich Winkler, Wolfgang Stechow and Percy Ernst Schramm were among the many young scholars at Freiburg who were greatly influenced by Vöge's teaching. In 1915, however, Vöge suffered a nervous breakdown, triggered, at least in part, by his intense despair over the destruction of medieval monuments in France by his German compatriots during World War I. In 1916 Vöge retired from the university and also retreated from the scholarly world at large, rarely venturing thereafter from the provincial town of Ballenstedt in the Harz region of Germany. Although he published sporadically until his death in 1952 – monographs on the late medieval sculptors Nikolaus Hagenower and Jörg Syrlin appeared in 1930 and 1950[29] – Vöge's withdrawal from active academic life in 1916 accounts in part for the low visibility of his writings, in contrast to the enduring international reputation of Goldschmidt.

Although their careers followed different paths after 1915, Vöge and Goldschmidt were among the prime movers who gave the developing discipline of art history decisive impetus, direction and meaning in turn-

of-the-century Germany. Both men were prominent writers and teachers whose work met with immediate response in their own day – unlike Aby Warburg, who was "discovered" only much later, and largely outside Germany.[30] Vöge and Goldschmidt, like Riegl in Vienna and Wölfflin in Basel (and Berlin),[31] were influential shapers of the discipline at the time of its professionalization. They are, in effect, the academic grandparents or great-grandparents of many scholars active today.

Although I have analyzed their publications here, I have not relied exclusively on investigation of their published texts.[32] Instead I have allowed archival documents of both a professional and personal sort associated with Vöge, Goldschmidt and their circle to determine the shape of my inquiry. These materials, which include correspondence, unpublished manuscripts and lecture notes, offer new and often unexpected insights into how these scholars perceived their critical activities. Prime among these documents are some 360 letters and postcards written by Vöge to Goldschmidt between 1892 and 1938.[33] They provide remarkably comprehensive evidence of a creative intellectual partnership between the two young men, particularly during the crucial decade of the 1890s. The bonding that lies behind their scholarly production emerges only from study of their publications together with these unpublished archival materials.[34] Indeed, Vöge's letters to Goldschmidt afford rich and compelling insights into the specific intellectual operations that helped define the conceptual contours of medieval art historical scholarship. At a time when pioneering art historical texts tend to be read and judged almost entirely apart from the conditions that elicited them, this kind of investigation can contribute to a clearer and more sensitive assessment of them.

THE PARAMETERS of this study are necessarily determined by the directions Goldschmidt's and Vöge's scholarship took. Because their research from the 1890s onward concentrated on the study of medieval sculpture and manuscripts, this book also emphasizes those media. The focus of their work was highly significant; although sculpture and illuminated manuscripts had received some treatment earlier in the century, they were not studied intensively in Germany until after the political consolidation of the German empire in 1871.[35] The new interest accorded medieval sculpture and painting after 1871 is important, for research paradigms were less

firmly established for these media than for architecture, which had been studied in Germany, Great Britain and France since the late eighteenth century. Thus, Goldschmidt's and Vöge's work on medieval sculpture and manuscripts arguably provides the most appropriate instrument with which to measure the discursive range of the "new" medieval art history during the 1880s and 1890s.

My investigation focuses on two related interpretative issues grappled with by these first-generation art historians – issues that figure importantly in the pioneering art historical discourse as a whole, and that I use here as barometers with which to measure the intellectual range in medieval art history during the 1880s and 1890s.

The first issue is this: how, and with what tools of analysis, does one assess the role of the artist, and of the artistic process, when evaluating works produced in the past, and how does one determine the relationship between form and artistic content in those works? In the case of the study of monuments from the Middle Ages, for which there exist few historical sources documenting either the makers or their working procedures, this issue acquires particular complexity. If, on the one hand, medieval artistic anonymity permits an unencumbered "scientific" reading of monuments as independent aesthetic objects (i.e., apart from their makers and the circumstances of their making), to what extent does this approach neglect the broader human dimensions of these monuments? Can "scientific" methods of art historical analysis attempt to account for medieval artistic creativity, and, if so, how? Such questions, which are the subject of ongoing critical debate today, assumed crucial dimensions during the 1880s and 1890s, when the territorial boundaries and analytical systems of the increasingly autonomous "science" of art history were first being established.

The second area of concern in the present study is to analyze how debates in the fledgling discipline of art history related to methodological controversies within the far more formidable field of the scholarly study of history in Germany during the 1880s and 1890s. Many points of intersection emerge, raising fundamental questions about the historical role of art. To what degree, for instance, can medieval artistic monuments be read as historical documents recording the mentality and cultural behavior of a period? And to what extent do the concerns and methods of the economic, political or cultural historian coincide with those of the art historian?

In this study I am interested in charting some of the dimensions as-

sumed by these issues during the 1890s. I not only investigate the shifting (and often contradictory) stances adopted by Goldschmidt and Vöge but also explore how their approaches relate to those formulated by their contemporaries, including Alois Riegl, Heinrich Wölfflin and Émile Mâle.

PART I, CHAPTER I, explores the range of critical and historical approaches applied to the study of the visual arts in Germany during the 1880s, the decade that provided a frame of reference for many art historical pioneers of the 1890s. I begin by outlining some of the ways in which medieval monuments and medieval artistry were studied prior to 1880, in order to establish the discursive parameters within or beyond which the young scholars trained during the 1880s could define and clarify their own art historical practice. I describe briefly the positions of a number of scholars who participated in the methodological controversies of this decade, but my discussion focuses primarily on the art historian Anton Springer (1825–91) and the cultural historian Karl Lamprecht (1856–1915).

Both Springer and Lamprecht were charismatic teachers. Goldschmidt conducted his university studies at Leipzig under Springer. Vöge studied briefly with Springer and then transferred to the University of Bonn, where, as newly discovered documents reveal, Lamprecht became his principal mentor. The teachings and methodological perspectives of Springer and Lamprecht, men of two different generations and outlooks, serve to illustrate some of the broader dichotomies and tensions within art history during the 1880s – tensions, for instance, between a "scientific" and impersonal connoisseurship, on the one hand, and a cultural historical method aimed at reading the work of art as an index of the mentality and collective psyche of a period. The teachings and writings of both Springer and Lamprecht displayed many inconsistencies and internal contradictions, and neither of these men definitively shaped the intellectual personalities of their students. However, Springer's and Lamprecht's teachings had broad implications for the ways in which notions of the medieval artist and artistry generally were played out conceptually in art historical scholarship of the 1890s. Special attention is given in Chapter 1 to Lamprecht's role as progenitor of art history. Although Lamprecht's formative impact on the developing discipline has not been recognized to date, course re-

cords, correspondence and other documents demonstrate that during the 1880s he exercised far-reaching influence upon the first group of art history students at Bonn, including Wilhelm Vöge, Aby Warburg and Paul Clemen (1866–1947).

Part II, "Monumental Styles in Medieval Art History," examines the conceptual unfolding of Vöge's and Goldschmidt's scholarship during the 1890s. Chapter 2 offers a careful analysis of Wilhelm Vöge's groundbreaking study of Gothic sculpture in France, *Die Anfänge des monumentalen Stiles im Mittelalter,* published in 1894. In this book, one of the most influential medieval art historical studies of the 1890s, Vöge identified the sculpture on the west facade of Chartres Cathedral as the first comprehensive manifestation of a monumental Gothic sensibility in sculpture. Vöge's study revealed a fundamental concern with the determinative role of human agency and individual artistic creativity in the production of twelfth- and thirteenth-century sculpture. Drawing on archival evidence I argue that Vöge's anthropomorphic interpretation of the generating forces and inner life of the Gothic style is best understood as a carefully conceived intellectual response to the issue of the role of the artist and of the creative process in the evaluation of historical works, and that this response assimilated impulses from a wide range of sources. I also suggest that Vöge's use of a "scientific" method (i.e., stylistic analysis) to uncover *das Menschliche* (the human element) in medieval art might be read as an attempt to integrate individuation and/or humanity with universal law or science.

Chapter 3 presents a more comprehensive view of the intellectual rhythms of the 1890s by examining and comparing the published oeuvre of Goldschmidt and Vöge from this decade. Although the work of these two men was by no means one-dimensional, Goldschmidt's writings, more than Vöge's, tended to be rigorously analytical and "scientific." Goldschmidt's major hermeneutical instrument was an exacting stylistic analysis, whereas Vöge's discourse during the 1890s displayed greater conceptual flexibility and methodological range, oscillating between scientific connoisseurship and a concern with the psychological aspects of medieval artistic creativity. The overlaps and divergences in Goldschmidt's and Vöge's work during the 1890s merit study not only in relation to broader controversies within the discipline but also in relation to the personal dia-

logue between the two scholars during this decade. I shall suggest that their distinctive investigative procedures were broadly symptomatic of positions taken in the late nineteenth-century debate over the nature and methodology of the newly formed human sciences, or humanistic studies (*Geisteswissenschaften*).

Part III, "Resonances," considers the reception (both immediate and long-term) of the 1890s writings of these two pathfinding interpreters of medieval art. Chapter 4 charts the range of scholarly responses to Goldschmidt's and Vöge's work in turn-of-the-century Germany, as well as in Austria, France, Great Britain and Italy. In many cases there appears to have been a noticeable gap between intentions articulated by Vöge and Goldschmidt and the perception of these intentions by others. Most scholars dwelt on the "scientific" and intellectually rigorous aspects of the men's work, largely overlooking concerns (Vöge's specifically) about the more personalized aspects of medieval artistic creativity.

The final chapter explores in a preliminary fashion the impact of 1890s scholarship on the directions taken by later discourse on art of the Middle Ages, particularly in the years following World War I. Although I discuss German, French and British scholarship, I have chosen to highlight American scholarship of the 1920s, for it was during these years that American historians of art first became major players on the international stage. In this chapter I consider the process of accelerated exchange among German, French and American scholars, as well as the inevitable shifts that accompanied the transplanting of Old World methods into an academic landscape distanced geographically and intellectually from the milieu that sponsored their shaping. My aim is to conduct a preliminary test of the extent to which pioneering American medievalists engaged, consciously or unconsciously, in a reshaping and reformulation of the methodological approaches first developed in Germany. Finally, I suggest some avenues awaiting further critical exploration.

MUCH INVESTIGATIVE work into the historiography of art history, and medieval art history in particular, remains to be done. This case study does not represent an attempt to "rescue" the methods or interpretative procedures of Goldschmidt and Vöge for the present, nor does it aim to make simple analogies between the critical activities of the founding art histori-

ans and practitioners of art history today. Instead I prefer to take an open position. What I offer here is a first step toward suggesting how a keen critical sense of the discipline's past can better equip us to meet its current uncertainties and self-questionings.

PART I

Mentalités

I

Art History and Cultural History during the 1880s: The Discursive Range

ART HISTORY, referred to in German as *Kunstgeschichte* or *Kunstwis-senschaft* (the latter term roughly translatable as the "science, or academic study, of art"), was among a number of fields of inquiry gradually accorded disciplinary status at German and Austrian universities during the second half of the nineteenth century. By 1874, eight permanent chairs for professors of art history had been established at universities in German-speaking Europe, including Bonn (1860), Vienna (1863), Strasbourg (1871), Leipzig (1872), Berlin (1873) and Prague (1874).[1] In September of 1873 an event took place that signaled an emerging self-consciousness in the new discipline: the first International Congress of the History of Art was held at the Austrian Museum of Art and Industry in Vienna.[2]

Because few professional art historians held university positions at the time, most of the sixty-four participants in the Congress came from museums, technical colleges or societies for historical preservation. Significantly, reports of the conference show that it was concerned not so much with the presentation of individual research as with debating the nature and goals of art historical practice and with introducing measures to enlarge its institutional and material base.[3] Among the resolutions of the Congress was one that asserted the desirability of establishing the study of

art history at all universities.[4] Those in attendance also endorsed a campaign to increase the availability of visual materials – photographs, plaster casts and the like – for art historical study. In order to promote further the "highest standards of scholarship in all areas of art history," a journal was launched that was to serve as a forum for the presentation of original research and for disseminating information about new books, art exhibitions and articles appearing in German-language and foreign periodicals. The first volume of this scholarly organ of art history, the *Repertorium für Kunstwissenschaft*, appeared three years later, in 1876.[5]

By 1893 and 1894, when the second and third International Congresses took place in Nuremberg and Cologne, significant progress had been made in the academic institutionalization of art history. Indeed some of the effects can be deduced from the rosters of participants.[6] In addition to those engaged in museum or preservation work, the lists of attendees at the 1893 and 1894 conferences show a significant increase in the number of university professors of art history. Moreover, some of the participants were young scholars who were conducting doctoral study in art history or who had recently completed their doctorates – a group not represented at the inaugural meeting.[7] The appearance at the conferences of the early 1890s of this new community of young art history professionals, among them some of the figures of central interest in this study,[8] can be attributed broadly to the cultural politics of Wilhelmine Germany. The political consolidation of the German state in 1871 accelerated efforts to institutionalize art history at universities, to record and classify historical monuments and to promote knowledge of the national cultural patrimony in newly founded museums.[9]

During the 1880s, and even more so during the 1890s, the number of students of art history at German universities, as well as the number of art historical studies published by German scholars, including those dealing with medieval art, was on the increase. The concern of the present chapter is to explore the situation obtaining in academic art historical spheres in Germany during the formative decade of the 1880s, the student years of Adolph Goldschmidt and Wilhelm Vöge. First, however, in order to put the developments of this decade in perspective, it is necessary to review briefly some of the ways in which artistic monuments, and those from the Middle Ages specifically, had been studied earlier in the century.

FROM THE EIGHTEENTH and early nineteenth centuries onward, lectures on art and art appreciation were relatively commonplace at universities in the German-speaking regions. Such lectures were not offered independently but rather in conjunction with other fields of inquiry, most often history, archaeology, theology and aesthetics.[10] Of greater import for the genesis of the independent discipline of art history was the appearance of the first comprehensive "histories" of art by German scholars during the first half of the nineteenth century. These included, for instance, Franz Kugler's (1808–58) *Handbuch der Kunstgeschichte* (Handbook of art history), published in 1842, and Anton Springer's handbook of the same title, which appeared in 1855.[11] Kugler's innovative *Handbuch* was the first intellectually rigorous attempt to arrange artistic "documents" from prehistoric to modern times into a systematic narrative sequence or pattern. The novel character of this approach reflected the increasingly "objective" and document-based procedures then being established for the study of history.[12]

To texts like these, which predated the professionalization of art history as an academic discipline, we could add the genre of scholarship devoted to the study of regional art and cultural landscapes (*Kunst-* and *Kulturlandschaften*). This sort of study included, for instance, Franz Kugler's *Pommersche Kunstgeschichte* (Pomeranian art history) of 1840 and Wilhelm Lübke's *Die mittelalterliche Kunst in Westfalen* (Medieval art in Westphalia) of 1853. These texts responded in part to the Romantic conviction that particular cultures and temperaments were determined to a great extent by local geographic and environmental conditions.[13] The attempt to locate works of art within their broader historical and cultural contexts assumed more ambitious proportions in Carl Schnaase's (1798–1875) *Geschichte der bildenden Künste* (History of the fine arts), which appeared between 1846 and 1864.[14] In this multivolume work, five volumes of which were dedicated to the Middle Ages, Schnaase painted on a large canvas the artistic monuments and the historical, intellectual and social ambience of the periods which he saw as sponsoring them.

Generally speaking, these histories were concerned with establishing chronological lines of development and were largely empirical. In terms of organization, they followed hierarchical schemes established in earlier centuries by academies of art and reinforced during the nineteenth century

by classificatory methods derived from the study of the natural sciences. The treatments of medieval art embedded within such handbooks reveal a great deal about trends in art historical study of the Middle Ages prior to 1870. The lengthiest sections were devoted to architecture. This is hardly surprising, since medieval architecture had served as a rallying point for patriotic sentiment and had attracted widespread scholarly and popular attention from the late eighteenth century onward.[15]

By contrast, all of the handbooks paid very little specific attention to medieval sculpture. Although authors frequently remarked upon the close relationship of architecture and sculpture during the Middle Ages, they acknowledged at the same time the paucity of information available to them regarding the origins and character of medieval sculpture.[16] Scholarly neglect of medieval sculpture until later decades of the nineteenth century was conditioned to a very large degree by the enduring influence of classicizing norms for sculpture prescribed by Johann Joachim Winckelmann (1717–68) and others during the eighteenth century. This influence was underscored in the first specialized history of the medium of sculpture, Wilhelm Lübke's *Geschichte der Plastik von den ältesten Zeiten bis auf die Gegenwart* (History of sculpture from ancient times to the present), first published in 1863 and issued in an expanded edition in 1871.[17]

Similarly, very little intensive art historical study of medieval painting was carried out during the first half of the nineteenth century. The investigation of illuminated manuscripts, most of which were of a religious nature and small in scale, tended to be confined to the efforts of learned clerics (often the custodians of the manuscripts) or, in some cases, to aristocratic owners or gentlemen-scholars.[18] The coverage devoted to this so-called "minor" art – and to monumental wall paintings of the Middle Ages – in pioneering manuals of painting by scholars such as Franz Kugler was slim in comparison to the attention given to painting from other periods.[19] The study of medieval painting was overshadowed in particular during the nineteenth century by a keen interest in Italian Renaissance painting, initiated by such scholars as Karl Friedrich von Rumohr, J. D. Passavant, Herman Grimm and Joseph Crowe and Giovanni Battista Cavalcaselle and reinforced by the writings of Jacob Burckhardt (1818–97).

An alternative forum for the study of medieval art during the nineteenth century emerged in an area of inquiry referred to as "Christian archaeology." Scholars of this field, many of whom were clerics, studied medieval

religious artifacts as pious documents of a great age of faith. A number of journals dedicated to Christian archaeology emerged all over Europe in the course of the 1840s and 1850s.[20] The journals were frequently connected with programs of moral and religious instruction or liturgical reform promoted vigorously by ecclesiastical authorities who saw their positions weakened at a time of growing secularism. Later in the century certain periodicals for religious art were launched specifically to resist the desanctification that threatened to accompany strictly art historical study of medieval art.[21] In these "Christian" journals, most of which tended to be topically diffuse in nature, isolated articles or notices on individual works of medieval sculpture or painting were interspersed with accounts of subjects ranging from ecclesiastical vestments and chalices to pavement tiles and church bells. Significantly, considerable stress was placed on the iconography or theological meaning of the objects examined rather than on their visual properties.

BY THE TIME of the consolidation of the German empire in 1871 and in the immediately following years, relatively little intensive study of individual works of medieval sculpture or manuscript illumination had been undertaken.[22] Important groundwork had been laid in comprehensive histories of art and of specific media, but such studies, which were directed toward an educated, but not necessarily specialized, audience, cannot be said to have formulated even the most basic critical approaches for the study and interpretation of medieval art. There were no "medieval art historians" or "specialists" of medieval manuscripts or sculpture in the present-day sense. The youthfulness of the art historical discipline as a whole at the outset of the 1880s was described perhaps most clearly by Anton Springer, professor of art history at Leipzig, who proclaimed in 1881 that art history had "barely outgrown its baby shoes."[23]

By the early 1890s, however, a community of ambitious young art history professionals had begun to form. Among them were Wilhelm Vöge and Adolph Goldschmidt. To begin to identify the conceptual stimuli that set in motion Vöge's and Goldschmidt's methodological approaches to the study and interpretation of medieval art is the task to which we now turn. It is first necessary to characterize the broad debates over the nature and methods of art history waged in the 1880s, when their work was starting

to take shape. These debates and the various options proposed seem to have contributed significantly to the strategies they later adopted in the study of medieval art and culture. Along with broader questions pertaining to the formulation of methods for studying the strictly visual character of a work of art, we focus on two issues of particular interest during this decade: first, consideration of the ways in which works of art might be seen as reflecting their historical epoch, and second, the extent to which formal elements can or should be interpreted as vehicles for the ideas and intentions of their period or maker. The discussion that follows here is anchored principally on Vöge's and Goldschmidt's teachers. Although a total recovery of the complex intellectual dynamics of the 1880s is beyond the scope of this study, a fragmentary picture gleaned from an examination of publications and archival documents can provide us with a notion of the typical range of competing intellectual positions to which Vöge, Goldschmidt and their peers were exposed during the 1880s.

THE ACADEMIC ITINERARIES followed by Vöge and Goldschmidt during their years of study display points of intersection as well as divergences. In 1884 Goldschmidt, the older of the two scholars, began his studies at the universities of Jena and Kiel.[24] Facilities for the study of art history had not yet been established at these two institutions, and, after familiarizing himself with the writings of Anton Springer, Goldschmidt transferred to Leipzig in the fall of 1886 to study with that scholar.[25] He completed his dissertation under Springer in 1889. Vöge, on the other hand, began his art historical studies in Leipzig in the summer semester of 1886. He remained in the Thuringian city for two semesters before embarking on an academic pilgrimage that led him to the universities of Bonn, Munich, and Strasbourg. Vöge completed his dissertation at Strasbourg in 1890. A thoughtful retracing of the academic travels of these two aspiring students of art history allows us to sample some of the multiple viewpoints represented within the new discipline during the 1880s. Let us begin by examining their point of common experience, namely, their acquaintance with Anton Springer at Leipzig.

During the 1880s, Anton Springer (Fig. 3) was the most prominent professor of art history in the German empire and one of the staunchest champions of the academic "science" then taking shape.[26] Springer, a younger

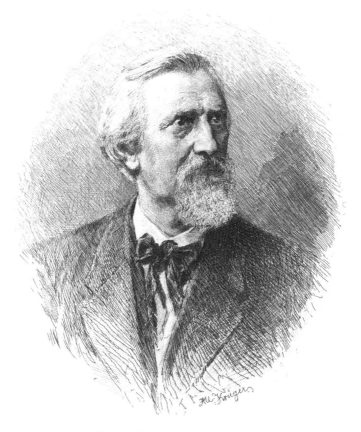

Figure 3. Anton Springer, etching by Albert Krüger. (Photo: after Anton Springer, *Aus meinem Leben*, 1892)

contemporary of Kugler and Schnaase, had had a colorful career that spanned four decades and a number of fields, including political journalism, philosophy, history and art history. He received his doctorate in 1848 with a dissertation on Hegel's philosophy of history.[27] Shortly thereafter Springer turned to the study of art history. During the 1850s he published a number of general art historical studies, which made him well known to a broad public. These included the *Kunsthistorische Briefe* (Art historical letters, 1852–57) and *Die Baukunst des christlichen Mittelalters* (Architecture of the Christian Middle Ages, 1854), as well as his celebrated *Handbuch der Kunstgeschichte* (Handbook of art history, 1855), reissued in many later editions.[28] In 1860 Springer was appointed to the chair of art history established that year at the University of Bonn.[29] In the spring of 1872 he

25

moved to the newly founded University of Strasbourg. Shortly thereafter Springer transferred to Leipzig, where he held the university's first chair of art history from 1873 until his death in 1891.

Springer occupies a central position in the historiography of art history in late nineteenth-century Germany. His importance can be attributed in large part to his success as a teacher, especially during his years in Leipzig. Indeed Springer, more than any other professor of art history in German-speaking Europe during the 1870s and 1880s, can be said to have produced a "school." Among those attending Springer's courses prior to 1885 who went on to careers in universities, museums or art-related fields were Heinrich Brockhaus, Alphons Dürr, Julius Lessing, Alfred Lichtwark, Richard Muther and Woldemar von Seidlitz;[30] among his students in the second half of the 1880s were Gustav Pauli, Harry Graf Kessler, Friedrich Sarre, Max J. Friedländer, Paul Clemen, Cornelius Gurlitt, Adolph Goldschmidt and Wilhelm Vöge.

SPRINGER'S WORK in art history took a number of shapes during his career. His earliest art historical publications of the 1850s, such as the *Handbuch der Kunstgeschichte,* shared the universalizing perspectives characteristic of many handbooks of the period. Reflecting Springer's historical training, these early studies demonstrated his concern with integrating the study of the artistic life of the past with the broader study of cultural history.[31] By his own admission, Springer soon became dissatisfied with this genre of scholarship, perceiving that it conveyed only shallow views of art and cultural history.[32] A fundamental shift in Springer's work occurred in the years around 1860, when he began to concentrate on study of the specifics of art works.[33] Although Springer did not lose sight of the broader historical and social forces he believed gave shape to works of art, his tendency to focus on material and philological detail over the next thirty years may help to explain why he never developed a coherent method for dealing with cultural history.

Springer's activities in the course of the following decades were governed by his desire to win recognition of art history as an academic "science" (*Wissenschaft*) and to place it on equal footing with more established disciplines. An essay that he published in 1881, entitled "Connoisseurs and Art Historians" but comprehending far more than the title suggests, con-

veys a lively sense of the polemics engaged in by this influential promoter of art history.[34] The essay also affords revealing insights into the goals and methodological procedures Springer envisioned for the discipline during these years, when its nature and essence (*das Wesen*) and, even more fundamentally, its legitimacy, were still being questioned in a variety of public and scholarly arenas.[35]

Maintaining that art history was a branch of history, differing from that more venerable discipline in the types of documents studied but not in method,[36] Springer eschewed any form of aesthetic consideration or abstract speculation in the study of artistic monuments, holding that such approaches were grounded in subjective impressions that compromised the objectivity of the ideal art historical enterprise. As he saw it, the primary instrument that permitted an informed understanding of the "laws of development in the visual arts"[37] was the trained eye. For Springer, precise critical knowledge of the object, or what he termed *Detailforschung,* or connoisseurship, was an indispensable component of art historical method.

Springer's program to systematize art history more or less coincided with the introduction of Giovanni Morelli's (1816–91) so-called "scientific connoisseurship." When Morelli first elaborated his theories in a series of articles, which appeared between 1874 and 1876 in the *Zeitschrift für bildende Kunst* under the pseudonym "Ivan Lermolieff,"[38] Springer, like his contemporaries in Vienna, such as Moriz Thausing (1835–84) and Thausing's student Franz Wickhoff, immediately sought support for his own approach in the theories of the Italian senator.[39] Springer's 1881 essay "Connoisseurs and Art Historians" was in fact one of the earliest comprehensive assessments of Morelli's method. Springer and Morelli had probably become acquainted with each other's work prior to the appearance of the articles in the *Zeitschrift für bildende Kunst;* not surprisingly, the Leipzig professor sent an offprint of his 1881 article to Morelli.[40]

Endorsing Morelli's writings in his essay, Springer outlined how comparative study of seemingly insignificant details, or characteristic shapes worked quasi-mechanically by the artist (Morelli's so-called *Grundformen*), could help identify the "signature" or hand of the master and permit a view into his artistic development.[41] In the 1881 article, Springer also pointed to the affinity between this kind of analytical approach to the study of art works and interpretative procedures employed in the natural sciences and medicine.[42] The "scientific" character of this "historical-

genetic" method had already been evoked by Springer in his double biography of Raphael and Michelangelo published in 1878. In the preface to this book, Springer advocated the study of drawings and photographic reproductions as aids to art historical inquiry, likening such tools to the "microscopes" employed by researchers in the natural sciences.[43]

It is clear from the memoirs of Springer's students that Morelli's novel theories attracted much attention in the Leipzig art history seminar during the 1880s. Goldschmidt has left us a description of the kind of comparative exercises carried out in Springer's seminars. The professor would often give each student or the entire class a group of photographs and then solicit opinions regarding date, period and provenance.[44] Goldschmidt's comments are amplified by those of his classmates Gustav Pauli (1866–1938) and Harry Graf Kessler (1868–1937), both of whom recalled that Springer frequently invoked Morelli as an authority in his teaching.[45] In view of these circumstances and considering the general prominence of Morelli in art historical spheres during these years, it is not surprising that the young Goldschmidt paid a visit to the elderly connoisseur in Milan in 1887.[46]

Springer stated in his 1881 essay that, like Morelli, he regarded strict connoisseurship as an aid to art history, but not as its end.[47] In the case of Morelli, it was precisely this point that many of his detractors chose to overlook, declaring that he reduced the study of art to an examination of fingernails, earlobes and the like. Though Morelli himself was not ignorant of issues pertaining to artistic creativity, such considerations were accorded a secondary position in his writings. This was certainly true of Springer's work as well. Beyond making references of a general sort to artistic imagination and spirit, Springer showed little interest in grappling with any psychological complexities or intuitive aspects of the creative process underlying an artist's outward shaping of forms.[48]

Springer placed questions of a more distinctly artistic sort on the sidelines of art historical inquiry, as is manifest in his 1878 study of Raphael and Michelangelo. In this book, he concentrated on detailed formal and iconographic analysis of the artists' works and located these within a more or less straightforward narration of biographical facts. Like many other art historical publications of the time, Springer's documentary, rather than interpretative, approach to the study of these two "great" artists reflected

the dominant genre of historical writing of the period, which concentrated on narrating the events of political history via the lives of great men.[49]

Springer's students were certainly not unaware of the limitations of their teacher's approach. His connoisseurship skills, for instance, were often based on secondhand rather than firsthand knowledge of the original works, as Goldschmidt and others recognized.[50] But, more importantly, Springer the art historian was deeply unartistic in nature, something that became abundantly clear to Gustav Pauli after he attended the lectures of Jacob Burckhardt in Basel.[51] In retrospect, we can see that this lack of artistic sensibility helped condition many of the questions Springer asked, as well as determining those he did not.

Springer's overriding concern with forging a secure scholarly technique for art history and his concomitant rejection of aesthetic considerations, put him at the opposite conceptual pole from those who in the same years stressed the humanity embodied in art works as the proper point of departure for art historical inquiry. One of the chief proponents of this position was a scholar of a younger generation, Robert Vischer (1847–1933), son of the celebrated aesthetician Friedrich Theodor Vischer (1807–87).[52] Though he is often overlooked today, Robert Vischer, whose cross-disciplinary work drew on the fields of aesthetics, philosophy, art history and psychology, played an important catalytic role in defining German art history of the 1880s. A brief consideration of Vischer's views can help illustrate some of the highly variable tensions between "science" and "humanity" existing within the intellectual range of art history during the period. Significantly, too, Vischer's alternative formulations would have been known to Springer's students, because their teacher clashed publicly with the younger scholar.

One of Vischer's first publications of an art historical nature was his highly polemical *Kunstgeschichte und Humanismus* (Art history and humanism) of 1880.[53] In this spirited treatise Vischer criticized the developing discipline of art history for becoming overly concerned with the pursuit of facts and documents rather than centering on the creative act and imagination. He held the community of supposedly "objective" art historians up to ridicule, asserting that their "one-sided" and "Darwinian" approach left no room for an appreciation of the art work as the product of a living human being with imagination and feelings.[54] Springer was among the art

historians whom he attacked by name. Vischer called for the destruction of what he termed "false barriers" between art history and aesthetics, in order to encourage an understanding of the material and of the more strictly creative dimensions of artistic practice.

Vischer's critical portrayal of the trends he saw crystallizing in art history brought to the fore a number of fundamental issues regarding the nature and perception of artistry and posed the question of how these were to be addressed within the art historical enterprise.[55] His insistence that empirical study of the external, formal language of an object could not sufficiently comprehend the experiential qualities of the artistic *Geist* (intellect or spirit) embedded within it introduced a note of variability into a purportedly rational system. At a time when attempts were being made to achieve recognition of art history as an autonomous and serious discipline, however, Vischer's theoretical stance and heated polemics were considered by many to be dangerously radical, and by the end of the 1880s he came to occupy a place on the margins of art history. Indeed the more established voices in the field, especially Anton Springer, challenged Vischer with vehemence. Springer's 1881 essay "Connoisseurs and Art Historians," for instance, in which he stressed the scientific nature of Morelli's method, appears to have been intended at least in part as a counterattack against Vischer.[56]

In 1886 Vischer published a series of collected essays under the title *Studien zur Kunstgeschichte* (Studies in art history).[57] In this work, Vischer moved even farther in his attempt to bridge an increasingly material-based art history with a kind of psychological aesthetics. In 1887 Springer published a scathing review in which he caricatured Vischer as a child pursuing false goals colored by his own vagaries in mood.[58] Echoing his earlier writings, Springer stressed the necessity of detached and strictly controlled observation for uncovering the laws of artistic development. To support his argument, he referred to the document-based historical school of Leopold von Ranke (1795–1886), indicating again the degree to which the fledgling discipline deferred to established intellectual standards in the historical profession during these years.[59]

In an account of Springer written in the first half of the 1920s, Wilhelm Waetzoldt described the eminent Leipzig professor as a positivist who approached problems in art history with the belief that they were wholly "understandable" and "describable."[60] Springer's confidence in the validity

and informative power of science certainly marked him as a man of his age, yet his method also responded in large part to the exigencies of the moment, as Springer perceived them. At a time when art history was dismissed in many circles as a field practiced by antiquarians, dilettantes and those pursuing arbitrary and undefined matters of taste, Springer saw the implementation of exacting interpretative procedures as a way to establish the credibility of the field. In retrospect, his effort to promote a systematic art historical "science" might be considered as having provided a positive dialectic at this point in history.[61]

Springer's autobiography and the memoirs of his students provide insights into this scholar's impact in the classroom during the 1880s. In his earlier years, Springer had enjoyed a wide reputation as a fiery and inspiring orator, and according to Goldschmidt, Paul Clemen and Harry Graf Kessler, these skills endured well into the 1880s.[62] Of particularly far-reaching significance is the fact that much of Springer's research during this decade concentrated on medieval manuscripts. In 1880 he issued a sort of manifesto in which he called for art historians to direct increased attention to the study of medieval manuscripts.[63] He responded to the call in his own work of the 1880s, publishing a number of pioneering studies of early medieval manuscripts, including *Die Psalter-Illustrationen im frühen Mittelalter mit besonderer Rücksicht auf den Utrechtpsalter* (Early medieval psalter illustration, with special consideration of the Utrecht Psalter, 1880), *Die Genesisbilder in der Kunst des Mittelalters mit besonderer Rücksicht auf den Ashburnham-Pentateuch* (Genesis cycles in medieval art, with special consideration of the Ashburnham Pentateuch, 1884) and *Der Bilderschmuck in den Sakramentarien des frühen Mittelalters* (Pictorial decoration in sacramentaries of the early Middle Ages, 1889).[64] In these studies Springer concentrated on constructing broad genealogies and families of Western medieval manuscripts by sorting and grouping them according to the artistic and iconographic currents he recognized in them.

Springer encouraged his students to study the iconography as well as the visual characteristics of medieval illuminated manuscripts in relation to liturgical and literary texts of the period – hymns, psalms, mystery dramas, epic poems and so on. He saw in literary sources a potential key to deciphering the visual culture of the Middle Ages. In Springer's view, close familiarity with medieval texts allowed the art historian to detect comparable iconographic "laws" or visual conventions within large groups of

manuscripts and to understand their significance within medieval culture. This is probably the form of cultural historical study in which Springer met with greatest success. Within German art history, Springer can be largely credited with extricating the study of medieval iconography from the predominantly ecclesiastical ambience in which it had resided until then.[65] Although a number of students profited from his expertise in manuscript studies and his comparative intertextual work during the 1880s, it appears that it was his doctoral student Adolph Goldschmidt for whom this training proved ultimately most fruitful.

WHEN WILHELM VÖGE (Fig. 4) transferred to the University of Bonn in May of 1887, he encountered an art historical scene that differed in a number of respects from that in Leipzig. Though a chair of art history had been established at the Rhenish university in 1860, there were no art history majors (*Vollkunsthistoriker*) at Bonn until the second half of the 1880s.[66] Upon his arrival Vöge found that he was one of only four students of art history, all of whom were in the relatively early stages of study. Among the other three was Aby Warburg (Fig. 5), with whom Vöge would form a lifelong friendship.[67] In the fall of 1887 they were joined by Paul Clemen (Fig. 6), who transferred to Bonn from Leipzig, largely on the advice of Vöge.[68]

Conforming to broad trends in the art history curriculum of German universities during the late nineteenth century, the work of the two men teaching art history at Bonn centered on the Italian Renaissance and related periods. The scholars in question were Carl Justi (1832–1912), a full professor, and Henry Thode (1857–1920), who had recently completed his *Habilitationsschrift*, or postdoctoral thesis (Figs. 7, 8).[69] Thode was only ten years older than his students, and according to Vöge he cut an elegant figure, providing a vivid contrast to the "grand old man," Anton Springer.[70] Thode was the son-in-law of Cosima Wagner, second wife of the composer Richard Wagner (1813–83), and his membership in the inner Wagnerian circle profoundly affected the character of his art historical scholarship, which at times tended toward undisguised hero worship.

In his *Habilitationsschrift* of 1885, *Franz von Assisi und die Anfänge der Kunst der Renaissance in Italien* (Francis of Assisi and the beginnings of Renaissance art in Italy), Thode studied the role of Saint Francis (d. 1226)

and the Franciscan order in shaping the character of trecento and quattro-cento art.[71] In this account he also re-created, in dramatic fashion, the personalities and intensely emotional lives of historical figures such as Saint Francis and Giotto. Vöge's transcripts show that he took five courses with Thode during the three semesters he spent at Bonn, including two that treated great artists of the Italian Renaissance, such as Donatello and Michelangelo.[72] During the winter semester of 1887–88, Vöge and his fellow students attended Thode's lecture course "Richard Wagner and the Work of Art in Bayreuth."[73] It is clear from the nature of Thode's scholarship that in courses such as these, which examined great masters of the distant and recent past, the young *Privatdozent* (lecturer) emphasized the role of the creative and heroic genius in inventing the truly great work of art.

Unlike the flamboyant and effusive Thode, Carl Justi, the senior art historian at Bonn, was a withdrawn and monkish scholar who commanded respect for the wide range of knowledge manifested in his publications rather than for his teaching skills.[74] Along with Warburg and Clemen, Vöge enrolled in Justi's courses on Vasari's *Vite,* on Netherlandish and German painting of the sixteenth to eighteenth centuries and in a course dealing with aesthetics and the visual arts.[75] Justi's work drew on his extensive background in philosophy, theology and history, and he could be termed a sort of cultural philosopher. His scholarship centered on the writing of biographies of "great men," among them Winckelmann, Velasquez and Michelangelo.

Justi dismissed a "mechanistic" art history grounded in evolutionary or biological schemes or in unreflective study of visible, material fact. Instead he sought to penetrate into the deep phenomenological dimensions of creative genius and to study the forces unleashed by such exceptional individuals in relation to an all-embracing cultural panorama. The comprehensiveness of Justi's vision was manifested in his celebrated monograph on Diego Velasquez, which appeared in 1888 while Vöge was in Bonn.[76] In this book Justi wove his visions of the "incommensurability of genius," and of the life and customs of seventeenth-century Spain, into a richly textured tapestry.[77] Justi was a master of the German language, and his literary talent contributed much to the evocative power of his scholarship. Although his approach to art history was highly individualistic, its primary focus was a particular type of *Künstlergeschichte,* namely, the history of great artists.

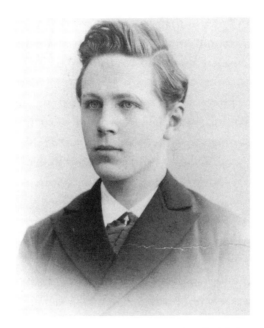

Figure 4. Wilhelm Vöge as a university student. (Photo: Klaus Dziobek and Ursula Hausen)

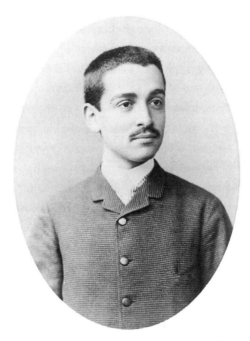

Figure 5. Aby Warburg as a university student. (Photo: Warburg Institute)

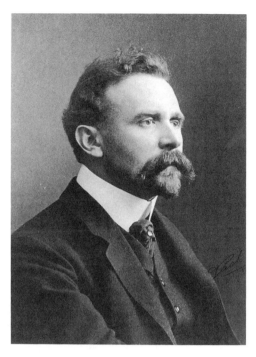

Figure 6. Paul Clemen, ca. 1900. (Photo: Courtesy of the Harvard University Archives)

MORE THAN the art historians Thode or Justi, however, it was a young professor in the history seminar who became Vöge's chief mentor at Bonn. This historian was Karl Lamprecht (Fig. 9), best known today for his twelve-volume *Deutsche Geschichte* (German history, 1891–1909) and three-volume *Deutsches Wirtschaftsleben im Mittelalter* (German economic life in the Middle Ages, 1885–86).[78] This highly energetic scholar had begun his career at Bonn in 1880 and, by the second half of the decade, was already acknowledged as the leading force in the junior ranks of the German historical profession. Significantly, the type of history Lamprecht practiced did not conform to the established conceptual boundaries of the academic discipline, which prescribed a document-based form of political history modeled on the work of Leopold von Ranke and his followers.[79] Instead Lamprecht tried to develop a "scientific" and comprehensive form of cultural history, in which he innovatively assigned a central role to art. He was in the process of constructing the theoretical scaffolding of his *Kulturgeschichte* when the first group of art history majors at Bonn – including Vöge, Warburg and Clemen – enrolled in his courses.[80]

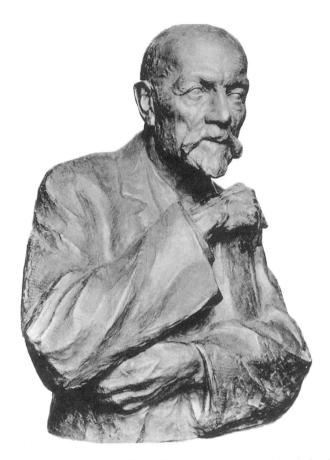

Figure 7. Carl Justi, bronze bust by Gisela Zitelmann, 1911, Kunsthistorisches Institut der Rheinischen Friedrich-Wilhelms-Universität, Bonn. (Photo: Rheinisches Amt für Denkmalpflege, Abtei Brauweiler)

Lamprecht's unconventional approach to the study of history stemmed in part from his unorthodox intellectual background. During his student years (1874–79), he strayed from the well-trodden path of political history, directing his attention instead to philosophy and to the developing fields of economic history and art history. He in fact spent a semester studying art history at the University of Munich.[81] Lamprecht was also greatly influenced in his formative years by the writings of the Swiss cultural historian Jacob Burckhardt and by that scholar's rich portrayals of Italian Renaissance history and culture in studies such as *Die Kultur der Renaissance in Italien* (The civilization of the Renaissance in Italy), first published in

36

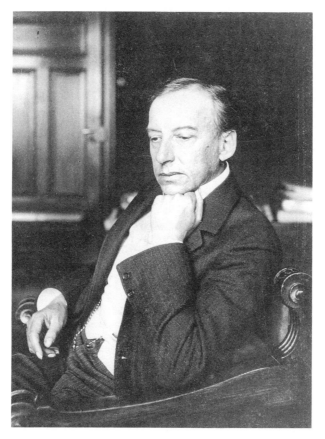

Figure 8. Henry Thode. (Photo: Kunsthistorisches Institut der Rheinischen Friedrich-Wilhelms-Universität, Bonn)

1860.[82] The inquisitive young man's ambition to formulate a kind of *histoire totale* predated the completion of his university studies.

In 1880, with the aid of his patron Gustav von Mevissen (1815–99), an enlightened businessman, lawyer and railway magnate from Cologne, Lamprecht secured a teaching position in the history seminar at the University of Bonn.[83] He remained there until 1890, when he transferred to the University of Marburg and then, in 1891, to Leipzig. During his years in the Rhineland, Lamprecht constructed the intellectual framework for a comprehensive history of civilization, especially German civilization.

Although he was greatly influenced by the older generation of German-speaking scholars writing cultural history – particularly Burckhardt – Lamprecht articulated a distinctly more "modern" position for cultural

Figure 9. Karl Lamprecht, ca. 1890. (Photo: Amata Niedner)

history. He strove, during the 1880s, to incorporate into his conceptual scheme the latest scientific findings of disciplines like psychology, sociology, anthropology and art history, all of which were in the process of being institutionalized at German universities. Although Burckhardt had drawn on a broad spectrum of knowledge for publications such as *Der Cicerone* (1855) or *Die Kultur der Renaissance in Italien,* his study of nonhistorical areas of inquiry was less programmatic and less comprehensive in scope than Lamprecht's. Burckhardt's cultural historical writings, like the cultural studies published by Anton Springer, were directed principally toward a humanistic ideal of education (*Bildung*). Lamprecht, on the other hand, stressed a more systematic and "scientific" approach to interdisciplinary research. During the 1880s, then, Lamprecht's updated conception of cultural history as a genuinely interdisciplinary enterprise represented the vanguard of cultural historical scholarship.

Because of deeply entrenched research biases within the German historical profession, however, academic historians considered cultural history a barely legitimate branch of the profession. In their view, it was amorphous by definition, its only distinguishing feature being a lack of regard for political history. Academic historians viewed cultural history, like art history, as a field of endeavor best left to dilettantes rather than as a prerogative of serious scholars. In his recent intellectual biography of Lamprecht, Roger Chickering has emphasized that cultural history was widely regarded, by the late nineteenth-century German historical community, as an *Oppositionswissenschaft*, or counterdiscipline, having negative, or even subversive, connotations.[84] Thus, by subscribing to a broadly based approach to history Lamprecht clearly recognized that he was taking a significant professional risk.

From the outset, his unconventional work aroused certain suspicions. Nevertheless, Lamprecht's efforts achieved considerable recognition during the 1880s. But the situation changed for the worse with the appearance of the first five volumes of his *Deutsche Geschichte* (1891–95), in which he portrayed German civilization over the centuries as an orderly progression through successive stages of consciousness, or what he termed *Kulturzeitalter*. Hostilities with the historical establishment escalated into full-fledged warfare. During the 1890s Lamprecht's cultural historical work in fact served as the primary focus of a bitter and broadly based methodological dispute (*Methodenstreit*) within the German historical community.[85]

Much of the criticism leveled by German historians was easily justified, for Lamprecht's work displayed a wide range of mechanical and conceptual flaws that arose in part from his impatience and his inclination to work as quickly as possible.[86] Lamprecht never reconsidered what he had written, sending his unedited manuscripts directly to the press. Although he read voraciously, he never took the time to digest fully what he had read. Thus, diverse and often conflicting strands of thought, randomly borrowed from a wide variety of sources, were linked in his work. The "extraordinary mélange of ideas that coexisted unstably in his capacious grasp," as Chickering has described it, was evinced most clearly in the *Deutsche Geschichte*.[87] Lamprecht's combative personality and lack of capacity for self-criticism only worsened the situation.

Although Lamprecht was ultimately discredited by his historically orthodox opponents, he was without doubt the most imaginative thinker

within the German historical community during the late nineteenth century. During the 1880s, when he was teaching in Bonn, the controversy surrounding his work had scarcely begun. Indeed this decade represents the most creative period in Lamprecht's thought, as well as the period of his greatest success. It is from this perspective that we need to consider his activities at this time, remembering that it was the body of work produced before 1890 that the young art history students Vöge, Clemen and Warburg knew.

During his years in the Rhineland, Lamprecht's cultural historical work, in contrast to that of Burckhardt, focused on the Middle Ages. This was not owing simply to his preference for this era over the more popular Renaissance. Lamprecht believed that the Middle Ages afforded a vital glimpse into the "youth" of the collective life of the German people and nation.[88] His belief in the "national" significance of the Middle Ages reflected an ideology that was deeply rooted in the political fabric of nineteenth-century Europe, and that acquired new urgency following the emergence of the German state.

During the 1880s, Lamprecht made important forays into art history in the process of constructing his cultural history program.[89] His belief that the history of a particular moment must be studied in all of its manifestations encouraged him to draw analogies between forms of material culture, such as political institutions and economic structures, and the manifestations of "ideal" or intellectual culture, which in Lamprecht's view embraced artistic and literary phenomena, music, philosophy and the like. He came to view the visual arts as the only clear manifestation of intellectual culture that could offer privileged access to the mentality (*die Mentalität, die Volksmentalität, die Volksseele*) of a period.

Lamprecht's attempt to construct a picture of a particular historical period through its art was not without precedent. A similar aim had been articulated earlier in the century in some of the universalizing histories of art – for example, Anton Springer's *Handbuch der Kunstgeschichte* and Carl Schnaase's *Geschichte der bildenden Künste*. Other models existed in writings of the French historian Hippolyte Taine (1828–93) and, above all, in the work of Jacob Burckhardt, which influenced Lamprecht from the earliest years of his intellectual formation. Like these scholars, Lamprecht saw works of art as distinctly legible barometers, in visual form, of the central outlooks or sensibilities of the society in which they were produced. Unlike

earlier scholars, however, whose positing of an essential unity between art and broader historical structures had rested on generalities, Lamprecht set out to provide specific demonstrations of his hypotheses. He also tried to contain the grand scope of his undertaking by imposing a periodization scheme that systematically divided German history into a succession of cultural epochs characterized by a stepwise advance of psychic differentiation.[90]

Lamprecht's programmatic desire to comprehend the Middle Ages in all of its dimensions led him to experiment with new methodologies. In his monumental *Deutsches Wirtschaftsleben im Mittelalter* (German economic life in the Middle Ages), published between 1885 and 1886, for instance, Lamprecht sought to construct a "total" view of the material culture of the Mosel region by studying the interactive dynamics of topography, demography and economic behavior, as well as of the religious and legal structures of the region.[91] According to Lamprecht's scheme, happenings in the material realm provided the catalyst for developments in the ideal or intellectual realm, where aesthetic sensibilities, tastes and moral attitudes took shape. Drawing on a system of analogies, he proceeded to posit the mutual dependency of the two realms. In this system, fundamental commonalities linked all dimensions of human experience at any given moment.[92] Lamprecht's assumptions about the reciprocal impact of the material and the ideal realms, as well as his tendency to abstract grand visions from the study of particulars, were grounded in "audacious speculation," as Chickering has observed.[93] Furthermore, many of the historian's arguments were based on an arbitrary selection of evidence.

But regardless of the weaknesses apparent in Lamprecht's highly unsystematic "system," the process of conceiving it in the 1880s encouraged him to investigate the visual arts as a kind of analytical shortcut to understanding the mentality and psychological behavior (*Seelenleben*) of an era. It is also especially significant for Lamprecht's study of visual materials during these years that his historical work concentrated on the early Middle Ages, an era for which consistent written documentation was often lacking. Given Lamprecht's métier as an historian, it is perhaps not surprising that his study of the visual arts focused on illuminated manuscripts. During the first half of the 1880s he published an astonishing number of articles and books on early medieval manuscripts, including a ground-breaking study of the late tenth-century Codex Egberti in Trier and of the early eleventh-

century Golden Gospels (Codex Aureus) of Echternach, as well as a book, *Initial-Ornamentik des VIII. bis XIII. Jahrhunderts* (Decorated initials from the eighth to thirteenth centuries), which appeared in 1882.[94]

In these studies, Lamprecht drew no firm distinction between his art historical and historical practice. In his 1881 article on the Codex Egberti and Golden Gospels of Echternach, for instance, he began by analyzing and comparing the condition, scripts and texts of the two codices, as well as the sequence, iconography and style of their illuminations. He then examined these elements in relation to the manuscripts' larger historical backdrop. At the time, this kind of comprehensive questioning of individual medieval monuments was virtually unknown in art historical circles. Lamprecht's novel approach is well illustrated by his book on artistic ornament, in which he studied decorated initials from the eighth through thirteenth centuries. On the one hand, this study demonstrated Lamprecht's acute powers of observation and his familiarity with the "scientific" art historical procedures then being introduced – he dissected and compared individual elements of the initials in a "Morellian" fashion, for example – and, on the other, it showed his concern to situate the study of specifics within a broad historical and cultural matrix. In this study Lamprecht portrayed, for the first time, the evolution of what he regarded as a specifically German ornamental sensibility from the period of the tribal wanderings to the era of the Hohenstaufen.

Lamprecht's art historical pursuits, his studies of manuscripts in particular, led him to establish regular contact with art historians. His work was praised by Anton Springer in Leipzig, whose own work during the 1880s concentrated on manuscripts.[95] Lamprecht was also in close contact with the handful of other manuscript scholars active at the time, including Léopold Delisle (1826–1910), at the Bibliothèque Nationale, and Hubert Janitschek (1846–93), professor of art history at the University of Strasbourg. In addition, Lamprecht's work was widely reviewed in art historical journals, and he published in the *Repertorium für Kunstwissenschaft*.[96]

By 1887 and 1888, when Vöge, Warburg and Clemen enrolled in Lamprecht's courses at Bonn, the *Deutsches Wirtschaftsleben im Mittelalter* had appeared, and the historian was dividing his boundless energies among a number of other projects. One of these was a collaborative investigation of the so-called Ada Gospels, a manuscript connected with the court school

of Charlemagne in the years around 800. As the initiator of this project, Lamprecht enlisted the skills of five other art historians and historians, in order to reach the most comprehensive understanding of the manuscript possible, for he intended this major exploration to shed new light on a particularly crucial moment in the genesis of the German nation.[97] His method of employing specialists from different fields for a monographic study of a manuscript, common in manuscript studies today, represents, it seems, the first endeavor of this sort. The monumental tome *Die Trierer Ada-Handschrift* appeared in 1889, accompanied by full-scale chromolithographs and photographs. It was greeted enthusiastically by scholars of art history, for they recognized that it provided an outstanding methodological model and highly visible stimulus for the developing field of manuscript studies.[98]

Lamprecht's conception of such innovative projects, and his broad approach to the study of art and culture, made a deep impression upon the young listeners attending his classes at Bonn. At the time, Lamprecht, like Thode, was only about ten years older than his students, so he was more like an older brother than a distant scholar in the mold of Justi. Moreover, like Anton Springer, Lamprecht was a gifted speaker and engaging pedagogue. A number of students in Bonn penned vivid descriptions of his "gripping" lectures.[99] Vöge declared that he found Lamprecht's view of history "fresh" and "invigorating" for his own work in art history, for Lamprecht did not concentrate on a mere accumulation of facts and data but rather on cross-sectional and interdisciplinary avenues of inquiry.[100] Vöge enrolled in a total of seven courses with Lamprecht during the three semesters he spent at Bonn,[101] which far exceeded the number of courses he took with either Justi or Thode.

During the winter semester of 1887–88, Lamprecht offered a seminar on the development of German cultural history, as well as a tutorial on German economic history. As Paul Clemen's unpublished memoirs reveal, only four students attended the latter course, all of them art history majors, including himself, Vöge and Warburg.[102] Because Aby Warburg kept most of the papers he accumulated in the course of his lifetime, his lecture notes from Lamprecht's course on German cultural history survive.[103] They offer rare insight into the remarkable range of ideas and methodological perspectives that Lamprecht imparted to his students. Furthermore, it was

precisely at this moment that Lamprecht was working out the conceptual framework for his *Deutsche Geschichte*. Thus, Warburg's lecture notes bear witness to an exceptionally fertile moment in Lamprecht's thought.

After presenting an historical survey of "antiquarian" understandings of *Kulturgeschichte* formulated by figures such as Descartes, Rousseau, Hegel, Taine, Buckle and Darwin, Lamprecht constructed a theoretical edifice for a modern cultural history. Drawing on an extensive bibliography, Lamprecht outlined the disciplines that complemented cultural history, such as constitutional history, linguistics, the history of literature, art history, economic history, anthropology and social psychology (*Volkspsychologie*). The bibliography alone, which Lamprecht communicated to the art history students, was extraordinary in scope. The remainder of the course examined the various phases he perceived in the progressive unfolding of the German national consciousness.[104]

Warburg's notes indicate clearly that Lamprecht's consideration of the "total" aspects of the cultural behavior of a period – ranging from economics and literature to the rituals and social customs of a given era – offered a rich interdisciplinary framework for the study of artistic monuments. Not only did Lamprecht convey to Vöge, Warburg and Clemen the notion that works of art were permeated with the psyche and collective mentality of their time, but his own work also served as a demonstration that scholarly inquiry in art history could and should combine the study of specific detail with broader, synthetic concepts.[105] Furthermore, the fact that Lamprecht's work at this time concentrated on medieval manuscripts rather than on Renaissance painting widened the investigative focus of art history materially as well as conceptually.

With reference to the broader panorama of academic politics, we must bear in mind that Lamprecht's practice of art history as cultural history occurred during years that also saw a clear opposing movement to separate art history from neighboring disciplines such as history and cultural history. During the early 1890s, for instance, Heinrich Wölfflin, who had studied under Burckhardt, consciously turned away from the broad cultural perspectives of his teacher and focused instead on study of the internal dynamics of art, especially as related to formal properties.[106] In broadly conceived terms, then, we must view Lamprecht's practice of an updated cultural history – then on the frontiers of knowledge – as representing one powerful but not uncontroversial option, conceptually speaking, for art

history at an important crossroads in the development of European histori-
cal thought generally.

IN THE FALL OF 1888, Vöge left Bonn for Munich, where he enrolled
for two semesters at the university.[107] His chief goal was to acquaint himself
with the rich art collections in the Bavarian capital. Vöge's stay in Munich
was likely recommended by Lamprecht, who had undertaken a similar
venture ten years earlier.[108] The prime objects of Vöge's study were the
manuscript holdings of the Hof- und Staatsbibliothek, and in fact his cor-
respondence shows him engaged in preliminary work for his dissertation
on Ottonian manuscripts.[109] Besides tracing or drawing a number of images
(Fig. 10) as he had done elsewhere to assist him in comparative study, for
example, in Trier (Fig. 11), Vöge also purchased a camera, an advanced
piece of technology at the time.[110] As Springer had emphasized earlier,
this kind of "microscope" potentially lent new accuracy and precision to a
rigorous, object-based art history. Vöge familiarized himself with the cam-
era's operation in the course of a number of research trips to other manu-
script repositories, including the diocesan library in Bamberg.[111]

Intellectually speaking, however, it is clear from Vöge's letters to family
and friends that the classroom component of his education was essentially
completed before he reached Munich. He attended lectures in history and
art history only fitfully at the university, finding that the professors paled
in comparison with those he had encountered in Bonn.[112] Therefore he
abandoned the idea of submitting his dissertation at Munich and trans-
ferred instead to the University of Strasbourg, where he rejoined his
friend Warburg.[113]

Hubert Janitschek (Fig. 12) occupied the chair of art history in Stras-
bourg. He had received his university training in Graz and Vienna and had
been a curator at the Austrian Museum of Art and Industry as well as a
professor at the University of Prague before his appointment to the Uni-
versity of Strasbourg in 1881.[114] He was principally a scholar of Renais-
sance art, and his earliest publications included a book on Leon Battista
Alberti's theoretical treatises (1877) as well as a study of art and society in
Renaissance Italy (1879).[115] In 1883, however, his work changed direction
when he embarked upon a long-term project to write a history of German
painting. Many of his publications during the 1880s concentrated on

45

Figure 10. Pencil tracings executed in 1888 or 1889 by Wilhelm Vöge, of individual figures and motifs in Ottonian manuscripts held in the Staatsbibliothek in Munich. Three pieces of tracing paper, later inked and mounted on cardboard. (Photo: Landesamt für Denkmalpflege Sachsen-Anhalt, Halle)

Figure 11. Drawing of Saint Gregory and his scribe, by Wilhelm Vöge, executed in 1887 or 1888 after the *Registrum Gregorii*, single leaf, ca. 984, Trier, Stadtbibliothek, Ms. 171/1626. Tracing paper, later mounted on cardboard. (Photo: Landesamt für Denkmalpflege Sachsen-Anhalt, Halle)

Figure 12. Hubert Janitschek, 1880s. (Photo: Collection of the Bibliothèque Nationale et Universitaire, Strasbourg)

manuscript illumination, especially of the Carolingian period.[116] It was largely owing to these new interests that he was in regular contact with Springer and Lamprecht during this decade. He collaborated with Lamprecht in the *Trierer Ada-Handschrift* project, discussing the art historical significance of the manuscript in relation to the various schools of Carolingian painting.

Surviving correspondence shows that Lamprecht played a mediating role in the decisions of Warburg, Clemen and Vöge to complete their studies in Strasbourg under Janitschek.[117] It was probably Janitschek's interest in the broad dimensions of Renaissance art and culture that prompted Lamprecht to recommend the Strasbourg professor to Warburg. In 1892 Warburg defended his dissertation on Botticelli's mythological paintings

The Birth of Venus and *Primavera*.[118] However, it was Janitschek's field of research in the second half of the 1880s, namely, medieval manuscripts, that attracted both Clemen and Vöge. Apart from Springer, with whom they had both studied earlier, there was then virtually no other art historian at a German university under whose supervision a dissertation on medieval manuscripts could have been written. Janitschek was in the final stages of his *Geschichte der deutschen Malerei* (History of German painting, 1890) when the three young men arrived in Strasbourg. Clemen completed his dissertation on images of Charlemagne, a topic suggested to him by Lamprecht, in 1889.[119] The following year Vöge finished his thesis on Ottonian manuscripts.

By all accounts, Janitschek was not a scintillating intellect nor an inspiring teacher. Vöge's and Clemen's correspondence, as well as the memoirs of Gustav Pauli, who studied briefly in Strasbourg, portray Janitschek as a kindly figure but absorbed almost entirely in work for his history of German painting, as well as in his duties as editor of the *Repertorium für Kunstwissenschaft*.[120] For these reasons, it appears that his influence on the methodologies adopted and developed by his students was not as extensive as that of Springer or Lamprecht. Indeed it is possible that Janitschek allowed his more gifted students a greater degree of independence than they might have found working with a stronger intellect.

To summarize briefly, a retracing of the most significant steps in the academic routes followed by Goldschmidt and Vöge during the second half of the 1880s helps us gauge the range of methodological perspectives to which they were exposed. By virtue of his more extensive travels, Vöge was exposed directly to a broader spectrum of ideas than was Goldschmidt.[121] As we have seen, Professors Springer, Justi, Thode, Lamprecht and Janitschek represented vastly different points on the intellectual and methodological scale of art history during the 1880s, and archival materials confirm that their students recognized this. The approaches of these scholars ranged from the exacting philological method of Springer and the cult of great artist-heroes espoused by Thode to the kaleidoscopic views of art and cultural history offered by Lamprecht.

Documents from the period as well as memoirs of students indicate that the venerable Springer and young Lamprecht were the most influential of

these figures. Both men were stimulating teachers; this role cannot be underestimated at a time in the history of art historical instruction when the spoken word carried greater weight than the image.[122] Both Goldschmidt and Vöge had direct experience of Springer, whose mission to anchor and defend art history as an autonomous academic discipline led him to promote a "scientific" method adhering closely to interpretative procedures in the natural sciences. Rejecting any form of aesthetic consideration, Springer practiced a disciplined and objective art history focusing on critical examination of the external language of artistic monuments. Yet it would be incorrect to view Springer's documentary approach as narrowly confined, for his cultural historical background guaranteed that he would remain to a certain degree sensitive to the role of art in broader historical contexts. In addition, he was well acquainted with the tools of historical research. These interests intersected perhaps most productively in his work on medieval manuscripts and iconography during the 1880s.

Vöge's encounters with Lamprecht coincided with the most creative period in the historian's career. During the 1880s Lamprecht was engaged in joint activities as an interpreter of art and an interpreter of culture. Although Lamprecht's work overlapped somewhat with that of Springer, the younger scholar's interdisciplinary work offered wide-ranging perspectives and was rich in speculation, whether concerned with the investigation of economic trends or the study of medieval manuscripts. As conversant with principles of connoisseurship as he was with analyzing tax records or land registers, Lamprecht attempted to master specific details and to extract comprehensive visions from them. His articulation of an updated *Kulturgeschichte* provided a number of provocative suggestions concerning the historical role of art. In Lamprecht's view, as we have seen, the visual arts represented that manifestation of the intellectual realm best suited to disclose the mentality of an era.

We cannot expect that these teachers and the theoretical positions they represented were the sole factors that helped condition Goldschmidt's and Vöge's scholarly work from the late 1880s on. However, it seems appropriate to ask whether any of these ideas can be detected in the configuration of their earliest scholarly undertakings, their dissertations.

Goldschmidt's 1889 doctoral thesis examined sculpture and painting in

the Hanseatic city of Lübeck between the fourteenth century and 1530.[123] As he pointed out in the introduction, scholarly study of medieval art in the Baltic region had, until then, focused exclusively on architecture.[124] Thus, in this study Goldschmidt made the first attempt to situate late medieval sculpture and painting of the northern German city within both local and international contexts. Young Goldschmidt's approach, which combined precise descriptions of the monuments with consideration of historical evidence, clearly reflected his training under Springer in Leipzig.

Goldschmidt began by sketching the importance of Lübeck as a trading center in the late Middle Ages, outlining the impact of these economic ties on art production.[125] Before proceeding to an analysis of the monuments, he examined the conditions of patronage, especially the role played by corporations in commissioning altarpieces and other works of sculpture and painting for city churches. Goldschmidt's visual acumen was demonstrated by his finely differentiated observations of the monuments, which in some cases led him to attribute them to specific artist-masters. His attempts to associate artists with specific commissions were supplemented by a list of masters for whom documentary evidence could be found in Lübeck archives.[126] Goldschmidt admitted that he did not have sufficient documentation to allow him to reconstruct the artists' individual or collective personalities; instead he envisioned the list of names as an aid to further research.[127] Significantly, too, Goldschmidt's monograph was among the first art historical publications in Germany to be accompanied by large, high-quality photographs. This scientific imaging medium lent important support to Goldschmidt's precise descriptions of the formal and iconographic character of the monuments.[128] The significance of his pioneering study was recognized by its reviewers, who unanimously praised both the conception of the project and the results.[129]

Goldschmidt's adherence to the interpretative principles endorsed by Springer is not surprising, given that the work was to be approved by him: indeed Goldschmidt dedicated his dissertation to Springer. Vöge, on the other hand, had a more complex decision to make. His university training had exposed him to a wider variety of approaches that could conceivably be applied to the study and interpretation of medieval art. In his Strasbourg dissertation, completed in July of 1890 and published in 1891, Vöge reconstructed an important school of Ottonian manuscripts associated today

with the scriptorium in Reichenau.[130] The dissertation of over four hundred pages submitted by the twenty-two-year-old exhibits a comprehensive command of issues pertaining to paleography, textual analysis, iconography and text–image relationships. Not surprisingly, the examiners at Strasbourg lauded its remarkable display of erudition and intellectual ingenuity.[131] Vöge indicated in the introduction that he had taken Lamprecht's *Die Trierer Ada-Handschrift* as the point of departure for his study.[132] In fact Lamprecht's support of Vöge's manuscript studies went even farther than providing a scholarly example: the historian arranged for his own patron, Gustav von Mevissen, to give a generous subsidy toward the publication of Vöge's thesis.[133]

Vöge carefully outlined his methodological approach in the introduction. Because manuscripts of the Ottonian period had been virtually unstudied until then, he asserted that he had been compelled to establish a foundation by attempting to delineate the identifying characteristics of one group of manuscripts.[134] He advocated connoisseurship and a trained eye as the most important tools for determining relationships among widely scattered works and for discerning "order" where it had not been recognized before. In his own words, he aimed to create "an organic and well-defined whole from chaos."[135]

Vöge's dissertation, *Eine deutsche Malerschule um die Wende des ersten Jahrtausends* (A German school of painting around the year 1000), was a brilliant exercise in Morellian connoisseurship. This was evident in Vöge's careful scrutiny of texts, iconographic motifs, colors and painting techniques, and in his sorting and grouping of them. German scholars immediately acclaimed the work as having forged a scientific model for the study of manuscripts.[136] In this critical, object-based book, in which he created a broad vision of a manuscript school in a manner modeled on the so-called schools of Renaissance painting,[137] Vöge did not direct his attention primarily toward the historical context, nor was he concerned with questioning the artistic processes, other than technical ones, that went into the making of the illuminations.[138] In other words, Vöge's doctoral thesis manifests a conscious decision to make selective use of the methods in his repertoire.

GOLDSCHMIDT'S AND VÖGE'S DISSERTATIONS, which marked them as young scholars of promise, anticipated a new level of specialized achieve-

ment in the study of medieval sculpture and painting by around 1890. As the two young scholars tested their own wings during the 1890s, the conceptual and methodological character of their work displayed elements of both constancy and change. It is to a critical examination of the directions taken by Goldschmidt's and Vöge's work during this seminal decade that we now turn.

PART II
"Monumental Styles" in Medieval Art History

2

Wilhelm Vöge and *The Beginnings of the Monumental Style in the Middle Ages* (1894)

WILHELM VÖGE'S SECOND BOOK was published in Strasbourg in 1894. In this study, entitled *Die Anfänge des monumentalen Stiles im Mittelalter,* or *The Beginnings of the Monumental Style in the Middle Ages,* Vöge presented the first critical investigation of the genesis of Gothic sculpture in France. Like other innovative writings of this decade – for example, those of Riegl, Wölfflin and Wickhoff – Vöge's study was of seminal importance in establishing Gothic sculpture as an area of art historical inquiry and in formulating investigative procedures for the study of medieval sculpture. Although certain aspects of Vöge's method have influenced the structuring of discourse on medieval sculpture well into the twentieth century, his *Urtext* has received very little critical analysis to date.[1]

Die Anfänge des monumentalen Stiles im Mittelalter displays far greater conceptual depth and sophistication than the dissertation Vöge had published three years earlier; nevertheless, there are many points of congruence between the two studies. Both display Vöge's ability to fashion comprehensive views of artistic developments from exacting scrutiny of individual works. Methodologically, Vöge's 1894 book represents in part a fine-tuning and transfer of analytical tools he had used for the study of illuminated manuscripts to the study of large-scale works of sculpture. What distinguished this publication from its predecessor was Vöge's willingness to

broach new and challenging problems in relation to the study and interpretation of medieval art – problems not occasioned solely by the shift in medium or scale. Indeed in his second book Vöge addressed a complex theoretical issue: he questioned the nature of the causal forces that propelled formal changes in artistic monuments of the Middle Ages and, by extension, the role of the interpreter in discerning and assessing such forces.

Vöge's investigation of the beginnings of the monumental style demonstrates a deep-rooted concern with the determinative role of human agency and individual artistic creativity in the production of twelfth- and thirteenth-century sculpture. Vöge depicted medieval sculptors as living individuals (*lebendige Menschen*) whose mental actions and manual processing of material operated in tandem to determine the shaping of forms. The prominent role Vöge assigned to artistic creativity and to the artistic process in this study raised a host of intriguing questions, for he applied these notions to the creation of works of art from the Middle Ages for which almost no documentation of individual artists and working methods exists. Vöge's exploration of artistic experience in twelfth-century Chartres also signaled a remarkable shift in his research, for such considerations had been largely absent from his dissertation three years earlier.[2]

Vöge's individualized anthropomorphization of the generating forces and the inner life of the Gothic style is best understood as a carefully conceived intellectual response to the theoretical issue of the role of artistry and the creative process in the evaluation of works produced in the past. His interpretative stance must be examined in relation to other visions of the directing principles of art conceived during the same years, which varied greatly in their orientation and emphasis. This chapter, after outlining the main arguments advanced in Vöge's 1894 study, introduces some of the intellectual stimuli that informed his particular definition and imaging of medieval artistry. A broad consideration of the types of methodologies and conflicting assumptions that motivated Vöge not only gives us insight into this scholar's vision and shaping of medieval art history but also adds valuable new dimensions to our understanding of the formation of art historical discourse in Germany during the 1890s.

Although the text of *Die Anfänge des monumentalen Stiles* provides a rich base for exploration, careful study of related archival materials throws into relief the conceptual processes underlying the configuration of Vöge's approach. These archival materials include Vöge's correspondence with his

family and with Paul Clemen. Most notable, however, is a comprehensive series of letters and postcards from Vöge to Adolph Goldschmidt that began in the late spring of 1892, just as Vöge was starting research for his sculpture project.[3]

Vöge's letters to Goldschmidt (Fig. 13) not only bear witness to the genesis and development of Vöge's book but also mark the beginning of an enduring friendship between two recognized pathfinders of art history. Goldschmidt was five years older than Vöge. The two young scholars had become acquainted during their student days in Leipzig, where they were both in attendance at the university during the winter of 1886–87.[4] Unpublished documents show that in 1890 they renewed their acquaintance in Strasbourg, when Goldschmidt paid a visit to Janitschek's doctoral seminar.[5] Certainly Vöge's and Goldschmidt's shared scholarly interest in both medieval manuscripts and sculpture solidified their friendship in the early 1890s, for they greatly admired each other's work. Their correspondence also shows that the two men were joined by a common sense of scholarly mission, for they were acutely aware that they were venturing into unexplored territory.[6] Vöge's correspondence with Goldschmidt from 1892 up to 1938 has survived, but the letters from the years 1892 to 1894 are of primary interest here, for they afford instructive glimpses into the intellectual genesis of *Die Anfänge des monumentalen Stiles im Mittelalter.*

It is somewhat surprising that Vöge decided to redirect his scholarly attention to the study of monumental sculpture immediately after completing an ambitious dissertation on manuscripts. In the preface to his dissertation (dated July 1891) he had, in fact, announced his intention to carry on with manuscript studies.[7] Newly discovered documents corroborate this statement, for they reveal that Lamprecht had enlisted Vöge to investigate the Echternach school of manuscripts for a luxury publication comparable to *Die Trierer Ada-Handschrift.* The Golden Gospels of Echternach were to serve as the centerpiece of the investigation, which was to be sponsored by the Society for the Study of Rhenish History (Gesellschaft für Rheinische Geschichtskunde).[8] Surviving records show as well that Lamprecht and Vöge did a great deal of preparatory work for this ambitious project before it was abandoned in late 1892 as too costly.[9] Vöge did not, however, abandon the study of illuminated manuscripts once he began

Figure 13. First page of letter from Wilhelm Vöge to Adolph Goldschmidt, dated 20 November 1892 in Paris. (Photo: Kunstgeschichtliches Institut der Albert-Ludwigs-Universität, Freiburg im Breisgau)

researching sculpture; simultaneous research on these two media was characteristic of both Vöge's and Goldschmidt's scholarship during this decade.[10]

Vöge conducted research for his sculpture project on-site in France between the late spring of 1892 and May of 1894. His letters to Goldschmidt show that he devoted the first months of his stay in Paris to improving his spoken French, familiarizing himself with earlier publications on medieval sculpture in France and establishing contact with French scholars.[11] Among those who aided Vöge in his research in Paris were Gaston Maspero (1846–1916), a prominent Egyptologist; Eugène Müntz (1845–1902), professor of aesthetics and the history of art at the École des Beaux-Arts; and Louis Courajod (1841–96), director of the department of sculpture at the Musée du Louvre.[12] At the time, Courajod was also interested in investigating the origins of French sculpture, and, significantly, Vöge attended his lectures at the École du Louvre.[13] Vöge gained further familiarity with monuments of sculpture in France by visiting the comprehensive plaster cast collection of the Musée de Sculpture Comparée and by acquainting himself with relevant photographic archives in Paris.[14] At the Bibliothèque Nationale he enthusiastically digested French scholarship while managing also to spend considerable time in the Salle des Manuscrits.[15]

From Paris Vöge journeyed by train to medieval monuments in the region, including Chartres Cathedral.[16] During the fall of 1892 he undertook extended trips to sites in or near the Ile-de-France, including Amiens, Beauvais and Bourges.[17] Goldschmidt, who went to France periodically for research purposes, accompanied Vöge on at least one of these excursions.[18] Vöge traveled widely in southern France during the autumn of 1893 in order to study the complex array of classical and medieval monuments in Provence.[19] His travels enabled him to establish contact with scholars of medieval art and culture working outside the Parisian orbit, among them Georges Durand (1855–1942), chief archivist in Amiens,[20] and Albert Marignan (1858–1936), founder and editor of the historical and philological journal *Le Moyen Âge*, who was particularly helpful during Vöge's research in southern France.[21] Vöge's acquaintance with the latter scholar was almost certainly facilitated by Lamprecht, for Marignan had studied with Lamprecht in Bonn in the mid-1880s and was responsible for the French translation of Lamprecht's dissertation.[22]

In addition to discussion of strictly scholarly matters, Vöge's letters provide insight into his day-to-day research routines and the various impediments he encountered in the course of conducting his fieldwork.[23] Above all, the letters radiate Vöge's enthusiasm for the French people and *paysage*, as well as his boundless admiration for the medieval architecture and sculpture of France.[24] These sentiments are clearly revealed in his book. Viewed within the broader historiography of medieval art history, *Die Anfänge des monumentalen Stiles* in fact marked the beginnings of a long-term fascination of German scholars (and subsequently other non-French scholars) with the study of Gothic sculpture in France.[25]

VÖGE OUTLINED HIS OBJECTIVES in the preface to his 376-page tome, which bears the subtitle "An Investigation into the First Golden Age of French Sculpture." In the first sentence Vöge emphasized that the book was not intended as a history of French sculpture.[26] Rather than writing a history per se, Vöge sought to undertake an investigation of the genesis (*die Entstehung*) of the Gothic style in northern French sculpture and to define its innermost substance and very being or essence (*das Wesen*) – an essence that, according to Vöge, was manifested most legibly in the west facade sculpture at Chartres (Figs. 14, 15).[27] There are numerous parallels in late nineteenth-century scholarship to Vöge's concern with "origins," "sources," "nature" and "development," including other seminal art historical texts such as Wölfflin's *Renaissance und Barock. Eine Untersuchung über Wesen und Entstehung des Barockstils in Italien* (Renaissance and baroque: An investigation into the nature and origin of the baroque style in Italy) of 1888.[28] Vöge's study, however, represents the first extensive exploration and analysis of such questions in relation to medieval sculpture, and Gothic sculpture specifically.

Vöge's decision to assess the nature of Gothic sculpture, and to do so by evaluating conditions at a carefully chosen site, distinguished his inquiry from earlier treatments of sculpture, including studies published in the immediately preceding years, such as Wilhelm Bode's *Geschichte der deutschen Plastik* (History of German sculpture, 1885), Franz von Reber's *Kunstgeschichte des Mittelalters* (History of medieval art, 1886) and Louis Gonse's *L'Art gothique* (1890).[29] Following patterns established earlier,

these scholars were concerned with identification and classification and with constructing comprehensive overviews of presumed "national" and international developments. Vöge's agenda also differed from the kind of learned exegesis practiced by clerics and iconographers, who read medieval sculptural ensembles as liturgical texts in stone. Although iconographic considerations figured importantly in Vöge's book, he accorded them a secondary role. Declaring that exclusive study of iconography resulted in a one-dimensional picture of medieval sculpture, he argued that a more balanced view of the forces determining the shaping and meaning of the sculpted forms at Chartres could be obtained by attempting "to descend into the workshop [or process] of art-making."[30] For Vöge, then, an understanding of the origins and nature of the Gothic style was inextricably connected to precise artistic operations, for he saw the artist as the most important force in shaping the material and giving it form.[31]

Vöge's study introduced several other "firsts" as well. Most earlier scholars, including the French architect-theorist Eugène Emmanuel Viollet-le-Duc (1814–79), had projected the Chartres jamb figures (Figs. 16, 17) as ornamental leftovers of a schematic Byzantinism or alternatively as "asparagus bunches" and "mummies wrapped in their bandages."[32] Vöge, however, saw the twelfth-century ensemble at Chartres as signaling the emergence of new, so-called Gothic values in medieval sculpture.[33] In doing so, Vöge rescued these works from being seen as decadent remainders from an earlier era, just as Wickhoff and Riegl reevaluated the art of late antiquity in positive terms during these same years.[34]

Specifically, Vöge insisted that the "monumental" style of the Chartres figures was determined by an intimate interaction between architecture and sculpture, in which architecture was the dominant partner.[35] Vöge's demonstration of the architectonic elements in the Chartres west facade sculpture, as well as his concern with specific material and technical conditions at the site, reflect his knowledge of the writings of Gottfried Semper (1803–79) and of other late nineteenth-century theorists of art and architecture.[36] Vöge's view that the ensemble manifested a new and creative reformulation of the dynamics linking sculpture and architecture has long since assumed canonical status in the study of Gothic sculpture.

After marking out his hypotheses, Vöge asserted that a full understand-

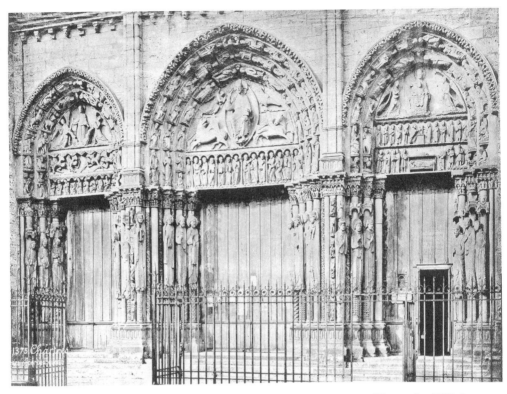

Figure 14. Royal Portal, west facade, Chartres Cathedral, ca. 1145–55. (Photo: after Wilhelm Vöge, *Die Anfänge des monumentalen Stiles im Mittelalter,* 1894)

ing of the monumental Gothic sensibility in sculpture could not be obtained either by technical or strictly aesthetic means. A careful tracing of sources, he argued, was necessary in order to gain insight into what he termed the "secrets of artistic production" and to distinguish between "tradition" and "innovation" in the culminating ensemble at Chartres.[37] Thus, Vöge set out to examine the origins and development of the Chartres sculpture and to trace its subsequent genealogy. His primary informing mechanism was stylistic analysis. Refuting earlier arguments regarding the Byzantine sources of the Chartres style, Vöge located the roots of the early Gothic style in France, specifically in Provence. He constructed a network of stylistic filiations along a linear axis, assessing first the sculptural traditions in Provence, Burgundy and Languedoc and then delineating those elements he saw as being appropriated and ultimately transformed on the west facade at Chartres. He went on to enumerate sites in the Ile-de-France that had taken Chartres as their model, such as Saint-Loup de

64

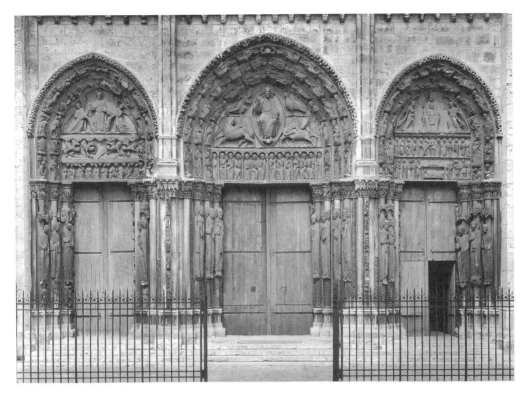

Figure 15. Royal Portal, west facade, Chartres Cathedral, ca. 1145–55. (Photo: Hirmer Fotoarchiv, Munich)

Naud, Corbeil, Étampes and Le Mans. In other words, Vöge constructed a network (or, in current critical terms, a narrative) of stylistic impulses both directed toward and emanating from the hub of the west facade of Chartres.

Vöge's residually Darwinian notions of evolution and the genealogical structure of his investigation reflected the prevailing "scientific" methods in art history prescribed by Springer and others – methods with which Vöge had already obtained significant and positively recognized results in his dissertation. His reliance on a "sensitive eye" (*empfindsames Auge*)[38] is understandable in view of the general absence of written records pertaining to the medieval monuments he studied. Both Vöge's copious footnotes and his letters to Goldschmidt show that he did a great deal of archival research for individual sites; however, he was not able to develop a secure chronology on the basis of written documents alone.[39] As Vöge saw it, only the most rigorous and comprehensive form of connoisseurship applied to

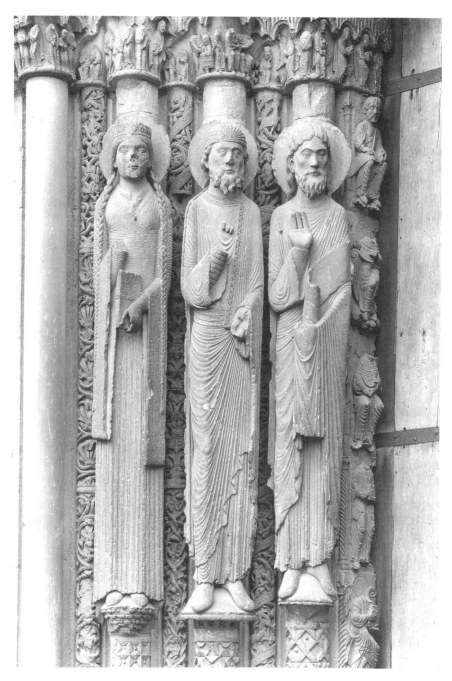

Figure 16. Figures from the left jamb, central portal, west facade, Chartres Cathedral, ca. 1145–55. (Photo: Hirmer Fotoarchiv, Munich)

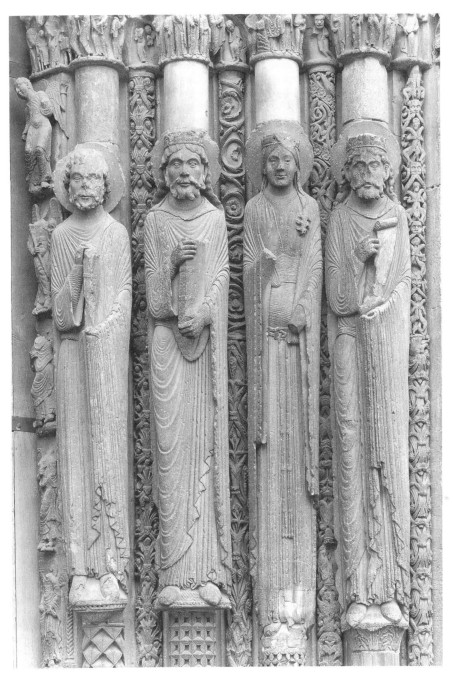

Figure 17. Figures from the right jamb, central portal, west facade, Chartres Cathedral, ca. 1145–55. (Photo: Hirmer Fotoarchiv, Munich)

the study of large-scale works of sculpture would enable him to forge a preliminary, empirical foundation upon which subsequent studies could be built.

CLEARLY, what distinguished Vöge's "science" from that of other scholars was the manner in which he perceived the Gothic style to have been generated and his conception of the forces or agents that had propelled its development. Throughout his book he portrayed the "new" and "original" formal elements at Chartres as the consequence of what he termed "conscious artistic efforts."[40] Vöge elaborated repeatedly upon this comment, as for instance, in the following passage: "Let us add at once that style never results from external influences but is born out of artistic spirit. Whatever the sources, the influences, the conditions may be, one can still maintain that style springs fully armed from the artist's mind."[41] We see here clearly Vöge's conviction that the prime movers behind stylistic change are living people or spirits (lebendige Menschen), that is, the artists themselves.[42] Furthermore, because he understood the formulation of style as resulting from the actions of an individual artist's intellect and from the actions of his hands (i.e., the technical processing of material), he interpreted stylistic links between geographically separate sites as evidence of "living relationships" (lebendige Beziehungen).[43]

Vöge's anthropomorphization of the generating forces underlying formal change in the Middle Ages gave rise to his most challenging and controversial position: that distinct artistic identities were present and discernible within a given sculptural enterprise, even in cases where no written records survived. Indeed Vöge ended up enlisting stylistic analysis to single out, in a highly elaborate fashion, work by the separate hands of individual medieval sculptors. At Chartres this led him to "discover" and identify by name the Headmaster (Hauptmeister), the Archivolt Master, the Master of Corbeil, the Master of the Two Madonnas, as well as a number of secondary masters (Nebenmeister) working there (Figs. 18, 19).[44]

His resulting analysis is remarkable, considering the detached and depersonalized views of artistic achievement many of his German-speaking contemporaries were seeking from this particular analytical method during the same years. In the early 1890s Alois Riegl, like Vöge, had directed his critical eye to the study of anonymous artifacts from the past – in his case,

ornamental forms from the ancient Egyptian through early Islamic eras. He published the results of his inquiry in the highly celebrated *Stilfragen* (Questions of style) of 1893.[45] But whereas Vöge insisted on the presence of "individualism at work" in the "collective enterprise" of the Chartres west facade in his publication of the following year,[46] Riegl portrayed stylistic change as a largely autonomous and internalized process governed by laws of impersonal causality. This does not mean that Riegl denied artistic motivation or the role of mental and psychological processes in the evolution of decoration. Such notions of the role of artistic intent and volition are firmly embedded in Riegl's notion of *Kunstwollen*, a concept that came to occupy center stage in his later work.[47] However, Riegl's and Vöge's interpretations of the nature of individual human action in the artistic process operated within totally different ideological frames. Essentially, Riegl's *Kunstwollen* denoted, in a way traceable to Hegel, a collective or universal will; the notion of *künstlerischer Wille* propounded by Vöge, on the other hand, posited a far more individualized notion of artistic volition.[48]

In the same years, Wölfflin was attempting to draw boundaries between a psychology of forms, or "history of artists," and a "history of art," which he saw increasingly as being delimited by study of the strictly physical aspects of artistic objects. During the late 1880s and early 1890s, an oppositional structure was taking shape in his work, effecting a separation between *das Menschliche*, or artistic considerations centering on the individuality of the artist, and *das Künstlerische*, or the abstract formal properties of a given work. In pursuing a "history of style" in his *Renaissance und Barock* of 1888, Wölfflin sought to uncover the "laws" that would permit him insight into the "inner life of art" – an inner life that he believed was largely independent of artistic considerations as a pure "history."[49]

Vöge's conception of artistry in twelfth-century Chartres might, then, be read as conversing with, or perhaps even as having been inspired by, studies such as Wölfflin's *Die Jugendwerke des Michelangelo* (The works of Michelangelo's youth) of 1891, in which Wölfflin deliberately placed greater emphasis on the internal development of forms than on Michelangelo's creative powers as an artist.[50] Vöge's emphasis on the creative powers of medieval artists for whom no written records exist represents, in fact, an almost complete inversion of the position Wölfflin had adopted vis-à-vis a comprehensively documentable artist, just a few years earlier.

Vöge's vision of the role of artists in the making of medieval monuments

Figure 18. Detail of figure from left jamb, central portal, west facade, Chartres Cathedral, ca. 1145–55, assigned by Wilhelm Vöge to the "Headmaster." (Photo: Hirmer Fotoarchiv, Munich)

Figure 19. Archivolt figures of the Liberal Arts, south portal, west facade, Chartres Cathedral, ca. 1145–55, assigned by Wilhelm Vöge to the "Archivolt Master." (Photo: Hirmer Fotoarchiv, Munich)

was also distinct from views articulated by French scholars. These tended to follow one of two main ideological avenues. On the one hand, such writers as Victor Hugo (1802–85) and Viollet-le-Duc had represented the medieval artist as a secular, free-thinking man of democratic ideals who challenged feudal and ecclesiastical authority. On the other, in the work of prominent Christian archaeologists like Adolphe-Napoléon Didron (1806–67) and Charles Cahier (1807–82), as well as of the ecclesiastical circle generally, this same "person" was depicted as a pious artisan dedicated to serving the church. Émile Mâle's influential *L'Art religieux du XIIIe siècle en France,* which appeared in 1898, just four years after Vöge's analysis of the "monumental style" at Chartres, represented a grand synthesis of the Christian-oriented trends of many of his French predecessors.[51] In contrast to Vöge's interest in the vital role of artistic identity in the formulation of the Gothic, Mâle was concerned with the articulation of ideographic principles. For Mâle, the generating force was located in the realm of ideas and religious dogma, or in what could be termed a "theological will." In this way, Mâle concentrated on iconography, not style, while continuing to assign an accessory role to artists, whom he regarded in collective terms as "humble" and "docile" interpreters of the "grand thoughts" of theologians.[52]

No scholar writing on medieval sculpture before Vöge or contemporary with him was – for whatever reasons – so profoundly interested in the intellectual and technical "nuts and bolts," or artistic processes, as he was. For Vöge these were the essential elements in the making of medieval sculpture and in the definition of its particular artistic character. But how did Vöge arrive at this conception, so alien to the methods of medieval art history of his day? Let us now attempt to unravel some of the theoretical and ideological strands woven into his imaging of the medieval masters at Chartres.

VÖGE'S UNDERSTANDING of medieval artistry is replete with assumptions that were widespread in nineteenth-century discourse. On the most basic level, his "living masters" at Chartres, like so many nineteenth-century intellectual models, were inspired by currents deriving from Hegelian spiritual history and from philosophical and literary texts of the Romantic period. During this era, mythical "national spirits" and "spirits of

an age" were frequently invoked in the process of constructing national self-images in the various ethnic and political regions of Europe. Occasionally such amorphous spirits assumed a more concrete literary form, as in young Goethe's genius-celebrating eulogy (1772) of Erwin von Steinbach, the emblematic master designer of the west facade of Strasbourg Cathedral. Although this figure is known only as a name, Goethe's essay invented considerable substance for the medieval master.[53] Vöge's Chartrain sculptors, such as the Headmaster and Archivolt Master, resonate loosely with this Romantic literary figure. Like Goethe's literary evocation, Vöge's "scientific" vision of medieval mastery was based on little or no written documentation. Moreover, his tracing of the French roots of the Gothic style and his insistence on the French genius of the masters he identified at Chartres bears a certain inverse correspondence to Goethe's championing of the distinctly German genius of Erwin von Steinbach.

In addition, Vöge's portrayal of French genius at Chartres betrays the general belief of his period that distinctive national temperaments and physiognomic traits were directly legible in the forms of medieval sculpture. Vöge held that the hypothesized French origins of the masters were responsible for the "eminently French" character of the forms they created.[54] In the introduction to his book he adopted a particularly confident stance on French genius, proclaiming that "culturally speaking, France was the most important land of the Middle Ages," and that it was "only on French soil" that "the secret of medieval genius reveals itself to us."[55] Regardless of whether he drew on scholarly observation, personal sentiment or a combination of the two, this strongly worded and essentially apolitical (or antipolitical) pronouncement was unusual at a time when much German and French scholarship on medieval monuments tended to be colored by the nationality of the author.[56]

Although Romantic celebrations of medieval mastery may have prefigured Vöge's shaping of the sculptors at Chartres in certain respects, both his published text and private correspondence indicate that he drew heavily on contemporary evaluations and characterizations of Italian Renaissance artistry. His portrayal of the individual artistic identities of the twelfth-century masters at Chartres echoes the mode of presentation employed for much more easily documentable Italian artists, such as Raphael and Michelangelo. Vöge's drawing of a methodological equation between the study of medieval art and that of Renaissance art is hardly surprising

in view of the pervasive emphasis (Wölfflin aside) on the Renaissance artist-genius in German-language scholarship at the time. As we saw earlier, Vöge's teachers Thode and Justi at Bonn had adopted this perspective. Vöge's portrayal of the conditions of medieval artistry at Chartres can be interpreted at least in part as an analogous form of *Künstlergeschichte*, or the "history of artists," a term he in fact employed in his book.[57]

Vöge proclaimed in the introduction to *Die Anfänge des monumentalen Stiles* that the study of medieval artistic identity was "equal in importance to the study of Renaissance geniuses."[58] It is interesting to note that he completed this book on the sculpture of Chartres in Florence and Rome, where he had traveled to study the work of Renaissance sculptors, including Jacopo della Quercia, Donatello and Michelangelo.[59] Vöge's correspondence with Goldschmidt confirms that there were no fixed conceptual boundaries separating his understanding of Renaissance art and theory from his interpretation of medieval sculpture. In letters and postcards sent to his friend from both France and Italy (Fig. 20), he frequently discussed medieval art in one sentence or paragraph and Renaissance artists in the next.[60]

Vöge's sorting out of "great masters" and "lesser masters" at Chartres is also broadly characteristic of art historical procedures and the proclaimed value judgments of his day. Like Justi in his *Diego Velazquez* or Wölfflin in his *Renaissance und Barock* (both published in 1888), Vöge believed that only the most gifted artists were capable of initiating stylistic change and determining the directions it took.[61] Thus in the making of the "masterpiece" at Chartres, Vöge assigned the leading role to the "dominating personality" of the *Hauptmeister*, or Headmaster.[62] Perhaps not too surprisingly, this enterprising figure has displayed remarkable longevity in medieval art historical scholarship since his initial appearance in 1894.[63]

It is important to point out that Vöge, like many of his generation, was strongly and persistently influenced by the writings of the philosopher Friedrich Nietzsche (1844–1900). Vöge's innovative masters at Chartres whom he saw as having "invented" the Gothic style in sculpture, would seem to belong within that circle of uniquely gifted individuals, or "great creators," such as Michelangelo, whose portrayal in much art historical literature of the period displayed strongly Nietzschean overtones. Letters to Clemen in fact reveal that Vöge spent much of the summer and early

Figure 20. Postcard from Wilhelm Vöge to Adolph Goldschmidt, postmarked in Rome on 6 July 1894. (Photo: Kunstgeschichtliches Institut der Albert-Ludwigs-Universität, Freiburg im Breisgau)

fall of 1890 familiarizing himself with the writings of Nietzsche.[64] Significantly, this occurred after he had completed his more strictly "scientific" dissertation on the Reichenau school of manuscripts. From this point onward his correspondence contains frequent references to Nietzsche.[65]

What ultimately emerges from Vöge's text, however, is that his arguably purposeful conflation of medieval and Renaissance artistry in *Die Anfänge des monumentalen Stiles* was grounded in his fundamental belief in the universality of the artistic process. As Vöge saw it, certain common features link the workings of the mind and hands of the creative individual, regardless of period. Vöge underscored this point in his depiction of medieval artistic practice, projecting artists of the Middle Ages as exponents of "artistic progress," which "consists in all eras of the artist advancing independently and spearheading new developments."[66] Consciously adopting a stance that diverged from that of Wölfflin and others, in much of his work during and after the 1890s Vöge displayed an unwavering concern with exploring artistic individuality and the intellectual and technical compo-

nents of the artistic process. This, for Vöge, was the central goal of the art historical enterprise.

IN ADDITION to the conceptual links between Vöge's master sculptors and notions of Renaissance artistry, textual and archival evidence indicate that a number of other, less readily apparent ideas figuring within Vöge's intellectual background influenced the way he portrayed medieval artistry at Chartres. It seems very likely, for instance, that his study of medieval art and cultural history with Lamprecht had implications of both a structural and conceptual sort for *Die Anfänge des monumentalen Stiles im Mittelalter*.

Both Lamprecht's and Vöge's studies of medieval artistic monuments displayed a sensitivity to concrete philological detail and broad vision. Like Lamprecht, Vöge read the visual arts as direct evidence of the medieval "mentality" and psyche. Indeed the resonance of Lamprecht's teachings appears to be registered in Vöge's quest to uncover "the living spirit in history" and the "artistic soul" (*die Künstlerseele, die Seele*) of the masters and their creations at Chartres.[67] Although the concerns of Lamprecht and Vöge were far from identical – Lamprecht, for instance, was interested in *das Typische*, while Vöge's concern was with *das Individuelle* – there are important conceptual parallels between their separate attempts to define the human dimensions of medieval culture.

During his student years Vöge had been highly enthusiastic about Lamprecht's radical approach to the study of history, which he saw as affording a particularly "vivid and penetrating understanding" of the past. Moreover, Clemen emphasized specifically in his memoirs that the young art history majors at Bonn – himself, Vöge and Warburg – were fascinated by Lamprecht's demonstration that artistic monuments, as well as written records, could be interpreted as documenting the soul (*die Seele*), or psychic state, of an era.[68]

There are also some potentially suggestive intersections between Vöge's interests and those of his friend Warburg, who maintained from the beginning of his career that the history of art should not concern itself with stylistic evolution in the abstract but instead with the decision-making process of real human beings, who seek guidance both from the present and the past. Although a detailed comparison of Vöge's and Warburg's work awaits further study, it seems certain that both men owed significant

intellectual debts to Lamprecht, though these must be seen as differing considerably in measure and extent.[69] Warburg's approach to the human dimensions of culture was broader in scope. This approach was reflected in the encyclopedic nature of his cross-disciplinary research library, the Kulturwissenschaftliche Bibliothek Warburg. Yet the common threads connecting Warburg's and Vöge's research programs, especially their willingness to probe behind the strictly visual dimensions of art, suggest that it was important for both men to have been introduced to the "secrets" of the "artistic psyche" in Lamprecht's "workshop" in Bonn.

Archival materials show that both kept in contact with Lamprecht until his death in 1915. However, it appears that Lamprecht's influence on Vöge was especially strong during the late 1880s and early 1890s.[70] Lamprecht, as we have seen, provided important encouragement for Vöge's manuscript studies. Furthermore, Vöge not only thanked Lamprecht for his support in the preface to *Die Anfänge des monumentalen Stiles* but also dedicated his second book to Gustav von Mevissen, Lamprecht's patron, who, at the historian's urging, had provided a large subsidy toward the publication of Vöge's dissertation.[71]

Viewed broadly, then, Lamprecht's investigations of a sort of historical psychology can be seen as having provided an important stimulus for Vöge's visualization of the mentality of twelfth-century masters. Just as Lamprecht uncovered a psychological presence behind the illuminated pages of manuscripts, Vöge perceived behind the stones and statues of Chartres Cathedral "their makers, living people at work, disclosing the depths of their souls."[72] Yet there are notable distinctions between Lamprecht's and Vöge's approaches that must be signaled here in order to comprehend more fully the range of original ideas contributing to *Die Anfänge des monumentalen Stiles.*

Lamprecht's notion of a collective mentality and psychic life (*Seelenleben*) operated almost entirely on an abstract level. By comparison, Vöge's interpretation was of a more literal, concrete sort, for he concentrated on enumerating the identifying characteristics and personalities of individual masters, as well as on chronicling their working methods. On one level, we must see Vöge's greater specificity, or "tangible" reading of forms, as being conditioned by what he had learned by other means, including contemporary art historical paradigms of Renaissance artistry. At the same time Vöge's text and related documents indicate that he sought additional sup-

port for his more tangible rendering of the medieval psyche from the psychological aesthetics of the art historian and polemicist Robert Vischer. Vischer's work, like Lamprecht's, stands within the context of late nineteenth-century investigations into the psychology of aesthetic perception, and experimental psychology in general.[73] But unlike the historian, Vischer provided specific directives for integrating psychological precepts in such a way as to facilitate an understanding of the mental and technical aspects of the artistic process.

In his *Kunstgeschichte und Humanismus* (Art history and humanism) of 1880 Vischer had openly criticized prominent practitioners of a "scientific" art history, such as Springer, declaring that straightforward evaluation of visually verifiable "facts" could not account for less palpable artistic urges or drives. In attempting to integrate a materially oriented art history with psychological considerations, Vischer insisted that it was necessary for the art historian to enter into or empathize with (*einfühlen*) the psyche of the artist.[74] Vöge's investigation of the medieval sculptors at Chartres resonates significantly with Vischer's ideas, though not with his polemic. Some of Vischer's writings were in fact cited in *Die Anfänge des monumentalen Stiles*, but Vöge appropriated far more from Vischer than a cursory glance at his footnotes would indicate.

Already in the introduction to his 1894 publication, Vöge referred to Vischer when declaring his intention to explore the "hidden process" of style formation (*Stilbildung*), describing Vischer's work on the subject as "stimulating" and "imaginative" (*geistvoll*).[75] A few pages later Vöge acknowledged that several German scholars before him had proposed that the sculpture on the Chartres west facade marked the beginning of a new artistic sensibility, though they had not elaborated their statements. Vischer was among the scholars mentioned.[76]

The essay Vöge cited was Vischer's "Zur Kritik mittelalterlicher Kunst," or "On the Criticism of Medieval Art," the first piece in his 1886 *Studien zur Kunstgeschichte* (Studies in art history).[77] In this essay, Vischer provided a positive assessment of the so-called schematic "Byzantine" style of the Middle Ages in western Europe. Rejecting the assumption that the style was uninspired and decadent, he argued that it was the result of a dialogue between the material and technical constraints imposed upon medieval craftsmen, on the one hand, and the demands of tradition on the other. He drew attention to the considerable degree of artistic creativity

and particularity evinced within these narrow confines during the Middle Ages. Although his essay was concerned primarily with two-dimensional works, such as mosaics and stained glass, he also made specific mention of the sculpture on the west facade at Chartres.[78] Vischer's position anticipated that of Vöge, and accordingly Vöge referenced this essay several times in his book.[79] However, a close comparison of Vischer's and Vöge's texts reveals that Vöge made a number of other borrowings that he did not acknowledge, indicating that he was more than just superficially affected by Vischer's work.[80]

In the essay just mentioned, Vischer reiterated briefly some of his earlier postulates regarding the "psychological acts" underlying the "mute forms" studied by the art historian, though he did not develop his arguments in any detail.[81] He provided a comprehensive demonstration of his approach to the evaluation of the creative process (*Phantasie-Prozess*)[82] in another article, which served as the methodological centerpiece of his *Studien zur Kunstgeschichte*. It was arguably this study, a 137-page essay on the artistic and technical principles of the work of Albrecht Dürer, that seems to have helped Vöge conceptualize the psychic and creative dimensions of the medieval sculptors at Chartres.[83] In comparison with the unbridled polemic of the earlier *Kunstgeschichte und Humanismus*, Vischer's "empathic" exposition of Dürer's creative process was more clearly structured and theoretically more consistent. Vischer incorporated concepts drawn from a wide variety of sources, but he achieved an undeniably original synthesis. Put succinctly, he meshed Semper's theories regarding the role of material and technique in the artistic process with ideas extracted from the empirical psychology of his day, in order to gain access to artistic intentions and to introduce the notion that past artists had created sensitively and purposefully in ways that could be described.

In the Dürer essay Vischer placed the accent on the artist's intensely creative nature, noting that earlier Dürer scholarship had been largely descriptive and factual in approach.[84] He was referring here specifically to the work of Moriz Thausing, professor of art history in Vienna, whose celebrated 1876 monograph on the life and art of Dürer adhered to staunchly Morellian principles of the sort also espoused by Springer.[85] Asserting that Dürer's theoretical work proved that he was a man of great introspection, Vischer undertook an investigation of the more "personal nature" of his art, that is, of the less quantifiable aspects of the creative

process underlying Dürer's mode of seeing and his manipulation of tools and materials.[86] Although Vischer's writings bore the strong imprint of Semper, he claimed that Dürer's art could not be understood simply from a study of techniques or materials; he also acknowledged that important artists did not create in a void but rather that they had recourse to sources and traditions, which they transformed through technical and mental prowess into something significantly new.[87]

Drawing on these assumptions, as well as on developing psychological theory, Vischer arrived at a very innovative and challenging formulation of the nature (*Wesen*) of Dürer's artistry. He portrayed the artist's intellect as entering into his tools and materials to such a profound degree (Vischer employed the term *sich einfühlen*) that a kind of fusion occurred between the artist's creative psyche (*Künstlertum*), his tool or instrument (*Mittel*) and the material (*Stoff*) he worked. In other words, through an unconscious process of *Durchfühlung* – the term itself betrays the half psychological, half material perspective from which Vischer was operating – the intangible and the tangible merged.[88] Because of the mutual empathy between the movements of the artist's mind, his hands, and the material (the tool acted as the instrument of linkage), the resulting art work embodied a "material metamorphosis of artistic spirit/creativity."[89] By extension, both the palpable and less palpable aspects of the artistic process were legible in the forms that remained even after the creative moment had passed.

Vischer's insistence that the art historian had to penetrate the psychological aspects of the artistic process in order to understand the work of art found many echoes in Vöge's interpretation of art-making at Chartres. Indeed the identification of the artists with their tools and materials envisioned by Vischer was reflected in Vöge's conscious tendency to refer to individual sculptors interchangeably as "the master" or "the chisel."[90] Since the artistic spirit of the masters fused with their tools and the styles they formulated, Vöge, like Vischer, believed that the movements of their hands as well as their personalities were equally retrievable in the material forms that they had shaped. Vöge offered many vivid pictures of the ways in which individual sculptors manipulated their chisels. He suggested, for example, that the Master of Corbeil could be differentiated from the "dominating" Headmaster by his "more sensitive handling of the chisel." He went on to assert that this sculptor's "refined forms" and "quiet elegance" were direct expressions of his artistic nature, or *Wesen*.[91]

Significantly, too, Vöge's conception of the style-creating (*stilschöpferisch*) powers of the masters at Chartres bears important, almost word-specific relations to Vischer's celebration of the style-forming power (*stilbildende Macht*) of Dürer.[92] Here it is also relevant to note that Wölfflin had employed this same term, *stilbildende Macht*, in his *Renaissance und Barock* when referring to great artist-geniuses such as Michelangelo and Raphael.[93] This referencing came at a time when Wölfflin was still residually interested in a psychological characterization of forms rather than in a strict "history" of them.[94] The synthesis of the forms, their formers and the process of forming at Chartres is perhaps most powerfully embedded in Vöge's description of his masters as being *stilvoll*, or "infused with style."[95] He also undertook to evoke their medieval *Stilgedanke* (style thinking)[96] and *Stilgefühl* (feeling for style).[97]

In addition to assimilating a number of Vischer's ideas regarding the artistic process, Vöge's *Die Anfänge des monumentalen Stiles* incorporated Vischer's view of the art historian's responsibility to interpret all aspects of creation, not simply material ones. From Vischer's perspective, it was not only the artist who empathized with his material; it was also the art historian, who needed to empathize with or even relive the process of artistry he described. When probing into the nature of Dürer's drawing, for instance, Vischer allowed himself to follow the "masterly contours" and marks made by Dürer's hand. As interpreter he experienced the "living pulse and earnest powers" contained within the marks made by Dürer.[98] The degree of Vischer's sensory identification with Dürer's creative acts is indicated by his report that he heard "the quill scratching on the quality hand-made paper."[99] Vöge empathized in a similar fashion with the masters at Chartres, entering their workshop and "eavesdropping" as they hewed the jamb figures from "raw, tectonic form."[100] Vöge's book is filled with such signs of Vischerian empathy.

To place Vöge's interest in Vischer's work within a larger context, it is useful to note that Vöge had been introduced to the contemporary literature on experimental psychology in the course of his studies with Lamprecht, as Warburg's notebooks demonstrate.[101] Moreover, Vöge's letters to Clemen show that he continued to explore psychological and physiological treatises and handbooks, especially in the second half of 1890.[102] But perhaps the most revealing evidence documenting the extent of Vöge's interest in psychological theories of art – and in Vischer's work specifically – is

contained in several letters Vöge sent to Goldschmidt in the fall of 1894. These letters reveal that Vöge had written to Robert Vischer, then professor of art history at the University of Göttingen, to inquire about submitting *Die Anfänge des monumentalen Stiles* to him as a postdoctoral thesis, or *Habilitationsschrift*.[103] The *Habilitation* with Vischer did not prove possible, for reasons that appear to have been more closely linked to the political situation in Vischer's art history seminar than to the contents of Vöge's book per se.[104]

VÖGE'S CONCEPTION of the mental and technical components of medieval art production – based on notions for which he gained certain suggestions from Lamprecht and Vischer – were further reinforced by broader ideas drawn from his experience of the contemporary, "modern" art scene in late nineteenth-century Europe. This is hardly surprising. Many other pioneers of art history during the 1890s, including Riegl, Wickhoff and Warburg, found points of orientation for the evaluation of monuments from the distant past in contemporary art and theory. In his discussion of material and technical conditions at Chartres, Vöge devoted considerable attention to the artist's process of working the stone. His footnotes show that this chapter was indebted in part to the theoretician Adolf von Hildebrand's (1847–1921) treatise *Das Problem der Form in der bildenden Kunst* (The problem of form in painting and sculpture), which was published in 1893, precisely when Vöge was researching the sculpture at Chartres.[105]

Susanne Deicher and Robert Suckale have recently explored Vöge's appropriation of Hildebrand's theoretical principles for his portrayal of the working methods of the sculptors at Chartres.[106] Deicher, in particular, has pointed to a number of relationships between the genesis of Vöge's conception of medieval artistic production and his reading of the modern sculptor's treatise. Although Vöge was developing his ideas before Hildebrand's treatise appeared, Deicher has proposed that certain aspects of Vöge's published argument, for example, his descriptions of the handling of the block and the working of the stone *avant la pose*, were structured in response to Hildebrand's writings.[107] Moreover, Hildebrand emphasized the artist's mental process and the realization of his ideas in his work, a view that

buttressed Vöge's conception of the creative powers of the sculptors at Chartres.

In addition to reflecting traits of Renaissance artists such as Michelangelo and Vischer's Dürer, then, Vöge's twelfth-century masters might be seen as bearing a certain conceptual resemblance to flesh-and-blood artist-theorists of the nineteenth century such as Hildebrand himself, who offered a contemporary demonstration of the sort of combined intellect and manual skill that Vöge posited for his "living spirits" at Chartres.[108] Within the broader context of the late nineteenth-century debate over the value of handcraft versus machine production, the life and work of such modern masters as Adolf von Hildebrand also stood as prominent symbols of the value of craftsmanship and of the handmade object, a value for which Vöge found an historical analogy in the west facade sculpture at Chartres. In his descriptions of the jamb figures he repeatedly lauded the handiwork of the sculptors, drawing attention to the arts-and-crafts or applied-arts (*Kunstgewerbe*) sensibility manifested in the intricate, coherent and closely worked details brought into the stone.[109]

Further evidence of the informing power of "living" art and theory on the conceptualization of Vöge's masters between 1892 and 1894 is furnished by his letters and postcards to Goldschmidt. We learn, for instance, that during the preparation of his manuscript Vöge was reading Richard Muther's history of nineteenth-century painting.[110] While in Paris he visited the Salons and likened the "secrets" of artistic production in the Middle Ages to those of Monet, Manet and Moreau.[111] Of interest, too, is a letter to Goldschmidt written in November 1893 in which Vöge thanked his friend for sending him an article written by the Munich painter Franz von Lenbach (1836–1904). That article, which concerned the role and importance of the study of the "history of artists" at academies of art, clearly struck a chord in Vöge, who was then researching the medieval artists at Chartres. In his thank-you note to Goldschmidt Vöge in fact termed Lenbach his "soulmate."[112] This vibrant rapport between conceptions of present and past art-making informed much medieval art historical scholarship at the turn of the century and beyond. Many of the pioneering medievalists in Germany as well as in France were in close contact with contemporary artists and wrote frequently, even interchangeably, on modern art and on monuments from the Middle Ages.[113]

ALL OF THESE CONSIDERATIONS introduce a final and particularly knotty issue concerning Vöge's fascination with the individual creative powers of his medieval masters: the question of how the nature and personality of the interpreting art historian intersects with his or her writing of the history of art. There are indications on a number of levels that the way in which twenty-six-year-old Vöge depicted the "youthful vitality" and creative psyches of the artists at Chartres was to a significant degree self-reflexive. Remarkably, he depicted the medieval sculptors as young men, like himself.[114] Moreover, Vöge possessed a deeply artistic temperament, as those who knew him emphasized.[115] This predisposed him (in contrast to someone like Springer) to appreciate the internal, as well as the external, dynamics of form. Although a detailed analysis of the impact of Vöge's personal sensibilities on his imaging of artistic volition at Chartres is beyond the scope of the present study, it is nevertheless important to introduce here some aspects of the issue.[116]

Vöge's correspondence with Goldschmidt between 1892 and 1894 demonstrates that he consciously equated the re-creative scholarly act of exploring and fashioning "the beginnings of the monumental style" with the creative achievements of the Chartres sculptors. In letters to his colleague from this period Vöge cast himself on several occasions in the metaphorical role of a sculptor. In judging his work, for instance, he "moved around, contemplated and touched from all sides" the materials he was in the process of shaping in words.[117] Like the sculpture on the west facade of Chartres Cathedral, his book was the product of what he conceived as mental action, as well as of the manipulation of tools – in Vöge's case, the tools of language. He seems to have been encouraged to chisel out verbal approximations of the forming and the forms of the Chartres sculpture not only by Vischer's theories but also by the many rhetorical gestures in nineteenth-century German literature.[118]

The structure of Vöge's discourse might be read on a certain level as necessitated by the directions taken by his arguments. Specifically, it alternates in a self-consciously Nietzschean way between a sort of Apollonian control – that is, precise scientific description – and the Dionysian lyricism of poetry and music. Indeed the literary voice of Vöge's *Die Anfänge des monumentalen Stiles* oscillates in rhythm and pacing from paragraph to paragraph, and at times from sentence to sentence, reaching a fever pitch of excitement in passages punctuated by numerous exclamation points or

question marks. Vöge seems to evoke for himself – and, ideally, for the reader – the exhilaration of the creative acts in twelfth-century Chartres through the word choice and syntax of passages such as the following (see Fig. 18):

> And these artists were on personal terms with nature! They injected fresh blood into traditional forms.
>
> Where is this illuminated more clearly than in the treatment of the heads! The schematically partitioned strands of hair have become wavy, flowing masses of curls, and hair and beards no longer appear glued on like wigs; the faces, so to speak, appear unmasked. . . . It is not portrait likenesses, nor the physiognomy that is novel here, but rather a lifelike typical beauty, comprehension of the lawful order of the living [i.e., human] form, and the youthful vitality of the masters, which, as it were, is exuded from their chisels. How the expressive powers of these faces have been transformed under the artists' hands! Rather than the sullenness and profound pensiveness of old age, we encounter here the vitality and tautness of manly energy, the flawlessness of masculine beauty and the laughter of youth.
>
> The bodies attest to the same! In spite of the tectonic constraints imposed upon the forms, no figure is conspicuously distorted, no limb unnaturally twisted in the fashion we remark upon occasionally at Arles![119]

Vöge's movement between verbal excitement and a more static or objective form of language appears to have been dictated by the nature of the subject he treated, though he was not always consistent. Whatever the strategy (intentional, or unintentional at times), Vöge's manipulation of language contributed significantly to the persuasiveness of his arguments.[120]

His exploration of language as a powerful tool of argument in art history was not nearly so evident in his dissertation as in *Die Anfänge des monumentalen Stiles*. In developing language as an expressive tool, Vöge was "feeling" his way, methodologically and rhetorically, through a discipline which itself was in the process of formation. His acute awareness of the power of words to evoke the expressive substance of the visual arts is suggested by a letter to Goldschmidt in which he referred to his book as "my small Laocoön" ("meinen kleinen Laokoon").[121] He was alluding here to Gottfried Ephraim Lessing's (1729–81) treatise of the same title, *Laokoon oder über die Grenzen der Malerei und Poesie* (*Laocoön, or On the Limits of Painting and Poetry*) of 1766. Lessing's treatise centered on a contest between the imitative capabilities of poetry (i.e., the verbal arts) and of the visual arts,

specifically the media of painting and sculpture. In making this reference, Vöge seems to have signaled his agreement with the priority Lessing had assigned to poetry.[122]

IN SUMMARY, Vöge's interpretation of the genesis and nature of twelfth-century sculpture assimilated impulses from diverse sources. For his exploration of "the hidden processes of style formation" Vöge drew inspiration from Semper's analysis of materials and techniques, from investigations of Renaissance artists, late nineteenth-century art and art theory, and experimental psychology. Viewed broadly, his 1894 study suggests something of the interdisciplinary context in which medieval art historical discourse first took shape. But though Vöge's understanding of twelfth-century sculpture incorporated a number of theories and analytical approaches unprecedented in medieval art historical discourse prior to 1894, these concepts were not always comfortably aligned.

Vöge's view of the medieval artistic process contained a number of paradoxes. At the most basic level, we find him applying a kind of anthropomorphic approach, shaped in part by the study of documentable Renaissance artists, to the study of artists for whom no comparable textual data was available. Similarly, with the support of late nineteenth-century artistic theory and psychology, Vöge "re-created" the twelfth-century sculptors at Chartres as living and thinking artists, though they belonged to a distant past. But, even more significantly, there was a fundamental paradox at the core of his approach – namely, a tension between "science," on the one hand (i.e., rigorous employment of stylistic analysis, or *Stilkritik*),[123] and "artistic creativity" on the other (i.e., consideration of the intellectual and technical logistics of artistic production, evocation of the creative moment).

This approach not only reflects the diverse and often contradictory nature of the sources he drew upon but also the broader dichotomies and tensions within art history (for example, the mutually exclusive "history of style" and "history of artists" positions), as well as within humanities scholarship in general in the late nineteenth century. In this regard, Vöge's particular conception of the genesis of Gothic sculpture manifests the double-edged thrust of the "human sciences," or *Geisteswissenschaften*, at the end of the nineteenth century: the study and explanation of general

historical trends and developments over time *and* the study of the actions and deeds of the individual human being.

In *Die Anfänge des monumentalen Stiles im Mittelalter* Vöge tried to reconcile the variability of human behavior with the scientific practice of art history. His desire to move beyond a simple, formalist reading of the sculpture at Chartres in order to retrieve artistic will in the Middle Ages bore the imprint of Justi, Lamprecht and Vischer and, more broadly, of the nineteenth-century intellectual milieu in which he had been trained; his attitudes were obviously affected as well by his own creative temperament. Although we recognize today that Vöge's methodological perspectives did not embody strictly objective scientific notions, neither did they cultivate unbridled subjectivity. Rather it appears that he operated with a keen and purposeful sense of the flexible boundaries of disciplined interpretation. In his view, insight into the "living" dimensions of art-making in the Middle Ages was possible only within an intellectual frame controlled by science. We recall in this regard his declaration that it was by means of a careful tracing of sources (i.e., rigorous visual analysis of stylistic "facts") that the less tangible aspects of artistic creation could be demonstrated.

Vöge's conscious hovering between two hermeneutical poles represented an important model for art history during the 1890s. Despite the contradictions inherent within his approach, *Die Anfänge des monumentalen Stiles* offered broad terms of discourse for the study and analysis of medieval art and had provocative implications for the role of the interpreter. To Vöge, the interpreter was ultimately responsible for mediating between art historical science and artistic spirit (*Geist*).

3

Thematic and Methodological Range in the Scholarship of Goldschmidt and Vöge to ca. 1905

Vöge's 1894 publication displayed much originality in its scope and conception, yet it represented only one of his critical endeavors in the 1890s, a decade during which Vöge and Goldschmidt, between them, published a total of some fifty books, articles and review essays and also launched university and museum careers. In order to gauge and contextualize some of the directions taken by discourse on the Middle Ages during the 1890s, it is useful to consider collectively the thematic and methodological range of their work, while remaining attentive to the collegial bonds that linked the two scholars during these years.

Though most of Vöge's and Goldschmidt's publications focused on the medieval era, their work, like that of many of their German-speaking contemporaries, spanned a variety of historical periods, media and geographic areas, reflecting not only the catholic nature of their scholarly interests but also their extensive travels during the 1890s. Vöge, for instance, continued to conduct research on early medieval manuscripts and on monumental sculpture in France and Germany but also directed his attention to small-scale ivory carvings as well as to the Italian Renaissance, publishing a book on Raphael and Donatello in 1896. Archival materials demonstrate that during these years he wrote several articles on Michelangelo, though he never published them. He also acquainted himself at first hand with the

monuments of late medieval sculpture in northern Europe that were to figure prominently in his later work.

Goldschmidt's research during the 1890s exhibited even greater diversity. His investigations of medieval art included Norman architecture in Sicily, manuscript illumination from the pre-Carolingian to Romanesque eras and also monumental sculpture in Germany between the twelfth and fifteenth centuries. He published simultaneously on Michelangelo and on Dutch and Flemish painting (the latter an area of inquiry that held special interest for him throughout his scholarly career). The broad spectrum of Vöge's and Goldschmidt's research during this decade suggests that the notion of a "medievalist" direction in art history was at the time far less specialized than it subsequently became in many countries outside of Germany.

Although the topics addressed by the two scholars varied greatly, their research during this decade remained, methodologically speaking, within familiar contemporary intellectual parameters. Goldschmidt's work in the 1890s might be seen as developing logically from the object- and document-based methods introduced in his doctoral thesis. Vöge's publications, on the other hand, displayed greater conceptual and methodological range, fluctuating between the kind of rigorous science practiced by Goldschmidt and an attempt to recover and describe the creative content of the forms he studied.

Their work had much in common. Most importantly, it was careful scrutiny of the object that served as the point of departure for their investigations. Vöge and Goldschmidt in fact belonged to the first professional group of art historians in Germany whose critical judgments were based almost without exception on careful firsthand study of the monuments. During the early years of their careers, they traveled incessantly, embarking on what was virtually a programmatic campaign to examine and reexamine artistic monuments in Britain, France, the Netherlands, Belgium, Italy, Switzerland and Austria, as well as Germany. In 1898 Vöge made a research visit to Istanbul, and travel within Europe was a constant feature of his work until his withdrawal in 1916 from the University of Freiburg.[1] Besides making frequent trips to Scandinavia throughout his career, Goldschmidt voyaged to Turkey in 1907, to Russia in 1909 and to Spain and the United States during the 1920s and 1930s.[2]

As Vöge's correspondence and Goldschmidt's memoirs reveal, both

men were conscious from the outset that their sustained contact with the monuments distinguished their scholarship from that of many of their predecessors, including Springer and Janitschek, whose travels had been limited, as well as from that of an older generation of scholars still active in the 1890s.[3] Goldschmidt penned a highly perceptive account of the armchair scholarship and teaching of the Renaissance scholar Herman Grimm (1828–1901), his colleague at the University of Berlin during this decade.[4]

Goldschmidt's scholarly initiatives following the completion of his 1889 dissertation provide insight into his ever-extending intellectual range as well as into his elaboration of method. Although late medieval sculpture in Lübeck and elsewhere in northern Europe remained an important area of inquiry for Goldschmidt, his thesis did not predict the directions his work would take in the following years. An extended sojourn in Italy and Sicily between late 1889 and June 1890 prompted him to conduct research on Norman palace architecture in Palermo.[5] Study of these monuments had been confined largely to local publications until that time. Goldschmidt's comprehensive investigation, which resulted in two lengthy articles later in the decade (1895 and 1898), represented his only major foray into the medium of architecture.[6] Marie Roosen-Runge-Mollwo and Wolfgang Krönig have recently discussed these studies in some detail, emphasizing the accuracy of Goldschmidt's observations and their fundamental importance for all later discussion of the monuments.[7] They have also pointed to the careful balance between visual evidence and historical research that was a constant feature of Goldschmidt's scholarship.

In an article on the Carolingian Utrecht Psalter, published in 1892, Goldschmidt demonstrated his expertise in yet another area of study.[8] He acknowledged that his interest in medieval illuminated manuscripts had been awakened by Springer during the second half of the 1880s.[9] A more immediate precedent for Goldschmidt's 1892 article seems to have been Vöge's dissertation, *Eine deutsche Malerschule* (A German school of painting), which was widely seen as establishing a methodological exemplar for the study of manuscripts. It had appeared the previous year, and it was during this period, when Goldschmidt was preparing his investigation of the Utrecht Psalter, that he and Vöge consolidated their friendship. A letter sent to Goldschmidt from Paris in July 1892 shows that Vöge did some footwork for Goldschmidt's article in Paris; in addition, they exchanged notes on relevant bibliography.[10] Keeping these circumstances in mind,

it is useful to consider this seminal article of 1892 as an index of Gold-schmidt's developing methodological perspectives.

In his essay, Goldschmidt attempted to establish the place of manufac-ture of the now widely celebrated ninth-century manuscript, which was then just beginning to attract scholarly interest. What little literature there was on the Utrecht Psalter usually associated it with Anglo-Saxon Eng-land.[11] Goldschmidt began his study by asking whether there were other manuscripts that manifested close stylistic affinities with the Psalter. He answered in the affirmative, pointing to the Ebbo Gospels, known to have been produced somewhere within the diocese of Reims during the reign of Louis the Pious (814–40) for Ebbo, archbishop of Reims. Proceeding inductively by means of an exacting stylistic analysis, Goldschmidt posited that the two manuscripts, though different in genre and iconography, were probably produced in the same scriptorium. His systematic comparisons of specific features in the two manuscripts were presented in a language remarkable for its clarity, economy and scientific precision.[12] A dedicatory poem contained in the Ebbo Gospels allowed Goldschmidt to identify the manuscript as a product of the scriptorium at the abbey of Hautvillers near Reims, and hence to trace the Utrecht Psalter to this scriptorium as well. Because historical evidence indicated that the Ebbo Gospels were executed between 823 and 833, an approximate chronological frame of reference was established for the Utrecht Psalter.

Having localized the two manuscripts, Goldschmidt went on to recon-struct the broader activities of the Hautvillers scriptorium, enumerating several other manuscripts that exhibited comparable physical characteris-tics, painting techniques, colors, script and iconography. He attributed a total of seven manuscripts to the school of Hautvillers in the first half of the ninth century.[13] Drawing on stylistic and iconographic evidence, he outlined the wider sphere of influence of the scriptorium, suggesting that certain elements of the Hautvillers manuscripts found resonance in works produced at Corbie and in Koblenz during the reign of Louis the Pious. He also pointed to affinities between certain miniatures in the Utrecht Psalter and ivories on the book cover of the Psalter of Charles the Bald (843–77).[14] Thus, by localizing the Utrecht Psalter, Goldschmidt provided a point of orientation for further scholarly interrogation of this and related works of the Carolingian era. In fact he ended his article on a highly pro-vocative note, asking whether and to what degree the style and character

of the manuscripts produced at Hautvillers were attributable to the presence of Anglo-Saxon artists, to artistic invention or to the copying of manuscripts of Early Christian or Byzantine provenance.[15]

Goldschmidt's modus operandi in this early article manifests many of the investigative principles he held to and refined throughout his career. Like his teacher Springer and many other scholars of his generation, Goldschmidt readily acknowledged that his analytical and descriptive procedures were influenced by scientific method. Although he, Vöge, Warburg, Clemen, Riegl, Wölfflin and others all grew up at a time when interest in the natural sciences was unusually high, they held particular personal fascination for Goldschmidt, who had wavered as a youth between a career in science or in art history. Certainly it was an attraction to scientific connoisseurship that led Goldschmidt to seek out Springer and encouraged his 1887 visit to Morelli.[16]

The scientific side of Goldschmidt's character dominated his scholarship. This is evident in the impartial, patently objective tone he adopted in his Utrecht Psalter article.[17] The 1892 article made clear that the key components of Goldschmidt's approach were "critical seeing" (in his words, *kritisches Sehen*, or *Kritik des Auges*), as well as a highly discriminating stylistic analysis (*Stilkritik*). Goldschmidt published two short methodological statements during his career, both of which reveal the relative (if not absolute) constancy of his approach.[18] The critical eye, according to Goldschmidt, was informed not only by practice but also by a vast store of firsthand knowledge, which enabled the art historian to go beyond mere description and to locate the object within its historical context. At the same time, keen visual analysis of stylistic features allowed the art historian to sort, analyze and classify groups of anonymously produced works and to perceive developmental sequences linking them.[19]

Goldschmidt was among the first to survey the terrain of medieval art, and he saw the introduction of intellectually rigorous standards for the analysis and classification of individual works and the establishment of basic data about those works (i.e., place of origin, date, chronology) as being necessary before more comprehensive questions could be asked.[20] In this regard, it is important to note that Goldschmidt was well aware that his hypotheses were liable to be revised, and that he had not exhausted all possibilities for study of a given monument.[21]

In 1892, the year in which he prepared and published his ground-breaking article on the Utrecht Psalter, Goldschmidt became *Privatdozent* at the University of Berlin. The two art historians teaching in Berlin at the time, Herman Grimm and his disciple Karl Frey (1857–1921),[22] concentrated their research on the Italian Renaissance, making Goldschmidt the first scholar with a medieval focus to teach art history at that institution. This was significant, for, as we have seen, the study of medieval sculpture and painting was virtually absent from the art history curriculum at German universities during the 1880s.[23] The expanded instruction on medieval painting and sculpture during the following decade can be attributed in large part to the fact that Goldschmidt and others of his generation with similar interests, including Vöge and Clemen, assumed university positions during this decade.[24]

Goldschmidt's entry into the ranks of the Berlin art historians was not entirely comfortable. As he recounted in his memoirs, his *Habilitationsschrift* on the twelfth-century Albani Psalter made Grimm and Frey so uneasy that he was asked to present a paper to the faculty examination commission on the more "acceptable" subject of Michelangelo or Raphael.[25] He chose to speak on the poetry and sculpture of Michelangelo, a topic he had pursued when he studied with Springer.

During the 1890s Goldschmidt retained a strong research interest in the art of Michelangelo; indeed he published two articles on him during this decade.[26] Vöge was also working on Michelangelo, and a postcard from Vöge to Goldschmidt sent from Paris on 16 December 1892 shows that already at that date the two scholars were exchanging bibliography on the Italian artist, indicating again the constant (and perhaps even necessary) conceptual cross-referencing between the study of medieval and Renaissance art during this era.[27]

Although Goldschmidt completed his *Habilitationsschrift* on the Albani Psalter in 1892, it was not published until 1895.[28] Not surprisingly, it was Vöge who wrote the major review of the monograph.[29] In this book Goldschmidt made further significant contributions to the study of medieval psalters, demonstrating in his introduction that varied text–image divisions in the manuscripts were probably determined by specific features of differing liturgies in western Europe and Byzantium. Close study of the physical and formal character of the psalter, including the painting tech-

nique, style and iconography, enabled him to determine that the manuscript had been made in England at the abbey of St. Albans. Goldschmidt further attempted to explain certain iconographic idiosyncracies of the illuminations in relation to historical and artistic circumstances in England following the Norman invasion. In the second half of his book he examined the decorated initials inspired by the Psalm texts and demonstrated that this form of imagery could help explain the treatment of similar motifs in twelfth-century monumental sculpture in Germany and Switzerland.[30]

Goldschmidt's other publications during the 1890s included studies of late medieval panel painting in Lübeck and elsewhere, as well as articles on genre painting and the seventeenth-century Dutch artist Willem Buytewech.[31] He also produced numerous book reviews on such topics as medieval sculpture in Italy and Germany, illuminated manuscripts and Carolingian and Ottonian architecture.[32] Between 1897 and 1902 he published four articles on twelfth- and thirteenth-century sculpture in Saxony that laid the foundation for virtually all later scholarship on medieval sculpture in central Germany.[33]

Klaus Niehr has recently discussed the long-term significance of these essays.[34] First, Goldschmidt accurately redated the two bronze tomb plaques of Archbishops Friedrich (d. 1152) and Wichmann (d. 1192) in Magdeburg Cathedral on the basis of comprehensive historical and visual evidence. This gave him a secure point of departure from which to trace the stylistic development of sculpture at Magdeburg and in Saxony as a whole. In an article of 1899, Goldschmidt posited that sculpted figures and reliefs mounted in the upper levels of the choir at Magdeburg Cathedral were originally destined for a sculpted portal of the type widespread in the Ile-de-France during the early thirteenth century. Goldschmidt's initial observation and his subsequent reconstruction of the portal contributed immeasurably to an understanding of the introduction of French artistic ideas into central Germany.[35]

In an article of the following year, Goldschmidt presented a panoramic overview of stylistic developments in Saxon sculpture, identifying the need to examine the works of this region in relation to Byzantine prototypes such as ivories, manuscripts and metalwork, as well as in relation to French sources.[36] An article of 1902 on the Golden Portal of Freiberg situated this early thirteenth-century sculptural ensemble for the first time within its broader European context. Three of these essays on Saxon sculpture were

94

reissued as a collective study (*Studien zur Geschichte der sächsischen Skulptur*) in 1902, indicating the degree to which Goldschmidt's investigation of these sites provided stimulus for ongoing study of medieval sculpture in Germany.[37] Moreover, Goldschmidt's matter-of-fact demonstration of the impact of French models on the sculpture at Magdeburg put him outside the fray of nationalist sentiment that colored much discourse on German medieval sculpture during the 1890s.[38]

In 1902, Goldschmidt also published an important study of the wooden door of the Church of Sant'Ambrogio in Milan, his only publication on Early Christian art.[39] He assembled comprehensive archaeological, icono-graphic and documentary evidence to prove that the door was one of the original fourth-century fittings of the church. In the same year Gold-schmidt also published his first article focusing exclusively on ivory carv-ings. He concentrated his attention increasingly on this subject following his move to Halle in 1904 (Fig. 21).[40]

Goldschmidt's influence on the developing discipline of art history dur-ing the 1890s did not, however, derive solely from his publications. He was also a popular and gifted teacher and was immensely successful in fostering interest among students at the University of Berlin in art of the Middle Ages and of other eras. Like his publications, the topics of his lectures and seminars were wide-ranging. They examined, for example, Netherlandish painting, Italian Renaissance painting, German sculpture of the Middle Ages, German art of the Gothic era, Dürer and Holbein, Baroque art in Italy and Italian sculpture from Niccolò Pisano to Michelangelo.[41] Gold-schmidt enjoyed a close working relationship with the curators of the Ber-lin Museums and regularly designed his classes around original works in the Berlin collections.

Above all, Goldschmidt was concerned with preparing his students for museum and university careers, training them to extract a maximum of information from intensive visual analysis of a given object or group of objects. The memoirs of his students show that Goldschmidt demanded exactness rather than generalities or abstract speculation. A report by Hans Jantzen (1881–1967) of an incident in a seminar he attended in Halle in the years around 1907 is telling in this regard.[42] When a student floundered in his exposition of a particular jamb figure, Goldschmidt advised him to imagine that he was a fly crawling over the figure and to describe the pro-jections and crevices in the drapery from the fly's perspective.[43] Others

Figure 21. Adolph Goldschmidt, Halle, 1904. (Photo: Staatsarchiv Hamburg, Bestand 622-1 Goldschmidt)

who attended Goldschmidt's seminars in Halle marveled at the enormous gulf that separated their teacher's controlled, impersonal demeanor in his lectures from his passionate engagement with the same topic under more informal conditions.[44]

THOSE WHO KNEW Goldschmidt well emphasized that the scientific side of his character was balanced by a strong artistic sensibility; deep down, he was as vitally involved in the objects he studied as Vöge. However, Goldschmidt drew and maintained a firm boundary between the *Wissenschaft* (science) of his professional activities and the domain of personal

taste and emotion and allowed very little interaction between them.[45] This had significant implications for his scholarly view of artists. In a manner comparable to Wölfflin's in the 1890s, he concentrated more on evaluating their stylistic development as dispassionately as possible than on investigating the dynamics of the individual creative process.

The remarks of Werner Weisbach, who attended Goldschmidt's lectures on medieval art in Berlin during the winter semester of 1896–97, are interesting in this regard. Although he acknowledged his admiration for Goldschmidt's visual acumen and his ability to discern developmental and "genetic" relationships among artistic monuments, Weisbach found that Goldschmidt's approach left little room to consider broader cultural forces or the intellectual and creative processes that went into the making of the works.[46] The strict division that Goldschmidt maintained between his scholarly and private feelings regarding artistry is all the more remarkable in view of the fact that during these same years he formed enduring friendships with two contemporary painters of international stature, Edvard Munch (1863–1944) and Max Liebermann (1847–1935).[47]

GOLDSCHMIDT'S MEMOIRS provide valuable insight into his teaching and other activities in Berlin during the 1890s.[48] Among the many students attracted to his lectures who went on to pursue distinguished careers in art history were the Swedes Johnny Roosval (1879–1965) and Axel Romdahl (1880–1951). Roosval later became professor of art history at the University of Stockholm, while Romdahl became director of the Göteborg Museum. Goldschmidt remained in contact with these men, both of whom played influential roles in the institutionalization of art history in Scandinavia.[49]

Although Goldschmidt's status as *Privatdozent* did not permit him to supervise doctoral dissertations at Berlin during the 1890s, he had a particularly profound impact on two students who regarded him as their doctoral adviser in all but name. These men were Arthur Haseloff (1872–1955) and Georg Swarzenski (1876–1957), whose ground-breaking dissertations on medieval illuminated manuscripts were stimulated and then guided by Goldschmidt's own research interests.[50] Later, as full professor (*Ordinarius*) in Halle (1904–12) and in Berlin (1912–32), Goldschmidt encouraged and helped shape some of the most promising scholars in the field of art history,

Figure 22. Adolph Goldschmidt (*center*) with students from the University of Halle during an excursion to Hildesheim, summer 1909. (Photo: Staatsarchiv Hamburg, Bestand 622-1 Goldschmidt)

supervising nearly one hundred doctoral dissertations (Fig. 22).[51] This impressive number does not take into account the hundreds of students who attended his lectures, nor does it include young scholars such as Erwin Panofsky, Hans Kauffmann and others who conducted postdoctoral work with him (Fig. 23).

It is of particular importance for this study to assess how Goldschmidt's efforts were understood in the 1890s within the larger context of art history. A letter from Aby Warburg to Goldschmidt in August 1903, following a conversation with him in Berlin, is informative in this regard.[52] In the letter Warburg sketched, in tabular form, his vision of the methodological state of the discipline at the time. He saw a panegyric "history of artists" (*Künstlergeschichte*) practiced over the centuries by scholars such as Vasari, Grimm, Thode and Justi, as being superseded by "style history" (*Stilgeschichte*), which he termed "the science of typical forms" (*die Wissenschaft der typischen Formen*). Warburg defined the aim of style history in expansive terms as the investigation of "the sociological conditions, the universally

Figure 23. Adolph Goldschmidt with students in the Kunsthistorisches Seminar, University of Berlin. *Left to right:* C. J. Hudig, E. Freiherr Schenk zu Schweinsberg, A. Goldschmidt, H. Kauffmann, A. von Schneider, R. Hoecker, E. Schilling, E. Panofsky. (Photo: Kunsthistorisches Institut der Freien Universität, Berlin)

existing inhibitions against which the heroic individual has to assert himself," thus placing his own name (and intellectual presuppositions) next to those of scholars such as Semper, Wölfflin, Vöge, Wickhoff, Goldschmidt, Hegel, Taine, Müntz and Lamprecht. Warburg then categorized these diverse thinkers according to the principal "restricting conditions" (*Bedingtheiten*) that they considered in their work. He listed seven categories and located Goldschmidt's name in three of these, noting that his friend's research took into account the restricting conditions of technique, iconography (i.e., the character and import of visual traditions) and "the nature of the educated man's sense of space."[53] Although Warburg's 1903 letter was an informal expression of opinion, it indicates that Goldschmidt's particularly systematic and disciplined practice of style history was perceived by sensitive contemporaries to be multidimensional – regardless of how his endeavors might be evaluated today.

WARBURG'S LETTER is also interesting in relation to Vöge, but more with regard to Warburg's methodological mapping of the discipline than for the place he accorded Vöge within his scheme of style history. Curiously, he placed Vöge's name in only one category of restricting conditions – that of technique – along with those of Semper and Goldschmidt.[54] In this instance Warburg may have been recalling Vöge's consideration of architectonic and material constraints in *Die Anfänge des monumentalen Stiles*, as well as the emphasis Vöge had placed upon technical considerations in his studies of manuscripts during the 1890s. Yet Warburg's correspondence with Vöge during the 1890s and later indicates that Warburg saw Vöge's work not only as having broader conceptual latitude than Goldschmidt's but also as expressing concerns that were closer to the texture of his own scholarship. Thus, of greater relevance for us here is the distinct methodological line Warburg drew in the 1903 letter between an older panegyric history of artists and the newer *Stilgeschichte*, which had by then gained the upper hand in contemporary art historical practice. As we have seen, Vöge's highly experimental *Die Anfänge des monumentalen Stiles im Mittelalter* partook of both of these discrete directions, though he developed a theoretically more sophisticated position vis-à-vis the history of artists than had the other scholars cited by Warburg. Many of the concerns Vöge articulated in his 1894 study remained clearly present in his other work of the 1890s.

VÖGE WAS IN ROME when *Die Anfänge des monumentalen Stiles* appeared in print at the end of July 1894. He had traveled to Italy in April of that year in order to familiarize himself with art works of the Italian Renaissance. Intellectually speaking, this shift in geography and historical era also marked a significant transition from the investigation of anonymous artistic personhood to documentable individual artistry. Vöge's correspondence with Goldschmidt shows that he was quite literally overwhelmed by the wealth of material on the Renaissance masters (in terms of both the quantity of art works and the amount of archival evidence).[55] He remained in Italy until late January or early February of 1895 and continued to focus his research on Renaissance artists and monuments until at least early 1896.

Archival materials uncovered since the appearance of Panofsky's biographical memoir of Vöge in 1958 help us trace the directions taken by

Vöge's thought between the completion of *Die Anfänge des monumentalen Stiles* and his 1897 appointment to the curatorial staff of the Berlin Museums. In a postcard sent to Goldschmidt from Rome on 7 July 1894, Vöge stated that he was already at work on a study evaluating the formation of Michelangelo's sculptural style.[56] In a postcard of 12 September mailed from Siena, Vöge projected optimistically that he would have a book on Michelangelo completed by the next spring, and that it would be preceded by a series of articles.[57] On 23 September he wrote from Bologna, where he hoped to uncover material for a chapter on Michelangelo and Jacopo della Quercia.[58] On 25 October Vöge reported from Venice that he had material for several articles on Michelangelo, asserting that he would return to Florence to work on them. He added that he would like to have the articles appear in the *Jahrbuch der Königlich Preussischen Kunstsammlungen*, the scholarly organ of the Berlin Museums.[59] Vöge's correspondence of November and December 1894 with Goldschmidt makes almost no mention of progress on this project, for he was more concerned with reporting affairs pertaining to his potential *Habilitation* with Vischer at Göttingen. In a letter of 21 November he mentioned that Georg Dehio, Janitschek's successor at the University of Strasbourg, had invited him to submit his *Die Anfänge des monumentalen Stiles* as a postdoctoral thesis at that institution.[60] Correspondence with his family in late December suggests that by that time, however, Vöge had modified his plans for the work on Michelangelo, scaling down the project and contemplating another publisher.[61]

On 21 January 1895 Vöge informed Goldschmidt in a postcard sent from Florence that he had made a discovery about Raphael, and that he planned a small publication on the subject.[62] His next missive to his friend was a postcard mailed from Strasbourg on 25 February announcing that he had been accepted for the *Habilitation* at the university there. He reported that he had delivered a paper on "Raphael and Donatello" for the examination committee, and that the topic of his inaugural lecture, scheduled for the beginning of the summer semester, was to be "Michelangelo and the Pisani."[63]

It is clear that Vöge expended a great deal of time and effort on the study of Italian Renaissance art, yet relatively few of these efforts took published form. Between February and August of 1895 he reworked his lecture on Raphael and Donatello, and it appeared as a book in 1896.[64] In 1895 he also published a short review of a study of Raphael's drawings.[65] But none

of Vöge's research on Michelangelo was published. Recently, however, two unpublished essays have resurfaced, "Michelangelo's Pitti Madonna and Its Model" and "Michelangelo and the Pisani," an article based on his inaugural lecture at Strasbourg. The two manuscripts can be securely assigned to the period between late 1894 and 1896.[66] In addition, the original text of the inaugural lecture given at Strasbourg on 4 May 1895 has survived.[67] Although this is not the place to present specific details of provocative arguments long thought to have been lost,[68] these newly uncovered materials, when examined together with *Raffael und Donatello* of 1896, provide important perspectives on Vöge's evolving investigative approaches during these years.

BROADLY SPEAKING, Vöge's primary concern in all of these writings on Italian Renaissance art was to gain insight into the nature of the artistic process – that is, he attempted to reconstruct and reexperience specific aspects of the creative processes of Michelangelo and Raphael, just as he had sought to do with the artists of Chartres in *Die Anfänge des monumentalen Stiles*. Vöge concentrated on the intellectual rather than the technical operations of the Renaissance artists. As in his 1894 book, he was interested specifically in exploring the relationship between tradition and the innovations of genius – that is, the ways in which artists, inspired by the work of their predecessors, transformed appropriated forms and ideas into something materially and conceptually new.

In the Pitti Madonna article, for instance, he argued that Michelangelo's relief did not refer to earlier Madonna and Child images but had been inspired instead by a specific figure carved for the pulpit in Siena Cathedral by Niccolò Pisano.[69] In essence, Vöge suggested that Michelangelo's genius lay in part in his creative response to the achievements of his dugento and trecento forbears.[70] This hypothesis was novel within discourse on Michelangelo during the 1890s, for the Renaissance master's oeuvre tended to be explained largely by his unencumbered genius or, alternatively, with reference to antiquity or his more immediate quattrocento predecessors.[71] Clearly, Vöge's commitment to investigating the workings of the mind and hand of this creative individual contrasted greatly with Wölfflin's quest to uncover the impersonal laws or principles of Michelangelo's development in these same years. It is therefore not surprising that Vöge

employed Wölfflin's *Die Jugendwerke des Michelangelo* (The works of Michelangelo's youth) of 1891 as a sort of conceptual foil for his essays.[72] Vöge expanded his vision of the "living relationships" between Michelangelo and his dugento and trecento predecessors in his manuscript on Michelangelo and the Pisani.[73]

Similarly, in his book on Raphael and Donatello, Vöge attempted to show that Raphael's depiction of expressive movements in certain frescoes for the Stanza della Segnatura were inspired by his study of bronze reliefs Donatello had made for the high altar of the Church of Sant'Antonio in Padua.[74] Significantly, he appears to have derived his point of departure from Robert Vischer, who had made some initial observations on Raphael's relationship to Donatello in his 1886 *Studien zur Kunstgeschichte.*[75] Vöge's 1896 study was reviewed by Wölfflin, who, rather predictably, criticized Vöge for reading too much into the mind of the artist.[76]

To Vöge, then, the Renaissance artists Raphael and Michelangelo, like the twelfth-century masters at Chartres, confirmed the universal rather than period-bound nature of artistic creativity.[77] In the scholarly apparatus accompanying these studies Vöge made reference to *Die Anfänge des monumentalen Stiles.*[78] Significantly, too, the language he used in *Raffael und Donatello* and in the Michelangelo articles paralleled many of the rhetorical strategies employed in the 1894 book. This extended not only to word choice but also to the conscious oscillation between impartial "science," in a Wölfflinian or Goldschmidtian sense, and a more evocative, highly charged mode of writing where Vöge engaged in an idiosyncratic form of authorial mimesis with the artists, responding once again to Vischer's call for intuitive empathy on the part of the interpreter.[79]

The conceptual parity between Vöge's understanding of the artistry of the Middle Ages and the Renaissance and the thematic range of his work are also indicated by the courses he offered at the University of Strasbourg. Topics he addressed ranged from Raphael and Michelangelo to French medieval sculpture and French painting and sculpture of the nineteenth century.[80] Furthermore, besides publishing *Raffael und Donatello* in 1896, Vöge researched medieval illuminated manuscripts, publishing an article on a tenth-century lectionary from Reichenau related to the Codex Egberti, as well as a lengthy review of a book on manuscript illumination in early medieval Trier. Both of these subjects were very closely related to his doctoral thesis.[81] In methodological terms, these two essays on medieval

manuscripts provide a striking contrast to his work on Raphael, Michelangelo and the sculptors at Chartres, for they are strictly scientific in character. Concerned exclusively with impersonal style history and technical issues, these articles demonstrate the seemingly ever-shifting bases of Vöge's strategies of interpretation.

Panofsky hypothesized that Vöge did not publish his work on Michelangelo precisely because it was "too personal."[82] Though this notion may have some validity, a number of other events of which Panofsky was unaware seem to have intervened as well. A letter of October 1896 to Vöge from Richard Stettiner, co-editor of the journal *Das Museum*, shows that Vöge had in fact written to him to inquire about submitting articles on Michelangelo to that journal.[83] Correspondence between Goldschmidt and Vöge's mother between late 1896 and the spring of 1897, however, indicates that Vöge was incapacitated for a lengthy period due to a stress-related illness.[84] Thus he may have been prevented from finishing the Michelangelo manuscripts (possibly the two previously cited), owing to his protracted illness. Shortly after his recovery Vöge was appointed to a curatorial assistantship in the Department of Christian Sculpture at the Berlin Museums, a position that absorbed nearly all of his energies from that period onward.[85]

Wilhelm Bode, the director of the Department of Christian Sculpture and of the Gemäldegalerie, was responsible for summoning Vöge from the academic sphere to Berlin. Vöge had established contact with Bode earlier in the decade and acknowledged the encouragement that he had received from him in the preface to *Die Anfänge des monumentalen Stiles*. Vöge arrived in Berlin in early 1898 and remained there until 1908, when he resumed his academic career by accepting a professorship at the University of Freiburg.[86]

At Berlin he was immediately charged with drawing up a catalogue of the ivory carvings in the Berlin Museums. The results of his intensive, firsthand study of a large group of works from the Early Christian through Gothic eras were published in 1900.[87] His catalogue remains a masterpiece of critical judgment based on a meticulous application of *Stilkritik*, amplified by historical evidence where available. Both in the format of individual entries and in its concise, matter-of-fact approach, this catalogue may be seen in many ways as a model for Goldschmidt's later corpus of ivories, *Die Elfenbeinskulpturen*, which appeared beginning in 1914. It is of course

important to point out here that both men lived in Berlin from 1898 to 1904, when Goldschmidt moved to Halle. Although the two scholars saw each other regularly in these years, they continued to send letters across the city, soliciting advice from each other for their research projects, some of which pertained to ivory carvings.[88]

Vöge's methodological approach in the catalogue of 1900 was significantly conditioned by the scientific conventions of the established genre of the catalogue raisonné. The remarks of Weisbach, who worked with Vöge on a smaller section of the catalogue dealing with Renaissance and Baroque ivories, support this notion. Not surprisingly, Weisbach termed his senior colleague a "pure style historian."[89] Yet the tension manifested earlier in the decade in Vöge's scholarship – between art historical science, on the one hand, and humanist concerns, on the other – was in fact equally present during these years.

In 1899, while preparing his catalogue of ivories, Vöge published an article in which he drew attention to an individual ivory carver active in the German-speaking regions during the second half of the tenth century.[90] This was an unusual topic, for historical data concerning the conditions of individual artistry in the early Middle Ages were virtually unobtainable. Through keen visual analyses and subtle evaluations of technical procedure, Vöge delineated the creative temperament and oeuvre of an Ottonian artist in a manner comparable to his earlier work examining the sculptors at Chartres, as well as Raphael and Michelangelo.[91]

Between 1899 and 1901 Vöge published a series of lengthy articles on the thirteenth-century sculpture at Bamberg, in which he again considered artistic initiatives of individual masters within the broader scheme of the genesis of the sculpture at that site.[92] The Bamberg ensemble occupied a particularly prominent position in German art historical scholarship at the turn of the century, for in 1890 Georg Dehio had pointed to Reims as a probable stylistic source for a number of the sculptures at the Franconian site.[93] Expanding on Dehio and, like him, refuting the nationalist interpretative stances of many of his contemporaries, Vöge pointed to Byzantine ivories as a common source that could help explain certain stylistic affinities between Bamberg and French sites. He proclaimed, furthermore, that definitive conclusions about the artistic origins and ambitions of the Bamberg masters could not be reached without detailed knowledge of thirteenth-century sculpture in France, most notably at Reims.

In addition to his curatorial duties at the Berlin Museums, in the years around 1900 Vöge managed to undertake a number of private scholarly projects that focused on examination of the plastic gestalt and *Geist* of Reims Cathedral (Figs. 24, 25).[94] His repeated study and photographic trips to that site led him to distinguish a number of individual sculptors within the collective enterprise, including the Visitation Master (*Visitatio-meister*) and the Joseph Master (*Josephmeister*).[95] Vöge's persistent concern with identifying the individual character of medieval artistry is also indicated by the topic "On the Meaning of Personality in French Medieval Art," which he chose for his inaugural address at the University of Freiburg.[96] We know the content of the lecture, for an expanded version was published in 1914 under the rubric "Pioneers of the Study of Nature around 1200."[97] In this essay, Vöge employed both his acute powers of observation and his remarkable rhetorical skills in order to outline the creative powers and psyches of the thirteenth-century "Master of the Kings' Heads" (*Königskopfmeister*) at Chartres and the "Peter and Paul Master" (*Peter- und Paulusmeister*) at Reims. Comparing their artistic self-consciousness to that of Italian masters such as Niccolò Pisano, Donatello, and Ghiberti, Vöge declared that it was the duty of the art historian to uncover artistic will and imagination behind the seeming anonymity of French medieval monuments.[98]

Although detailed exploration of Vöge's scholarship in the years just prior to his tragic breakdown of 1915 is beyond the scope of the present study, it is important to point out that Vöge continued to operate within the relatively "open" methodological parameters he had established during the 1890s. Prior to his departure from the Berlin Museums, Vöge wrote a second major catalogue in which he classified the monumental wood, stone and bronze sculptures from northern Europe in the collection.[99] The eminently factual, succinct and impartial mode of analysis and presentation again provided a dramatic contrast to the highly personalized nature of many of Vöge's other studies appearing during these same years. Research for this catalogue, which embraced works of the later Middle Ages (or Northern Renaissance), introduced Vöge to individual artists of the fifteenth and sixteenth centuries active in the German regions, including Veit Stoss, Konrad Meit, Nikolaus Hagenower and Jörg Syrlin. Vöge published studies of these sculptors from 1908 onward, and it was to these fifteenth- and sixteenth-century masters that he returned in his later work.[100]

IN SUMMARY, Goldschmidt's and Vöge's pioneering studies of medieval painting and sculpture during the 1890s and the years immediately following manifested an extraordinary range of investigative concerns and approaches. Neither scholar's work was methodologically fixed. Vöge's writings displayed greater conceptual and rhetorical latitude, alternating with apparent ease between impartial science and a "living" interpretation of forms. Goldschmidt's seemingly more concrete approach to the study of medieval monuments did not rest on a narrow definition of "scientific" style criticism, for it also incorporated iconographic and historical considerations (i.e., history as defined within orthodox academic circles of the time) in order to help establish the date, sequence and the original context or location of a given work. In addition, both Goldschmidt's and Vöge's conceptions of medieval art during the inaugural years of their professional careers were informed by their work on monuments from other eras, especially the Renaissance.

The common denominator in their scholarship was their extensive and virtually unparalleled firsthand knowledge of monuments and their careful scrutiny of the formal and iconographic properties of individual works. Significantly, this was also the point where their work diverged, for Vöge, unlike Goldschmidt, was concerned with probing the internal, as well as external, dynamics of the forms he studied. Vöge's fascination with the less tangible aspects of artistic creation encouraged him to seek support for his approach from diverse sources, ranging from contemporary art and art theory to experimental psychology.

The distinctive accents of the two scholars – Goldschmidt's *Sachlichkeit*, or scientific matter-of-factness, and Vöge's desire to reconcile scientific laws with an intuitive reexperiencing of artistic creation – can be attributed in large part to their personal sensibilities, as well as to the differences in their educational backgrounds. Yet by the same token, the common and divergent elements in their thought are broadly symptomatic of positions taken in many late nineteenth-century debates over the nature and methodology of the newly formed human sciences, or humanistic studies (*Geisteswissenschaften*).

During the 1880s and 1890s, many German scholars, most notably the philosopher Wilhelm Dilthey (1833–1911), grappled with the task of constructing a vision of the intellectual operations that could be defined as common to the physical sciences (*Naturwissenschaften*) and the human sci-

Figure 24. Postcard from Wilhelm Vöge to Adolph Goldschmidt, postmarked in Reims on 15 June 1903, showing Virgin and Child on trumeau of central portal, west facade, Reims Cathedral. (Photo: Kunstgeschichtliches Institut der Albert-Ludwigs-Universität, Freiburg im Breisgau)

Figure 25. Postcard from Wilhelm Vöge to Adolph Goldschmidt, postmarked in Reims on 17 June 1903, showing south side of Reims Cathedral. (Photo: Kunstgeschichtliches Institut der Albert-Ludwigs-Universität, Freiburg im Breisgau)

ences.[101] Stated briefly, Dilthey acknowledged that the two areas of inquiry shared a number of intellectual procedures and analytical categories, including observation, description, classification, induction, deduction and the use of models. But the human sciences, he argued, were distinguished from the physical sciences by their study of the activities of individual human beings, for which strictly technical descriptive procedures and classificatory schemes were not always adequate to generate understanding. According to Dilthey, "we explain nature, but understand mental life."[102] As a counterweight to scientific methodologies, Dilthey advocated a hermeneutic of sympathetic intuition, or *Verstehen*, by which the scholar of the human sciences could reexperience meaning (mental content, such as an idea, intention or feeling) objectified in cultural products, including art works and certain forms of social institutions. In Dilthey's view, this process of mental reenactment, when accompanied by scientific rigor, had the potential to disclose those dimensions of experience unique to humanistic studies.

In setting Dilthey's methodological appraisal of the human sciences alongside Vöge's and Goldschmidt's scholarship of the 1890s, it is important to stress that the ideas of all three took root in common intellectual soil. As we saw earlier, Vischer had advocated similar principles of inquiry in his art historical writings. A number of common threads appear to link his concepts of *Einfühlung* and *Nachfühlung* with Dilthey's definitions of re-creative experience (*erleben, nacherleben*).

Goldschmidt's approach to the study of artistic monuments embodied those scientific verification procedures most clearly shared by the human and physical sciences – procedures that, if employed alone, did not risk penetrating or attempting to penetrate the human content and experience existing behind the visual stratum. Goldschmidt's practice of art historical science always accorded a secondary role to considerations of human agency and artistic psychology. The Diltheyian process of *Verstehen* was really never engaged.

The work of Vöge, on the other hand, incorporated both sides of the hermeneutic model proposed by Dilthey and displayed the tension between science and human agency resident in this approach. As we have seen, Vöge's individual artists were viewed as playing an active originating role in the making of art. It was the interpreter's task to unravel the originality. In this regard it is important to signal Vöge's experimentation with

descriptive language as a tool for reconstituting meaningful experience in art historical discourse. Though Vöge's approach may appear today to have been more randomly structured than philosophically sophisticated or systematic, the very fact of his engagement with scientific method as well as with the variability of human agency represented an innovative and important countercurrent in the writing of art history at the end of the nineteenth century.[103]

VÖGE'S AND GOLDSCHMIDT'S REFLECTIONS on the nature, practice and writing of art history occurred against a backdrop of collegial interest and constant interpersonal exchange. Both men were acutely conscious of the experimental nature of their particular interpretative procedures, and recognized that specific aspects of their work as well as their conclusions would always remain subject to revision. In this regard it is crucial now to consider the history of the reception of their work. How were their "monumental" agendas received and perceived by scholars in Germany and elsewhere during the 1890s and later? In tracing the reception of their work, an effort must be made to determine those features of their methods that endured, as well as those that did not – and, in either instance, to ask why.

PART III

Resonances

4

German and International Responses at the Turn of the Century

CONSIDERING THE LACK of specialized studies of medieval manuscript illumination and sculpture prior to the 1890s, it is understandable that Vöge's and Goldschmidt's publications were immediately greeted with enthusiasm by their contemporaries. The response to their work tended to reflect linguistic and national borders that were determined both by the location of the objects or monuments studied and the presence or absence of institutionalized art history – and hence of a professional audience. Goldschmidt's 1890s publications, which focused primarily on German and Italian topics, had broadest resonance among art historians in Germany and Austria. Though Vöge addressed a number of German topics, his investigations of medieval sculpture were of special interest for the French *archéologie nationale.* His work therefore met with an immediate response not only in Germany and Austria but also in France. At the turn of the century France was the only country outside German-speaking Europe with a community of scholars of art and archaeology of comparable size and expertise.

The chief aim of this chapter is to gauge the nature and range of national and international response to the critical approaches, findings and interpretations developed by Vöge and Goldschmidt during the 1890s. Though greatest emphasis is placed on the reception of their work by the year 1905,

some consideration is also given here to the impact that their 1890s publications had up to the outbreak of World War I.

Because of its extraordinary scope and pace, Vöge's and Goldschmidt's scholarly production of the 1890s provided decisive stimulus in many areas of the developing discipline. Their individual and collective contributions to the study of medieval art were perhaps greatest in the areas of Carolingian and Ottonian manuscripts, twelfth- and thirteenth-century sculpture in Germany and France and medieval ivories. The catalogues of ivories and medieval sculpture prepared by Vöge for the Berlin Museums established scholarly standards for catalogues of medieval objects undertaken shortly thereafter both in Europe and in the United States.[1] In addition, a number of Vöge's and Goldschmidt's publications on nonmedieval subjects also broke new ground and provided new intellectual stimulus.[2]

It would be impossible to explore all the particulars of response to the complex arguments put forward in their 1890s scholarship. For the present study it is more useful to sketch a broad, if provisional, overview of the immediate and long-term reception of their work through a selected case study. A careful tracing of the scholarly reaction to Vöge's *Die Anfänge des monumentalen Stiles im Mittelalter,* augmented by documentation pertaining to the reception of Goldschmidt's work, provides provocative insights into both the generic and specific responses their work provoked.

Vöge's *Die Anfänge des monumentalen Stiles* provides an important focus for a *Rezeptionsgeschichte* because of its complex and inclusive conceptual bases. In this book Vöge tried to integrate the "scientific" approach of his manuscript studies – an approach that was generally characteristic of Goldschmidt's scholarship – with analysis of the nature of the artistic process and creativity. To an important degree, this study encapsulated the discursive range of both his own and Goldschmidt's work during the 1890s. Thus it provides a useful example for gauging the character of the response to diverse methods employed by the two scholars.

On a strictly historical level, Vöge's 1894 book is highly significant because of its early date and ambitious scale. Conceived during the early 1890s, when the discipline of art history was still amorphous in many ways, Vöge's study constituted the first attempt to construct a synthetic vision of the genesis of French medieval sculpture. Comparable publications by Goldschmidt, such as *Studien zur Geschichte der sächsischen Skulptur* or *Die Elfenbeinskulpturen,* came only later. The catalytic role played by Vöge's

book in the structuring of discourse on medieval sculpture was comparable to the impact exerted on the study of other media by equally experimental texts of the 1890s, including Riegl's *Stilfragen* (1893) and Wickhoff's *Die Wiener Genesis* (The Vienna Genesis, 1896). Furthermore, unlike many other pioneering German-language publications in art history that may be better known today, Vöge's work stimulated international reaction from virtually the moment it appeared.

THE NUMBER of serious and lengthy reviews of Vöge's book that rapidly appeared in scholarly journals – there were at least eight – suggests the immense interest that it aroused. Although this scale of response would be remarkable by today's standards, it was even more so at a time when only a limited number of art historical journals existed. The reviews were undertaken by major scholars, including Georg Dehio, Paul Clemen, Herman Grimm, Émile Mâle, Albert Marignan and Adolfo Venturi (1856–1941).

Without exception, the reviewers drew attention to the value of the "science" in Vöge's book – that is, to the important results yielded by a rigorous stylistic analysis. Dehio, for instance, praised Vöge's application of "the German method of style criticism" to "French material" in an extensive review for the *Repertorium für Kunstwissenschaft*.[3] Pointing out that Vöge had directed his attention to an area of inquiry that had hitherto been neglected – namely, the genesis of medieval sculpture – Dehio declared that Vöge's text illustrated precisely what could be achieved by the science (*Wissenschaft*) of art history where means (*Mittel*) had previously been lacking.[4] Dehio then proceeded to discuss Vöge's arguments for the novelty of the west facade sculpture at Chartres, outlining Vöge's careful weighing of visual evidence as well as his filiational scheme. Though he acknowledged that some of Vöge's hypotheses would likely undergo revision, Dehio paid tribute to the pioneering nature of the book, proclaiming that it would enable "subsequent research to stride forward where earlier it had taken only faltering steps."[5] Dehio's endorsement of Vöge's "scientific" approach is further documented by his suggestion that the young scholar submit the book as his *Habilitationsschrift* at the University of Strasbourg.

Other German scholars reacted in a similar fashion to Vöge's mode of analysis. Paul Clemen, who had commended Vöge's dissertation as a "scientific" model for the investigation of illuminated manuscripts, stressed

the equally foundational significance of Vöge's study of medieval sculpture in a review published in *Kunstchronik*, a newsletter accompanying the Berlin- and Vienna-based *Zeitschrift für bildende Kunst*.[6] He praised Vöge's characterization of the originality of the style and technique at Chartres. In addition, he noted that Vöge was the first scholar to address the problem of direct sources for the west facade sculpture, and that he had done so by adopting a "scientific" investigative strategy.[7] After outlining the network of influences Vöge had established through rigorous stylistic analysis as well as by evaluating iconographic and technical issues, Clemen concluded that the level of discussion, clarity and astuteness that had enabled Vöge to arrive at his conclusions was unmatched by any German-language scholarship on the Middle Ages published in the previous decade.[8] Clemen suggested, too, that the method and results developed in Vöge's book were of considerable relevance for the study of media other than sculpture.[9]

Alexander Schnütgen, editor of the *Zeitschrift für christliche Kunst*, claimed that Vöge's investigative procedure was "so entirely thorough and rigorous, so multifaceted and objective, so clear and convincing" that the results opened entirely new perspectives on the development of eleventh- and twelfth-century sculpture in France.[10] He emphasized, too, that the young scholar's comparative method and "genetic" lines of argument were significantly complemented and expanded by his wide range of technical and iconographic considerations.[11]

Albert Marignan's detailed six-page review of Vöge's book, published in *Le Moyen Âge*, in 1894, played an instrumental role in disseminating knowledge of *Die Anfänge des monumentalen Stiles* within the French scholarly community.[12] Saluting Vöge's book as "the first scientific study of the genesis of monumental sculpture in France," Marignan lauded the "serious and methodical manner" in which the German scholar approached the task of determining the influence of southern French schools of sculpture on northern France.[13] He dwelt especially on those aspects of Vöge's study he felt would be of particular interest to his French audience. Although Marignan emphasized his German colleague's championing of the French genius manifested at Chartres, he also drew attention to the strictly disinterested (i.e., scientific) scholarly practices that distinguished Vöge's study from earlier French scholarship.

Marignan singled out Vöge's theories about the architectonic conception of the Chartres figures, as well as the systematic genealogical nature

of his investigation, terming it a "masterpiece of criticism."[14] He also praised the notion of associating stylistically related works with the hands of itinerant masters, noting that Vöge's book presented a "new method" to French scholars, whom Marignan generically characterized as having concentrated on basic descriptions of individual monuments and their iconography rather than examining links among sites or the individual travels and manners of the artists who had created the monuments.[15] Concluding his review, Marignan said that Vöge's book merited close study, for it described "the history of twelfth-century sculpture in France" and had succeeded in "proving" the originality of the monuments studied.[16]

Vöge's book in fact generated enormous and sustained interest among French scholars. The president and board of the Société Archéologique d'Eure-et-Loir initiated plans almost immediately for a French translation, so that French scholars could profit from the methodological foundations laid by the German art historian.[17] An abridged version of Vöge's text, along with an accompanying commentary that summarized what were seen as the most novel perspectives developed by Vöge, appeared in 1901.[18]

Even before this translation appeared, Émile Mâle published an article in 1895 in *La Revue de Paris* on "Les Origines de la sculpture française du moyen âge," a subject that was specifically conditioned by his reading of Vöge's work; indeed Vöge's book was the first study cited.[19] In the twenty-six-page article Mâle surveyed the hypotheses concerning the antique and Byzantine origins of French eleventh- and twelfth-century sculpture advanced by earlier French archaeologists, including Charles Cahier, Anthyme Saint-Paul and Viollet-le-Duc, as well as by such contemporary scholars as Louis Courajod. He then drew attention to Vöge's "penetrating" and "ingenious" study, crediting the German scholar with being the first to solve convincingly the riddle of how the "masterpiece" of the west facade at Chartres had been produced.[20] He paraphrased Vöge's arguments for the southern French (Provençal) sources of the Chartres ensemble, terming *le maître de Chartres* a "man of genius" and "the first Gothic sculptor."[21]

Vöge's discussion of Provençal sculpture in his 1894 book affected the study of sculpture in northern Italy as well. Here, of course, geographic proximity was important. In 1895, the same year in which Mâle's essay appeared, Adolfo Venturi published a review of Vöge's book in the *Archivio storico dell'arte*.[22] Venturi's assessment of Vöge's achievements generally cor-

responded to those of other scholars, for he portrayed the book as a "magisterial demonstration" of "rigorous method" that would incite and guide future research.[23]

THIS CURSORY SAMPLING of reviews[24] suggests that shortly after the book's publication a gap developed between Vöge's articulated intentions and the perception of his work by his contemporaries. Vöge's primary concern had been to trace the nature (*Wesen*) and genesis (*Entstehung*) of Gothic sculpture; as we have seen, this involved both a scientific analysis of visual evidence and an attempt to "descend" into the "workshop" of individual creative activity. Most of those who read the book, however, saw in Vöge's monument-specific study the attractive possibility of an intellectually rigorous system for examining and constructing "histories" of Gothic sculpture. In other words, the reviews tended to isolate the "science" in Vöge's text and chose not to confront his portrayal of human agency, mentality and the psychology of form in medieval sculpture.

Few of the reviewers reacted to the more expressive or evocative aspects of Vöge's text. Though certain nuances of Vöge's descriptive language might have been lost on non-German readers (and neutralized even further through translation), it is remarkable that even German art historians chose to emphasize the "scientific" and "objective" character of Vöge's text, making only passing references to its literary voice.[25] Collectively they managed to divorce the more aesthetic character of Vöge's language from any attempt to enable the reader to reexperience an individual act of creation.

It appears from the reviews – whether German, French or Italian – that Vöge's depiction of the "living" mentality and artistic presence of the twelfth-century masters at Chartres met with responses that partly misinterpreted or misrepresented his intentions. Dehio and Herman Grimm, for instance, criticized Vöge's personalized and animated rendering of "masters" and "hands" at Chartres, characterizing it as an oversharpening (*Überschärfe*) of stylistic criticism.[26] Simply stated, they felt that Vöge's depiction of the masters exceeded the proper bounds of the personally disinterested, and hence intellectually pure, science of style. Scholars who did accept the notion of individual itinerant masters, and the resulting characterizations of artistry, did not pursue it beyond its simple face value as an

interpretative possibility. In other words, "the master" (*der Meister, le maître*) soon became just another analytical category, one devoid of any need to grapple in depth with the conditions of individual artistic volition. The deep ideological structure of Vöge's investigation of the personhood of individual masters was either marginalized or ignored in favor of the convenient visible surface structure, with its filiational narrative unfolding systematically from chapter to chapter.

Vöge himself contributed to the confusion. Despite the unequivocal introductory statement that his book was not intended as a "history" of French sculpture, his text was contradictory in this regard. He proclaimed in several passages that the "systematic tracing" of "links between sites and masters" would "replace chaos" with "history."[27] But assertions such as these, as well as the overall scientific drive of his text, were not the only factors that determined the general response. His book appeared at a point when the study of form and style was in the process of being developed as a scientific instrument of the discipline of art history. In the course of the 1890s, *Stilkritik* was in fact assigned ever more informing power as it was refined by Riegl, Wölfflin, Wickhoff, Goldschmidt and others as the preeminent critical tool of art history.

At a time when practitioners of the new disciplinary science were searching for repeatable analytical and classificatory systems, Vöge's book, with its broad developmental visions, gained much of its force from the microscopic examination of stylistic elements. It seemed therefore to offer an excitingly modern investigative scheme for the study of medieval sculpture. By contrast, the notion of *Einfühlung*, or Vöge's "living" depiction of medieval artistry, which aimed to enhance an understanding of the creative process and of the created object, was less replicable, less "objective" and hence less useful in securing the disciplinary status of a self-aggrandizing art history. The tension between science and humanity in Vöge's approach was solved, for most readers, by what seems to have been a conspicuously one-dimensional reading.

In order to gain further insight into the broader intellectual constellation of 1890s art history, it is useful to examine the imprint Vöge's book left on the increasingly specialized scholarship on medieval sculpture published in both Germany and France up to about 1905. Once a scientific

model had been established, the second half of the 1890s in Germany saw a remarkable proliferation of monographic treatments of sculptural ensembles. The sort of filiational scheme and verification procedures that Vöge had devised were applied by other scholars, including Artur Weese, Karl Franck-Oberaspach and Kurt Moriz-Eichborn, to studies of sculptural programs at sites such as Bamberg, Strasbourg and Freiburg im Breisgau.[28] Vöge's master-centered scheme also gave important stimulus to the discovery and enshrinement in print during these years of itinerant medieval artists such as the Bamberg Master, the Strasbourg Master and the Naumburg Master.[29] Although German-language scholarship shows some precedent for this form of artistic nomenclature for anonymous medieval artists,[30] it became much more widespread and elaborate in medieval art historical discourse after the 1894 debut of Vöge's Headmaster, Master of Corbeil and other masters at Chartres. Among Vöge's surviving papers are letters sent to him by virtually all German scholars who conducted research on medieval sculpture in the second half of the 1890s and later.[31] These letters document the strong impetus provided by *Die Anfänge des monumentalen Stiles* toward a particular form of scholarship in Germany.

Although the enthusiastic response to Vöge's "science" by German-speaking scholars was understandable, in view of the fact that they were the generating force behind the institutionalization and formalization of the discipline, the equally enthusiastic reaction of Émile Mâle is somewhat more surprising. Like Vöge and Goldschmidt, the French scholar had embarked on his career in the 1890s.[32] By 1898 he had consolidated his reputation as an iconographer with his *L'Art religieux du XIIIe siècle en France*. Yet as we saw earlier, already in an 1895 review of Vöge's book Mâle had professed great admiration for the German scholar's "penetrating study." Mâle's continuing fascination with Vöge's work was evident in his publications of the following six years.

In 1897 Mâle published an article in the *Revue de l'art ancien et moderne* in which he examined the Portal of Saint Anne on the west facade of Notre-Dame Cathedral in Paris.[33] In this essay, he essentially set out to prove a point suggested by Vöge. The German scholar had proposed that the hand of the "Master of the Two Madonnas" was detectable both in the tympanum of the south portal on the Chartres west facade and in the tympanum of the Saint Anne portal at Notre-Dame. Championing Vöge's comparative method in the introduction to his article, Mâle proceeded to

"mettre en lumière," in greater detail than had Vöge, the diverse artists who had contributed to the fashioning of the Paris portal.[34] Mâle's essay, in which he tried to sort out those parts of the portal that he thought were executed by the Chartrain master from those by lesser members of his workshop was extraordinary in its careful imitation of Vöge's principles of inquiry.

Yet Mâle's employment of stylistic analysis, his evocation of the "creative energies" of the artists and his depiction of the handling of the chisel by individual masters[35] in his 1897 article could not have been more different from his portrayal of these masters as "humble and docile interpreters" of the "grand thoughts" of theologians in his celebrated book of the following year. The contradiction here is certainly noteworthy. What in fact was Mâle's agenda?

In *Die Anfänge des monumentalen Stiles* Vöge had specifically mentioned an 1892 article by Mâle in which the French scholar had examined capitals from the cloister of La Daurade in the Toulouse Museum.[36] Vöge criticized Mâle in that context for restricting his study to a description of the capitals themselves rather than attempting to gain a broader picture through the tracing of stylistic and workshop affiliations.[37] Clearly Mâle's experimentation with the German scholar's method in his 1897 article must be seen in part as a response to Vöge's critique. Mâle also cited Vöge's study several times in his *L'Art religieux du XIIIe siècle en France*, but in this case only with reference to his treatment of iconographic questions.[38]

Mâle's great esteem for the German scholar's approach was also demonstrated in an article of 1901, where he assessed the accomplishments made in the study of medieval art in France during the previous twenty years.[39] The essay, which appeared in the *Revue de synthèse historique*, not only provided a useful summary of the state of research on medieval architecture and sculpture in France at the time but also offered Mâle's trenchant criticisms of the weaknesses he perceived in the work of his French colleagues. The article, which is full of praise for the "solidity" and "synthetic" and "organized nature" of the work of his German neighbors, appears to have been conceived as a sort of manifesto, designed to incite more rigorous efforts on the part of his French compatriots. In the section of his article dealing with sculpture, Mâle again devoted much attention to Vöge's *Die Anfänge des monumentalen Stiles*, terming it the "only book" on the history of French sculpture that was "truly rich in ideas."[40] He reviewed Vöge's

stylistic network as well as his arguments for the presence of individual artists at Chartres, describing several of his chapters as "models of archaeological criticism."[41] He concluded his discussion of Vöge's study by exhorting his colleagues to follow it as a model for the study of thirteenth-century sculpture at French cathedrals.[42]

Mâle also alluded to the debate over the origins of French sculpture that Vöge's book had awakened, stating that the most recent French literature appeared to refute at least some aspects of Vöge's chronology. He was referring here to studies by Marignan, who attempted unsuccessfully in 1898 and 1899 to redate the sculpture on the Chartres west facade to the early thirteenth century, as well as to the work of Maurice Lanore, who demonstrated more convincingly in 1899 and 1900, that the sculpture on the west facade of the Royal Abbey of Saint-Denis predated that of Chartres.[43] In 1902 Robert de Lasteyrie (1849–1921), professor at the École des Chartes, published his *Études sur la sculpture française au moyen âge*, in which he argued that many sculptural ensembles at southern French sites, including Saint-Trophime at Arles, which Vöge had viewed as precursors of the Chartres west facade, were in fact executed at a later date than the Chartres Royal Portal.[44] Although Marignan, rather than Vöge, was the principal target of de Lasteyrie's vehement polemic, his discovery obviously affected to some degree the contemporary prestige of Vöge's book.

Yet some French scholars, including Mâle and Louise Pillion, a student of André Michel (1853–1925), recognized that de Lasteyrie's arguments affected Vöge's results only in terms of material detail, rather than detracting from the methodological value of his investigative "system." In her 1908 essay on "Les Historiens de la sculpture française," in *La Revue de Paris*, for example, Pillion lavished praise on Vöge's book, declaring that despite the need for some modifications of his chronology, Vöge's mode of inquiry remained "ingenious" and French medieval scholarship owed him a great deal.[45] She dwelt specifically on Vöge's effort to reconstitute artistic individuality in the twelfth century, as well as on his "convincing application" of the "German method of stylistic analysis" to the study of French sculpture.[46]

Vöge's continued fieldwork at French cathedral sites until 1914 necessarily meant that he developed and maintained close ties with French scholars. Letters from such prominent scholars as Georges Durand, André Michel, Camille Enlart, Raymond Koechlin, Paul Vitry and Marcel Aubert

are preserved among his papers.[47] This correspondence indicates the consistent respect that his work engendered among the French. In a letter sent to Vöge in the years following the appearance of de Lasteyrie's study, Koechlin went so far as to assure the German scholar that "vous êtes notre *bahnbrecher*" ("you are our pioneer").[48]

At the same time, however, it is important to bear in mind that apart from Mâle, Marignan and several others, French scholars tended to know Vöge's work indirectly (i.e., through detailed book reviews or an abridged translation) rather than at first hand. Vöge, in fact, remarked in a letter to Goldschmidt that French scholars had difficulty grasping the fine points of his arguments owing to their lack of command of the German language.[49] Thus, much of the French response to specific hypotheses put forward by Vöge occurred at some distance from the original text. Nevertheless, the lessons of Vöge's stylistic network and master scheme, reinforced by subsequent studies of Chartres and other sites in the immediately ensuing years, were quite thoroughly absorbed into French scholarship by about 1905, although investigations of medieval sculpture by French scholars tended to remain more iconographically oriented than those of their German counterparts. Because of the historical point at which Vöge's influence penetrated French scholarship, certain aspects of his approach remained active in French work on medieval sculpture even during and after World War I, when French scholars categorically repudiated German art historical scholarship on the Middle Ages, in an attack led by Mâle.[50] Vöge remained alive as an influence in France, not so much in name as in cumulative scholarly effect.

THE METHODOLOGICAL IMPACT of Vöge's book on British and American scholarship on medieval sculpture prior to World War I was negligible, since very few scholars in either country were qualified to respond critically to it. In 1909 an English couple, Margaret and Ernest Marriage, published a book with Cambridge University Press entitled *The Sculptures of Chartres Cathedral*, with text in both English and French.[51] This study, which was aimed at an educated audience rather than at scholars per se, represented the most complete description of the sculpture at Chartres available in English at the time. The text and bibliography show that the authors were familiar with the most recent scholarship on the Chartres

west facade, but they mentioned only briefly Vöge's masters and the opinions of French scholars, including de Lasteyrie and Marignan.[52] The most important scholarly study of medieval sculpture published in Britain prior to World War I, Edward Prior and Arthur Gardner's *An Account of Medieval Figure-Sculpture in England* (1912), shows that British scholarship on monumental sculpture was largely antiquarian and descriptive in nature, and that it remained more or less impervious to any methodological trends on the Continent.[53]

Much the same was true of American scholarship on medieval sculpture at the turn of the century. Courses in "fine art" and in "Christian archaeology" became a routine part of the curriculum at universities such as Harvard and Princeton in the late nineteenth century, and significant holdings of European scholarship were assembled at the libraries of these institutions and elsewhere. Arthur Frothingham (1859–1923), an archaeologist at Johns Hopkins University, published a textbook on medieval sculpture in 1901, but the section on medieval sculpture was dependent methodologically on translations of earlier German "histories" rather than on current scholarship.[54] The most internationally prominent American practitioner of art history at the time was the connoisseur Bernard Berenson (1865–1959), whose scientific, Morelli-inspired activities occurred for the most part on the European side of the Atlantic, though his influence was increasingly felt in America after 1900.[55] It is important to mention, too, that Paul Clemen spent a semester teaching at Harvard University in 1907–08 under the auspices of the Germanic Museum, founded at Harvard in 1903.[56] Clemen's visit to Harvard played an important role within the context of German-American cultural relations. It does not appear to have been calculated to exert long-term impact on the development of a discipline that did not yet exist in any substantial form in America.

TURNING BACK to 1890s Germany, the focus of our investigation, it may be useful to consider again in more detail the nature of the response to Vöge's complex publication. Was Vöge aware of the forces that produced the slippage between the conception and reception of his study? If he was, why did he not try in some way to articulate his recognition publicly? During the 1890s Vöge did in fact try to draw attention to the limitations of an art history founded on an exclusive evaluation of formal properties. This

is evident not only in *Die Anfänge des monumentalen Stiles* but also, for example, in his unpublished writings on Michelangelo, in which he argued against the increasingly formalistic work of Wölfflin. Yet Vöge certainly also knew that his work, like that of Dilthey and others, was experimental and fraught with contradictions and indecision, as it oscillated between two opposing hermeneutical poles. Any overt protests against the "scientific" readings of his book were in a sense precluded by the very fact that *Stil* was, and remained, an integral component of his scholarly approach. As we shall see later, it was only in the 1920s that Vöge took a definitive stance on the "science" of stylistic criticism, but then in relation to developments in the discipline in the intervening years.

The attraction of *Stilkritik* as a factual and learnable brief for art history and one that could ensure the scientific status and autonomy of the discipline is suggested in letters written by the Vienna-schooled Max Dvořák (1874–1921) to Goldschmidt shortly after the turn of the century.[57] The broader context of Dvořák's letters is significant, for at the time he and Franz Wickhoff were attempting to launch a review journal, the *Kunstgeschichtliche Anzeigen*, which, as he explained to Goldschmidt, aimed to demonstrate the "objectivity" and "exact science" of art history.[58] Goldschmidt was targeted as a contributor, as was Vöge, for Dvořák counted them among the "phalanx of researchers" whose work embodied "scientific criticism and method."[59] In a 1903 letter to Goldschmidt, Dvořák called for an objective form of art history comparable to the study of political history.[60] Though Springer had drawn a similar analogy between art history and the scientific and objective methods of political history some twenty years earlier, Dvořák's concern in the years around 1900 took on different meaning in the aftermath of the acrimonious *Methodenstreit* that had erupted in the historical discipline in Germany during the second half of the 1890s.

As we noted earlier, the methodological dispute pivoted on the cultural historical work of Lamprecht, whose psychosociological approach to the study of German history was ultimately discredited (by 1899) by the more orthodox members of the German historical community. The dispute within the historical discipline did not take place in an intellectual vacuum, and, as Roger Chickering has recently suggested, it is likely that its outcome had significant consequences for related disciplines such as art history.[61] Though the issue of the specific relations between the *Methodenstreit*

and the development of methodology in art history awaits further investigation, it seems likely that the dispute within the well-established historical discipline had important – if subtle – ripple effects on the young field of art history, with which it was by nature closely allied.

Indeed Lamprecht's intellectual and ideological defeat in the 1890s may have encouraged the refinement of stylistic analysis as a neutral, scientific method – one capable of constructing and documenting art historical narratives like those of "mainstream" political history. As had been demonstrated vividly in the case of Lamprecht, scholars could put their careers at risk if they engaged in abstract speculation or psychologically based modes of inquiry.

Viewed in this broader intellectual context, the one-dimensional scientific response to Vöge's work by his German contemporaries – precisely at the point when the *Methodenstreit* was taking place – becomes all the more comprehensible. Yet it also becomes more complex, because Lamprecht's concern with the life of the soul (*Seelenleben*) and mentality in the Middle Ages had contributed, in a direct and important fashion, to the conception of Vöge's book. Indeed the selective reading of *Die Anfänge des monumentalen Stiles* at the turn of the century in a sense mirrored the fate of the cultural historian. Lamprecht had attempted to broaden the investigative framework of history, but his defeat ultimately led to a narrowing of that field. Similarly, where Lamprecht's thought left some residue in the developing field of art history, that effect, too, was pushed to the periphery.

THOUGH THE DOMINANCE of scientific trends in historical studies precluded any productive reaction to Vöge's hypotheses regarding the "living" dimensions of medieval artistry during the 1890s, this aspect of his method was not totally neglected in later years. During the period dominated by the writings of Freud and by Expressionist art, German-speaking scholars – including Wilhelm Worringer (1881–1965), Richard Hamann (1879–1961), Max Dvořák and Wilhelm Pinder (1878–1947) – psychologized the medieval artist even more forcefully. This occurred in the years between 1906–07 and 1925, when medieval art was being called upon as a source of inspiration for individual expression and spiritualism in modern art.[62] At the same time, a number of significant developments in the fields of philosophy, psychology and sociology (and later the cataclysmic events of

war) contributed to a considerable erosion of faith in the absolute validity of all scientific systems, particularly among the younger generation of intellectuals.

At least some of those younger scholars publishing on medieval sculpture found a precedent for their concerns in the associative and aesthetic dimensions of Vöge's 1894 publication. In 1910, for example, Hamann dedicated a book on sculpture and architecture at Magdeburg Cathedral to Vöge, declaring in his introduction that he felt a particular affinity between the way of thought, or fundamental attitude (*Gesinnung*) of *Die Anfänge des monumentalen Stiles* and that of his own publication.[63] Following Vöge's conceptual model, he stated specifically that his study probed the artistic and creative content of the works, as well as stylistic laws and developmental sequences. Hamann underscored this point in the subtitle of his book, terming his study a contribution to the "history" as well as the "aesthetics" of medieval art.[64]

Hamann had completed a dissertation in philosophy under Dilthey at the University of Berlin in 1902 and had also studied art history there under Goldschmidt and Wölfflin.[65] Considering the intellectual influences to which he had been exposed, it is not surprising that his early work, which included articles on aesthetics and psychology,[66] demonstrated a tendency to integrate scientific and humanist concerns as Vöge had done. Many of Hamann's later endeavors, including both his publications and extensive photographic campaigns, concentrated on medieval art in France and Germany, and he therefore remained in close contact with the older scholar from the turn of the century onward.

Vöge's work was also well known to Dvořák. In a letter sent to Vöge in 1905, in which he solicited a contribution to the *Kunstgeschichtliche Anzeigen*, Dvořák stressed that the German scholar occupied a prominent place among the small group of art historians who practiced art history "in a truly scientific manner."[67] Yet Dvořák later sought a historical vision larger than that permitted by strict adherence to art historical "science"; his name is often associated today with the concept of art history as *Geistesgeschichte*, or the history of ideas. In his highly influential 1918 essay "Idealismus und Naturalismus in der gotischen Skulptur und Malerei" (Idealism and naturalism in Gothic sculpture and painting), he argued for the spiritual content of medieval art and of the medieval artistic imagination, which he saw as being conditioned by the *Weltanschauung* of medieval

Christianity.[68] Although the Viennese scholar was less concerned with the individual creator's experience than he was with how that experience reflected the collective psyche of a particular period or geographic area, the intellectual stimulus he received from Vöge's *Die Anfänge des monumentalen Stiles* and other publications is evident from his notes. Moreover, the two men had remained in contact. In 1914, for instance, Vöge sent Dvořák an offprint of his essay "Pioneers of the Study of Nature around 1200," to which the Viennese scholar responded with a highly enthusiastic thank-you letter.[69]

Wilhelm Pinder seems to have shared the greatest number of Vöge's creative interests in the practice of art history, though the work of the two scholars was quite different. Letters from Pinder to Vöge dating from the years between 1907 and 1943 demonstrate clearly that the two men had great admiration for each other's work.[70] Like Vöge, Pinder was a scholar with artistic inclinations who immersed himself in the creative process of the works he studied, using the German language as an expressive tool. His numerous publications on medieval sculpture included *Der Naumburger Dom und seine Bildwerke* (Naumburg Cathedral and its sculptures) of 1925, in which he conjured up a mystical image of the spirit and personality of the Naumburg Master.[71] Although this is not the place for an extended comparative study of the concerns and careers of the two scholars, it is important to point out that, unlike the "scientific" interpreters of Vöge's work, Pinder was profoundly interested in the creative input of the artist, as well as of the art historian.[72]

EVEN THOUGH the multiple interpretative perspectives in Vöge's experimental text were recovered, at least in part, in the years after 1905, this recovery was very much the product of the moment and represented, from a broader, early twentieth-century viewpoint, the exception rather than the rule. Ultimately it was the repeatable and scientifically "pure" analytical framework that *Die Anfänge des monumentalen Stiles* seemed to offer that continued to dominate its reception in both Germany and elsewhere prior to World War I. Not surprisingly, reviews and publications from the period show that Goldschmidt's work met with a similar reception.[73]

In view of these patterns of response and the subsequent geographic expansion and institutional acceptance of art history as a formalized aca-

demic discipline after the war, it is important to examine the degree to which the trends in the reception of Vöge's (and Goldschmidt's) 1890s scholarship increasingly solidified into research paradigms for the study of medieval sculpture – paradigms continuing through the 1920s and thereafter, when the specialized study of medieval art was being carried out at a vastly accelerated pace in both Europe and America.

5

Implications for Later Discourse in Medieval Art History

By 1920, thirty years after Goldschmidt and Vöge began their careers, the material and intellectual circumstances of art history had changed considerably. Art history had been integrated as an autonomous discipline within the German academic system, and specialized institutes with libraries and visual collections had been established at most universities. After the war, the growing number of students attracted to the field led to a rapid increase in the quantity of German-language scholarship during the 1920s. The geographic boundaries of the discipline were also extended well beyond German-speaking Europe and France when an important foothold for art history was established in the United States.

By 1920 the careers and personal fortunes of Goldschmidt and Vöge had also taken different paths. After suffering a nervous breakdown during the war years, Vöge had relinquished his position at the University of Freiburg in 1916. From then on he sought solitude in the provincial Harz town of Ballenstedt, where he remained more or less in isolation until his death in 1952. He did not publish again until 1928. With one exception, his late publications (six articles and two books, which appeared between 1928 and 1951) were concerned exclusively with German sculptors of the fifteenth and sixteenth centuries.[1] Methodologically these works sustained the con-

cerns and approaches of Vöge's earlier scholarship. But his studies of individual artists of the late Middle Ages were increasingly more personal and idiosyncratic in nature – probably owing in part to Vöge's scholarly and personal isolation. His 1916 withdrawal from the academic community meant that he no longer played a central role in the development of art history in Germany. However, his ground-breaking 1890s publications on the sculpture of the twelfth and thirteenth centuries continued to have enduring influence.

By contrast, Goldschmidt's scholarly profile during the 1920s was public and international. He was at the zenith of his career and was widely acknowledged as the world's foremost authority on medieval art. Following his return from Halle to the University of Berlin in 1912, he continued to expand his reputation as a prolific scholar and brilliant teacher. His scholarly activities, unlike those of Vöge, appear to have been only slightly impeded by World War I. The first volume of Goldschmidt's highly acclaimed *Die Elfenbeinskulpturen,* or corpus of ivory carvings, appeared in 1914. This volume, which treated Carolingian ivories, was supplemented by a companion volume on Ottonian carvings in 1918. Two further volumes on Romanesque ivories were published in 1923 and 1926. In 1930 and 1934 the corpus of Western ivories was supplemented by a two-volume corpus of Byzantine ivories, which Goldschmidt co-authored with his student Kurt Weitzmann.[2] Goldschmidt's *Die Elfenbeinskulpturen* was internationally admired for its discriminating stylistic observations and precise iconographic analyses, as well as for its careful documentation. It quickly established the scholarly standard for art historical corpora, especially for the medium-based sorting and grouping of works from the medieval West and Byzantium, as well as from the Early Christian era.[3]

During these years Goldschmidt also published books, articles and reviews on a number of other subjects, many of which developed from topics addressed in his earlier work. His continuing interest in monumental sculpture of the German-speaking regions in the Middle Ages led him to publish a study on sculptures of the Virgin and Child in 1923, as well as a monograph on the sculptural ensembles at Freiberg and Wechselburg in 1924.[4] In 1926 and 1932 he contributed two volumes to a corpus of early medieval bronze doors in the German-speaking regions, a project initiated by Richard Hamann, then professor at Marburg University.[5] A two-

volume study of Carolingian and Ottonian manuscript illumination, which summarized much of Goldschmidt's research in this area over the previous thirty-five years, appeared in both German and English editions in 1928.[6]

At the same time Goldschmidt continued to teach. He supervised some forty-five dissertations at Berlin between 1918 and 1932, in addition to instructing hundreds of other students in lectures and seminars. Alexander Dorner, Albert Boeckler, Rudolf Wittkower, Ulrich Middeldorf, Alfred Neumeyer, Kurt Weitzmann and Josepha Weitzmann–Fiedler were among the doctoral students he directed.[7] During these years, too, numerous honors were bestowed upon Goldschmidt in Germany and elsewhere. He was the first German art historian asked to lecture in the United States following World War I and crossed the Atlantic three times on invitation during the 1920s and 1930s.

Having noted the expanding institutional base of art history and the changed personal and professional circumstances of Vöge and Goldschmidt following the war, the chief concern of the present chapter is to explore the continuing resonance and metamorphosis of their 1890s scholarship during the 1920s and later. Goldschmidt, who, along with Wölfflin, was one of the primary forces in German art history of the postwar period, exerted a truly profound influence on the intellectual shaping of the discipline. Elaborating upon the scientific and historical foundations established in the early years of his career, Goldschmidt's work and teaching provided an ongoing demonstration of what could be obtained from the practice of a patently objective (and positivistic) stylistic method. Goldschmidt's pivotal role in art history arose not only from his travels and the wide dissemination of his publications but also from his work as a teacher and mentor. He encouraged and helped shape some of the most promising scholars in the field (not all of them medievalists) during the 1920s.

As a private scholar, Vöge did not exert this kind of direct impact on the discipline during these years, yet his continued correspondence with Goldschmidt indicates that he kept abreast of developments in the field through his reading and his epistolary exchanges with former colleagues and students, including Hamann, Panofsky and Haseloff.[8] In addition, he exerted a pervasive influence on the art historical community, simply because his earlier publications were still widely read and admired. Archival materials reveal that during the 1920s and later Vöge was routinely sought out by scholars from Germany and elsewhere, both by those who had

known him earlier and by members of the younger generation, particularly those studying medieval sculpture.

COMPREHENSIVE STUDY of the dynamics of art history in Germany following World War I, as well as the political, ideological and economic factors that helped shape those dynamics, has not yet been undertaken.[9] For the present study it is important to identify some of the methodological currents within 1920s scholarship on medieval sculpture and to consider in a preliminary fashion both how that scholarship was responsive to the pioneering 1890s writings and how it was predictive of directions taken by later art historical scholarship on both sides of the Atlantic.

With the exception of several well-known texts by such scholars as Panofsky and Pinder,[10] German-language publications of the 1920s on medieval sculpture have received little historiographical scrutiny. Given this situation and the quantitative explosion of art historical literature during these years, the task of assessing methodological trends and developments is formidable. A little-known but remarkable publication of 1924, *Die Kunstwissenschaft der Gegenwart in Selbstdarstellungen* (Art history of the present in self-portraits) edited by Johannes Jahn (1892–1976), then assistant at the Institut für Kunstgeschichte at the University of Leipzig, offers a potentially useful point of departure for such an assessment.[11]

The book consists of a collection of essays by eight art historians, each of whom was asked to reflect on the state of the discipline at the time, as well as on the nature of his own art historical practice. With the notable exception of the pioneering American medievalist Arthur Kingsley Porter (1883–1933), all of the contributors were German-speaking. They were Cornelius Gurlitt, Julius von Schlosser, August Schmarsow, Hans Tietze, Carl Neumann, Josef Strzygowski and Karl Woermann. In the introduction Jahn proclaimed that these self-portraits, or self-representations, were intended in the broadest sense to provide a cross-section of the methodological perspectives embraced by the discipline, as well as to encourage dialogue between art historians whose approaches differed.[12] Thus, the essays and the introduction by Jahn document (at least in part) the complex methodological tenor of art historical practice in Germany in the early 1920s.

Die Kunstwissenschaft der Gegenwart in Selbstdarstellungen appeared as one

volume in a series examining the methodological programs of a number of disciplines in Germany, including medicine, law, philosophy and history.[13] Undertaken following World War I, the project was evidently intended to consolidate, at a moment of national humiliation, the monumental achievements of German academic culture in the years between roughly 1880 and 1920. The inclusion of a volume on art history clearly indicates that the young discipline had by then been recognized as an established field of study. The alliance of art history with medicine, law and philosophy simultaneously lent the field considerable status and prestige.

In his introduction Jahn tried to outline the principal directions taken by German art historical thought during the previous thirty years. Though Jahn made no claim to be all-inclusive, his summary represented an important early – and generally accurate – attempt to distinguish between and account for the various critical activities of his contemporaries.

Jahn began by crediting "the new focus on formalism" with many of the advances made by the discipline since the 1890s.[14] He proposed that the abandonment of "aesthetic dogmatism" enabled scholars to recognize the autonomy and intrinsic value of long-neglected eras and subjects (e.g., the art of late antiquity and Baroque architecture and sculpture). He stressed that the character of artistic practice in the early years of the twentieth century and the concomitant development of a modern sensitivity to the "primitive" had contributed to an appreciation of historical eras that had once been considered decadent.[15] Jahn declared that in addition to gaining "new" territory for the discipline, the systematic study of form had shed new light on a much wider range of monuments from the past. He praised in particular the insights into the character and filiation of medieval sculpture that had been afforded by this approach.[16]

Jahn acknowledged more generally the role of conceptual models borrowed from other disciplines in the development of contemporary art historical method.[17] He noted, for instance, the influence of biology (i.e., the natural sciences) on conceptions of the organic development of form, as well as on efforts to discover "laws" through the study of formal properties. He also pointed out that psychological precepts had been appropriated by art historians in order to help recover and define the collective artistic volition (*Kunstwollen*) of a given era through the sensitive and systematic study of form.

Although it is clear from Jahn's text and from his other writings that he

favored formalism as an interpretative strategy, he was careful to acknowledge the criticism leveled against this method by certain important scholars.[18] Echoing their critiques, he pointed out that the exclusive consultation of form could isolate an object from the historical circumstances in which it had taken shape. He also asserted that conceptions of systematic laws and principles of formal development often reflected intellectual constructions of the modern era rather than responding to the history of the objects themselves.[19] Jahn added that this problem had been overcome to some extent by exploring the historical continuity of forms and the relative import of the form and iconography of a given work in relation to the wider cultural ambience of its day.[20]

Yet, as Jahn observed, other scholars disapproved of making overly generalized links between art works and their historical context and argued that the primary concern of art history was to investigate artistic monuments as expressions of a carefully defined collective mental attitude of their day – an attitude also detectable (and hence verifiable) in other spheres of cultural activity, including politics, literature, music, social experience and religion.[21] Although this intellectual program displayed certain affinities with earlier agendas of cultural history, Jahn saw the move to explore *das Psychische* in artistic monuments as being more closely related to contemporary Expressionist concerns.[22]

At the conclusion of his account, Jahn commented on the varied talents and educational backgrounds of those who studied art history, stating that only very few researchers were capable of uniting all of the significant critical perspectives (i.e., *Stilkritik*, history and psychological considerations) in their work.[23] He maintained that certain scholars, some of them the most prominent in the field, eschewed theoretical discussion of art historical procedure, regarding the collecting, analysis and comparison of objects as the only true directive of art historical research. Jahn pointed out, however, that the investigative procedures of these art historians provided fertile ground for those involved in the construction of systematic theories of art historical method.[24]

Nothing in Jahn's 1924 survey stands out as being strikingly new. Indeed his account displays considerable continuity with the patterns that had emerged prior to World War I in the scholarly reaction to Vöge's 1894 book on French sculpture. The ongoing elaboration of the analytical tool of stylistic analysis held center stage, despite criticism. Arguments for a

more spiritually or aesthetically oriented art history were assigned a comparatively minor role.

In 1924, the year that marked the appearance of *Die Kunstwissenschaft der Gegenwart in Selbstdarstellungen,* Hermann Beenken (1896–1952), a colleague of Jahn's at Leipzig, published a study entitled *Romanische Skulptur in Deutschland* (Romanesque sculpture in Germany).[25] Beenken's choice of topic demonstrated a shift in scholarship on medieval sculpture following the war. Although sculpture of the twelfth and thirteenth centuries continued to be investigated, increased emphasis was placed on study of works from the eleventh, early twelfth, and fourteenth and fifteenth centuries. In other words, the accent fell on sculpture from eras that pre- and postdated the so-called "flowering" (*Blütezeit*) of the Gothic style, a trend that many scholars of the period openly attributed to the taste for abstraction in contemporary art.[26] Beenken's monograph was among the earliest programmatic attempts to fashion an overview of sculpture of the eleventh and twelfth centuries in Germany.[27]

The book merits close attention, not so much for its content as for its historical positioning and interpretative strategy. Beenken belonged to the generation of scholars who embarked on art historical careers following the war. He achieved a certain prominence in the field during the 1920s and 1930s, particularly through his publications on medieval sculpture.[28] He had studied under Wölfflin and was in contact with a number of older scholars, including Hamann, Schmarsow, Pinder and Vöge. Vöge's papers show that Beenken solicited his advice on a number of occasions during the 1920s.[29] Beenken also appears to have visited the reclusive scholar in Ballenstedt. Some of Beenken's publications during the 1920s, including a 1928 article discussing links between the sculpture at La Charité-sur-Loire and the Chartres west facade, took Vöge's *Die Anfänge des monumentalen Stiles* as a specific methodological point of departure.[30] Viewed broadly, Beenken represented a rather typical scholar of the younger generation who was well acquainted with 1890s scholarship, though he necessarily operated at some remove from it. For present purposes, his publications, including *Romanische Skulptur in Deutschland,* which attracted wide readership at the time, can be seen as indicators of distinctive methodological currents in postwar German medieval scholarship.

In the preface to his book Beenken asserted that the study of Romanesque sculpture required careful analysis of stylistic phenomena, which in turn provided the basis for "historical classification" (*historische Einordnung*) of the material.[31] He began by citing Goldschmidt's article of 1900 on the stylistic development of sculpture in Saxony, which he praised as the most important publication to have appeared in the field in the two previous decades.[32] Beenken then went on to outline his own methodology. Despite the paucity of written sources, Beenken claimed that the scholar's "sense of historical order" demanded that he search (by means of stylistic analysis) for connections between works and for fixed points of orientation. This method, he argued, allowed for the emergence of a general picture of the "step-by-step development of form," which he likened to phases in the human life span.[33] According to Beenken, "the systematic comparison of a given style with other styles" permitted insight into distinct phases within an overall development and led to an understanding of a style's "inner logic." He proclaimed matter-of-factly that such a procedure demanded "historical objectivity" from the scholar rather than "subjective thoughts and emotions."[34]

Beenken's vision of the evolution of eleventh- and twelfth-century sculpture was remarkable for its unquestioning reliance on abstract constructions. The book displayed a seamless and self-contained stylistic system whose ties to history were very remote. Yet in Beenken's account style was equated with history. Microscopic study and comparison of formal elements such as drapery folds enabled Beenken to define with great confidence stylistic currents (*Stilströmungen*), developmental stages (*Stilphasen*), turning points (*Stilwenden*) and laws (*Stilgesetze*). Beenken's normative classification of stylistic phenomena allowed him to localize specific formal characteristics (he spoke, for instance, of "Trier folds")[35] and hence the works that displayed those characteristics. By the same token, the tracing and comparison of stylistic currents in groups of monuments permitted him to construct their chronological sequences and histories.

The components of Beenken's method were present in prewar scholarship. What distinguished his work from earlier publications – and especially from the experimental writings of the 1890s, whether those of Wölfflin, Goldschmidt or Vöge – was its further standardization and elaboration of earlier methodological trends (i.e., trends apparent in the selective and largely one-dimensional reception of Vöge's work), so that they

became universally applicable recipes for the study of medieval sculpture. Though 1920s scholarship requires much further study, it appears that this large-scale systematization and rationalization of art historical method coincided with a moment of rapid expansion in the field. This growth must have encouraged a certain codification of art historical practice and heightened the appeal of methods that promised solid results.

The tendency to employ style (*Stil*) as a neutral, scientific and uniquely powerful tool of art history is manifested not only in the scholarship of men such as Beenken but also in the work of some of the most innovative thinkers of the era. Panofsky's *Deutsche Plastik des elften bis dreizehnten Jahrhunderts* (German sculpture from the eleventh to the thirteenth century) of 1924, a curious book that has engendered much scholarly attention and controversy over the years, displayed not only the panoramic breadth of the author's humanist background but also his command of a scientific *Stilkritik* related to that of Goldschmidt, under whom he had done his postdoctoral work.[36]

The extremes to which *Stilkritik* was extended in this period are apparent in publications such as Hans Weigert's *Die Stilstufen der deutschen Plastik von 1250 bis 1350* (Stylistic phases in German sculpture, 1250–1350) of 1927, in which the young scholar neatly attempted to classify and label monuments according to their manifestation of a "stiff style" (*starrer Stil*), "swollen style" (*schwellender Stil*), "loose style" (*schlaffer Stil*) or "hovering style" (*schwebender Stil*).[37] This style-directed history (as Weigert put it, *Stilgeschichte*) of thirteenth- and fourteenth-century sculpture, which clearly borrowed terminology from contemporary sculptural practice,[38] was based on Weigert's conception of the "historical locus of form" (*Periodik der Form*).[39] In contrast to the efforts of "scientific" scholars of an earlier generation, such as Goldschmidt, whose *Stilkritik* had always remained attentive to concrete issues of historical documentation, Weigert's form of history was largely abstract.

On the basis of stylistic evidence Beenken had also detected the "hands," or artistic signatures, of individual masters, including the Gustorf Master and the Master of Saxon Choir Enclosures, in the eleventh- and twelfth-century works he studied.[40] In several cases he went on to characterize their artistic personalities and to assign specific works to the early, middle or late part of their careers.[41] Beenken's formulaic interpretation of the "master" notion in *Romanische Skulptur in Deutschland* was consistent with

earlier interpretations of Vöge's 1894 book. Mere references to individual "masters" served as sufficient justification for stylistic change. As a cipher for individual artistic creativity, the *Meister* formula applied by Beenken was only marginally concerned with issues of individual artistic volition and the artistic process.

The solidification of the "master" as an analytical category in art history of the 1920s led to the uncovering of a number of "new" masters, including the twelfth-century Samson Master (*Samsonmeister*), active along the Rhine, and to the elaboration of identities already well established in the canon, including the Naumburg Master and Strasbourg Master.[42] The intellectual scaffolding offered by this itinerant-master hypothesis was widely accepted; it was used not only by scholars of average intellectual ambitions, such as Beenken, but also by major figures such as Hamann, Pinder, Panofsky and Hans Jantzen.[43]

The letters Vöge sent to Goldschmidt during the 1920s show that he read works by all of the authors mentioned here, as well as most other publications on medieval sculpture that appeared during this decade. His views on the development of art history, and on scholarship on the Middle Ages specifically, are scattered throughout this correspondence. In a letter written to Goldschmidt on 2 January 1927, Vöge expressed his discomfort with the current investigative trends in medieval art history. His remarks were tinged with characteristic irony:

> At the moment so much is being published on the thirteenth century that one has to be at a large institute in order to have access to all of it. All of these classifications according to "masters" and "hands" that Beenken and others are currently pursuing disturb me greatly. . . . Think about how many hands they would dissect Dürer's oeuvre into! It is regrettable that Dürer's work is relatively well documented, for such a project would provide these people with much busywork.[44]

Clearly, Vöge recognized the risk of methodological superficiality in the stylistic networks and token "masters" that multiplied rapidly in this period. The ultimate irony of the situation was that the selective reading of *Die Anfänge des monumentalen Stiles* by many scholars at the turn of the century and later had contributed to the propagation of this sort of investigative strategy. Adhering to his earlier concerns, Vöge continued, during the 1920s and later, to carry out "living" explorations of individual masters; in

this regard his works went distinctly against the grain of the scholarship of the period, just as they had earlier. Not all German art historical writing of the 1920s and later was strictly formulaic and predictable style history. Important cross-disciplinary and interpretative work was carried out, for instance, by scholars at the University of Hamburg and the Kulturwissenschaftliche Bibliothek Warburg during these years. However, the analytical framework provided by stylistic analysis and "distilled" masters was destined to be sustained in later scholarship on medieval sculpture for a number of decades.

LIKE GERMAN MEDIEVAL SCHOLARSHIP of the 1920s, the work of French and British scholars tended to develop along methodological avenues established prior to World War I. In France, a vehement anti-German position had been articulated publicly for art history during World War I by Mâle. It therefore comes as no surprise that German scholarship of the 1920s found little resonance in France. French writings tended to pursue the lines mapped out in the volumes on medieval art published in André Michel's *Histoire de l'art* in the early years of the century. As we have seen, at this time French scholarship on medieval sculpture derived important stimulus from the theories and analytical framework of Vöge's 1894 study, as well as from highly developed French traditions of iconographic analysis.

Because many of the most prominent French scholars of medieval sculpture during the 1920s, including Mâle, Marcel Aubert, Louise Pillion, Paul Vitry and Paul Deschamps, were educated prior to the war, it is not surprising that they continued to refer to Vöge's pioneering study, though usually in connection with de Lasteyrie's critique of it. The extent to which French scholarship of the 1920s built on a Franco-German tradition of prewar scholarship is evident in studies such as Aubert's *La Sculpture française du moyen âge et de la renaissance* of 1926 and *La Sculpture française au début de l'époque gothique, 1140–1225* of 1929, as well as in Paul Deschamps's *La Sculpture française à l'époque romane, XIe et XIIe siècles* of 1930.[45] The stylistic networks and filiational schemes traced by these authors closely resemble those first outlined by Vöge, though differing in certain specific details and interpretative results.

The postwar years also witnessed a marked increase in the volume of

scholarship on medieval sculpture published in Britain. Topically, British writings concentrated on sculpture in the British Isles, and increasingly also on related sites in France. Conforming largely to the methodological character of earlier national scholarship, British publications tended to be descriptive, critically amorphous and written for the educated public rather than for specialists. By the 1920s formalized art history had not yet been introduced into British universities.

Publications such as Fred H. Crossley's *English Church Monuments, A.D. 1150–1550: An Introduction to the Study of Tombs and Effigies of the Mediaeval Period* (1921), to cite a prominent example, continued essentially antiquarian traditions of studying medieval monuments as documents of heraldry, historical costume and methods of warfare rather than as components of a critically complex "history" of art in the German sense.[46] Arthur Gardner, who had issued a series of photographs in 1915 on the sculpture at Reims, following the bombing of the cathedral, published a study entitled *Medieval Sculpture in France* in 1931, as well as *A Handbook of English Medieval Sculpture* in 1935, in which he organized his discussion of the monuments in a straightforward fashion, according to historical period and type.[47] With few exceptions, these and other studies by British-born scholars during the 1920s and 1930s were based exclusively on British, French and American scholarship. This situation changed rather remarkably when many German-trained scholars arrived in Britain as émigrés in the second half of the 1930s.

THE NATURE OF THE EXCHANGES between pioneering American medievalists and their European counterparts following World War I is more complex. Although this topic would best be addressed in a separate study,[48] it is important at least to indicate some of the dynamics here. During the 1920s art history became institutionalized at a number of American universities and colleges, and pioneering American scholars made their debut on the international stage.[49] Isolated both geographically and ideologically from the national borders that conditioned the intellectual contours of art history in Europe, Americans elaborated a branch of the discipline that negotiated between the science of art history as developed in Germany and the traditions of the French *archéologie nationale*.

The formalized study of art history in America coincided with what

has been termed the "golden age" of American scholarship. The academic culture of the young country was characterized by great confidence, an eagerness to learn from prestigious Europeans, as well as a spirit of intellectual adventure. American scholarship was largely formalist and anti-theoretical in nature, without being bound to particular European models. From the last decades of the nineteenth century onward, many Americans had studied at European universities. In addition, evocative literary works such as Henry Adams's *Mont-Saint-Michel and Chartres* had, prior to World War I, stimulated broader public interest in medieval Europe.[50] Increased contact with Europe during the war and in the years immediately following contributed to a widening of intellectual horizons and, in the case of humanities scholarship, to heightened curiosity about eras not figuring within the American past. Many of the most prominent art historical pioneers in America specialized in the art of the Middle Ages.

This growing academic interest in the Middle Ages was encouraged by the acquisition of medieval monuments and objects by many American museums,[51] which was facilitated, at least in part, by the currency problems and inflation that plagued Europe following the war. Although economic hardships severely limited the geographic scope of research conducted by European scholars in the postwar years and thus helped to determine the distinctly national character of German and French publications of the period,[52] the research and travels of American scholars were largely unaffected. Most of the early practitioners of art history in America were wealthy, well-educated individuals whose virtually limitless financial resources equaled the scope of their intellectual ambitions.

Harvard and Princeton Universities served as focal points for the development of art history in America during the 1920s. Though courses in art history and art appreciation were by this time being offered at many other institutions, Harvard and Princeton acquired particular importance because they had the largest graduate programs.[53] Scholars from these two universities played a leading role in the founding of the College Art Association in 1913.[54] Another landmark in the formalized study of art history in the United States was the creation by Charles Rufus Morey (1877–1955) of an iconographic index of Christian art at Princeton University in 1917.[55] In addition to Morey, important scholars of medieval art and archaeology at Princeton included Earl Baldwin Smith (1888–1956), Ernest DeWald (1891–1968) and Albert M. Friend, Jr. (1894–1956). At Harvard the intel-

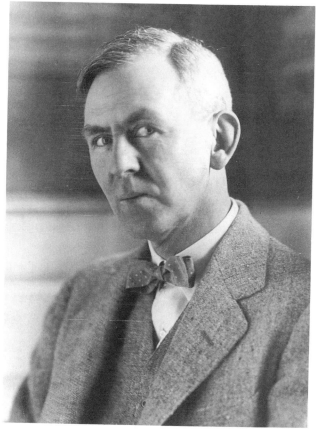

Figure 26. Arthur Kingsley Porter, ca. 1930. (Photo: Courtesy of the Harvard University Archives)

lectual landscape of medieval art history was shaped by Arthur Kingsley Porter and Chandler Rafthon Post (1881–1959), as well as by scholars of history and literature, including Charles Homer Haskins and E. K. Rand.[56]

During the 1920s there was much cooperation between the two institutions, especially in matters pertaining to the training of graduate students in art history. Cooperation extended to research projects and publications as well. *Art Studies,* an international journal of art history edited by faculty members at Harvard and Princeton, was launched in 1923.[57] It was through the combined efforts of the two institutions that prominent European scholars, including Goldschmidt, were invited to America for extended periods as guest lecturers during the 1920s and 1930s.

Arthur Kingsley Porter (Fig. 26) was the American scholar who pub-

lished most extensively on medieval sculpture during the 1920s. He had produced a book on medieval architecture in 1909 and a four-volume study of Lombard architecture in 1915; for the second of these he was awarded a medal by the Société Française d'Archéologie.[58] He traveled extensively in Europe both before and after the war. On the basis of what he termed his "laboratory work," Porter began to publish on monumental sculpture of the Middle Ages in 1915. In the course of the next fifteen years he published on Romanesque sculpture in Italy, France, Spain and Ireland.[59] All of these projects attested to the astonishing range of his knowledge of the scholarly literature and monuments, as well as to his enormous energy. His best-known work, *Romanesque Sculpture of the Pilgrimage Roads*, which consisted of one volume of text and nine portfolios of photographs, was published in 1923.[60] This extraordinary publication had a profound influence on the shaping of art history in America and commanded international attention.

Porter's concentration on Romanesque sculpture paralleled the concerns of many European scholars of the period. Methodologically his study blended a German-derived stylistic science with certain iconographic concerns and with an American pragmatism. In his introduction Porter outlined his criticisms of French archaeological theory, declaring that French study of the development of Romanesque architecture and sculpture not only adhered to "evolutionary" and "stereotypical" formulas based on a progression from "lower" to "higher" forms but that it also approached all European architecture from the perspective of the artistic hegemony of the Ile-de-France.[61] Disclaiming such "Darwinistic" conceptions,[62] Porter outlined the vitality of the pilgrimage in the Middle Ages and argued that the pilgrimage routes in France and Spain had been important channels of communication, uniting Europe culturally and artistically.[63]

Predictably, Porter's thesis unleashed a storm of controversy, most notably among nationalist French scholars. Of greater interest here are the methods he used to support his hypothesis. Arguing that the works themselves were the only true historical documents, Porter practiced a form of stylistic analysis from which he derived filiational networks and itinerant-master hypotheses.[64] As a newcomer to the field, Porter's employment of *Stilkritik* was understandably not as careful or finely tuned as that of his German counterparts. In a number of cases, Porter confidently identified works at geographically distant sites as works by the same hand on the

basis of similarities in iconography or the handling of drapery that German scholars found too general and thus inconclusive.[65] Porter's picture of the ideas, motifs and style that had traveled with amazing rapidity along the pilgrimage routes was heavily populated by masters whom he classified, according to their degree of artistic genius, as "head masters," assistants or as "inferior hands."[66] Following his European models, Porter also attempted to distinguish between "advanced" and *retardataire* stylistic phenomena and to trace the artistic sources and national origins of the itinerant masters. Ultimately Porter's investigative procedures at times rested on "facile formulas"[67] not unlike those he criticized in his own introduction.

Porter's text shows that he was extremely well acquainted with French, German, Spanish, Italian and British scholarship. In *Romanesque Sculpture of the Pilgrimage Roads* he expressed his admiration of Vöge's *Die Anfänge des monumentalen Stiles,* terming it the German scholar's "fundamental work."[68] Porter's remarks are significant, in view of the methodological statement he published in Jahn's *Die Kunstwissenschaft der Gegenwart in Selbstdarstellungen* the following year.[69]

In the 1924 essay Porter openly admitted that his early publications had been greatly influenced by French medieval scholarship, which he described as focusing almost exclusively on the technical study of architecture.[70] Although Porter acknowledged the value of such schooling, he stated that concentration on technical issues tended to disguise the "living" human dimensions of the monuments.[71] He also drew attention to the importance of the iconographic method, outlining at the same time the dangers inherent in an overly rigid application of it.[72] In regard to stylistic analysis, he stated that the method had been formulated by Giovanni Morelli for the study of Italian Renaissance painting, and that it had in the meantime (i.e., by 1924) been widely applied to the study of art from all eras. He credited Vöge with being the first to apply this method to the study of French monuments of the Middle Ages.[73] In a manner clearly echoing the German scholar, Porter proclaimed the falsity of any notion of the absence of artistic personality in medieval art.[74] He also stated that stylistic criticism was more important than other methods in art history, not only because it was capable of solving many "historical problems" but also because it enhanced the aesthetic awareness of the interpreter.[75]

Porter's shift to a German-style mode of analysis is evident in a comparison of his earliest writings on medieval sculpture with the methodologi-

cally "tightened" ones that appeared slightly before and continued after his 1923 book. It is significant in this regard that he began to solicit the advice of a number of German scholars of medieval sculpture shortly after 1920. In 1921, for instance, he established contact with Vöge, describing *Die Anfänge des monumentalen Stiles* as "absolutely fundamental" and declaring that the German scholar had "shown the way" to his "followers."[76] Surviving correspondence between the two scholars extends from 1921 to 1931.

Although Vöge's aesthetic and psychological concerns did not go unnoticed by the American scholar, it was the rigorous intellectual structure that *Die Anfänge des monumentalen Stiles* seemed to offer that most directly influenced Porter's work. Porter's view of Vöge's book during the 1920s thus approximated the European reception of it at the turn of the century. The attraction that the standardized version of Vöge's analytical framework with its secure results held for Porter is also demonstrated by a 1923 article in *Art Studies* written by his student Alan Priest.[77] Here the young scholar attempted to "refine" Vöge's hypotheses concerning the role of the Saint-Denis Master and other sculptors at Chartres. The article, which featured a somewhat mechanical imitation of the stylistically propelled "masters" and "hands" theory, helped to disseminate Vöge's "method" in America at a fairly early point.[78]

American scholars during the 1920s were fascinated not only by the work of Vöge, Goldschmidt and other German scholars but by the method of stylistic analysis in general. This accounts for many of the broad similarities between German and American medieval scholarship during this decade, though American scholars often ventured farther than their European colleagues in exploring the informative power of style.[79]

By the time of Goldschmidt's first visit to the United States in 1927–28, the stylistic method had already taken firm root in American art historical scholarship.[80] His sojourn in the United States – during which he taught at Harvard University (Figs. 27, 28), lectured at Princeton, Wellesley College and the Metropolitan Museum of Art (as well as other institutions) and also served as a consultant to private collectors and museums – did much to enhance the prestige of the German "science" of art history in America.[81] In 1931, during a second trip to the United States, Goldschmidt was awarded an honorary doctorate by Princeton. By the time of

his third and final voyage to the United States in 1936 to receive an honor-
ary doctorate at Harvard, American art history was becoming even more
heavily influenced by German methods because of the increasing number
of German-trained émigré scholars on American soil,[82] many of whom
were Goldschmidt's own former students.

CERTAINLY not all of the German methods transplanted to America cen-
tered on the analysis of style. Panofsky's iconological approach, for in-
stance, which had its genesis during the years he taught at the University
of Hamburg (1921–33), focused on issues of textual meaning and on the
interpretation of the individual art work in relation to broader cultural
phenomena.[83] Similar interpretative directions were evident in the work of
a group of other influential émigré scholars active in Britain and America,
such as Fritz Saxl, Edgar Wind, William Heckscher and Adolf Katzenel-
lenbogen, all of whom had also been associated with the interdisciplinary
community of scholars in Hamburg in the 1920s and early 1930s.[84] During
the 1940s and 1950s scholars as ideologically divergent as Hans Sedlmayr,
Günter Bandmann and the American-based Otto von Simson published
studies on medieval architecture that also addressed issues of meaning.[85]

But as several scholars are now beginning to demonstrate, publications
that addressed issues of meaning and theory routinely met with severe crit-
icism or were ignored in post–World War II Germany – largely, one sus-
pects, because of the strident National Socialist scholarly rhetoric of the
previous decade. German scholarship following the war kept a safe dis-
tance from theoretical speculation and sought "refuge once again in a spe-
cialized hard and fast 'science' of art history, the borders of which did not
extend beyond an exacting [technical] knowledge of the works them-
selves."[86] Despite the presence of Panofsky and other like-minded scholars
in America during the 1950s and later, the dominant mode of inquiry in
humanities departments in the United States was, as Panofsky acknowl-
edged, largely formalist.[87] The developing Cold War context increasingly
discouraged any divergence from formalist norms. In this regard, it is im-
portant to point out that the postwar decades also saw the rebuilding or
expansion of European and American universities, a situation that, once
again, helped to promote a certain standardization of methods. Much art

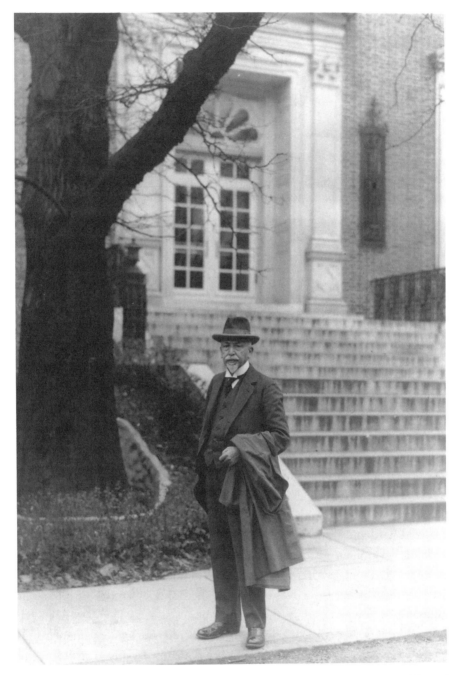

Figure 27. Adolph Goldschmidt in front of the entrance to the Fogg Art Museum, Harvard University, 1927–28. (Photo: Staatsarchiv Hamburg, Bestand 622-1 Goldschmidt)

Figure 28. Adolph Goldschmidt with Kuno Francke, founder of the Germanic Museum at Harvard University, in front of plaster cast of the Golden Portal of Freiberg, Adolphus Busch Hall, 1927–28. (Photo: Courtesy of The Busch-Reisinger Museum, Harvard University Art Museums)

historical scholarship produced on both sides of the Atlantic in the 1950s, 1960s and 1970s was strongly conformist – that is to say, formalist and politically neutral in character.

For the study of medieval sculpture, the 1950s and 1960s constituted an era in which belief in the omnipotence of stylistic analysis – not as a tool, but as the self-contained and self-sufficient end of art history – enjoyed its greatest authority and durability on both sides of the Atlantic. The spirit of 1920s scholarship, with its construction of linear stylistic narratives, labeling and classification of formal elements and filiational schemes populated by masters, reverberated loudly in the postwar work of many notable scholars. As Willibald Sauerländer has remarked in recent years, the controversies over dating, hands and masters that characterized many writings of this period transformed the study of medieval sculpture into a kind of hermetic *Faltenphilologie*, or "philology of drapery folds" – in other words, a history of medieval art in which the consideration of precise historical, political and social conditions played little or no interpretative role.[88]

It is important to point out here that Vöge's writings enjoyed a renaissance during the 1950s and 1960s. In 1951 Louis Grodecki, a Polish-born émigré scholar in France familiar with German scholarship, in an article on the transept portals at Chartres published in the *Art Bulletin,* called for a return to "the study of the ateliers, brilliantly initiated by Wilhelm Vöge."[89] In 1955, three years after Vöge's death, Richard Hamann, who together with his son Richard Hamann-MacLean had remained in constant contact with the secluded scholar since the 1920s, published a monumental study, *Die Abteikirche von St. Gilles und ihre künstlerische Nachfolge* (The Abbey Church of St. Gilles and its artistic progeny).[90] As Hamann acknowledged, this book was greatly indebted in both content and method to Vöge's *Die Anfänge des monumentalen Stiles,* a study that, as we have seen, provided Hamann with important intellectual stimulus throughout his career. In 1958 Vöge's essays on medieval sculpture, specifically those dealing with works of the twelfth and thirteenth centuries, were collectively reissued in Germany under the title *Bildhauer des Mittelalters* (Sculptors of the Middle Ages). This event brought the turn-of-the-century writings of the art historical pioneer into prominence once again, but primarily as a methodological exemplar for studies of style.

The many reviews of this book that appeared in European and North American journals at this time are of great interest.[91] Although some reviewers drew attention to the presence of both scientific and psychological concerns in Vöge's essays, the accent in virtually all of the reviews fell on the importance of his broad developmental visions of style based on the careful study of particulars. Most scholars advocated a return to Vöge's writings as a point of departure for the ongoing scholarly examination of medieval sculpture. The important phenomenon of the republication of "classic" texts and their cyclical impact on the configuring and reconfiguring of methodologies in this period in art history generally remains to be investigated. The reception of *Bildhauer des Mittelalters* in 1958, now at great remove from Vöge and from the intellectual conditions in which he worked, reinforced and even strengthened the character of the initial "scientific" readings of his scholarship.

In 1959, for instance, Grodecki published a lengthy article entitled "Wilhelm Vöge et l'état actuel des problèmes" in the *Bulletin monumental,* in which he outlined and praised the value of many of Vöge's hypotheses

concerning sculpture at Chartres, Reims and other sites, thereby not only bringing to the surface again Vöge's "scientific" investigative process but also reintroducing a number of his named artistic personalities, such as the "Master of the Kings' Heads" at Chartres.[92] This article reintroduced many of Vöge's theories not only to French scholars but also to many younger American-born medievalists, who had turned almost exclusively to the study of French scholarship and French monuments of the Middle Ages after World War II.

Willibald Sauerländer was perhaps the most important young German scholar trained after the war whose work during the 1950s, 1960s and early 1970s was decisively molded by his knowledge of Vöge's work and the then-current reassessment of it. Sauerländer's many publications from this period, including highly influential articles examining sculpture at such sites as Senlis, Laon, Chartres and Paris, as well as his books, *Von Sens bis Strassburg* (From Sens to Strasbourg) of 1966 and *Gotische Skulptur in Frankreich, 1140–1270* (Gothic sculpture in France, 1140–1270) of 1970, reveal a clear debt to scientific interpretations of Vöge's method.[93]

The reverberation of a "modernized" understanding of Vöge's writings was also evident in the work of many other German and English-speaking scholars of these years. Among the scholars directly affected were Bernhard Kerber, Whitney Stoddard, Teresa Frisch, Robert Branner and George Zarnecki.[94] The work of an even larger group of scholars was affected by the translation into English and French of major studies such as Sauerländer's *Gotische Skulptur in Frankreich.*[95] Thus, in many cases, scholars in Europe and America took up "new" Vöge-based methodological norms without necessarily having direct or conscious knowledge of the 1890s writings from which they were derived.

Though the ideological and conceptual fabric of art history has undergone significant change in the past ten or fifteen years, certain aspects of these earlier research paradigms remain present in much specialized scholarship on medieval sculpture written today.[96] One of the most provocative questions for medieval art history today is how such a self-generating and self-perpetuating system could have enjoyed such immense success for so long without carrying with it, if only in the background, some recognition of Vöge's "other half" – the half concerned with the nature of the artistic process and the psychology of form in medieval art.

MANY QUESTIONS regarding the construction of art history since its inception as a discipline in the 1890s remain to be asked. Indeed much further research needs to be undertaken in order to confirm, modify and refine our understanding of the trends in the study of medieval art outlined here and to gauge more exactly the degree to which they reflect larger movements in the discipline.

The fact remains that the days of the art historical pioneers are long past. The fundamental corpus of works that the discipline chooses to treat has been charted. As has been argued in this book, this charting often occurred in ways that did not reflect the original intentions and full interpretative range of the pioneering inquiries. Until recently, many of the more provocative aspects of the work of some of the most fertile minds of the late nineteenth century – scholars including Vöge, Warburg, Lamprecht and Riegl – have been, if not forgotten, marginalized. Though the aims, knowledge and methods of today's practitioners differ substantially in kind and ideology from those of the founding scholars, a clearer and more sensitive assessment of their work can help to encourage the methodological revision now under way in most sectors of the field of art history.

Notes

Introduction

1. An archivally based study of the political, cultural and educational policies and mandates that led to the founding of art history institutes at individual German universities in the 1870s, 1880s and 1890s remains a desideratum. As this would involve consulting administrative records at various levels of bureaucracy (e.g., imperial, ministerial, state, university) in a number of regions, some of which are no longer in Germany, such a project would probably have to be collaborative in nature. Heinrich Dilly, *Kunstgeschichte als Institution. Studien zur Geschichte einer Disziplin* (Frankfurt am Main: Suhrkamp, 1979), has assembled much valuable information, particularly for the pre-1870 period. For a recent commentary on the lack of a synthetic study of the institutionalization of art history in late nineteenth-century Germany and the difficulty of such an undertaking, see Wolfgang Beyrodt, "Kunstgeschichte als Universitätsfach," *Kunst und Kunsttheorie, 1400–1900*, Wolfenbütteler Forschungen, 48, ed. Peter Ganz, Martin Gosebruch, Nikolaus Meier and Martin Warnke (Wiesbaden: Otto Harrassowitz, 1991), pp. 313–33.

2. In this study I am concerned with German scholarship (i.e., writings by scholars in the German empire) treating monuments of medieval art in northern Europe, particularly in the regions of present-day Germany and France. The medieval art historical scholarship by nineteenth-century French scholars is better known today, for reasons I sketch briefly later on; detailed consideration of it would require another book. Thus, I refer to French discourse only in specific instances where it affected, or was affected by, the German scholarship that is the focus of this study. I also draw on French scholarship for comparative purposes. See esp. Chapters 4 and 5 of the present volume.

3. A. L. Rees and Frances Borzello, eds., *The New Art History* (London: Camden Press, 1986), serves as an overtly polemical example. On page 7, for instance, the editors outline what they see as some of the dominant characteristics of the "old" art history: "the tradition's

claim to be value-free, its belief in the impartiality of historians, its refusal to admit aesthetics and criticism as part of historical study, its suspicion of theoretical reflection, its obsession with fact-gathering."

4. This venerable tradition dates back to the early nineteenth century, when a number of institutions dedicated to the study of the cultural heritage of France, such as the École des Chartes (1804), the Société des Antiquaires de France (1821) and the Commission des Monuments Historiques (1837), were established. For a recent discussion of the study of the Middle Ages and medieval archaeology in early nineteenth-century France with bibliography, see Tina Waldeier Bizzarro, *Romanesque Architectural Criticism: A Prehistory* (Cambridge: Cambridge Univ. Press, 1992). Periodicals also founded at the time, including the *Bulletin monumental* (1834) and the *Congrès archéologique de France* (also 1834) continue today to concentrate on the study of monuments within France. At French universities the topics of master's and doctoral theses in medieval art history follow a similar pattern. See the lists of topics in the recently established periodical *Histoire de l'art: Bulletin d'information de l'Institut National d'Histoire de l'Art* (from 1988).

5. See, for instance, the annual listings of master's and doctoral theses completed at British universities in the September issues of *Kunstchronik* or the profiles of major British presses publishing on medieval art. Although there was a long tradition of antiquarian scholarship and interest in the Middle Ages in England, institutionalized art history arrived there relatively late. The first chair of art history coincided with the founding of the Courtauld Institute of Art in 1932.

6. Erwin Panofsky expressed this opinion in his 1953 essay "Three Decades of Art History in the United States. Impressions of a Transplanted European," republished in *Meaning in the Visual Arts: Papers in and on Art History by Erwin Panofsky* (Garden City, N.Y.: Doubleday [Anchor], 1955), pp. 321–46. See page 328 for the relevant passages, for instance: "where European art historians were conditioned to think in terms of national and regional boundaries, no such limitations existed for the Americans."

7. Here again I am referring principally to scholarship treating medieval monuments in northern Europe. Such trends are easily confirmed through a review of the topics treated in North American dissertations on medieval art history (which appear annually in the June volume of *Art Bulletin*), or by consulting the indexes to periodicals such as *Gesta*, published by the International Center of Medieval Art in New York, and *Speculum*, the journal of the Medieval Academy of America.

8. Other regions occupying a marginal position in art historical scholarship dealing with the Middle Ages in northern Europe include the southern Low Countries (present-day Belgium), Scandinavia and eastern Europe. In the case of the latter, the neglect can be attributed at least in part to the inaccessibility of these regions until recently. It is to be hoped that the eastern European countries will attract increased attention from art historians now that political barriers have been lifted.

9. This book does not explore the role of gender politics in the development of art history, but it takes as a given that many of the conceptual structures characteristic of late nineteenth-century scholarship, some of which are discussed here (e.g., the great man/master paradigm), were the product of the exclusively male community of scholars who shaped art history.

10. For relevant statistics, see Chapter 1 of the present volume.

11. Although I often refer to Wilhelm Vöge and Adolf Goldschmidt as "medieval art historians" or as "specialists" of "medieval art history" in this book, they would not necessarily have described themselves in these terms at the turn of the century. I use these terms here as a convenience because Vöge and Goldschmidt concentrated their efforts on the art of

the Middle Ages and contributed significantly to the intellectual base of this now largely independent subdiscipline.

12. See Chapter 1 to the present volume. Barbara Miller Lane, "National Romanticism in Modern German Architecture," *Nationalism in the Visual Arts*, Studies in the History of Art, 29; *Center for Advanced Study in the Visual Arts, Symposium Papers XIII*, ed. Richard A. Etlin (Hanover, N.H.: University Press of New England, 1991), pp. 111–47, examines medievalizing traditions in German nineteenth-century architecture (e.g., "imperial" revivalist architecture; the historic preservation of medieval monuments) with reference to the contemporary political context. For a recent case study, see Michael J. Lewis, *The Politics of the German Gothic Revival: August Reichensperger* (Cambridge, Mass.: MIT Press with the Architectural History Foundation, 1993).

13. Riegl and Wölfflin did not concentrate their work on the medieval art of northern Europe (see note 2 to this Introduction). There is an enormous bibliography on each of these scholars, who are discussed in virtually every treatment of the formalization of art historical practice. For the recent literature on Riegl, see Margaret Olin, *Forms of Representation in Alois Riegl's Theory of Art* (University Park: Pennsylvania State Univ. Press, 1992), and Margaret Iversen, *Alois Riegl: Art History and Theory* (Cambridge, Mass.: MIT Press, 1993). Recent studies of Wölfflin include Meinhold Lurz, *Heinrich Wölfflin. Biographie einer Kunsttheorie* (Worms: Wernersche Verlagsgesellschaft, 1981). Joan Hart is currently preparing a book entitled *Heinrich Wölfflin and the Antimonies of Experience in Art* (Cambridge: Cambridge University Press, forthcoming); I have not been able to consult it.

14. For the sake of clarity, it is important to emphasize that the present study is essentially concerned with scholars of medieval art within the German empire. Wickhoff, Riegl and von Schlosser were Austrian, while Wölfflin, who was Swiss, taught for many years in Germany (see note 31 to this Introduction). The work of the German scholars Warburg and Friedländer did not concentrate on the Middle Ages (compare note 13). The French medievalist Émile Mâle is discussed in Chapters 2 and 4. My decision to focus this book on the generation of medieval art historians in Germany whose careers began around 1890 meant that I can give relatively little attention to the older generations of scholars who taught and published on medieval art during the 1890s. Prominent among these scholars were Georg Dehio (1850–1932), professor at the University of Strasbourg from 1892, and August Schmarsow (1853–1936), professor of art history at the University of Leipzig from 1893.

15. See Chapter 1.

16. For Goldschmidt, see most recently Kurt Weitzmann, *Adolph Goldschmidt und die Berliner Kunstgeschichte* (Berlin: Kunsthistorisches Institut der Freien Universität, 1985) and Marie Roosen-Runge-Mollwo, ed., *Adolph Goldschmidt, 1863–1944. Lebenserinnerungen* (Berlin: Deutscher Verlag für Kunstwissenschaft, 1989). The latter is an annotated edition of Goldschmidt's memoirs, written for his family during the early 1940s and published for the first time in 1989. Roosen-Runge-Mollwo provides a full bibliography of Goldschmidt's writings, pp. 465–79. See also my article "Adolph Goldschmidt, 1863–1944," *Dictionary of Medieval Scholarship*, vol. 3, ed. Helen Damico (New York: Garland Press, in press).

17. Adolph Goldschmidt, *Lübecker Malerei und Plastik bis 1530* (Lübeck: B. Nöhring, 1889).

18. Adolph Goldschmidt, *Der Albanipsalter in Hildesheim und seine Beziehung zur symbolischen Kirchensculptur des XII. Jahrhunderts* (Berlin: G. Siemens, 1895). See Chapter 3 of the present volume for a discussion of Goldschmidt's scholarship during the 1890s.

19. Arthur Haseloff, *Eine thüringisch-sächsische Malerschule des 13. Jahrhunderts* (Strasbourg: J. Heitz, 1897); Georg Swarzenski, *Die Regensburger Buchmalerei des X. und XI. Jahrhunderts. Studien zur Geschichte der deutschen Malerei des frühen Mittelalters* (Leipzig: K. W. Hiersemann, 1901). Goldschmidt's status as a *Privatdozent* (lecturer) in Berlin prevented him

from conducting doctoral examinations; Haseloff held his doctorate officially from the University of Munich, and Swarzenski received his from the University of Heidelberg. See the tributes to Goldschmidt in the forewords to these two studies.

20. For lists of the doctoral dissertations supervised by Goldschmidt, see *Festschrift für Adolph Goldschmidt zum 60. Geburtstag am 15. Januar 1923* (Leipzig: E. A. Seemann, 1923), pp. 143–48, and *Das siebente Jahrzehnt. Festschrift Adolph Goldschmidt zu seinem 70. Geburtstag am 15. 1. 1933 dargebracht von allen seinen Schülern, die in den Jahren 1922–1933 bei ihm gehört und promoviert haben* (Berlin: Würfel Verlag, 1935), pp. 173–74.

21. Adolph Goldschmidt, "Drei Elfenbein-Madonnen," *Das Hamburgische Museum für Kunst und Gewerbe dargestellt zur Feier des 25jährigen Bestehens von Freunden und Schülern Justus Brinckmanns* (Hamburg: Verlagsanstalt und Druckerei A.-G., 1902), pp. 277–81.

22. Adolph Goldschmidt, *Die Elfenbeinskulpturen aus der Zeit der karolingischen und sächsischen Kaiser VIII.–XI. Jahrhundert*, 2 vols. (Berlin: B. Cassirer, 1914 and 1918); *Die Elfenbeinskulpturen aus der romanischen Zeit XI.–XIII. Jahrhundert*, 2 vols. (Berlin: B. Cassirer, 1923 and 1926); Adolph Goldschmidt with Kurt Weitzmann, *Die byzantinischen Elfenbeinskulpturen des X.–XIII. Jahrhunderts*, 2 vols. (Berlin: B. Cassirer, 1930 and 1934).

23. Vöge was Erwin Panofsky's dissertation adviser. See Panofsky's biographical memoir of his teacher ("Wilhelm Vöge: 16. Februar 1868–30. Dezember 1952") in the foreword to the collection of essays by Vöge published under the title *Bildhauer des Mittelalters. Gesammelte Studien von Wilhelm Vöge* (Berlin: Gebr. Mann, 1958), pp. ix–xxxii. This book also contains a bibliography of Vöge's publications, pp. 245–48. Panofsky's memoir was translated into English by Ernest Hassold: Erwin Panofsky, "Wilhelm Vöge: A Biographical Memoir," *Art Journal* 28(1) (1968), pp. 27–37. My citations follow the original German version. For Panofsky's essay, see also note 25 to this Introduction.

24. Wilhelm Vöge, *Eine deutsche Malerschule um die Wende des ersten Jahrtausends. Kritische Studien zur Geschichte der Malerei in Deutschland im 10. und 11. Jahrhundert*, Westdeutsche Zeitschrift für Geschichte und Kunst, Ergänzungsheft VII (Trier: Fr. Lintz, 1891).

25. Wilhelm Vöge, *Die Anfänge des monumentalen Stiles im Mittelalter. Eine Untersuchung über die erste Blütezeit der französischen Plastik* (Strasbourg: J. Heitz, 1894; repr. Munich: Mäander Verlag, 1988). The German text of Panofsky's 1958 memoir of Vöge (cited in note 23 to this Introduction) is included in the 1988 reprint, pp. 377–402.

26. Wilhelm Vöge, *Raffael und Donatello. Ein Beitrag zur Entwicklungsgeschichte der italienischen Kunst* (Strasbourg: J. Heitz, 1896).

27. *Beschreibung der Bildwerke der christlichen Epochen in den Königlichen Museen zu Berlin. I. Teil: Die Elfenbeinbildwerke* (Berlin: W. Spemann, 1900); *Beschreibung der Bildwerke der christlichen Epochen in den Königlichen Museen zu Berlin. IV. Teil: Die deutschen Bildwerke und die der anderen cisalpinen Länder* (Berlin: G. Reimer, 1910).

28. Erwin Panofsky, *Die theoretische Kunstlehre Albrecht Dürers (Dürers Ästhetik)* (Berlin: G. Reimer, 1914). Panofsky's dissertation was published in full under the title *Dürers Kunsttheorie, vornehmlich in ihrem Verhältnis zur Kunsttheorie der Italiener* (Berlin: G. Reimer, 1915).

29. Wilhelm Vöge, *Niclas Hagnower. Der Meister des Isenheimer Hochaltars und seine Frühwerke* (Freiburg im Breisgau: Urban-Verlag, 1931), and *Jörg Syrlin der Ältere und seine Bildwerke, II. Band: Stoffkreis und Gestaltung* (Berlin: Deutscher Verein für Kunstwissenschaft, 1950). Vöge had planned a work of several volumes on Syrlin; the "second" volume cited here was an expanded version of the first, which was destroyed in the final stages of production when the Berlin publishing house was bombed during World War II. See Vöge's comments, *Jörg Syrlin*, p. 9. Compare Panofsky, "Wilhelm Vöge," p. xxxi.

30. Many students of art history today, especially those who are not fluent in German, tend to equate older German art history with Warburg. Yet at the turn of the century, by which time Goldschmidt and Vöge had well-established reputations, Warburg was a private

scholar whose work was little known. Warburg's thought did not greatly influence mainstream German art history in his own day (he died in 1929) outside of an important group of scholars (e.g., Erwin Panofsky, Fritz Saxl) associated with his library in Hamburg during a brief and highly creative period in the 1920s. With the exodus of these scholars and Warburg's library from Germany after the advent of the National Socialist regime, Warburg's work became much better known outside of Germany than in its country of origin. In recent years Warburg has been "discovered" on a large scale owing to his ambivalence, lack of system, and predilection for violating disciplinary boundaries – all of which have been very appealing to poststructuralist thought. See, for instance, Horst Bredekamp, "'Du lebst und thust mir nichts.' Anmerkungen zur Aktualität Aby Warburgs," *Aby Warburg. Akten des internationalen Symposions Hamburg 1990,* ed. Horst Bredekamp, Michael Diers and Charlotte Schoell-Glass (Weinheim: VCH, Acta Humaniora, 1991), pp. 1–7; Margaret Iversen, "Aby Warburg and the New Art History," *Aby Warburg,* pp. 281–87. Warburg, who was a close friend of Vöge and Goldschmidt, is discussed in the present volume, esp. Chapters 1 and 5.

31. At the turn of the century, Wölfflin taught at the universities of Munich (1889–93), Basel (1893–1901) and Berlin (1901–12). He later returned to the University of Munich (1912–24) and spent the final years of his academic career at the University of Zurich (1924–34). Wölfflin and Goldschmidt were colleagues at the University of Berlin between 1901 and 1904. They formed a lifelong professional friendship during these years; see Roosen-Runge-Mollwo, *Goldschmidt. Lebenserinnerungen,* pp. 459–62 ("Anhang VIII: Adolph Goldschmidt und Heinrich Wölfflin").

32. Recent historiographical studies in art history that are based on the study of published texts or on secondary literature include Michael Podro, *The Critical Historians of Art* (New Haven: Yale Univ. Press, 1982), Michael Ann Holly, *Panofsky and the Foundations of Art History* (Ithaca, N.Y.: Cornell Univ. Press, 1984), Donald Preziosi, *Rethinking Art History: Meditations on a Coy Science* (New Haven: Yale Univ. Press, 1989), Georg Kauffmann, *Die Entstehung der Kunstgeschichte im 19. Jahrhundert* (Opladen: Westdeutscher Verlag, 1993), as well as the panoramic overviews by Germain Bazin, *Histoire de l'histoire de l'art de Vasari à nos jours* (Paris: Albin Michel, 1986) and Udo Kultermann, *Geschichte der Kunstgeschichte. Der Weg einer Wissenschaft* (Düsseldorf: Econ-Verlag, 1966; 2d ed., Munich: Prestel Verlag, 1990). The latter has also appeared in an English translation, *The History of Art History* (Pleasantville, N.Y.: Abaris Press, 1993). My citations from Kultermann follow the 1990 German edition.

33. These materials are held at the Kunstgeschichtliches Institut at the Albert-Ludwigs-Universität in Freiburg im Breisgau. All quotations from unpublished documents in this book are from my own transcriptions. I have followed the older German orthography and punctuation in order to reproduce more accurately the character of the original (and often colloquial) handwritten documents.

34. I have a study in progress that considers in a more comprehensive manner than is possible here the personal relationship between Goldschmidt and Vöge and the diverse ways in which it affected their scholarship. I presented a paper on this subject ("Adolph Goldschmidt and Wilhelm Vöge: Male Bonding between the Pioneers of Medieval Art History") at the College Art Association meeting in Seattle, February 1993.

35. Studies of medieval sculpture tended to focus on the Gothic era, especially the thirteenth century, which scholars considered to have been the apogee of medieval artistic and cultural achievement. For an introduction to this subject, see my article "Gothic Sculpture as a Locus for the Polemics of National Identity," *Concepts of National Identity in the Middle Ages,* Leeds Texts and Monographs, New Series 14, ed. Simon Forde, Lesley Johnson and Alan V. Murray (Leeds: University of Leeds, 1995), pp. 189–213. By the same token, research

on manuscripts concentrated on the Carolingian and Ottonian periods, eras then projected as marking the birth of the German nation. Generally speaking, scholarship on medieval art during the late nineteenth century in Germany and elsewhere was informed by the nationalist political attitudes of the period. Goldschmidt's and Vöge's publications, however, do not contain the overt chauvinism characteristic of much scholarship of the period. See Chapters 2 and 3.

Chapter 1. Art History and Cultural History during the 1880s

1. The other two universities were Giessen (1874) and Königsberg (1830). In Giessen the chair of art history resulted from the renaming of an already extant chair of architecture when the professorships for architecture and engineering at Giessen were transferred to the Technische Hochschule in Darmstadt, and Josef Maria Hugo von Ritgen (1811–89), professor of architecture, remained behind in Giessen. Although Ritgen's chair was renamed, this chair of art history was not renewed following his retirement. A chair of art history was reestablished at Giessen in 1898. See Heinrich Dilly, *Kunstgeschichte als Institution*, p. 237. Compare Wilhelm Waetzoldt, "Die Stellung der Kunstgeschichte an den deutschen Hochschulen," *Atti del X Congresso Internazionale di Storia dell'Arte in Roma (1912). L'Italia e l'arte straniera* (Rome, 1922; repr. Nendeln, Liechtenstein: Kraus Reprint, 1978), pp. 24–32. Waetzoldt's survey of art history instruction at German universities, polytechnical institutes and art academies covered the years to 1913. There are slight (i.e., one- or two-year) discrepancies in the dates given by Dilly and Waetzoldt for the establishment of the art history chairs at Strasbourg and Leipzig. Dilly gave the year in which the chair was established, whereas Waetzoldt appears to have cited the year in which the chair was first occupied. See Dilly, pp. 236–37, for statistics regarding the teaching of art history at German-speaking universities as an adjunct to disciplines such as aesthetics or theology. However, as he pointed out, only the universities with chairs (*Ordinarien*) of art history guaranteed continuity of instruction in the field. Dilly, p. 55, also discussed the establishment of chairs of art history at polytechnical schools in German-speaking Europe. Dilly's book focuses on the years between 1760 and 1870. The classic study of the German academic system in the late nineteenth and early twentieth centuries is Fritz Ringer's *The Decline of the German Mandarins: The German Academic Community, 1890–1933* (Cambridge, Mass.: Harvard Univ. Press, 1969; repr. Middletown, Conn.: Wesleyan Univ. Press, 1990).
2. See Dilly, *Kunstgeschichte als Institution*, pp. 161–64. The Vienna conference was organized by the art historians Rudolf Eitelberger von Edelberg (1817–85), Moriz Thausing (1838–85), Friedrich Lippmann (1838–1903) and Carl von Lützow (1832–97), in conjunction with the world exposition of 1873 held in Vienna. Most of the participants were from German-speaking Europe. According to Dilly, p. 164, the introduction of an international conference for art history in 1873 followed a practice instituted earlier in other disciplines, including chemistry (1860), botany (1864) and medicine (1867). For a more recent assessment of the Congress, see Gerhard Schmidt, "Die internationalen Kongresse für Kunstgeschichte," *Wiener Jahrbuch für Kunstgeschichte* 36 (1983), pp. 7–22 (including a reprint of the original program and list of participants).
3. See the conference program reprinted in Schmidt, "Die internationalen Kongresse," and Schmidt's accompanying comments. The conference participants discussed a wide range of issues: the administration and cataloguing of public collections of art, the restoration and preservation of artistic monuments, instruction in art history in schools and universities and the availability of reproductions of works of art (such as photographs and plaster casts) to assist in study and teaching.

4. Dilly, *Kunstgeschichte als Institution*, pp. 233–34, has discussed the dimensions of this resolution, with bibliography. The conference debates regarding the status of the academic discipline of art history were reflected in an inaugural lecture delivered by Moriz Thausing the following month (October 1873) upon his appointment as associate professor (*Extraordinarius*) of art history at the University of Vienna. This important lecture, "Die Stellung der Kunstgeschichte als Wissenschaft," was published in Thausing's *Wiener Kunstbriefe* (Leipzig: E. A. Seemann, 1884), pp. 1–20, and has recently been republished in the *Wiener Jahrbuch für Kunstgeschichte* 36 (1983), pp. 140–50.

5. Compare Schmidt, "Die internationalen Kongresse," p. 9. The first volume was edited by Franz Schestag, curator of the imperial and royal collection of engravings in Vienna. The second volume, edited by Hubert Janitschek, professor of art history at the University of Prague, and Alfred Woltmann, professor at Strasbourg, did not appear until 1879. In the foreword to this volume (n.p.), the editors reiterated the goal of the undertaking: "welches dazu bestimmt ist, der streng wissenschaftlichen Forschung auf allen Gebieten der kunstgeschichtlichen Disciplin als Organ zu dienen." The journal appeared until 1931, when it was merged with the *Zeitschrift für bildende Kunst* and the *Jahrbuch für Kunstwissenschaft* to form a new periodical, the *Zeitschrift für Kunstgeschichte*, which continues to be a prominent scholarly journal of art history today.

6. *Offizieller Bericht über die Verhandlungen des Kunsthistorischen Kongresses zu Nürnberg 25.–27. September 1893* and *Offizieller Bericht über die Verhandlungen des Kunsthistorischen Kongresses zu Köln 1.–3. Oktober 1894*, reprinted in *International Congress on the History of Art: 2nd–9th Congress, 1893–1909* (Nendeln, Liechtenstein: Kraus Reprint, 1978), pp. 1–85 (1893 Congress, pp. 1–2, list of attendees), and pp. 1–102 (1894 Congress, pp. 3–4 for the attendees). Each Congress is paginated separately.

7. The 1893 conference, held at the Germanisches Nationalmuseum in Nuremberg, had sixty-three participants. The roster indicates that approximately seventeen or eighteen of the attendees were young scholars (Dr. phil., cand. phil., *Privatdozent*). The 1894 Congress, held in the city hall in Cologne, attracted ninety-four participants; approximately twenty-five belonged to the "new scholar" category.

8. Paul Clemen, for instance, attended the 1893 and 1894 conferences. Adolph Goldschmidt, Aby Warburg and Max J. Friedländer attended the 1894 conference. Clemen and Warburg are discussed later in this chapter. Vöge, who was conducting research in France between 1892 and 1894, did not participate in either conference. See Chapter 2.

9. For essays on these and related subjects, see Ekkehard Mai and Stephan Waetzoldt, eds., *Kunst, Kultur und Politik im Deutschen Kaiserreich*: vol. 1, *Kunstverwaltung, Bau- und Denkmal-Politik im Kaiserreich* (Berlin: Gebr. Mann, 1981).

10. Dilly, *Kunstgeschichte als Institution*, esp. pp. 173–206. The second half of the nineteenth century saw heightened attempts to establish the disciplinary separateness of art history vis-à-vis these other fields. See, for instance, Moriz Thausing's inaugural lecture of 1873, "Die Stellung der Kunstgeschichte als Wissenschaft."

11. Franz Kugler, *Handbuch der Kunstgeschichte* (Stuttgart: Ebner und Seubert, 1842); Anton Springer, *Handbuch der Kunstgeschichte. Zum Gebrauche für Künstler und Studirende und als Führer auf der Reise* (Stuttgart: Rieger, 1855). I have discussed nineteenth-century German discourse on medieval sculpture, including some of the handbooks and other publications mentioned here, in greater detail in my article "Integration or Segregation among Disciplines? The Historiography of Gothic Sculpture as Case Study," *Artistic Integration in Gothic Buildings*, ed. Virginia Chieffo Raguin, Kathryn Brush and Peter Draper (Toronto: Univ. of Toronto Press, 1995), pp. 19–40.

12. During the early nineteenth century the German historical profession became increasingly document-based and objective in outlook. This mode of history research and writing was

to have significant implications for art history. For valuable accounts of major trends in the development of German historical methodology during the nineteenth century, see Georg G. Iggers, *The German Conception of History: The National Tradition of Historical Thought from Herder to the Present*, rev. ed. (Middletown, Conn.: Wesleyan Univ. Press, 1983), and the essays in Georg G. Iggers and James M. Powell, eds., *Leopold von Ranke and the Shaping of the Historical Discipline* (Syracuse: Syracuse Univ. Press, 1990). Recently Hayden White, Peter Paret and others have drawn attention to the novel-like character of the act of arranging documented events of history into a narrative sequence or pattern. See Hayden White, *Metahistory: The Historical Imagination in Nineteenth-Century Europe* (Baltimore: Johns Hopkins Univ. Press, 1973); idem, *The Content of the Form: Narrative Discourse and Historical Representation* (Baltimore: Johns Hopkins Univ. Press, 1987); Peter Paret, *Art as History: Episodes in the Culture and Politics of Nineteenth-Century Germany* (Princeton: Princeton Univ. Press, 1988). Gabriele Bickendorf has closely analyzed different genres of historical and art historical writing in the early nineteenth century. See her *Der Beginn der Kunstgeschichtsschreibung unter dem Paradigma "Geschichte." Gustav Friedrich Waagens Frühschrift "Ueber Hubert und Johann van Eyck"* (Worms: Wernersche Verlagsgesellschaft, 1985), and her 1991 article "Die Anfänge der historisch-kritischen Kunstgeschichtsschreibung," *Kunst und Kunsttheorie, 1400–1900* (as in Introduction, note 1), pp. 359–74.

13. Franz Kugler, *Pommersche Kunstgeschichte nach den erhaltenen Monumenten dargestellt* (Stettin: Gesellschaft für pommersche Geschichte und Alterthumskunde, 1840); Wilhelm Lübke, *Die mittelalterliche Kunst in Westfalen nach den vorhandenen Denkmälern dargestellt* (Leipzig: T. O. Weigel, 1853).

14. Carl Schnaase, *Geschichte der bildenden Künste,* 7 vols. (Düsseldorf: J. Buddeus, 1843–64). A second edition was published in Düsseldorf between 1866 and 1879. Volumes 3 through 7 examined the art of the Middle Ages. For a contemporary review of the importance of the histories of art written by Kugler and Schnaase, see Wilhelm Lübke, "Die heutige Kunst und die Kunstwissenschaft," *Zeitschrift für bildende Kunst* 1 (1866), pp. 3–13.

15. For instance, in Kugler's *Handbuch der Kunstgeschichte* of 1842, some 124 pages were devoted to Romanesque and Gothic (*germanisch*) architecture (pp. 418–82; 515–75), while painting of the same periods was accorded a total of fifteen pages (pp. 504–12; 594–601). For the study of medieval architecture in the late eighteenth and early nineteenth centuries (and earlier), see Tina Waldeier Bizzarro, *Romanesque Architectural Criticism*, and Paul Frankl, *The Gothic: Literary Sources and Interpretations through Eight Centuries* (Princeton: Princeton Univ. Press, 1960).

16. For instance, Kugler, *Handbuch der Kunstgeschichte,* pp. 604, 609.

17. Wilhelm Lübke, in his book, *Geschichte der Plastik von den ältesten Zeiten bis auf die Gegenwart* (Leipzig: E. A. Seemann, 1863; 2d ed., 1871), attempted to construct the first comprehensive history of sculpture from the ancient Near Eastern civilizations to modern times. Lübke discussed the neglect of medieval sculpture, compared to the extensive study of ancient Greek sculpture, in his foreword. Significantly, this lack of precise information about medieval sculpture was reflected in the archaeologically inexact sculpture carved for neo-medieval building projects of the early to mid-nineteenth century. Such projects included, for instance, the campaign to complete Cologne Cathedral (from 1842), as well as restorations of sculptural programs at cathedral sites in France during the 1850s and 1860s. For Cologne, see Peter Bloch, "Kölner Skulpturen des 19. Jahrhunderts," *Wallraf-Richartz-Jahrbuch* 29 (1967), pp. 243–90, and "Sculptures néo-gothiques en Allemagne," *Revue de l'art* 21 (1973), pp. 70–79. For restorations of Romanesque and Gothic sculptural programs in France, see "Viollet-le-Duc et la sculpture," *Viollet-le-Duc,* exh. cat., Galeries Nationales du Grand Palais, ed. Bruno Foucart (Paris: Éditions de la Réunion des musées nationaux, 1980), pp. 144–73.

For a recent discussion of Winckelmann's impact on the development of art historical writing, see Alex Potts, *Flesh and the Ideal: Winckelmann and the Origins of Art History* (New Haven: Yale Univ. Press, 1994).

18. Publications of men such as Comte Jean-François Auguste Bastard d'Estang (1792–1883) and John Obadiah Westwood (1805–93) belonged to the latter categories. Works such as Westwood's *Palaeographica sacra pictoria: Being a series of illustrations of the ancient versions of the Bible copied from illuminated manuscripts, executed between the fourth and sixteenth centuries* (London: Bohn, 1849) characteristically had little text and reproduced illuminated pages or details in order to assist in study of ornamental designs, national paleographic traditions and calligraphy. Michael Camille, "The *Très Riches Heures*: An Illuminated Manuscript in the Age of Mechanical Reproduction," *Critical Inquiry* 17 (1990), pp. 72–107, has discussed critically some of the roles played by reproductions (such as engravings and lithographs) in the study of illuminated manuscripts in the nineteenth and twentieth centuries.

19. Franz Kugler, *Handbuch der Geschichte der Malerei* (Berlin: Duncker und Humblot, 1837); a second edition of Kugler's *Handbuch* (1847) was prepared by Jacob Burckhardt. The 1837 edition had two large parts, one of which was almost entirely devoted to the painting of the Italian Renaissance (*Handbuch der Geschichte der Malerei in Italien seit Constantin dem Grossen*). In the second section, *Handbuch der Geschichte der Malerei in Deutschland, den Niederlanden, Spanien, Frankreich und England,* painting through the Gothic period (manuscripts, wall painting and stained glass) received only a forty-three-page treatment (pp. 1–43). Kugler also published several short descriptive studies of medieval manuscripts accompanied by small-scale illustrations under the title "Bilderhandschriften des Mittelalters," *Kleine Schriften und Studien zur Kunstgeschichte. 1. Teil* (Stuttgart: Ebner und Seubert, 1853), pp. 1–95. See also Gustav Friedrich Waagen, *Handbuch der Geschichte der Malerei. Die deutschen und niederländischen Malerschulen,* 2 parts (Stuttgart: Ebner und Seubert, 1862). In this 635-page account of German and Netherlandish painting to 1810, Waagen devoted fewer than fifty pages to medieval manuscript illumination and wall painting between the years 800 and 1350 (pp. 1–49). Waagen also indicated the earlier literature.

20. These included the *Annales archéologiques* (Paris: Librairie archéologique, 1844–72); *The Ecclesiologist* (Cambridge: Stevenson and Rivingtons, 1842–68); *Kölner Domblatt: Amtliche Mittheilungen des Central-Dombau-Vereins* (Cologne: DuMont-Schauberg, 1845–1885/92); *Organ für christliche Kunst. Organ des christlichen Kunstvereins für Deutschland* (Cologne, 1851–73); *Zeitschrift für christliche Archäologie und Kunst* (Leipzig: T. O. Weigel, 1856–58). For an informative account of the propagandistic agendas of these journals, see Georg Germann, *Gothic Revival in Europe and Britain: Sources, Influences, Ideas,* trans. Gerald Onn (London: Lund Humphries and the Architectural Association, 1972), esp. Part III, pp. 99–165. Countless books dealing with Christian archaeology also appeared at this time. See, for instance, Adolphe-Napoléon Didron, *Manuel d'iconographie chrétienne* (Paris: Imprimerie Royale, 1845), and Heinrich Otte, *Grundzüge der kirchlichen Kunst-Archäologie des deutschen Mittelalters* (Leipzig: T. O. Weigel, 1855). See also Ferdinand Piper, *Einleitung in die Monumentale Theologie* (Gotha: Rud. Besser, 1867; repr. Mittenwald: Mäander Verlag, 1978). The reprint edition contains an important assessment of Piper's text by Horst Bredekamp, "Monumentale Theologie: Kunstgeschichte als Geistesgeschichte," pp. E2–E47.

21. The preface to the first volume of the *Zeitschrift für christliche Kunst* (Düsseldorf: L. Schwann, 1888–1921) is informative in this regard. It was penned by Alexander Schnütgen (1843–1914), a prominent member of the cathedral chapter in Cologne and the first editor of the journal. See "Zur Eröffnung der Zeitschrift," *Zeitschrift für christliche Kunst* 1 (1888), cols. 1–6.

22. Although monumental painting had also been neglected, this book focuses on the study of illuminated manuscripts, since that area corresponds more closely to Vöge's and Goldschmidt's work.

23. Anton Springer, "Kunstkenner und Kunsthistoriker," *Im neuen Reich* 11(2) (1881), p. 750: "Kaum dass die Kunstgeschichte den Kinderschuhen entwachsen ist." Springer emphasized the many problems facing the young discipline that remained to be solved. This article was reprinted with minor changes in Springer's *Bilder aus der neueren Kunstgeschichte*, 2d ed., vol. 2 (Bonn: Adolph Marcus, 1886), pp. 379–404. My citations are from the original publication.

24. Goldschmidt described his studies at Jena and Kiel in his memoirs. See Roosen-Runge-Mollwo, *Goldschmidt. Lebenserinnerungen*, pp. 47–59, 65–69, with annotations. Goldschmidt, p. 67, outlined the general state of the academic study of art history in the mid-1880s. Emphasizing that the field was not yet regarded as an academic science, he pointed to the discipline's lack of firm territorial boundaries, as well as to the doubts that the upstart discipline met with from natural scientists, philologists and historians. Goldschmidt's principal teacher in Jena was Friedrich Klopfleisch (1831–1918), a professor of prehistory who enlisted Goldschmidt's help in preparing an inventory of artistic monuments in Thuringia; the student was assigned to draw a number of the buildings and other monuments they visited. Goldschmidt, pp. 56–57, stated that he sharpened his observational skills through these practical exercises. Like many other middle- and upper-class men of his day, Goldschmidt had received instruction in drawing and painting as a youth. Roosen-Runge-Mollwo has published a number of Goldschmidt's graphic works in her edition of his memoirs.

25. Ibid., pp. 69–73, for Goldschmidt's studies in Leipzig.

26. For Springer, see his memoirs, *Aus meinem Leben* (Berlin: G. Grote, 1892); the memoirs, which were published posthumously, contain a supplementary essay by Hubert Janitschek, "Anton Springer als Kunsthistoriker," pp. 358–82. See also Paul Clemen, "Anton Springer," *Allgemeine deutsche Biographie*, vol. 35 (Berlin: Duncker und Humblot, 1893), pp. 315–17, and esp. Wilhelm Waetzoldt, *Deutsche Kunsthistoriker*, vol. 2 (Leipzig: E. A. Seemann, 1924), pp. 106–30. A summary is provided by Kultermann, *Geschichte der Kunstgeschichte*, pp. 116–19; Michael Podro, *The Critical Historians of Art*, pp. 152–58, presents a selective account of Springer's work.

27. Springer's doctoral thesis, *Die Hegel'sche Geschichtsanschauung. Eine historische Denkschrift* (Tübingen: L. F. Fues, 1848), forms the centerpiece of the discussion of Springer by Podro, *The Critical Historians of Art*. In his dissertation Springer attacked Hegel's view of history; Podro outlines Springer's alternative approaches, especially as related to the study of art in history.

28. Anton Springer, *Kunsthistorische Briefe. Die bildenden Künste in ihrer weltgeschichtlichen Entwicklung* (Prague: F. Ehrlich, 1857); *Die Baukunst des christlichen Mittelalters. Ein Leitfaden* (Bonn: H. Cohen, 1854); *Handbuch der Kunstgeschichte*.

29. Dilly, *Kunstgeschichte als Institution*, p. 238, has noted that this chair, or full professorship (*Ordinarius*), was the first established for "Neuere und Mittlere Kunstgeschichte" at a German university.

30. See the list of students in *Gesammelte Studien zur Kunstgeschichte. Eine Festgabe zum 4. Mai 1885 für Anton Springer* (Leipzig: E. A. Seemann, 1885), n. p. This 1885 *Festschrift* for Springer was the first such art historical *Festschrift* published in Germany. See Paul Ortwin Rave, *Kunstgeschichte in Festschriften. Allgemeine Bibliographie kunstwissenschaftlicher Abhandlungen in den bis 1960 erschienenen Festschriften* (Berlin: Gebr. Mann, 1962), p. 10.

31. Springer, *Handbuch der Kunstgeschichte*, "Vorwort des Verfassers," pp. vii–viii. See also Podro, *The Critical Historians of Art*, pp. 152–58.

32. Springer, *Aus meinem Leben*, pp. 222–23.

33. Compare Waetzoldt, *Deutsche Kunsthistoriker*, vol. 2, esp. pp. 118–19, or Clemen, "Anton Springer," pp. 316–17. It is curious that Podro, *The Critical Historians of Art*, did not take

account of the fact that Springer's work changed direction around 1860. This is important, for Springer's influence upon the developing field of art history stemmed not so much from his universalizing early work, including his 1848 dissertation, as from his "scientific" research and teaching in art history at Strasbourg and Leipzig between 1872 and 1891. Podro's analysis dwells exclusively on Springer's early writings (see Podro's notes, pp. 242–44) and relies on his autobiography, which also concentrates on the professor's early career. Thus Podro offers only a partial picture of Springer's impact as a "critical historian of art." Podro, pp. 152–77, groups the thought of "early" Springer (1850s and 1860s) together with that of Aby Warburg ("From Springer to Warburg"). Although there were certain similarities in their thought, especially in relation to Springer's essay "Das Nachleben der Antike im Mittelalter" (1850s or early 1860s), reprinted in *Bilder aus der neueren Kunstgeschichte*, vol. 1, pp. 1–40, it appears that Warburg's developing notion of art as an index of cultural behavior may have been more directly influenced by other sources.

34. Springer, "Kunstkenner und Kunsthistoriker," pp. 737–58.

35. Ibid., p. 758. Springer provided a vivid description of the prejudiced attitudes toward the field held by the public, artists and historians – views that, according to Springer, could be overcome by the practice of a disciplined art historical method. He referred to the question of the nature (*das Wesen*) of art history, p. 745.

36. Ibid., p. 750: "die letztere [art history] ist eine Wissenschaft, von den anderen historischen Disciplinen durch den Gegenstand, aber nicht durch die Methode unterschieden."

37. This was the title of Springer's inaugural lecture at the University of Leipzig in April 1873. See Anton Springer, "Über das Gesetzmässige in der Entwicklung der bildenden Künste," *Im neuen Reich* 3(1) (1873), pp. 761–72.

38. The articles were published in installments. See Giovanni Morelli [Ivan Lermolieff], "Die Galerien Roms. Ein kritischer Versuch," *Zeitschrift für bildende Kunst* 9 (1874), pp. 1–11, 73–81, 171–78, 249–53; 10 (1875), pp. 97–106, 207–11, 264–73; 11 (1876), pp. 132–37, 168–73. These writings were later expanded and included in Giovanni Morelli [Ivan Lermolieff], *Kunstkritische Studien über italienische Malerei*, 3 vols. (Leipzig: F. A. Brockhaus, 1890–93). For Morelli's methods, see Jaynie Anderson, "Giovanni Morelli et sa définition de la 'scienza dell'arte,'" *Revue de l'art* 75 (1987), pp. 49–55; idem, "Giovanni Morelli's Scientific Method of Attribution – Origins and Interpretations," *L'Art et les révolutions. Section 5: Révolution et évolution de l'histoire de l'art de Warburg à nos jours. Actes du XXVIIe Congrès International d'Histoire de l'Art, Strasbourg 1–7 septembre, 1989* (Strasbourg: Société Alsacienne pour le Développement de l'Histoire de l'Art, 1992), pp. 135–41; Hayden B. J. Maginnis, "The Role of Perceptual Learning in Connoisseurship: Morelli, Berenson and Beyond," *Art History* 13 (1990), pp. 104–17. Anderson has published a detailed biography and discussion of Morelli's method, entitled "Dietro lo pseudonimo," in her recent critical edition of Giovanni Morelli, *Della Pittura italiana. Studii storico-critici. Le Gallerie Borghese e Doria-Pamphili in Roma* (Milan: Adelphi, 1991), pp. 491–578. See also the recent series of essays on Morelli and his wide sphere of influence in *Giovanni Morelli e la cultura dei conoscitori. Atti del Convegno Internazionale, Bergamo, 4–7 giugno 1987*, 3 vols., ed. Giacomo Agosti, Maria Elisabetta Manca, Matteo Panzeri and Marisa Dalai Emiliani (Bergamo: P. Lubrina, 1993).

39. Compare Julius von Schlosser, *Die Wiener Schule der Kunstgeschichte* (Innsbruck: Universitäts-Verlag Wagner, 1934), pp. 159–71.

40. According to the Morelli scholar Jaynie Anderson (letter to the author, 3 May 1994), Springer could have met or corresponded with Morelli any time prior to the appearance of the *Zeitschrift für bildende Kunst* articles in 1874–76. Morelli had a wide acquaintance among German art historians from the 1840s onward, and his letters often mention young unnamed German scholars who visited him. From at least 1861 Morelli was interested in the

problems of Raphael's formation and in the artistic definition of Raphael's father, Giovanni Santi. He would have been known among connoisseurs and art historians for this specialist knowledge, and it would have been natural for someone like Springer, who studied Raphael and Michelangelo during the 1870s (see the discussion later in this chapter) to consult him. Springer is mentioned in a number of letters Morelli wrote to Jean Paul Richter between 1876 and 1891. See Irma Richter and Gisela Richter, eds., *Italienische Malerei der Renaissance im Briefwechsel von Giovanni Morelli und Jean Paul Richter, 1876–1891* (Baden-Baden: Grimm, 1960), for instance, p. 31 (1878), pp. 184–86 (1881), p. 514 (1887), and especially correspondence dating from the months following the appearance of Springer's "Kunstkenner und Kunsthistoriker" article. See pp. 191–92 (November 1881); pp. 209–11 (February 1882; Morelli quoted a letter from Springer in which the German professor termed himself a "grateful student" of Morelli); pp. 220–21 (April 1882; in this letter, written in Rome, Morelli reported that Springer and his family were in Rome and that Springer had already paid him two visits).

Morelli's copy of Springer's 1881 article is preserved in Morelli's library, now in the Biblioteca dell'Accademia di Brera in Milan (MISC.Q.VI.86/15). It contains many annotations in Morelli's hand expressing his agreements with and objections to specific aspects of Springer's account. See Anderson's comments on the annotations in Giovanni Morelli, *Balvi magnus und Das Miasma diabolicum*, ed. and intro. by Jaynie Anderson (Würzburg: Königshausen und Neumann, 1991), p. 19, n. 17. For explorations of the role of the Springer–Morelli exchange in the dissemination of the Morellian method in Germany, see the following articles in Agosti et al., eds., *Giovanni Morelli e la cultura dei conoscitori*: Gabriele Bickendorf, "Die Tradition der Kennerschaft: Von Lanzi über Rumohr und Waagen zu Morelli," vol. 1, pp. 25–47; Wilhelm Schlink, "Giovanni Morelli und Jacob Burckhardt," vol. 1, pp. 69–81; Silvia Ferino Pagden, "Raffaello come *test-case* della validità del metodo morelliano," vol. 2, pp. 331–49. I am very grateful to Jaynie Anderson for these references.

41. Springer, "Kunstkenner und Kunsthistoriker," esp. pp. 741–43, where he discussed Morelli's method, referring to the connoisseur by name.

42. Ibid., p. 743: "Wer z.B. von naturwissenschaftlichen Studien herkommt, findet den Weg zur Kunstkennerschaft, so weit dieselbe auf analytischen Untersuchungen sich aufbaut, rasch und leicht. Er ist von seiner Fachwissenschaft geübt, zu scheiden und zu trennen, die Gesammterscheinung in ihre Bestandtheile zu zerlegen, auch das Kleine zu beachten und das Charakteristische festzuhalten. In der That trifft man bei Naturforschern, Medicinern häufig den rechten Kennerblick. Auch Morelli hat in seiner Jugend den ärztlichen Beruf ausgeübt." Springer's assertion that Morelli had practiced medicine during his youth was not entirely correct; Morelli had studied medicine but never practiced it. Morelli noted this mistake on the offprint Springer sent him. For Morelli's annotations, see Morelli, *Balvi magnus* p. 19, n. 17.

43. Anton Springer, *Raffael und Michelangelo* (Leipzig: E. A. Seemann, 1878), p. iii: "Erst als der unendlich reiche Schatz von Handzeichnungen und Skizzen, bis dahin in den Sammlungen vergraben und schwer zugänglich, durch die Photographie gehoben wurde, konnte die historisch-genetische Methode nachdrücklich betont und der Kunstgeschichte eine tiefere wissenschaftliche Grundlage gegeben werden. Ähnlich wie der Gebrauch des Mikroskops die äusserliche Naturbeschreibung in eine organische Naturgeschichte verwandelte, so hat das Heranziehen der Handzeichnungen zum Studium der neueren Kunstgeschichte erst erfüllt, was der Name verheisst, und die letztere zu einer wahrhaft historischen Disciplin erhoben." Compare Springer's rationale for his establishment of a photograph collection for the art history institute at Strasbourg in his autobiography, *Aus meinem Leben*, pp. 296–98.

44. Roosen-Runge-Mollwo, *Goldschmidt. Lebenserinnerungen*, pp. 70–71. Goldschmidt admitted that he found this kind of exercise very lame ("sehr dürftig"), especially since Springer himself often did not have knowledge of the original works. This was owing in part to the fact that during his years in Leipzig Springer suffered from a recurring illness that severely restricted his travels. Furthermore, there were no significant public art collections in Leipzig where such exercises could have been carried out.

45. Gustav Pauli, *Erinnerungen aus sieben Jahrzehnten* (Tübingen: Rainer Wunderlich, 1936), p. 75. Pauli was director of the Kunsthalle in Bremen between 1899 and 1914 and director of the Kunsthalle in Hamburg from 1914 to 1933. Kessler, who attended Springer's lectures during the late 1880s, left a vivid account of Springer's "Morellian" teachings. See Harry Graf Kessler, *Gesichter und Zeiten. Erinnerungen* (Berlin: S. Fischer, 1935), pp. 257–58, esp. p. 258, where he outlined Springer's arguments regarding the study of individual artistic "signatures": "Wie keine zwei Eichen dieselben Äste oder Blätter trügen, so formten auch nie zwei Künstler oder Kunstschulen einen Ohrlappen, eine Gewandfalte genau gleich. Aus einem Kunstwerk diese einmaligen Formen herausziehen, die wie Fingerabdrücke seinen Urheber, den Ort und die Zeit seiner Entstehung anzeigten, sie zu Steckbriefen zusammenstellen und an ihrer Hand die Überlieferung nachprüfen, das war für ihn [Springer] Ausgangspunkt und sichere Grundlage der Kunstwissenschaft. Alles andere: die Einfühlung in die Kunst als solche, die Bewertung des einzelnen Kunstwerkes nach ästhetischen oder weltanschaulichen Gesichtspunkten, kam hinterher und lag ausserhalb der Wissenschaft. Was er vortrug, war also weniger eine Einführung in die Kunst als eine Untersuchung ihres Formwandels, eine Morphologie der Kunst."

46. Roosen-Runge-Mollwo, *Goldschmidt. Lebenserinnerungen*, p. 76, n. 68, mentions that Goldschmidt visited the Italian senator during a month-long trip to Italy following his first semester at Leipzig. A number of Goldschmidt's letters and postcards to his family from this period are preserved in Berlin at the Staatsbibliothek Preussischer Kulturbesitz (Nachlass 168). In a postcard sent to his parents from Milan on 16 March 1887 (Bl. 189), for instance, Goldschmidt stated: "Ich besuchte gestern noch den Senator Morelli, der mir seine schöne Gallerie zeigte." The fact that Springer and Morelli knew each other undoubtedly encouraged Goldschmidt's visit to the Italian connoisseur. In his letters to Jean Paul Richter (note 40 to the present chapter), Morelli mentioned specifically that young scholars studying in Leipzig and Vienna were recommended to him. See *Italienische Malerei der Renaissance im Briefwechsel von Giovanni Morelli und Jean Paul Richter*, for instance, p. 245 (letter of December 1882, in which Morelli described an encounter in Florence with Henry Thode, Heinrich Brockhaus and Franz Wickhoff).

47. Springer, "Kunstkenner und Kunsthistoriker," pp. 742–44. See also pp. 752–57, for Springer's critical assessment of the ways in which scholarly attempts to define relationships between an artist's work and the larger cultural milieu in which it took shape enriched art history, on the one hand, and rested on generalities, on the other. Morelli [Ivan Lermolieff], "Die Galerien Roms. Ein kritischer Versuch," (1874), for instance, p. 6: "Nur durch das ernste Studium der Form gelangt man nach und nach dazu, den Geist, der sie belebt, zu erkennen und zu erfassen." In the same paragraph Morelli also referred to "die Seele, der Geist, das Wesen des Meisters."

48. Springer, "Kunstkenner und Kunsthistoriker," pp. 752–54, 757, referred repeatedly to "artistic imagination" (*Künstlerphantasie*) and to the art historian's task of addressing the creative processes and psychology of the artist. However, Springer's theoretical stance on the subject was not pursued to any great depth in his scholarly practice. As I suggest later, Springer's reference to these issues in his 1881 essay should perhaps be viewed in relation to the ideas on artistic creativity voiced a year earlier (1880) by Robert Vischer.

49. Springer, *Raffael und Michelangelo*. In his 1881 essay "Kunstkenner und Kunsthistoriker,"

Springer made direct comparisons between the study of artistic "greats" and the "greats" of political history, p. 751: "Die Kunstgeschichte kennt nur Persönlichkeiten, in welchen sich die herrschende Richtung typisch wiederspiegelt, oder welche auf den Gang der Entwicklung Einfluss geübt haben. Wie lächerlich würde es sich ausnehmen, wenn in der politischen Geschichte eines Jahrhunderts oder einer Nation auch die ganz unbedeutenden Staatengebilde, die thatenlosen Regenten und nichtssagenden Durchschnittsminister ausführlich behandelt, in der deutschen Geschichte z.B. auch die folgenleeren Ereignisse in den kleinsten Fürstenthümern erzählt würden." Springer stated repeatedly that the art historian must master the tools of historical research. See, for instance, p. 757.

50. Roosen-Runge-Mollwo, *Goldschmidt. Lebenserinnerungen*, pp. 70–71. See also note 44 to this chapter.

51. Pauli, *Erinnerungen*, pp. 84–85, compared the outlooks and personalities of the two scholars: "Springer war freilich der angesehenste akademische Lehrer der Kunstgeschichte im damaligen Deutschland, Burckhardt aber war eine europäische Persönlichkeit. Gemeinsam war ihnen die Herkunft vom Geschichtsstudium, die Richtung auf universalhistorische Betrachtung und das Gefühl für das Gesetzmässige im Gang der Geschichte. Im übrigen freilich – welcher Unterschied! ... Während Springer eigenem Geständnis zufolge nie einen Reim geschmiedet hatte, war Burckhardt eine Künstlernatur, zeichnerisch, musikalisch und poetisch begabt: ein Enthusiast und wie alle Künstler von ausgeprägten Sympathien und Antipathien." Pauli's assessment was confirmed by Paul Clemen in his unpublished memoirs, "Lebenserinnerungen (bis 1906)," typescript, deposited at the Rheinisches Amt für Denkmalpflege, p. 21: "er [Springer] war im Grunde unromantisch und kein eigentlich musischer Mensch, dafür ein strenger Zensor und ein unerbittlicher Erzieher." Clemen expanded further on these statements, pp. 20–21: "Er [Springer] war nicht Geschichtsphilosoph ... sein Historismus liess immer eine philologische Schulung erkennen. Von dem spekulativen philosophischen Idealismus, zu dem er sich anfänglich, ursprünglich von Hegel ausgehend, bekannt hatte, hatte er sich abgewandt, und er stand ebenso der mehr ästhetisch-literarischen Behandlung feindlich gegenüber, er suchte seine Wissenschaft ganz neu aufzubauen." See also Waetzoldt, *Deutsche Kunsthistoriker*, vol. 2, esp. p. 119. For Clemen see this chapter.

52. For a summary of Robert Vischer's career, see Kultermann, *Geschichte der Kunstgeschichte*, pp. 143–46; Waetzoldt, *Deutsche Kunsthistoriker*, vol. 2, pp. 37–39; and most recently, *Empathy, Form, and Space: Problems in German Aesthetics, 1873–1893*, intro. and trans. by Harry Francis Mallgrave and Eleftherios Ikonomou (Santa Monica, Calif.: Getty Center for the History of Art and the Humanities, 1994), esp. pp. 17–29, 309–10, 323. The volume also contains an English translation of Vischer's dissertation *Über das optische Formgefühl. Ein Beitrag zur Aesthetik* (Leipzig: H. Credner, 1873), pp. 89–123.

53. Robert Vischer, *Kunstgeschichte und Humanismus. Beiträge zur Klärung* (Stuttgart: G. J. Göschen, 1880), in particular the essay "Über das Verhältniss der Kunstgeschichte zur Aesthetik," pp. 5–25.

54. Vischer, "Über das Verhältniss," for instance, p. 21, where he mocked those scholars whose assessment of an art work rested on "Katalogisiren, Datenbestimmen, Urkundenjagd, Notizenhäufung, Technologie." He stated the goal of his treatise on page 3: "Ich strebe zu zeigen, dass der Kunsthistoriker, weit entfernt, zu meinen, sein ganzes Geschäft bestehe in Aufstapelung gesichteten Stoffes, vielmehr nicht nur mit gut geschulten Begriffen aus der Aesthetik, sondern als ganzer, warmer Mensch mit Auge, Gefühl, Phantasie, mit seiner Seele bei der Arbeit sein soll." On page 22, Vischer asserted that study of an art work could not rest entirely on an historically based method but that it also demanded "Eindringen in das Wesen, in Dasjenige an der Sache, was dem Quell der Erkenntniss verwandt ist, d.h. in den Geist." See Chapter 2 for more discussion of Vischer's writings.

55. Vischer defended the aesthetic content of art works; he also considered the subjective content that the viewer or interpreter brought to contemplation of them. See *Empathy, Form, and Space,* pp. 17–29.

56. Springer's essay in fact appeared the following year. Springer did not refer to Vischer by name, but it seems clear that he was caricaturing the younger scholar's position in passages such as the following, where he referred to the sort of "enthusiast" who reexperiences the artist's "soul," p. 743: "Allmählich hat sich dieser [the enthusiast] in seinen Liebling so hineingelebt, ist dem geistigen Zuge des letzteren so genau nachgegangen, dass er im einzelnen Falle mit grosser Sicherheit behaupten kann, so nur habe der Meister die Natur, den Menschen aufgefasst, oder so habe sie dieser niemals auffassen können. Beweise darf man von ihm nicht fordern. . . . Er wird sich auf ein 'Etwas' in seiner Seele, auf seine Empfindung berufen." The lip service Springer paid to artistic imagination in this essay (see my earlier comments) should probably also be seen in relation to his reading of Vischer's essay.

57. Robert Vischer, *Studien zur Kunstgeschichte* (Stuttgart: A. Bonz, 1886).

58. Anton Springer, "Buchbesprechung: Robert Vischer, *Studien zur Kunstgeschichte,*" *Göttingische gelehrte Anzeigen* (1887), pp. 241–56. In his lengthy review, Springer parodied Vischer's ideal view of the art historian and declared, p. 256, that Vischer had failed in his attempt to bridge the discipline of art history with speculative aesthetics. See also Waetzoldt, *Deutsche Kunsthistoriker,* vol. 2, p. 127. For a more sympathetic review, see Wilhelm Lübke, "Kunstlitteratur: *Studien zur Kunstgeschichte* von Robert Vischer," *Kunstchronik* 22 (1887), cols. 241–46.

59. Springer, "Buchbesprechung: Robert Vischer," p. 242. Springer drew specific analogies with the writing of political history.

60. Waetzoldt, *Deutsche Kunsthistoriker,* vol. 2, p. 128: "In Springers Methode feiert der Historismus des 19. Jahrhunderts seinen Triumph. Alles ist begreifbar, verstehbar, beschreibbar geworden."

61. Later such "scientific" art historical practice lost this function. See Chapters 4 and 5.

62. Roosen-Runge-Mollwo, *Goldschmidt. Lebenserinnerungen,* p. 70; Clemen, "Anton Springer," p. 317; idem, "Lebenserinnerungen," typescript, p. 21. Harry Graf Kessler, *Gesichter und Zeiten,* p. 257, also captured the excitement of Springer's lectures: "Springer, der ein alter Demokrat und grossdeutscher Feuerkopf war, hatte sich aus der Politik in die Kunstgeschichte zurückgezogen, aber sein Temperament in die Fachwissenschaft mitgebracht. Seine Vorträge waren Reden. Er behandelte uns wie ein Parlament. Er fühlte sich als Parteiführer und kämpfte leidenschaftlich gegen die feindliche Fraktion." For a list of the topics of Springer's courses from summer semester 1886 through summer semester 1887, see *Paul Clemen. Zur 125. Wiederkehr seines Geburtstages,* Jahrbuch der Rheinischen Denkmalpflege, 35 (Cologne: Rheinland-Verlag, 1991), pp. 5–8. Some of these courses, which included treatments of Raphael and Michelangelo as well as medieval art and history, would also have been attended by Vöge (summer semester 1886 and winter semester 1886–87) and Goldschmidt (from late 1886).

63. Anton Springer, "Die Miniaturmalerei im frühen Mittelalter," *Zeitschrift für bildende Kunst* 15 (1880), pp. 345–53, esp. p. 353. The study of manuscripts, most of which were produced anonymously and about which very little detailed knowledge was available in Germany prior to ca. 1875, provided a particularly attractive forum for the application of a Morellian comparative method. In his 1881 essay "Kunstkenner und Kunsthistoriker," pp. 741–42, Springer made this point within his discussion of Morelli's approach, stating specifically that in seeking to uncover the origins and personality of the maker(s) of a manuscript scholars did not study front pages or frontispieces ("Titelschriften") but, rather, insignificant details that revealed the *Künstlerschnörkel,* or "signature," of the artist-master. Springer

maintained that close scrutiny of such *Künstlerschnörkel* permitted the provenance of a manuscript to be determined.

64. Anton Springer, *Die Psalter-Illustrationen im frühen Mittelalter mit besonderer Rücksicht auf den Utrechtpsalter* (Leipzig: Hirzel, 1880); *Die Genesisbilder in der Kunst des Mittelalters mit besonderer Rücksicht auf den Ashburnham-Pentateuch* (Leipzig: Hirzel, 1884); *Der Bilderschmuck in den Sakramentarien des frühen Mittelalters* (Leipzig: Hirzel, 1889).

65. Compare Clemen, "Anton Springer," pp. 316–17; Waetzoldt, *Deutsche Kunsthistoriker*, vol. 2, pp. 120–22.

66. Springer, as we have seen, occupied the chair of art history at Bonn when it was first established. I borrow the term *Vollkunsthistoriker* from Paul Clemen, who employed it in a description of circumstances in the Bonn art history seminar during the late 1880s. See Clemen, *Carl Justi. Gedächtnisrede zur hundertsten Wiederkehr seines Geburtstages* (Bonn: F. Cohen, 1933), p. 44.

67. Aby Warburg began his studies in art history at Bonn in the winter semester of 1886–87. His matriculation records, held in the university archives at Bonn (*Anmeldebuch:* Königlich Preussische Rheinische Friedrich-Wilhelms-Universität zu Bonn, No. 63 des Universitätsalbums) show that he remained there through the winter semester of 1887–88 (a total of three semesters). He studied at the University of Munich during the summer semester of 1888 and spent the winter semester of 1888–89 in Florence with a group of art history students led by Professor August Schmarsow of Breslau, who was campaigning for the establishment of a German art history institute (the present Kunsthistorisches Institut) in Florence. Warburg returned to Bonn for the summer semester of 1889 (*Anmeldebuch:* Königlich Preussische Rheinische Friedrich-Wilhelms-Universität zu Bonn, No. 467 des Universitätsalbums) and transferred to Strasbourg in the fall of 1889. See the discussion later in this chapter. For an account of Warburg's studies in Bonn, see Ernst Gombrich, *Aby Warburg: An Intellectual Biography*, rev. ed. (Chicago: Univ. of Chicago Press, 1986), pp. 25–38, 50–53.

The other two art history students in Bonn were Hermann Ulmann (b. 1866) and Ernst Burmeister (b. 1867). Ulmann's matriculation records (*Anmeldebuch:* Königlich Preussische Rheinische Friedrich-Wilhelms-Universität zu Bonn, No. 88 des Immatrikulations-Registers) show that he arrived at Bonn in the winter semester of 1885–86 and stayed there through the summer semester of 1887. Burmeister (*Anmeldebuch:* Königlich Preussische Rheinische Friedrich-Wilhelms-Universität zu Bonn, No. 395 des Universitätsalbums) studied at Bonn between the summer semester of 1886 and the winter semester of 1887–88. Both Ulmann and Burmeister wrote their dissertations under Schmarsow at the University of Breslau. However, the two young student colleagues of Warburg and Vöge died by the mid-1890s. See the tribute to Ulmann by Henry Thode, "Hermann Ulmann," *Repertorium für Kunstwissenschaft* 19 (1896), pp. 247–48. Thode, p. 248, mentioned the death of Burmeister.

68. Paul Clemen spent two semesters at Bonn: the winter semester of 1887–88 and the summer term of 1888. Although his matriculation records have been lost, correspondence from the period and Clemen's memoirs indicate that he enrolled in many of the same classes as Vöge and Warburg. Clemen transferred to the University of Strasbourg during the winter semester of 1888–89 and completed his dissertation there in 1889. In 1893 Clemen became the first conservator of artistic monuments in the Rhineland. In his capacity as Provincial Conservator, a position he held until 1911, Clemen published extensively on Rhenish works of art and architecture and drew up a series of important inventories, entitled *Die Kunstdenkmäler der Rheinprovinz*. As professor of art history at Bonn from 1901 until 1935 he enjoyed an international reputation. Recent studies on Clemen include *Paul Clemen, 1866–1947. Erster Provinzialkonservator der Rheinprovinz*, exh. cat., Rheinisches Landesmuseum, Bonn

(Cologne: Rheinland-Verlag, 1991), and the collection of essays in *Paul Clemen. Zur 125. Wiederkehr seines Geburtstages.* Clemen remained a lifelong friend of Vöge and Goldschmidt, both of whom he met in Leipzig. See also Chapter 3, note 24.

69. See Herbert von Einem, "Bonner Lehrer der Kunstgeschichte von 1818 bis 1935," *Bonner Gelehrte. Beiträge zur Geschichte der Wissenschaften in Bonn. Geschichtswissenschaften. 150 Jahre Rheinische Friedrich-Wilhelms-Universität zu Bonn* (Bonn: Bouvier, 1968), pp. 410–31, esp. 417–24 (Justi), p. 424 (Thode).

70. In 1889 Thode became director of the Städelsches Kunstinstitut in Frankfurt, but he transferred shortly thereafter to a teaching position at the University of Heidelberg. A description of Thode in one of Vöge's letters to his family has been published in Panofsky's memoir of Vöge in *Bildhauer des Mittelalters*, pp. xii–xiii. In a letter to Clemen written from Poppelsdorf (Bonn) on 16 May 1887 (Vöge's letters to Clemen are preserved at the Landesamt für Denkmalpflege Sachsen-Anhalt, in Halle), Vöge described his teacher: "Also Thode – kleidet sich nach der neusten Mode, stösst allen Cigarettenqualm durch die Nasenlöcher aus; kann ganz famose Geschichten erzählen, ist im persönlichen Umgang ausserordentlich liebenswürdig und auch sehr eifrig im Unterricht."

71. Henry Thode, *Franz von Assisi und die Anfänge der Kunst der Renaissance in Italien* (Berlin: G. Grote, 1885). See the review by Eduard Dobbert, "Henry Thode, *Franz von Assisi und die Anfänge der Kunst der Renaissance in Italien*," *Göttingische gelehrte Anzeigen* (1887), pp. 257–73.

72. Vöge's matriculation records (*Anmeldebuch:* Königlich Preussische Rheinische Friedrich-Wilhelms-Universität, No. 439 des Universitätsalbums) show that he enrolled in the following courses offered by Thode: "Über die grossen italienischen Maler des 16. Jahrhunderts," "Geschichte der italienischen Sculptur von Donatello bis auf Michelangelo" (summer semester 1887); "Geschichte der Architektur von der altchristlichen Zeit an," "Übungen im Beschreiben und Bestimmen von Kunstwerken," "Richard Wagner und das Kunstwerk von Bayreuth" (winter semester 1887–88). These course offerings are also listed in the academic calendars of the University of Bonn (*Verzeichnis der Vorlesungen an der Rheinischen Friedrich-Wilhelms-Universität zu Bonn*) for these years.

73. Warburg and Clemen were among the students who also attended the lecture course. Clemen, "Lebenserinnerungen," typescript, p. 28, reported on Thode's lectures: "Er hatte sich . . . mit Daniela von Bülow, der Stieftochter von Richard Wagner, der Enkelin von Franz Liszt verheiratet – durch sie war er von der Welt Wagners gefangen genommen – eine öffentliche Vorlesung 'Richard Wagner und das Kunstwerk von Bayreuth,' in der er sich uneingeschränkt zu dem Bayreuther Meister bekannte, weckte ebensoviel begeisterte Zustimmung und Gefolgschaft als scharfe und ablehnende Gegnerschaft." The biography and memoirs of Wilhelm Valentiner (1880–1958), who studied under Thode in Heidelberg in 1904–05 and went on to a distinguished career in Germany (Berlin Museums) and America (for instance, the Metropolitan Museum of Art, the Detroit Institute of Arts), conjure up the Wagnerian spirit of Thode's lecture-performances. See Margaret Sterne, *The Passionate Eye: The Life of William R. Valentiner* (Detroit: Wayne State University Press, 1980), esp. pp. 37–39, 48–50.

74. For Justi, see Clemen, *Carl Justi. Gedächtnisrede;* Waetzoldt, *Deutsche Kunsthistoriker*, vol. 2, pp. 239–76; Kultermann, *Geschichte der Kunstgeschichte*, pp. 124–26.

75. Vöge took four courses with Justi: "Geschichte der niederländischen und deutschen Malerei vom 16.–18. Jahrhundert," "Kunsthistorische Übungen im Anschluss an Vasari" (summer semester 1887); "Aesthetik der bildenden Künste," "Kunsthistorische Übungen im Anschluss an Vasaris Leben Leonardos" (winter semester 1887–88). Warburg also enrolled in these classes and took other courses with Justi in subsequent semesters.

76. Carl Justi, *Diego Velazquez und sein Jahrhundert*, 2 vols. (Bonn: Cohen und Sohn, 1888). Justi's other biographies included *Winckelmann. Sein Leben, seine Werke und seine Zeitgenossen,*

3 vols. in 2 (Leipzig: F. C. W. Vogel, 1866–72); *Michelangelo. Beiträge zur Erklärung der Werke und des Menschen* (Leipzig: Breitkopf und Härtel, 1900) and *Michelangelo. Neue Beiträge zur Erklärung seiner Werke* (Berlin: G. Grote, 1909).

77. Waetzoldt, *Deutsche Kunsthistoriker*, vol. 2, p. 255, employed this phrase. In contrast to scholars such as Springer, Justi's primary concern was to probe the psychology of the creative genius and to grasp genius in both its rational and irrational aspects. Justi's discourse was largely self-reflexive; that is, he empathized with the creative sensibilities of those he studied.

Vöge's matriculation records show that he also enrolled (winter semester 1887–88) in a lecture course on "Ausgewählte Kapitel der Aesthetik" offered by the philosopher-psychologist Theodor Lipps (1851–1914), whose work gained prominence during the years he taught at the universities of Breslau (1890–93) and Munich (1894–1913). Vöge, however, appears to have abandoned Lipps's lecture, as he did not obtain the instructor's signature ("Bescheinigung des Docenten über den Tag der Abmeldung") at the end of the semester in order to certify his attendance in the class. Vöge's friends Warburg and Burmeister completed this course (and others) with Lipps.

78. Karl Lamprecht, *Deutsche Geschichte*, 12 vols. (Berlin: R. Gaertner, 1891–1909); idem, *Deutsches Wirtschaftsleben im Mittelalter. Untersuchungen über die Entwicklung der materiellen Kultur des platten Landes auf Grund der Quellen zunächst des Mosellandes*, 3 vols. (Leipzig: Alphons Dürr, 1885–86). For Lamprecht's bibliography, see Herbert Schönebaum, "Zum hundertsten Geburtstag Karl Lamprechts am 25. Februar 1956," *Wissenschaftliche Zeitschrift der Karl-Marx-Universität Leipzig*, Gesellschafts- und sprachwissenschaftliche Reihe, 5 (1955–56), pp. 7–16. For the major historical studies on Lamprecht, see Luise Schorn-Schütte, *Karl Lamprecht. Kulturgeschichtsschreibung zwischen Wissenschaft und Politik*, Schriftenreihe der Historischen Kommission bei der Bayerischen Akademie der Wissenschaften, 22 (Göttingen: Vandenhoeck und Ruprecht, 1984), pp. 345–67, and Roger Chickering, *Karl Lamprecht: A German Academic Life (1856–1915)* (Atlantic Highlands, N.J.: Humanities Press International, 1993), pp. 453–79.

79. See Chickering, *Karl Lamprecht*, Chapters 2 and 3, pp. 22–105, for an assessment of Lamprecht's intellectual positioning vis-à-vis the historical profession in nineteenth-century Germany.

80. See my article "The Cultural Historian Karl Lamprecht: Practitioner and Progenitor of Art History," *Central European History* 26 (1993), pp. 139–64, in which I explore the nature of Lamprecht's art historical endeavors during the 1880s and their impact upon the developing field of art history. I also present previously unpublished archival materials pertaining to Lamprecht's dealings with Warburg, Clemen and Vöge.

81. Ibid., pp. 145–46, for the literature. During his stay in Munich (summer semester 1878) Lamprecht familiarized himself with art collections in the city, especially the manuscripts in the Hof- und Staatsbibliothek. He refined his codicological skills and also digested much of the art historical scholarship published up to that time.

82. Jacob Burckhardt, *Die Kultur der Renaissance in Italien. Ein Versuch* (Basel: Schweighauser, 1860). Between 1860 and 1885 Burckhardt's influential book was published in five German editions and was translated into several foreign languages. For the most recent treatment of Lamprecht's university training, see Chickering, *Karl Lamprecht*, Chapter 2, pp. 22–66; idem, "Young Lamprecht: An Essay in Biography and Historiography," *History and Theory* 28 (1989), pp. 198–214.

83. For Lamprecht's stay in the Rhineland and his developing conception of cultural history during these years, see Chickering, *Karl Lamprecht*, Chapter 3, pp. 67–105; idem, "Karl Lamprecht (1856–1915) und die methodische Grundlegung der Landesgeschichte im

Rheinland," *Geschichte in Köln* 31 (1992), pp. 77–90; idem, "Karl Lamprechts Konzeption einer Weltgeschichte," *Archiv für Kulturgeschichte* 73 (1991), pp. 437–52.

84. See Chickering, *Karl Lamprecht*, pp. 87–93.

85. See ibid., Part II, "The Destruction of the Historian," pp. 108–283, for a critical assessment of the methodological dispute within the historical discipline, as well as its broader ramifications.

86. See ibid., Chapter 4, pp. 108–45; idem, "Young Lamprecht" for provocative discussions of how the historian's tempestuous personality and the events of his life affected the nature of his scholarship.

87. Chickering, *Karl Lamprecht*, p. 119. See pp. 109–11 for a discussion of some of the ways in which Lamprecht's sloppy and imprecise language contributed to the confusion generated by his work. Chickering, pp. 119–22, has outlined some of the diverse philosophical currents that coexisted in Lamprecht's *Deutsche Geschichte*. Lamprecht's search for historical unities rested on a synthetic strain of German historicism descended from Leibniz, Herder, Hegel, the German Romantics and the early writers of cultural history. On the other hand, Lamprecht's belief in the interdependence of different spheres of human activity, governed by a regularly paced dynamic of historical development, was informed by writers of the positivist tradition, including Comte and Marx. Chickering, pp. 122–39, has discussed the intellectual configuration of the first volumes of the *Deutsche Geschichte*, as well as the many contradictions inherent within them.

88. Lamprecht, *Deutsche Geschichte*, vol. 12 (Berlin: R. Gaertner, 1909), p. 4, for his statement that the Middle Ages afford "deutliche und in ihrer Art einzige Einblicke in das Jugendleben eines Volkes, in die Werdezeit nationalen Lebens und Wirkens." Although not published until 1909, this statement was written in 1878.

89. See my article "Karl Lamprecht: Practitioner and Progenitor of Art History"; Gombrich, *Aby Warburg*, pp. 30–37; Alfred Doren, "Karl Lamprechts Geschichtstheorie und die Kunstgeschichte," *Zeitschrift für Aesthetik und allgemeine Kunstwissenschaft* 11(4) (1916), pp. 353–89; more generally, historical studies such as Chickering, *Karl Lamprecht*, Schorn-Schütte, *Karl Lamprecht*, and Herbert Schönebaum, "Vom Werden der deutschen Geschichte Karl Lamprechts," *Deutsche Vierteljahrsschrift für Literaturwissenschaft und Geistesgeschichte* 25 (1951), pp. 94–111.

90. Put very briefly, Lamprecht's *Kulturzeitalter* scheme reflected his belief that the German *Volk* had moved away from a primary identification with its founding tribal groups, or *Stämme*, toward an ever-increasing individualism and "subjectivism." Although Lamprecht modified his periodization scheme several times in the course of preparing his *Deutsche Geschichte*, it had acquired more or less the following shape by the late 1880s: the "Symbolic" period (to 350 A.D.), the "Typical" (350–1050), the "Conventional" (1050–1450), the "Individualistic" (1450–ca. 1750), and the "Subjectivistic" period (ca. 1750 to his own day).

91. Karl Lamprecht, *Deutsches Wirtschaftsleben im Mittelalter*. See Ursula Lewald, "Karl Lamprecht und die Rheinische Geschichtsforschung," *Rheinische Vierteljahrsblätter* 21 (1956), pp. 279–304, esp. pp. 294–99, for an account of the significance of Lamprecht's study and the reactions of German historians to it. See also Chickering, *Karl Lamprecht*, pp. 80–83.

92. See Chickering, *Karl Lamprecht*, pp. 79–80, 118–21, for the most recent evaluation of the assumptions underlying Lamprecht's use of analogies. Chickering, pp. 121–39, like earlier historians, has pointed to a number of flaws in Lamprecht's conceptual scheme. Lamprecht, for instance, did not consider the possibility of a time lag between developments in the material realm and the broader intellectual ramifications he posited. Moreover, Chickering, p. 135, has observed that Lamprecht's philosophical prioritizing of the ideal realm

(where national consciousness resided) was oddly juxtaposed with the historical priority of material conditions.

93. Ibid., p. 119.

94. Karl Lamprecht, "Der Bilderschmuck des Cod. Egberti zu Trier und des Cod. Epternacensis zu Gotha," *Jahrbücher des Vereins von Alterthumsfreunden im Rheinlande* 70 (1881), pp. 56–112, plates 3–10 (line drawings); idem, *Initial-Ornamentik des VIII. bis XIII. Jahrhunderts* (Leipzig: Alphons Dürr, 1882). With regard to the latter publication, it is interesting that Lamprecht knew the publisher's son, who had studied at Leipzig during the same years as Lamprecht and had received a doctorate in art history under Springer. The Codex Egberti is located in Trier (Stadtbibliothek, Ms. 24), while the Golden Gospels of Echternach are now held in Nuremberg (Germanisches Nationalmuseum, Ms. 156142/KG 1138).

95. See, for instance, the review by Springer in the *Göttingische gelehrte Anzeigen* (1883), pp. 769–84.

96. Karl Lamprecht, "Bildercyclen und Illustrationstechnik im späteren Mittelalter," *Repertorium für Kunstwissenschaft* 7 (1884), pp. 405–15.

97. Karl Lamprecht, ed., *Die Trierer Ada-Handschrift*, Publikationen der Gesellschaft für Rheinische Geschichtskunde, 6 (Leipzig: Alphons Dürr, 1889). Lamprecht outlined the goals of the project in the introduction, pp. vii–viii. Those participating in the project included Lamprecht's manuscript colleague Hubert Janitschek in Strasbourg, as well as Alexander Schnütgen of the cathedral chapter of Cologne, whose collection of medieval art now forms the core of the Schnütgen Museum in Cologne. The Ada Gospels are held in Trier (Stadtbibliothek, Ms. 22).

98. See, for instance, the reviews by Anton Springer, *Göttingische gelehrte Anzeigen* (1890), pp. 633–51; and Joseph Neuwirth, *Repertorium für Kunstwissenschaft* 13 (1890), pp. 196–210. The publication is physically large (approximately 46 × 35 cm.) and contains thirty-eight full-scale reproductions (thirty-five photographs and three chromolithographs). Lamprecht's *Die Trierer Ada-Handschrift* was an outstanding example of a new genre of manuscript studies combining in-depth scholarly analysis with high-quality techniques of reproduction. In this connection, it is important to point out that Lamprecht's study predated Franz Wickhoff's seminal *Die Wiener Genesis* (Vienna: F. Tempsky, 1895), which represented a similar sort of endeavor, by six years.

99. See my discussion of Lamprecht's teaching and its reception by history and art history students during the 1880s in "Karl Lamprecht: Practitioner and Progenitor of Art History," pp. 153–62.

100. Vöge's enthusiasm for Lamprecht's approach to the study of history was manifested in a number of letters he sent to Clemen, who was still in Leipzig, during the summer semester of 1887. In a letter of 18 June 1887, for instance, Vöge stated: "Wenn ich ganz offen sein soll, muss ich sagen, dass ich – was die Richtung meines Studiums angeht, – mit Bonn zufrieden bin. . . . Dazu kommt nun Lamprecht – der mich eigentlich hier hält." Vöge expressed his opinion that the kind of comprehensive social, economic and legal history taught by Lamprecht was far more important for the training of an historian of medieval art than classical archaeology (prescribed by most German universities at the time as the minor field requirement [*Nebenfach*] for art history). Continuing, he asserted: "Auch gewinnt man eine innerliche Anschauung, ein eindringendes Verständnis der Geschichte . . . Lamprecht ist frisch und lebendig in Vortrag . . . und durch und durch wissenschaftlich. . . . Ich werde eben im Winter, hoffe ich, mehr an ihm haben." In a letter of 16 July 1887 in which Vöge attempted to persuade Clemen to transfer from Leipzig to Bonn, he described the topics of courses to be offered during the winter semester: "Lamprecht hat uns heute gesagt, dass er Deutsche Kulturgeschichte des Mittelalters lesen werde und

zwar liege es ihm daran, die Verbindung der materiellen und geistigen Kultur aufzuzeigen und nachzuweisen. Jedenfalls werden Recht, Verfassung und Wirtschaft die Grundlage bilden, und es wird sich eine Fülle von ganz neuen und wichtigen Gesichtspunkten ergeben. Er sagte mir heute, dass er auch ein Heft von Springers Kulturgeschichte besitze – nannte es aber keine Kulturgeschichte, sondern mehr eine Verbindung von Kunstgeschichte mit Archäologie. Jedenfalls wird Lamprecht (nach dem was ich ungefähr von Springers Kolleg gehört habe), ganz und gar anderes lesen. . . . Lamprecht ist ein ganz kostbarer Kerl." (Vöge then proceeded to describe a class trip to Cologne Cathedral with Lamprecht.) Vöge stated in a letter of 16 May 1887 that he found Lamprecht's perspectives so stimulating "dass ich vorziehe, Justi zu schwänzen – statt Lamprecht – wo beide collidieren."

101. The courses were: "Ausgewählte Kapitel aus der rheinischen Kunstgeschichte," "Deutsche Wirthschaftsgeschichte," and "Wirthschaftsgeschichtliche Übungen" (summer semester 1887); "Grundzüge der deutschen Kulturentwickelung im Mittelalter" and "Historische Übungen: Deutsche Verfassungs- und Wirthschaftsgeschichte" (winter semester, 1887–88); "Deutsche Geschichte bis zum Vertrage von Verdun (843)" and "Erklärung der Germania des Tacitus" (summer semester 1888). In addition, during his stay in Bonn, Vöge took a total of five other history courses from Lamprecht's colleagues Alfred Dove (1844–1916), Carl Menzel (1835–97) and Moriz Ritter (1840–1923). Vöge probably enrolled in these courses, which dealt with historical sources, paleography and aspects of German history, in order to familiarize himself further with the tools of historical research. He made little or no mention of these courses and instructors in his correspondence; his enthusiasm was reserved for the classes he took with Lamprecht.

102. Clemen, "Lebenserinnerungen," typescript, pp. 28–29: "Neben ihm [Thode] stand als Historiker der junge Karl Lamprecht . . . der für uns junge Kunstwissenschaftler ein Führer und Ratgeber ward. Strenge historische Methodik lehrte er in seinen Vorlesungen, Studium der geschichtlichen Quellen aller Art. Es kam unserem noch unsicheren Suchen entgegen, dass für ihn als Deuter der Seele einer Epoche auch ihre künstlerischen Zeugnisse sprechend waren. Er hatte im besonderen auch die Bilderhandschriften herangezogen. . . . Daneben erschloss er uns ganz neue Gebiete und die Kühnheit und Weite seines Blickes hatte gerade für uns outsider etwas Bestrickendes. Eben war sein erstes frühes, Aufsehen erregendes Hauptwerk 'Deutsches Wirtschaftsleben im Mittelalter' erschienen – unvergesslich die Übungen an der Hand von Quellen zur Wirtschaftsgeschichte, vor allem auch der Weistümer, die er in seinem gastfreien Hause in Poppelsdorf mit dem Blick in den Schlosspark abhielt – kein einziger Historiker dabei, als einzige Hörer die zu einer Einheit verbundenen, damals in Bonn studierenden vier jungen Kunsthistoriker – ausser mir Wilhelm Vöge, Aby Warburg, Ernst Burmeister." Warburg's course records show that he took a total of three courses from Lamprecht during the summer semester of 1887 and winter semester of 1887–88. He enrolled in another course when he returned to Bonn for the summer semester of 1889.

103. Warburg's lecture notes from Lamprecht's courses on "Ausgewählte Kapitel aus der rheinischen Kunstgeschichte" (13 pages, summer semester 1887), "Grundzüge der deutschen Kulturentwickelung im Mittelalter" (95 pages, winter semester 1887–88) and "Deutsche Geschichte vom Ausgang der Staufer bis auf Kaiser Max" (146 pages, summer semester 1889) are preserved at the Warburg Institute, London.

104. Warburg's notes show that Lamprecht's morphological scheme for the *Kulturzeitalter* was well developed by this time.

105. See Chapters 2 and 4. In the case of Warburg (compare Gombrich, *Aby Warburg*, pp. 30–37), Lamprecht's interweaving of historical, literary and artistic evidence of a given period must have helped prompt the young man to reflect upon how art was permeated

with the habits, social attitudes and mentality of its time. The eldest son of a prominent banking family in Hamburg, Warburg was able to become a private scholar and to establish a celebrated research library that reflected his complex and idiosyncratic approaches to *Kulturwissenschaft* (a term that might be translated as the "science of culture"). Transferred to England prior to World War II, the Kulturwissenschaftliche Bibliothek Warburg forms the nucleus of the Warburg Institute at the University of London. Compare Dieter Wuttke, "Aby M. Warburgs Kulturwissenschaft," *Historische Zeitschrift* 256 (1993), pp. 1–30.

106. For a discussion of Wölfflin's studies with Burckhardt and his gradual turning away from cultural history, see, for instance, Lurz, *Heinrich Wölfflin*, esp. pp. 53–58. Lurz, part 3, has discussed Wölfflin's intellectual development during the 1880s, 1890s and later. See also Joseph Gantner, ed., *Jacob Burckhardt und Heinrich Wölfflin. Briefwechsel und andere Dokumente ihrer Begegnung, 1882–1897*, 2d ed. (Basel: Schwabe, 1989).

107. *Amtliches Verzeichnis des Personals, der Lehrer, Beamten und Studierenden an der königlich bayerischen Ludwig-Maximilians-Universität zu München, Winter-Semester 1888/89* (Munich: Kgl. Hof- und Universitäts-Buchdruckerei von Dr. C. Wolf und Sohn, 1888) p. 95 (listing of Wilhelm Vöge as a student of history); *Sommer-Semester 1889*, p. 93 (listing of Vöge as a student of art history). Aby Warburg was recorded as an art history student in the same official register, *Sommer-Semester 1888*, p. 97.

108. Lamprecht spent the summer semester of 1878 at the University of Munich. See note 81 to this chapter.

109. In a letter to his family of 6 November 1888, Vöge outlined his research schedule at the Hof- und Staatsbibliothek, stating that he worked there every weekday from 8 A.M. until 1 P.M. Vöge furnished Clemen with progress reports. In a letter written during November 1888 (n.d.), Vöge reported the following: "Ich bin mit dem Gang meiner Arbeiten auf der Staatsbibliothek recht zufrieden. Es ist mir gelungen, nicht weniger als vier Prachtevangeliare mit Illustrations-Cyclen für Trier mit zweifelloser Sicherheit festzulegen. Ich schliesse das Limburger Evangeliar an, das ebenfalls entschieden – wenn auch nicht ohne Zwischenglied – mit jenen zusammenhängt. Ich habe so ein ganz ausserordentlich günstiges, an einem Ort festliegendes Material gewonnen, das ich in Bamberg noch zu erweitern hoffe – auch hier wird sich noch mehreres ergeben müssen." Two of the four manuscripts in Munich were the Gospel Book of Otto III (Cod. Cim. 58, now Clm. 4453) and the Pericopes Book of Henry II (Cod. Cim. 57, now Clm. 4452).

110. Vöge spoke of his new camera in a letter of 1 February 1889: "Mein Apparat kostet (die Kamera 110 Mark mit 3 Doppelcassetten) . . . ; dazu habe ich ein französisches Objectiv erworben; mein Hauswirt, der Dr. Stoss, hat dasselbe – es kostet nur 35 Mark und leistet dasselbe wie der Voigtländer für 84." On 14 February 1889 Vöge reported some technical problems: "Die Aufnahmen, die ich jetzt auf der Staatsbibliothek mache, sind gut, leider Gottes zeigen fast alle an der einen Seite einen etwas dunkleren breiten Streif; ich habe Gott sei Dank jetzt den Grund davon herausgefunden." Since Vöge did his own developing, he asked Clemen for advice regarding the type of paper he should purchase and said that he would send some proofs to his friend.

111. In a letter to Clemen of 8 March 1889 Vöge reported that he had had difficulty obtaining permission to photograph in the Bamberg manuscript collections.

112. Vöge's letters to Clemen show that at the beginning of his stay in Munich he attended some medieval history classes with Hermann Grauert (1850–1924), as well as some art history courses with the *Privatdozent* Berthold Riehl (1858–1911), son of the cultural historian Wilhelm Heinrich Riehl (1823–97). However, Vöge considered Berthold Riehl, who was just beginning his career at the time, too young and inexperienced to supervise a doctoral thesis. (In 1890 Riehl became *Extraordinarius* and in 1906 the first *Ordinarius* for

art history at the University of Munich; see Sybille Dürr, *Zur Geschichte des Faches Kunstgeschichte an der Universität München*, Schriften aus dem Institut für Kunstgeschichte der Universität München, 62 [Munich: Tuduv, 1993], pp. 44–50.) Moreover, as a student of medieval art Vöge wished to take a minor in history, rather than in archaeology, which was required of art history students in Munich at the time. Vöge's letters reveal that this archaeology requirement had also figured importantly in his decision to leave Leipzig.

113. Clemen enrolled on 31 October 1888 in Strasbourg (No. 165 in the matriculation list, Philosophische Fakultät, Kaiser-Wilhelms-Universität, winter semester 1888–89) and completed his dissertation by early April 1889. He had therefore left Strasbourg by the time Vöge and Warburg arrived. Warburg enrolled on 23 October 1889 (No. 79 in the matriculation list, Philosophische Fakultät, winter semester 1889–90), and his thesis defense was held on 12 May 1892. Vöge matriculated at the beginning of November 1889 (No. 151, as in the preceding case) and submitted his dissertation in the late spring of 1890. During their student days in Strasbourg the three young men had rooms in the same building at Züricherstrasse 8. See the matriculation records (AL 103 7 [1 Mi-W.2]) held at the Archives Départementales du Bas-Rhin in Strasbourg.

114. For Janitschek, see the necrology by Hugo von Tschudi, "Hubert Janitschek," *Repertorium für Kunstwissenschaft* 17 (1894), pp. 1–7, which summarizes Janitschek's career and his publications. Janitschek had studied philosophy and aesthetics at Graz before completing his *Habilitation* in 1878 in Vienna under Eitelberger. Janitschek's work was therefore concerned with broad cultural and aesthetic issues as well as with detailed analyses of the visual characteristics of art works. After teaching at Strasbourg from 1881 onward he was named Springer's successor at Leipzig in 1892; however, Janitschek died the following year in Leipzig. For the Strasbourg professor, see also Liliane Châtelet-Lange, "L'Institut d'Histoire de l'Art de Strasbourg," *Formes. Bulletin de l'Institut d'Histoire de l'Art de Strasbourg* 7 (1989), pp. 13–31, esp. pp. 19–21; Jindřich Vybíral, "Hubert Janitschek. Zum 100. Todesjahr des Kunsthistorikers," *Kunstchronik* 47 (1994), pp. 237–44.

115. Hubert Janitschek, *Leone Battista Albertis kleinere kunsttheoretische Schriften* (Vienna: W. Braumüller, 1877); *Die Gesellschaft der Renaissance in Italien und die Kunst* (Stuttgart: W. Spemann, 1879).

116. For instance, "Zwei Studien zur Geschichte der carolingischen Malerei," *Strassburger Festgruss an Anton Springer zum 4. Mai 1885* (Berlin and Stuttgart: W. Spemann, 1885), pp. 1–30; and the section of Lamprecht's *Die Trierer Ada-Handschrift* entitled "Die künstlerische Ausstattung," pp. 63–111. Janitschek's massive 663-page *Geschichte der deutschen Malerei*, Geschichte der deutschen Kunst, 3 (Berlin: G. Grote, 1890) incorporated the results of his earlier research.

117. See my article "Karl Lamprecht: Practitioner and Progenitor of Art History," p. 156, n. 61, and p. 158, n. 66, for the archival evidence.

118. The dissertation was published the following year. See Aby Warburg, *Sandro Botticellis 'Geburt der Venus' und 'Frühling.' Eine Untersuchung über die Vorstellungen von der Antike in der italienischen Frührenaissance* (Hamburg and Leipzig: Leopold Voss, 1893).

119. Paul Clemen, *Die Porträtdarstellungen Karls des Grossen, Erster Theil* (Aachen: Verlag der Cremer'schen Buchhandlung, 1889). The entire dissertation appeared in the *Zeitschrift des Aachener Geschichtsvereins* 11 (1889), pp. 185–271; 12 (1890), pp. 1–147. The role played by Lamprecht in Clemen's choice of dissertation topic is confirmed by Clemen in his memoirs, "Lebenserinnerungen," typescript, p. 29: "Von Lamprecht erhielt ich auch die erste Anregung zu meiner Doktorarbeit 'Die Porträtdarstellungen Karls des Grossen,' die ich nun in ihren Wandlungen auch in ihrer Übersetzung in das Mythische an der Hand der literarischen Überlieferung verfolgte. Ihren sichtbaren Zeugen spürte ich in ganz Deutschland nach. Ich verdanke dem gebefreudigen Gelehrten wichtige Anregungen –

auch in Leipzig, wohin ihn später über Marburg seine Bahn führte . . . habe ich ihn wiederholt aufgesucht, ich ging jedesmal innerlich bereichert von ihm fort."

120. See, for instance, Pauli, *Erinnerungen,* pp. 64–65; Clemen, "Lebenserinnerungen," typescript, p. 34, was more generous: "Als Lehrer auf dem Katheder vermochte er [Janitschek] nicht allzuviel zu geben, aber im Einzelgespräch teilte er sich gern mit, immer gütig und hilfsbereit." Vöge's correspondence shows that he complained to Clemen about Janitschek's scholarship prior to moving to Strasbourg. Once installed in Strasbourg, Vöge wrote to Clemen on 9 January 1890: "Das wirklich Herzliche des persönlichen Umgangs ist ja recht lieb, aber im übrigen ist er doch um das geistige Wohl seiner Schüler nicht so sehr besorgt." On 26 July 1890 Vöge stated: "ich finde bei Janitschek unglaublich wenig echte Bildung, es ist äusserst bedauerlich, dass man so wenig von ihm haben kann." According to Vöge, Warburg held a higher opinion of their teacher: "Das Urteil der hiesigen Kunsthistoriker ist ein kindheitliches, besonders Warburg ist ziemlich erbaut auf Janitschek" (letter of 9 January 1890). The other art history students in Strasbourg during these years included Gabriel von Térey (1864–1927), who later became director of the Museum of Fine Arts in Budapest, Paul Weber (1868–1930) and Eduard Firmenich-Richartz (1864–1923).

121. This is not to say that Goldschmidt was unaware of alternative approaches to the study of artistic monuments, for the methodological controversies of these years were well known to all in the field, as well as to those who read books and journals on art history. Goldschmidt, however, did not have the same direct experience of a group of teachers who provided "living" demonstrations of widely ranging approaches to the study and interpretation of works of art.

122. During the student years of Vöge, Goldschmidt and their circle, the apparatus for slide projection was just being developed and improved upon. As we saw earlier, Springer and others relied on photographs for teaching or on verbal descriptions alone. The projection of images for instruction in art history became more widespread during the 1890s. On the development of this "scientific" instrument of art history with specific dates and documentation, see Heinrich Dilly, "Lichtbildprojektion – Prothese der Kunstbetrachtung," *Kunstwissenschaft und Kunstvermittlung,* ed. Irene Below (Giessen: Anabas-Verlag, 1975), pp. 153–72.

123. Goldschmidt, *Lübecker Malerei und Plastik bis 1530.*

124. Ibid., foreword, n.p.

125. Ibid., "Die Hansa und die geistlichen Brüderschaften," pp. 1–3.

126. Ibid., "Verzeichniss. Lübecker Maler und Bildhauer bis zum Jahre 1530," pp. 30–37. Goldschmidt was assisted in his archival work by Dr. Wilhelm Brehmer (1828–1905) of Lübeck, who had already made a number of notes on the artists active in the city during the late Middle Ages.

127. Ibid., p. 30.

128. Goldschmidt's study was accompanied by forty-three plates made by the photographer Johannes Nöhring in Lübeck. The book itself was physically large (approximately 43 × 31 cm.), and although the individual plates varied in size, they were also large in scale. See also Roosen-Runge-Mollwo, *Goldschmidt. Lebenserinnerungen,* pp. 72–73, for Goldschmidt's evaluation of this study.

129. Goldschmidt's book was reviewed, for instance, by Friedrich Schlie, director of the Grossherzogliches Museum in Schwerin, in the *Repertorium für Kunstwissenschaft* 13 (1890), pp. 402–12; by Richard Graul, *Kunstchronik* N. F. 2 (1891), cols. 22–23; and by F. L. (probably Friedrich Leitschuh), *Zeitschrift für christliche Kunst* 3 (1890), cols. 101–03. Graul stated: "Der Verfasser hat mit echtem Forschersinn die Lübecker Kunstdenkmäler in der Stadt

selbst und in der Diaspora gesammelt, historisch geordnet und mit feinem Verständnis kritisch erörtert. . . . Kurz Goldschmidts verdienstvolle Arbeit bietet der Belehrung die Menge und gereicht dem Verfasser nicht minder zur Ehre als dem Leipziger Meister kunstgeschichtlicher Forschung [Springer], dem sie gewidmet ist."

130. Wilhelm Vöge, *Eine deutsche Malerschule um die Wende des ersten Jahrtausends*. Vöge tentatively located the manuscript "school" in Cologne. It was reassigned several years later to Reichenau, a circumstance that does not affect the scholarly value of Vöge's observations concerning individual manuscripts. See Henry Mayr-Harting, *Ottonian Book Illumination: An Historical Study*, 2 vols. (London: Harvey Miller, 1991), for recent references to Vöge's century-old dissertation; according to Mayr-Harting (vol. 2, p. 224), it helped lay "the foundations of Ottonian art scholarship."

131. See Panofsky's biographical memoir of Vöge, *Bildhauer des Mittelalters*, pp. xiii–xiv.

132. Vöge, *Eine deutsche Malerschule*, p. 1. The dissertation was illustrated with photographs taken by Vöge.

133. For the archival evidence and the broader context of Lamprecht's support of Vöge's manuscript studies, see my article "Karl Lamprecht: Practitioner and Progenitor of Art History," pp. 157–60. In the preface (n.p.) to his dissertation, Vöge thanked von Mevissen, as well as Lamprecht, "der mich während meiner Studien oft und liebenswürdig gestützt hat." Vöge also expressed his gratitude to Clemen, who had shared findings on manuscripts held in libraries in Paris and Brussels.

134. Vöge, *Eine deutsche Malerschule*, introduction, pp. 1–7, esp. pp. 1–3.

135. Ibid., p. 2: "Nicht vom Ort, vom Material ist auszugehen . . . sondern für die Beobachtung dieses in seinen einzelnen uns erhaltenen Resten und Bruchstücken sind die Organe zu schärfen und auszubilden, mit anderen Worten Entwicklung einer eigentlichen Kennerschaft auch für diese Frühkunst ist das wichtigste Rüstzeug für diese Forschung; erstes und wichtigstes Resultat: die Gewinnung breiter, zusammenhängender Stoffmassen, Einheiten höherer Ordnung, mit Hülfe derer es einzig und allein gelingen kann, aus einem Chaos ein Ganzes, Organisches und Gegliedertes ins Dasein zu rufen." On page 4, Vöge drew attention to the number of problems to be resolved by the "young discipline"; in a manner reminiscent of Springer he advocated precise and detailed knowledge of the objects as a first step toward constructing a comprehensive view of art production during a given era. Vöge's comparative neglect of the historical context may help explain why he incorrectly assigned the school to Cologne (see note 130 to the present chapter).

136. See the important review by Paul Clemen, "Litteratur: Wilhelm Vöge, *Eine deutsche Malerschule um die Wende des ersten Jahrtausends*," *Jahrbücher des Vereins von Alterthumsfreunden im Rheinlande* 93 (1892), pp. 233–40, which situated Vöge's "epoch-making" study in relation to earlier scholarship on manuscripts, for instance, p. 235: "Was der vorliegenden Arbeit ihre für die geschichtliche Behandlung der Bildhandschriften und der frühmittelalterlichen Malerei überhaupt epochemachende Stellung einräumt, liegt in der Verfeinerung und Zuspitzung der Methode, in der Übertragung der längst für die ausgebildete Zeit und die Perioden der entwickelteren Kunst geltenden Gesichtspunkte auf die primitiven Kunstzweige und in der Ausbildung einer eigenen Kennerschaft auch für diese Frühkunst als des wichtigsten Rüstzeuges für die Forschung. Der Verfasser giebt in der That in seiner Arbeit zugleich ein Hand- und Lehrbuch zum Erwerb dieser Kennerschaft." See also the review from the *Kölnische Zeitung* which was reprinted in *Kunstchronik* N. F. 4 (1893), col. 11; unidentified reviewer (K.) in *Zeitschrift für christliche Kunst* 6 (1892), cols. 190–91; Franz Xaver Kraus, "Litteraturbericht: Christliche Archäologie, 1890–91," *Repertorium für Kunstwissenschaft* 15 (1892), p. 404, who stated: "Das Buch Vöge's ist die Erstlingsschrift eines Gelehrten, welcher sich durch diese sofort als einer der vornehmsten

Mitarbeiter auf dem kunstgeschichtlichen Gebiete documentiert." Vöge's dissertation played a central role in promoting the study of medieval manuscripts by German scholars. For the broader reception of Vöge's work, see Chapter 4.

137. Vöge, *Eine deutsche Malerschule*, in the introduction, pp. 1–7, elaborated repeatedly on the notion of a "school." He noted that although the tracing of a school on the basis of technical, stylistic and iconographic evidence was well established for the study of art of later periods (i.e., the Renaissance), it had not yet been applied widely to the study of medieval artistic monuments.

138. Indeed the artist virtually disappeared behind Vöge's careful tracing of sources, gestures, motifs and painting techniques. As we saw earlier, the Morellian form of connoisseurship tended to assign greater importance to the uncovering of an artist's signature or hand rather than to a consideration of the creative or conceptual processes underlying the making of a work. See, for instance, Vöge, pp. 6–7, or p. 108: "Die Apokalypse A. II. 42 der Bamberger Bibliothek . . . gehört ebenfalls der Schule von A u. M an, unser Kodex ist unzweifelhaft aus derselben Malerschule hervorgegangen; es muss allerdings entschieden geleugnet werden, dass in A. II. 42 dieselbe Hand vorliegt wie in A. I. 47; die erstere Hs. wird man als eine Werkstattarbeit des in A. I. 47 thätigen Künstlers bezeichnen können. . . . Wenn man innerhalb dieser Familie von Hss. auf die feineren Unterschiede der Individuen achtet, so tritt eine merkwürdig enge Verwandtschaft von A. I. 47 zu dem Aachener Kodex (A) hervor. In jedem der zwei Kodices ist nur je eine Schreiberhand zu konstatieren."

Chapter 2. Wilhelm Vöge and *The Beginnings of the Monumental Style in the Middle Ages*

1. Though Vöge's book is mentioned often in the scholarship on medieval sculpture (see Chapters 4 and 5) as well as in surveys of Vöge's career (including Panofsky, "Wilhelm Vöge," pp. xv–xvii, and Kultermann, *Geschichte der Kunstgeschichte*, pp. 186–88), it has not been the subject of much critical or interpretative study. Recently Susanne Deicher, "Produktionsanalyse und Stilkritik. Versuch einer Neubewertung der kunsthistorischen Methode Wilhelm Vöges," *Kritische Berichte* 19(1) (1991), pp. 65–82, has discussed some of the technical aspects of Vöge's model of medieval artistic production. See also my article "Wilhelm Vöge and the Role of Human Agency in the Making of Medieval Sculpture: Reflections on an Art Historical Pioneer," *Konsthistorisk Tidskrift* 62 (1993), pp. 69–83.

2. The absence of the artist in Vöge's 1891 dissertation contrasts drastically with his celebration of artistic individuality in 1894. Though the scale and greater immediacy of twelfth-century works of sculpture in stone (as compared to manuscripts) probably contributed to Vöge's decision to explore their makers, archival materials suggest that the directional shift in Vöge's work was informed by a wide range of stimuli, some of which he began to consider only after the dissertation was completed (although, as we shall find, he had been aware of them earlier). Vöge's correspondence with Goldschmidt reveals that he was very conscious of the difference in approach between his two studies. In a letter dated 1 September 1892 from Paris, where Vöge was conducting research for his second study, he commented: "Ich denke nicht solch ein Monstrum zu gebären, wie opus I, sondern will das Ding in einem den Denkmälern würdigen Style bringen." Panofsky, "Wilhelm Vöge," p. xv, drew on Vöge's letters to his family to suggest that Vöge consciously altered his approach after he had completed his doctorate.

3. The earliest surviving postcards, letters and visiting cards from Vöge to Goldschmidt date from April and May of 1892. To my knowledge, Goldschmidt's responses to Vöge's letters

have not survived; however, we know something of their contents, since Vöge referred to them in his letters. We owe the preservation of Vöge's correspondence with Goldschmidt to Carl Georg Heise (1890–1979), a protégé and long-time friend of Aby Warburg, who was also from Hamburg. At the urging of his mentor, Heise spent his first semester of university study with Vöge in Freiburg, as he recounted in *Wilhelm Vöge zum Gedächtnis*, Freiburger Universitätsreden, N. F. 43 (Freiburg im Breisgau: Hans Ferdinand Schulz Verlag, 1968), pp. 5–26. After attending Vöge's lectures for one semester, Heise transferred to Halle to study with Goldschmidt for two semesters and later (1916) completed his dissertation at Kiel under the direction of Graf Georg Vitzthum von Eckstädt. Heise served as director of the Lübeck Museum für Kunst und Kulturgeschichte from 1920 until his removal from office in 1933; following World War II he became director of the Hamburg Kunsthalle (to 1955). Heise, pp. 18–19, stated that he did not remain in contact with Vöge after the latter's breakdown in 1915–16; however, when Goldschmidt was forced to leave Nazi Germany in 1939, he gave his collection of letters from Vöge to Heise for safekeeping (p. 5). Heise did not publicize this fact until he gave a lecture commemorating the one hundredth anniversary of the year of Vöge's birth at the Kunstgeschichtliches Institut in Freiburg in January 1968. He drew on some of Vöge's letters for his lecture, now published as *Wilhelm Vöge zum Gedächtnis*. Heise subsequently transferred these materials to the Kunstgeschichtliches Institut in Freiburg, where they are preserved in a black wooden box bearing Heise's handwritten label "Briefe von Wilhelm *Vöge* an Adolph Goldschmidt. *Wichtige Dokumente.*" In preparation for his lecture Heise added dates, usually in ink, to the postcards, letters and envelopes, but most of these are incorrect, as an examination of the postmarks shows. For Heise, see Jörg Träger, "Carl Georg Heise," *Zeitschrift für Kunstgeschichte* 43 (1980), pp. 113–15. Heise also published his personal memoirs of Warburg, *Persönliche Erinnerungen an Aby Warburg* (New York: Eric M. Warburg, 1947; repr. Hamburg: Gesellschaft der Bücherfreunde, 1959), and edited a series of personal memoirs of Goldschmidt by scholars such as Hans Jantzen, Otto Homburger and Erwin Panofsky, *Adolph Goldschmidt zum Gedächtnis, 1863–1944* (Hamburg: Hauswedell, 1963).

4. The Leipzig university studies of Goldschmidt and Vöge overlapped for several months; the letters Goldschmidt sent to his parents from Leipzig begin on 21 October 1886 (Berlin, Staatsbibliothek Preussischer Kulturbesitz, Nachlass Adolph Goldschmidt, No. 168). At the time Goldschmidt was much farther on in his studies than Vöge, who was just beginning his university career. Given the small size of German universities in the 1880s and the fact that the two students had friends in common, including Paul Clemen and Gustav Pauli, we can assume that they became acquainted – if only slightly – in Leipzig. After Vöge transferred to Bonn he developed a close friendship with Aby Warburg, who had known Goldschmidt from childhood. (Both families belonged to the Jewish banking community in Hamburg.) Warburg is mentioned frequently in Vöge's letters to Goldschmidt during the 1890s.

5. In a letter to Clemen dated 30 December 1889 from Strasbourg, Vöge reported that "Goldschmidt (Leipzig) kam neulich hier durch, reiste nach Palermo; er hat Diss. gemacht über Lübecker Plastik und Malerei (bis 1530). Ist sehr fleissig. Er kam in Janitscheks Kolleg, derselbe war etwas erregt und sprach 'auf Best' wie Warburg sagt." In a letter mailed to his parents from Strasbourg on 3 December 1889 (Berlin, Staatsbibliothek Preussischer Kulturbesitz, Nachlass 168, Bl. 273–74), Goldschmidt related that he had attended Janitschek's seminar with Warburg the previous afternoon ("Des Nachmittags ging ich mit Warburg in ein Colleg") and that Janitschek, who was already familiar with Goldschmidt's newly published dissertation, was very friendly ("sehr freundlich") toward him. He also informed his parents that in the evening he had dined with Warburg and a colleague of Warburg, who may well have been Vöge.

6. Vöge explicitly stated, in a postcard written to Goldschmidt from Paris on 27 August 1892,

that he hoped to have another manuscript completed by the beginning of the next year "in the usual 'pioneering' mode" ("Ich hoffe, am Anfang des nächsten Jahres ein erstes Manuscript fertig zu haben, in der üblichen 'bahnbrechenden' Fassung"). Similarly, in a postcard of 12 September 1892 sent from Paris, he noted his and Goldschmidt's shared concern with the investigation of "beginnings" or "origins" ("die Anfänge"). Heise, *Wilhelm Vöge zum Gedächtnis,* esp. pp. 19–24, also pointed to their common interests. The friendship of Vöge and Goldschmidt during the 1890s is discussed in an article I have in progress on "Male Bonding," where I explore in greater depth than is possible here the significance of the personal, more private layer of discourse contained in Vöge's letters to Goldschmidt.

7. Vöge, *Eine deutsche Malerschule,* "Vorwort," n.p.

8. See my article "Karl Lamprecht: Practitioner and Progenitor of Art History," p. 159, for a discussion of the archival evidence. The final chapter of Vöge's dissertation, *Eine deutsche Malerschule,* pp. 379–86 ("Anhang: Exkurs. Material zur Geschichte der Echternacher Malerschule"), provided a point of departure for the investigation, as did Lamprecht's earlier article on the Golden Gospels of Echternach.

9. See my "Karl Lamprecht: Practitioner and Progenitor of Art History," p. 159. In addition, Vöge mentioned the project several times in letters to Goldschmidt and Clemen. In a postcard sent from Paris on 29 July 1892 he informed Goldschmidt that "Die Gesellschaft für Rheinische Geschichtskunde hat mich mit der Publikation des Echternacher Codex beauftragt." He had already broached the topic in a letter written to Goldschmidt on 21 May 1892 from Bonn, where he was visiting their common friend Clemen.

10. In 1893, for instance, as Vöge was preparing his study of French sculpture, he published "Die Mindener Bilderhandschriftengruppe," *Repertorium für Kunstwissenschaft* 16 (1893), pp. 198–213. The article was closely related to his dissertation research.

11. Vöge's transcripts from Bonn University (Chapter 1, note 72) show that he had taken four courses in French language and literature there. He arrived in Paris for the first time in early June 1892. In a letter sent to his brother-in-law (husband of his only sibling, an elder sister) from Paris on 5 July 1892, he reported that in the evenings he had an hour of French conversation practice with a French professor and that he spent each day working at the Bibliothèque Nationale. Continuing, he stated: "Die Bearbeitung der französischen Plastik ist sehr schwierig, man kommt nur langsam weiter, dagegen habe ich mir bereits eine gute Kenntnis der hiesigen Sammlungen angeeignet und im allgemeinen recht viel gelernt. Ich habe ein ganz scharf gefasstes Thema noch nicht gefunden, werde aber voraussichtlich Chartres zum Ausgangspunkt nehmen; die Literatur ist enorm."

12. Vöge thanked these scholars, as well as others in both France and Germany, in the foreword to his book, pp. ix–xi. In a letter written to Goldschmidt from Paris on 20 November 1892, Vöge remarked that many of his mornings were expended on visits to French scholars. Gaston Maspero and Samuel Berger (1843–1900), a distinguished biblical and manuscript scholar, had invited him to attend meetings of the Académie Française, which he found highly entertaining: "Ich kann durch Vermittlung Berger's oder Maspero's gelegentlich an den Sitzungen der Akademie française teilnehmen; sehr amüsant, fast dem Théâtre français noch vorzuziehen, wenn man gut sitzt." In a letter to his family sent from Paris on 17 February 1893 he asserted: "Herr Eugène Müntz von der École des Beaux-Arts hat mich äusserst zuvorkommend empfangen; ich arbeite dort von Zeit zu Zeit auf der Bibliothek." Müntz taught at the École from 1884; he assumed the chair held by Hippolyte Taine upon the latter's death in 1893. From 1887 on, Courajod lectured at the École du Louvre on the history of French sculpture (in addition to his curatorial duties at the museum). See the necrologies by André Michel, "Louis Courajod," *Gazette des beaux-arts,* 38th yr., 3d per.,

vol. 16 (1896), pp. 203–17, and Wilhelm Bode, "Louis Courajod," *Repertorium für Kunstwissenschaft* 19 (1896), pp. 396–400.

13. Courajod's publications focused on French sculpture of the early Middle Ages, as well as on Italian and French sculpture of the Renaissance. His writings included *Alexandre Lenoir, son journal et le Musée des monuments français*, 3 vols. (Paris: H. Champion, 1878–87); *Histoire du département de la sculpture moderne au Musée du Louvre* (Paris: E. Leroux, 1894); and, with P.-Frantz Marcou, *Musée de Sculpture Comparée (moulages), Palais du Trocadéro. Catalogue raisonné publié sous les auspices de la Commission des Monuments Historiques, XIVe et XVe siècles* (Paris: Imprimerie Nationale, 1892). Following Courajod's premature death, his lectures were edited by Henry Lemonnier and André Michel and published under the title *Leçons professées à l'École du Louvre (1887–1896)*, 3 vols. (Paris: A. Picard, 1899–1903). These lectures, as well as an extract published earlier, *Les Origines de l'art gothique. Leçon d'ouverture du cours d'histoire de la sculpture française* (Paris: E. Leroux, 1892), show that Courajod's concerns with the origins of Gothic sculpture diverged from those of Vöge – for the French scholar researched the early medieval origins; he investigated, for instance, links between Christian art in the West and the art and iconography of the Orient, Byzantium and Ravenna (as Vöge indicated in *Die Anfänge*, p. vii). In a letter to Goldschmidt written on 20 November 1892 from Paris, Vöge stated: "Ich folge im Winter (7. Dezember) Courajod's Cours im Louvre über französische Plastik; er hat Gott sei Dank alles über sich ergehen lassen, und giebt bereitwillig, was er hat." Vöge was probably referring here to Courajod's scholarly generosity to German scholars. As Bode emphasized in his necrology "Louis Courajod," Courajod was one of the few scholars in French museum circles who established friendly relations with his German counterparts immediately following the Franco-Prussian War (1870–71). Courajod shared many of the specific interests of his Berlin colleague, whom he saw regularly in Germany, Italy and Paris. See Bode, *Mein Leben*, 2 vols. (Berlin: H. Reckendorf, 1930), vol. 1, p. 161; vol. 2, p. 10. For Bode's support of Vöge's research for *Die Anfänge des monumentalen Stiles*, see note 29 to this chapter.

14. See Vöge, *Die Anfänge*, p. xiv, for an outline of the resources available to scholars in Paris. In a postcard sent to Goldschmidt immediately upon his arrival in the French capital (2 June 1892), Vöge solicited his colleague's advice concerning the relevant photographic archives in the city.

15. Vöge's correspondence with his family and with Goldschmidt shows that he conducted research on manuscripts at the Bibliothèque Nationale and elsewhere in the summer and fall of 1892 and early 1893; he frequently exchanged bibliography on manuscripts with Goldschmidt and also did some footwork (tracings, textual and visual analyses of manuscripts) for his friend.

16. Vöge decided to take the sculpture at Chartres as the point of departure for his study shortly after his arrival in Paris, as indicated by a letter to his brother-in-law (5 July 1892, see note 11) and a postcard sent to Goldschmidt on 13 July 1892: "Ich werde meine Plastik um Chartres gruppieren; weiss der Teufel, ob sich was ergiebt." Within several weeks of his arrival in Paris Vöge had visited the Royal Abbey of Saint-Denis, as well as a number of nonmedieval sites, including Versailles (letter of 15 June 1892 to his sister).

17. Vöge's letters and postcards to Goldschmidt and to his family serve as partial records of his itinerary; he traveled to Chartres a number of times during the fall of 1892 and spring of 1893. In a postcard sent to Goldschmidt from Angers on 6 October 1892 he reported: "Ich habe noch viel vor mir, Dep. Cher, Indre et Loire, Allier, Yonne, etc. etc. Resultate gut." He remained more or less continuously in France until May 1894, making only one extended trip to Germany (March to July 1893) for a required period of military duty. Vöge's trips to the Départements were interspersed with stays in Paris. In a letter sent to

Goldschmidt from Paris on 3 September 1893, Vöge enumerated some of the sites he had visited in recent weeks: "Nun sitze ich wieder im reizenden Paris; Châlons, Reims, Laon, Soissons, Würzburg, Karlsruhe, Strassburg etc. liegen bereits hinter mir."

18. Vöge reported that he had spent time with Goldschmidt in a letter to his sister written in Paris on 17 February 1893. Heise, *Wilhelm Vöge zum Gedächtnis*, p. 19, stated that the two men formed their friendship in France in 1892 ("In Frankreich haben die beiden 1892 vor den plastischen Monumenten des Mittelalters Freundschaft geschlossen"); as we have seen, however, the two men knew each other and corresponded before Vöge traveled to France. Moreover, there is no evidence that Goldschmidt visited Vöge in France prior to February 1893. Vöge sent two postcards to Goldschmidt (who was in Paris at the time) from Chartres on 22 and 23 February 1893 expressing his regret that Goldschmidt was unable to join him in Chartres. Clemen was in Paris shortly after Vöge's arrival in June 1892; Vöge remarked upon the impending visit in the letter to his brother-in-law written in Paris on 5 July 1892.

19. Vöge outlined his plans in a letter sent to Goldschmidt on 3 September 1893: "Programm: etwa drei Wochen hier in Paris; dann Lyon, Méditerranée. Ich hoffe, in Südfrankreich noch den Stein der Weisen zu finden, weniger in den Kirchen als in den Museen." He spent much of October and November 1893 in southern France and was back in Paris by Christmas. His stops en route included Brou, Dijon, Le Puy, Vallence-sur-Rhône, Orange, Avignon, Aix-en-Provence, Marseille, Toulon, Cannes, Arles, Nîmes, Aigues-Mortes, Saint-Gilles-du-Gard, Montpellier, Béziers, Carcassonne, Toulouse, Moissac, Cahors, Bordeaux, Poitiers and Orléans.

20. Vöge, *Die Anfänge*, p. x, expressed his thanks to Durand. Durand, author of *Inventaire sommaire des archives communales antérieures à 1790* (Amiens: Piteux, 1891), later published the standard monograph on Amiens cathedral, *Monographie de l'église Notre-Dame, cathédrale d'Amiens*, 2 vols. (Paris: A. Picard, 1901–03). This work was reviewed by Vöge, "Die Kathedrale von Amiens. Besprechung von Georges Durand, *Monographie de l'église Notre Dame, cathédrale d'Amiens*," *Allgemeine Zeitung*, Munich, no. 172 (suppl.), (30 July 1902), pp. 201–04 (reprinted in *Bildhauer des Mittelalters*, pp. 110–18). See also Chapter 4 for Vöge's contacts with Durand and other French scholars.

21. Vöge first met Marignan in Paris in February of 1893 (letter to his sister of 17 February 1893). Marignan had launched *Le Moyen Âge* with two other scholars in 1888; his review of Vöge's *Eine deutsche Malerschule*, which appeared in that journal later in 1893 (*Le Moyen Âge* 6 [1893], pp. 263–64), was probably a direct consequence of their meeting. Although Marignan had been educated in Paris and spent much time there, he was from southern France, and when Vöge traveled in the south he visited Marignan at his country residence near Montpellier. Vöge's letters to Goldschmidt show that the French scholar served as a guide to medieval monuments in the region and that he assisted Vöge in his archival research by introducing him to local historians and archivists. Marignan had comprehensive knowledge of German-language medieval scholarship, for he had also studied in Germany (see note 22 to this chapter). Vöge mentioned, in a letter to Goldschmidt written on 5 November 1893 and mailed from Aix-en-Provence on 7 November, that Marignan was anxious to translate the book he was preparing into French. Although this plan ultimately did not come to fruition, Marignan was among those French scholars who reviewed Vöge's 1894 publication (see Chapter 4). Vöge saw Marignan repeatedly in the course of his travels in France and elsewhere and remained in contact with him until at least 1903–04. Marignan's publications included *La Foi chrétienne au quatrième siècle* (Paris: A. Picard, 1887), *Histoire de la sculpture en Languedoc du XIIe au XIIIe siècle* (Paris: Bouillon, 1902), *Étude sur le manuscrit de l'Hortus deliciarum* (Strasbourg: J. Heitz, 1910) and *Les Fresques des églises de Reichenau. Les Bronzes de la cathédrale d'Hildesheim* (Strasbourg: J. Heitz, 1914). In 1902 Vöge

reviewed Marignan's book *Un Historien de l'art français: Louis Courajod. I. Les Temps francs* (Paris: Bouillon, 1899) in *Repertorium für Kunstwissenschaft* 25 (1902), pp. 101–06 (reprinted in *Bildhauer des Mittelalters*, pp. 11–15). For a review of Marignan's career and publications, see Maurice Wilmotte, "Albert Marignan," *Le Moyen Âge,* 46 (October–December 1936), pp. 241–43.

22. For Marignan's studies with Lamprecht, see Herbert Schönebaum, "Karl Lamprecht: Leben und Werk eines Kämpfers um die Geschichtswissenschaft, 1856–1915," unpub. ms, 1956, pp. 166–69, copies of which are deposited at the universities in Leipzig and Bonn, as well as at the Historisches Archiv der Stadt Köln; Schorn-Schütte, *Karl Lamprecht*, p. 313. In his necrology, Wilmotte, "Albert Marignan," pp. 241–42, mentioned Marignan's departure from France in 1884 to study at the universities of Berlin, Halle and Bonn, noting that Lamprecht was the professor in Germany with whom he developed the closest ties. Wilmotte reported that Marignan kept in touch with Lamprecht until the outbreak of World War I. (These letters are preserved at the Universitätsbibliothek Bonn, Nachlass Lamprecht, S 2713, Korr. 36.) Not surprisingly, the historian's name appears in Marignan's correspondence with Vöge; he refers to our "vieil ami Lamprecht" in an undated letter, probably from 1902 or 1903, now preserved in Halle, Landesamt für Denkmalpflege Sachsen-Anhalt. Lamprecht's 1878 dissertation, *Beiträge zur Geschichte des französischen Wirthschaftslebens im elften Jahrhundert* (Leipzig: Duncker und Humblot, 1878), appeared in Marignan's French translation as *Études sur l'état économique de la France pendant la première partie du moyen-âge* (Paris: A. Picard, 1889).

23. Hindrances included cold and rainy weather (letter to Goldschmidt from Toulouse, 19 November 1893) and frustration at the great amount of time consumed by requisite acts of *politesse*. In a postcard sent to Goldschmidt from Chartres on 21 February 1893, for instance, Vöge stated: "Bereits drei Besuche hinter mir: chanoine, chanoine et conservateur, Président des conservateurs. Man ist sehr gütig; doch konnte ich heute nicht arbeiten."

24. For instance, a postcard to Goldschmidt from Vallence-sur-Rhône, 18 October 1893: "Komme eben von Le Puy und bin noch ganz entzückt von Leuten und Gegend; es ist eine Lust zu leben!"; a letter to his colleague sent from Toulouse on 19 November 1893: "Überall freut mich die reizende Güte der Franzosen; wie rasch ist man nicht hier heimisch!" Heise, *Wilhelm Vöge zum Gedächtnis*, p. 23, cited the latter, but his transcription is incorrect, as a comparison with the original letter confirms.

25. Vöge's admiration of French culture had, of course, many precedents in the cultural and intellectual life of the German-speaking regions. In the decades since the appearance of Vöge's book, many German art historians, including Richard Hamann, Hans Jantzen, Willibald Sauerländer, Dieter Kimpel and Robert Suckale, have directed much scholarly attention to the study of French medieval sculpture. It is interesting to note in this regard that very few French scholars have conducted investigations of medieval sculpture in Germany. See also Chapters 4 and 5.

26. Vöge, *Die Anfänge*, p. vii. He went on to say that establishing the foundations for a history of French medieval sculpture would be a life's work. Yet Vöge was somewhat inconsistent, for elsewhere in his book he employed the term "Geschichte" (history) while referring to his undertaking. See the discussion in Chapter 4.

27. Vöge outlined these thoughts in the preface and introduction to his book, pp. vii–xi and pp. xiii–xxi, respectively, esp. pp. viii, xiv, xix, xx.

28. Heinrich Wölfflin, *Renaissance und Barock. Eine Untersuchung über Wesen und Entstehung des Barockstils in Italien* (Munich: T. Ackermann, 1888).

29. Wilhelm Bode, *Geschichte der deutschen Plastik*, Geschichte der deutschen Kunst, 2 (Berlin: G. Grote, 1885); Franz von Reber, *Kunstgeschichte des Mittelalters* (Leipzig: T. O. Weigel,

1886); Louis Gonse, *L'Art gothique: L'architecture–la peinture–la sculpture–le décor* (Paris: Quantin, 1890). Bode's study, which was the first comprehensive history of German sculpture, was prompted by an influx of German medieval art into the Berlin Museums. See Bode, *Mein Leben*, esp. vol. 1, pp. 190–91; vol. 2, pp. 17–18. In 1888 Bode and Hugo von Tschudi published the first comprehensive catalogue of the expanding sculpture collections of the Berlin Museums, *Beschreibung der Bildwerke der christlichen Epoche* (Berlin: W. Spemann, 1888). Vöge, *Die Anfänge*, p. xi, accorded Bode first place among those German scholars who had supported his research. Later Bode arranged for Vöge to become a curatorial assistant in the Department of Christian Sculpture in the Berlin Museums. Von Reber's and Gonse's studies, which encompassed all media, were more popularizing and overtly nationalistic in their outlook. See my "Gothic Sculpture as a Locus for the Polemics of National Identity." Von Reber was director of the Bayerische Staatsgemäldegalerien; Gonse, whose publications concentrated largely on modern and Oriental art, became editor of the *Gazette des beaux-arts*. For an account of Gonse's career, see André Michel, "Louis Gonse," *Gazette des beaux-arts*, 64th yr., 1st part (1922), pp. 85–88. Vöge, *Die Anfänge*, pp. xiv, xvii, cited Gonse several times in the introduction to his book, for Gonse was among those scholars who viewed the sculpture on the Chartres west facade as marking the beginnings of a new sensibility (see note 33 to this chapter).

30. Vöge, *Die Anfänge*, p. xx: "Uns liegt es fern, das Ikonographische zum Ausgangspunkt der Untersuchung zu machen. Die Richtung mittelalterlicher Kunstforschung besonders in Deutschland geht seit dem Vorgange Springer's zu einseitig auf die Deutung des Inhalts der Bildwerke; man zieht es vor, sich an der Hand ikonographischer Vergleichung rasch über weite Strecken zu orientieren, statt nach dem Wesen der Kunstwerke zu fragen und den Versuch zu machen, in die Werkstatt der Kunst hinunter zu steigen."

31. Continuing, Vöge, ibid., p. xx, asserted: "Die Kunstwerke, auch die unvollkommenen und mittelalterlichen, auffassen als Geschöpfe eines künstlerischen Geistes, als Gebilde einer Künstlerhand und Einblick zu gewinnen suchen in den verborgenen Process der Stilbildung, das ist für uns, wie ich meine, das erste und das letzte."

32. Eugène Emmanuel Viollet-le-Duc, *Dictionnaire raisonné de l'architecture française du XIe au XVIe siècle*, vol. 8 (Paris: Morel, 1866), in his lengthy essay on "Sculpture," pp. 97–279, described the Chartres jamb figures as follows, p. 118: "Ce sont de grandes figures longues qui semblent emmaillottées dans leurs vêtements comme des momies dans leurs bandelettes, et qui sont profondément pénétrées de la tradition byzantine." Vöge employed Viollet-le-Duc's arguments as a point of orientation for his own; for the specifics of his critique, see note 35 to this chapter. In a postcard written to Goldschmidt from Paris on 24 March 1894 he asserted: "Ich habe meinen 'Klotz' Viollet-le-Duc gefunden." Vöge's letters to Goldschmidt show that he was engaged in a fundamental reworking of his manuscript at the time he made this statement. Vöge greatly admired certain achievements of Viollet-le-Duc, praising especially, p. xxi, note 1, what he termed the French scholar's "transformation of archaeology into aesthetics"; that is, Viollet-le Duc wrote "the history of medieval architecture from the point of view and concerns of an artist," something that helped "recover artistic instincts and ideas in the Middle Ages" ("Worin beruht doch das unvergleichliche Verdienst von Viollet-le-Duc's 'Dictionnaire'? Er setzt die Archäologie um in Aesthetik. Er schreibt die Geschichte der mittelalterlichen Architektur mit den Interessen und von den Gesichtspunkten des Künstlers aus, er arbeitet an der Wiederentdeckung der künstlerischen Instinkte und Ideen").

33. Vöge was not the first scholar to make this observation; Schnaase, Lübke, Gonse and others had commented on "novel" elements that they perceived in the Chartres west facade sculpture, as Vöge acknowledged, ibid., pp. xvii, 11. However, the statements of earlier scholars

consisted of two or three sentences rather than the sort of comprehensive explanation attempted by Vöge.

34. For instance, Franz Wickhoff, *Die Wiener Genesis,* and Alois Riegl, *Spätrömische Kunstindustrie* (Vienna: K. K. Hof- und Staatsdruckerei, 1901). Vöge's 1894 publication on the Chartres west facade sculpture shared Wickhoff's and Riegl's concern with the examination of so-called transitional periods.

35. According to Vöge, *Die Anfänge,* esp. Chapter 2 (for instance, pp. 53–54), and Part III ("Die Zusammenhänge mit der weiteren Entwicklung und die Bedeutung des Tektonischen in der französischen Plastik des Mittelalters"), Viollet-le-Duc overlooked this point, hypothesizing instead that the "stiff, hieratic" qualities of the Chartres west facade sculptures reflected close-fitting clothing of the twelfth century, which inhibited body movements. See Vöge's remarks on this explanation, pp. 53–54, 325, 327 ("Während es ihnen [the jamb figures] an der Stirne geschrieben steht, dass die Künstler, die sie schufen, mit den tektonischen Bedingungen gerungen habe, fasst Viollet-le-Duc sie, man möchte sagen, als Genrefiguren aus dem Leben!)." For Viollet-le-Duc's interpretation of the jamb sculptures as twelfth-century clotheshorses (with references to Vöge's critique), see Willibald Sauerländer, "Kleider machen Leute: Vergessenes aus Viollet-le-Ducs 'Dictionnaire du mobilier français,'" *Arte medievale* 1 (1983), pp. 221–40. As Sauerländer, p. 238, pointed out, Vöge exaggerated Viollet-le-Duc's "trivialization" of the Chartres figures in order to strengthen his arguments for the importance of *das Tektonische* at Chartres.

36. These theorists included Viollet-le-Duc (cited repeatedly by Vöge); Karl Böhme, a follower of Semper, *Der Einfluss der Architektur auf Malerei und Plastik* (Dresden: Gilbers, 1882), cited in Vöge's *Die Anfänge,* p. 297, note 1; and Adolf von Hildebrand (discussed later in this chapter), among others.

37. Vöge, *Die Anfänge,* p. 11: "Das Schöpferische einer längst verblichenen Leistung scharf zu erfassen, und strahlend wie am ersten Tage wieder aufleuchten zu lassen, das ist auf dem Wege aesthetischer und technischer Analyse allein nicht möglich. Auch genügt es dazu nicht, das Werk mit anderen Schöpfungen der Zeit zu vergleichen, man muss vielmehr diejenigen Kunstwerke nachweisen können, auf die es unmittelbar zurückgeht. Erst wenn wir die Quellen auffinden, vermögen wir zu sagen, wie die Chartrerer Meister denn eigentlich verfahren sind, vermögen wir in ihren Werken originale Leistung und traditionelles Erbe zu scheiden."

38. Ibid., p. 8.

39. Vöge's archival work is evident in the notes throughout the book; in addition, he devoted a chapter to questions raised by the lack of firm archival evidence (Chapter 7: "Die chronologischen Schwierigkeiten").

40. Vöge, *Die Anfänge,* p. 10, termed the style and composition of the sculpture "eine That bewusster künstlerischer Konsequenz."

41. Ibid., p. 58: "Fügen wir gleich hinzu, der Stil ist niemals eine Folgeerscheinung äusserer Einflüsse, sondern das Geschöpf des künstlerischen Geistes. Einerlei welches seine Quellen sind, unter welchen Einwirkungen und Anstössen er zustande kommt, er entspringt sozusagen in voller Rüstung aus dem Haupte des Künstlers." I cite the English translation of several excerpts from Vöge's *Die Anfänge,* translated as "The Beginnings of the Monumental Style in the Middle Ages" by Alice Fischer and Gertrude Steuer in *Chartres Cathedral,* ed. Robert Branner (New York: W. W. Norton, 1969), p. 142. See also Vöge, *Die Anfänge,* p. 291: "War hier das Originale nicht vielmehr die Eingliederung der Skulptur in einen neuen architektonischen Organismus, die damit im Zusammenhang stehende Umgestaltung des Stiles, das selbstständige Verhältnis dieser Werke zur Natur, ihre technische Überlegenheit? Alles dies aber gehört den Künstlern!"

42. Compare Vöge, *Die Anfänge*, pp. 65–66 (cited in note 67 to this chapter).

43. Ibid., p. 48: "es handelt sich nicht notwendiger Weise um eine Filation fertiger Monumente, und nicht geradezu um directe Zusammenhänge zwischen denen, die uns erhalten blieben, sondern um lebendige Beziehungen der hinter ihnen stehenden Ateliers und Meister."

44. Vöge declared repeatedly, for instance, ibid., p. 5, that stylistic differences allowed him to perceive different "hands" at work on the west facade at Chartres. In Parts I and II of his book he enumerated various masters and distinguished confidently between their artistic identities, maturity, and skill levels on the basis of the forms they made.

45. Alois Riegl, *Stilfragen. Grundlegungen zu einer Geschichte der Ornamentik* (Berlin: G. Siemens, 1893). An English translation of this book has recently appeared: Alois Riegl, *Problems of Style: Foundations for a History of Ornament*, trans. Evelyn Kain, annotations and introduction by David Castriota, preface by Henri Zerner (Princeton: Princeton Univ. Press, 1992).

46. Vöge, *Die Anfänge*, p. 165: "Vielseitigkeit der einzelnen Kräfte, Selbständigkeit im Zusammenarbeiten."

47. Riegl introduced the term in his *Stilfragen* but did not emphasize it there. For recent discussions of Riegl's changing views of this concept, see Olin, *Forms of Representation in Alois Riegl's Theory of Art*, esp. pp. 71–72, 148–53; Iversen, *Alois Riegl: Art History and Theory*, esp. pp. 2–18.

48. Compare Olin (see note 47), p. 87: "Riegl's view of history did not center on a respect for the individuality of the isolated fact or situation. The value of individual fact lay only in the germ of universality that it contained as a link in the causal chain, in its capacity to elucidate general law."

49. Wölfflin, *Renaissance und Barock*, p. ix, described the aims of his book in the following way: "Sie soll ein Beitrag zur Stilgeschichte sein, nicht zur Künstlergeschichte. Meine Absicht war, die Symptome des Verfalls zu beobachten und in der 'Verwilderung und Willkür' womöglich das Gesetz zu erkennen, das einen Einblick in das innere Leben der Kunst gewährte. Ich gestehe, dass ich hierin den eigentlichen Endzweck der Kunstgeschichte erblicke." See the translation of this passage in the preface to the English edition of Wölfflin's *Renaissance and Baroque*, trans. Kathrin Simon (Ithaca: Cornell Univ. Press, 1964), p. xi. This polarity between interpretations of *das Künstlerische* and *das Menschliche* in art history was emphasized in many reviews of the period; see, for instance, Carl von Lützow, "Neue Michelangelo-Litteratur," *Zeitschrift für bildende Kunst* N.F. 3 (1892), pp. 267–70. Wölfflin's *Die Jugendwerke des Michelangelo* (see note 50 to the present chapter) was among the books he discussed. For an assessment of some of the diverse philosophical underpinnings of Wölfflin's thought, see Joan Hart, "Reinterpreting Wölfflin: Neo-Kantianism and Hermeneutics," *Art Journal* 42(4) (1982), pp. 292–300. For Wölfflin's interest in empirical psychology during the late 1880s, see note 94 to the present chapter.

50. Heinrich Wölfflin, *Die Jugendwerke des Michelangelo* (Munich: T. Ackermann, 1891), pp. iii–iv: "Zunächst möge man hier nicht die Lebensgeschichte des jungen Michelangelo erwarten, sondern lediglich den Versuch, seine Kunstentwickelung darzustellen. . . . Der Biograph kann es als Schriftsteller nicht verantworten, den Gang der Erzählung immer zu unterbrechen durch formale Analysen und Vergleichungen, und dadurch geht natürlich Manches verloren; es ist z.B. fast unmöglich, dass die stilistische Entwickelung des Künstlers rein und vollständig zur Darstellung komme. Es stellt sich also das Bedürfniss ein nach einer ergänzenden Art der Betrachtung, aus der das Lebensgeschichtliche völlig ausgeschieden ist und man nichts vor Augen hat als die Folge der Werke selbst, nach einer Betrachtung, wo die analytische Methode einmal ganz zu ihrem Rechte kommt. Ich habe diesen Versuch hier gewagt."

51. Émile Mâle, *L'Art religieux du XIIIe siècle en France. Étude sur l'iconographie du moyen âge et sur*

ses sources d'inspiration (Paris: E. Leroux, 1898). Mâle's study, which was submitted as a doctoral thesis, appeared in a number of French editions from 1898 onward and was published in a German translation in 1907 and in English in 1913. My citations follow the original 1898 edition. In the preface, pp. i–xiv, Mâle surveyed the study of medieval art by nineteenth-century French scholars. His overview not only illuminates his particular stance but also reveals the degree to which interpretations of medieval artistry by French scholars were influenced by politico-religious circumstances in nineteenth-century France. See also Chapter 4 to this volume. For recent critical comments on Mâle's approaches to the study of medieval art, see Michael Camille, "Mouths and Meanings: Towards an Anti-Iconography of Medieval Art," *Iconography at the Crossroads,* ed. Brendan Cassidy (Princeton: Princeton Univ. Press, 1993), pp. 43–57; and idem, *Image on the Edge: The Margins of Medieval Art* (Cambridge, Mass.: Harvard Univ. Press, 1992).

52. For instance, Mâle, *L'Art religieux du XIIIe siècle,* pp. 498–99: "Non, les artistes du moyen âge ne furent ni des révoltés, ni des 'penseurs,' ni des précurseurs de la Révolution. Il est devenu inutile aujourd'hui de les présenter sous ce jour pour intéresser le public à leur oeuvre. Il suffit de les montrer comme ils furent vraiment: simples, modestes, sincères. Ils nous plaisent mieux ainsi. Ils furent les interprètes dociles d'une grande pensée, qu'ils mirent tout leur génie à bien comprendre."

53. See the discussion of the significance of Goethe's essay by W. D. Robson-Scott, *The Literary Background of the Gothic Revival in Germany: A Chapter in the History of Taste* (Oxford: Clarendon Press, 1965), pp. 76–95, and Paul Frankl, *The Gothic: Literary Sources and Interpretations through Eight Centuries,* pp. 417–28. Goethe's essay "On German Architecture" appears in an English translation by John Gage in *German Essays on Art History,* ed. Gert Schiff (New York: Continuum, 1988), pp. 33–40. Although not of direct relevance for *Die Anfänge des monumentalen Stiles,* it is interesting to note that Vöge recalled Goethe's literary figure later in his letters to Panofsky, addressing Panofsky frequently as "Meister Erwin." I will treat the Vöge–Panofsky correspondence in a separate article.

54. For example, Vöge, *Die Anfänge,* p. xix: "Wie ist die französische Gothik so eminent französisch! . . . und wie ist diese Plastik, die wir uns anschicken zu studieren, so ganz und gar französischen Geistes, die Vorzüge und Abgründe seines entzückenden Wesens verratend, den Duft dieses immer blühenden Baumes gleichsam ausströmend!"; p. 51, note 3, when discussing the physiognomy of the jamb figures: "Ist es wunderbar, wenn diese typische Schönheit französische Züge trägt?"

55. Ibid., p. xiii: "Eine Untersuchung über die mittelalterliche Kunst Frankreichs bedarf nicht der Rechtfertigung. Trotz Kaiser und Reich, Frankreich ist das wichtigste Kulturland des Mittelalters, hier lebt dasselbe sein intensivstes Leben, hier gestaltet sich letzteres zu den klassischen Daseins- und Kunstformen. . . . Und das Problem der Entstehung des mittelalterlichen Stiles wird immer zunächst auf französischem Boden studiert werden müssen; erst hier enthüllt sich uns das Geheimnis des mittelalterlichen Genius."

56. I have discussed some of these tropes and their consequence for later scholarship in my article "Gothic Sculpture as a Locus for the Polemics of National Identity." The Franco-Prussian War (1870–71), in particular, encouraged German and French scholars to adopt nationalistic definitions of medieval sculpture.

57. Vöge, *Die Anfänge,* p. 163.

58. Ibid., p. xix: "ebenbürtig dem Studium der grossen Genies aus der Zeit der Renaissance."

59. The preface to Vöge's book, p. xi, is signed and dated "Rom, im Mai des Jahres 1894." Panofsky, "Wilhelm Vöge," pp. xvii–xviii, briefly discussed Vöge's Italian sojourn. Vöge's letters to Goldschmidt reveal that he was in Italy from the end of March 1894 to late January 1895. Genoa, Turin, Pisa, Pistoia, Lucca, Siena, Bologna and Arezzo were among the sites he visited; he also had extended stays in Florence, Rome and Venice. During this

period he frequently saw many of his colleagues, including Warburg, Hermann Ulmann (from his student days in Bonn), Goldschmidt and Marignan. See Chapter 3 for a discussion of the reciprocity between Vöge's research on medieval and Renaissance topics.

60. See Chapter 3.

61. Great artists possessed an artistic will or vision; see Justi, *Diego Velazquez*, for instance, pp. 122: "Diese Kraft der Initiative ist, was man Genie nennt. Das sind die Menschen, welche wegen ihrer grossen, auf ihrer Person beruhenden Wirkung allein eine besondere Geschichte verdienen"; pp. 123–24: "Um mich scholastisch auszudrücken, jenes Allgemeine von Stamm, Schule und Zeit, das er [the artist-genius] von andern hat, mit andern theilt und auf andere vererbt, ist nur sein secundäres Wesen, das Individuelle, Idiosynkrasische, seine erste Substanz. Das Merkmal des Genius ist also die Initiative." See Wölfflin, *Renaissance und Barock*, pp. 3–4: "Es ist die Aufgabe der Künstlergeschichte, den ganzen Reichthum der schaffenden Kräfte aufzuzählen und den Individualitäten im Einzelnen nachzugehen; die Stilgeschichte beschäftigt sich nur mit den grossen, den eigentlich stilmachenden Genien und darf von allem Persönlichen mit dem Hinweis auf die entsprechende Litteratur sich entledigen."

62. In the introduction to *Die Anfänge*, p. xix, Vöge termed the Royal Portal at Chartres "the masterpiece" ("das Meisterwerk"); on p. 231, he referred to "die dominierende Persönlichkeit des Hauptmeisters."

63. See Chapters 4 and 5.

64. In a letter sent from Strasbourg in 1890 (undated, but probably written in late spring), Vöge expressed his interest in familiarizing himself intensively with contemporary philosophy and psychology ("Man kann, scheint es, ohne eine Kenntnis der neuesten Forschungsresultate auf diesem Gebiete überhaupt über Welt und Menschen nicht philosophieren. Zum Studium eines älteren Philosophen etwa Kants habe ich ganz und gar keine Neigung; doch fühle ich die Notwendigkeit eines philosophischen Denkens"). Vöge's letters to Clemen between July and September of 1890 show that in that period he read the corpus of Nietzsche's writings; he borrowed many of Nietzsche's publications from Janitschek's personal library (letter to Clemen, 9 July 1890) and made specific requests to his friend for those writings Janitschek did not possess (for instance, in a postcard mailed from Strasbourg on 21 July 1890, he asked Clemen to send him copies of *Jenseits von Gut und Böse*, published in 1886, and *Zur Genealogie der Moral* of 1887). For the growing influence of the writings of Nietzsche among members of Vöge's and Clemen's generation in the early 1890s, see the memoirs of Gustav Pauli, *Erinnerungen*, p. 119.

65. Vöge had submitted his dissertation to Janitschek in the early summer (June) of 1890. He made countless references to Nietzsche in his correspondence with Goldschmidt and others throughout his lifetime, so that it is impossible to detail them here. See Heise, *Wilhelm Vöge zum Gedächtnis*, esp. pp. 13–14, for an account of the manner in which Vöge introduced him to the writings of Nietzsche (in Vöge's words, "süsses Gift," or "sweet poison") during the first year of his university studies.

66. Vöge, *Die Anfänge*, pp. 290–91, referred to medieval artistic practice as an expression of "künstlerischen Fortschritt," which "zu allen Zeiten darin bestanden hat, dass der Künstler selbständig vordringt und bahnbricht." The fundamental commonalities linking artists were also underscored by Vöge, p. 310, note 1, where he likened the achievements of the sculptors at Chartres to those of Rembrandt during his early career.

67. Vöge, ibid., p. xxi, concluded the introduction to his book by pointing to the necessity of "saluting the living spirit" in history ("Was wäre die Geschichte, wenn wir es nicht vermochten, in den Resten vergangener Jahrhunderte den lebendigen Geist zu grüssen!"). He frequently evoked the "soul" or "artistic soul" of the masters, as for example on pp. 65–66: "Und hinter den Statuen und Steinen erscheinen uns die Meister, die lebendigen

Menschen; wir beobachten sie beim Werke, wir sehen auf den Grund ihrer Künstlerseele. Ihre Instincte und Absichten, ihre Aesthetik und Ideale, die Folgerichtigkeit und Klarheit ihres Stilgefühls, ihre Jugend und ihre Feinheit, ihr Ernst und ihr Eifer, ihr Mut, der Heisshunger des Neuen, die glückliche Verwertung des Alten, das alles liegt zu Tage." This passage appears in an English translation in Branner, ed., *Chartres Cathedral*, p. 145: "And behind the statues and stones appear their makers, living people at work, disclosing the depth of their souls. Their instincts and intentions, their aesthetics and ideals, the coherence and purity of their sense of style, their youth and sophistication, their earnestness and zeal, their daring and driving towards the novel, their felicitous use of traditional elements are all revealed." Numerous variants on these themes appear elsewhere in Vöge's text.

68. See Chapter 1, notes 100, 102, for the citations from Vöge's correspondence and Clemen's unpublished memoirs.

69. I plan to undertake a comparative analysis of the early work of Vöge and Warburg, in which I will consider Lamprecht as one of many factors influencing their intellectual developments.

70. See my article "Karl Lamprecht: Practitioner and Progenitor of Art History," pp. 157–60.

71. In doing so, Vöge literally followed in Lamprecht's footsteps, for Lamprecht had dedicated his *Deutsches Wirtschaftsleben im Mittelalter* to the same person. See my article "Karl Lamprecht," pp. 159–60.

72. See Vöge, *Die Anfänge*, pp. 65–66 (cited at note 67).

73. Vischer's earlier writings included *Über das optische Formgefühl. Ein Beitrag zur Aesthetik,* and *Luca Signorelli und die italienische Renaissance. Eine kunsthistorische Monographie* (Leipzig: Veit, 1879). For Vischer's career, see Chapter 1 of the present volume and Hermann Glockner, "Robert Vischer und die Krisis der Geisteswissenschaften im letzten Drittel des neunzehnten Jahrhunderts. Ein Beitrag zur Geschichte des Irrationalitätsproblems," *Logos. Internationale Zeitschrift für Philosophie der Kultur* 14 (1925), p. 297–343 (part 1); 15 (1926), pp. 47–102 (part 2). In his memoirs, the Baroque scholar Werner Weisbach (1873–1953), a colleague of Vöge at the Berlin Museums from 1898 onward (see Chapter 3), evoked the fiercely independent personality of Vischer. See Weisbach's *'Und alles ist zerstorben.' Erinnerungen aus der Jahrhundertwende* (Vienna: H. Reichner, 1937), pp. 200–02.

74. See Chapter 1. In his *Über das optische Formgefühl* of 1873, Vischer had already employed the terms *Einfühlung* and *Nachfühlung,* for example, pp. 36–37 (in his chapter on "Der Phantasiewille"), predating the usage and development of these concepts by such thinkers as Theodor Lipps (see Chapter 1, note 77 to the present volume) and Georg Simmel (1858–1918) at the turn of the century.

75. Vöge, *Die Anfänge*, pp. xx–xxi, note 3.

76. Ibid., pp. 10–11.

77. Vischer, "Zur Kritik mittelalterlicher Kunst," *Studien zur Kunstgeschichte*, pp. 1–57.

78. Ibid., p. 40. He cited a passage from Lübke's *Geschichte der Plastik* that emphasized the integration of architecture and sculpture on the Chartres west facade, as well as the individuality of the jamb figures.

79. Vöge, *Die Anfänge*, as in the passages already cited; see also *Die Anfänge*, p. 58, note 1.

80. These included a number of loose conceptual borrowings from Vischer's "Zur Kritik." Compare, for instance, Vischer, p. 26, describing deeply ingrained artistic traditions in positive terms ("Wo sie aber noch auf der Stufe elementarer Anfänge steht oder auf diese zurückgeht, da wird aus der Noth eine Tugend gemacht"), and Vöge, *Die Anfänge*, p. 54, describing the architectonic constraints at Chartres in positive terms ("Es ist für diese nordfranzösischen Meister charakteristisch, dass dieser ausserordentliche tektonische Zwang, dem sie sich unterwerfen, nicht in erster Linie als Zwang empfunden ist, vielmehr der Ausgangspunkt wird für ihr stilschöpferisches Gestalten; er wirkt hier nicht hemmend,

sondern im Gegenteil erziehend, anregend, man macht hier aus der Not eine Tugend!"),
as well as the more direct adaptation of concepts contained in another essay in Vischer's
book discussed next.

81. Vischer, "Zur Kritik," pp. 52–53.

82. Ibid., p. 53.

83. Vischer, "Albrecht Dürer und die Grundlagen seiner Kunst," *Studien zur Kunstgeschichte,*
pp. 156–293. Vischer placed this lengthy study at the center of his book. Weisbach, *'Und
alles ist zerstorben,'* pp. 200–01, recalled the impact of Vischer's essay upon his understand-
ing of Dürer's artistry. For Springer's criticism of Vischer, see Chapter 1 to the present
volume. Woldemar von Seidlitz, who had studied under Springer, published a compara-
tively favorable review of Vischer's 1886 book in "Litteraturbericht: Robert Vischer, *Studien
zur Kunstgeschichte,"* *Repertorium für Kunstwissenschaft* 11 (1888), pp. 179–83.

84. Vischer, "Albrecht Dürer," p. 215.

85. For Thausing and other early Viennese art historians, see Chapter 1, esp. notes 2 and 4.
Thausing published *Dürer. Geschichte seines Lebens und seiner Kunst* (Leipzig: E. A. Seemann,
1876); 2d ed., 2 vols. (Leipzig: E. A. Seemann, 1884). In the foreword to *Studien zur Kunst-
geschichte,* p. vii, Vischer stated that he had completed the Dürer essay five years earlier (i.e.,
in 1881), and that his polemic was addressed specifically to Thausing's interpretative stance
on Dürer.

86. Vischer, "Albrecht Dürer," for instance, pp. 157, 214, 223, 225, 250 (where he characterized
Dürer's "tief künstlerische Natur"); after mentioning the artist's theoretical work, p. 223,
he stated, p. 225: "wir müssen nun versuchen, dem persönlichen Wesen seiner Kunst etwas
näher zu kommen." At the beginning of his essay, Vischer, p. 157, asserted that the art
historian had a duty to investigate the artist's "geheime Eigenarten," or "innermost peculi-
arities," an idea that resonates with Vöge's aim to penetrate the "hidden" or "innermost
processes" and "secrets" ("Geheimnisse") of artistic production in twelfth-century
Chartres.

87. Ibid., pp. 232, 255.

88. The artist assumed something of the material with which he worked, and vice versa. See,
for instance, ibid., p. 234, where Vischer described Dürer's working of copper plates with
a metal stylus: "Die Bearbeitung der Metallfläche mit dem Stichel weckt in ihm eine quali-
tativ übereinstimmende Kraft gediegenster Verarbeitung. Mit eiserner Schärfe prägt und
modelt er die Formen durch, gräbt er sich ein in die Erscheinung und holt den strahlenden
Geist heraus. Der Reiz seiner Stiche . . . besteht zu gutem Theil darin, dass man das tech-
nische Instrument und sein Material, beide im dichten Kontakt ihrer Eigenschaften, unbe-
wusst durchfühlt. Das in ihnen enthaltene Künstlerthum gemahnt selber so gedrang und
schneidig wie Erz und Eisen, schlägt an die Erscheinung wie das Schwert auf den Schild,
wühlt sich in ihr Wesen ein wie der Stichel in die Platte. Stoff und Mittel, Ich und Welt
werden gleich scharf und prall." By extension, the artist developed an empathic relation-
ship with the objects/subjects he represented. See p. 250, where Vischer stressed Dürer's
Stoffsinnigkeit: "Ebenso stoffsinnig, wenn auch seltner und nicht in so charakteristischer
Art, verbindet sich seine tief künstlerische Natur mit Stoffen und Harnischen, beruhigt
sich in fügsamer Wolle, sattem, mildleuchtendem Sammt."

89. Waetzoldt, *Deutsche Kunsthistoriker,* vol. 2, pp. 137–38, esp. p. 137, for Vischer's conception
of a "'stoffliche Metamorphose' der künstlerischen Phantasie."

90. Like Dürer and his stylus, Vöge's masters "felt into" or empathized with their tools; see
Die Anfänge, p. 51, where Vöge characterized the youthful "life feeling" of the Chartres
sculptors as existing on the blades, or cutting edges, of their chisels ("das jugendliche
Lebensgefühl der Meister, das gewissermassen auf der Schneide ihres Meissels ist"). See

also p. 138, where Vöge celebrated the "Kunst des Meissels" and employed "Meissel" interchangeably with "Künstler": "Die oberen Parteien der seitlichen Tympanen . . . gehören ebenfalls dem gleichen Meissel." See also pp. 26, 235, 258, for his further visions of "der Meissel" and "die Meisselführung."

91. Ibid., p. 235: "Der 'Meister von Corbeil' ist feiner, vornehmer. Von grösserer Zartheit des Meissels, weiss er selbst einen Körper strengster tektonischer Bildung wie mit einer weichen samtenen Haut zu umkleiden; die Köpfe sind in der Feinheit ihrer Formen, in ihrer stillen Hoheit der unmittelbare Ausdruck seines künstlerischen Wesens."

92. Vöge, ibid., referred to the masters' "stilschöpferisches Vermögen" (p. 27), their "stilschöpferische Arbeit" (p. 52) and their "stilschöpferisches Gestalten" (p. 54).

93. Wölfflin, *Renaissance und Barock*, pp. 3–4 (cited in note 61 to the present chapter). No extended critical comparison of the language used by German-speaking pioneers of art history (i.e., individual terms, their philosophical or ideological sources and of the meanings assigned to them by different scholars) has been undertaken to date.

94. Wölfflin's dissertation, *Prolegomena zu einer Psychologie der Architektur* (Munich: Dr. C. Wolf und Sohn, 1886), reprinted in Heinrich Wölfflin, *Kleine Schriften (1886–1933)*, ed. Joseph Gantner (Basel: Schwabe, 1946), pp. 13–47, also bore the imprint of Robert Vischer. When outlining his arguments for the experience of architectural forms, Wölfflin referred, for instance, pp. 17–18, to Vischer's concepts of a bodily and intellectual *Miterleben* or *Mitfühlen*, citing specifically his *Über das optische Formgefühl*. Wölfflin also drew on other writings on empirical psychology, including those of Hermann Lotze (1817–81) and Wilhelm Wundt (1832–1920). Not surprisingly, certain of Wölfflin's ideas in his *Prolegomena* resonated with Vöge's *Die Anfänge*. See, for example, Wölfflin, p. 15: "Die Formen werden uns bedeutend dadurch allein, dass wir in ihnen den Ausdruck einer fühlenden Seele erkennen. Unwillkürlich beseelen wir jedes Ding. Das ist ein uralter Trieb des Menschen." Wölfflin's dissertation has recently been translated into English; see Heinrich Wölfflin, *Prolegomena to a Psychology of Architecture*, in *Empathy, Form, and Space*, pp. 149–90 (pp. 39–51 for the accompanying commentary).

95. Vöge, *Die Anfänge*, p. 329; here he cited Viollet-le-Duc's conception of the term.

96. Ibid., p. 276.

97. Ibid., p. 138.

98. Vischer, "Albrecht Dürer," pp. 244–45: "Wir glauben zu spüren, wie seine meisterliche Hand den Konturen folgt und im freien Hintasten auch die kleineren Abformen, Absätze, Höckerchen, Fältchen, die Schrunden, Narben und tausendfachen Spuren der Individualität und der Vergänglichkeit berührt. Wir fühlen ihren lebendigen Puls, ihre treuherzige Kraft."

99. Ibid., p. 245: "Wir hören die Feder auf dem guten alten Büttenpapier kritzeln. Es ist nicht zu sagen, wie persönlich und unmittelbar lebensnah seine Zeichnungen und Holzschnitte zu uns sprechen."

100. Vöge, *Die Anfänge*, p. 54: "Gewiss ist nichts interessanter, als zu diesen Künstlern in die Werkstatt zu treten, das Herauswachsen ihrer Gestalten aus der tektonischen Rohform zu belauschen." The empathic side of Vöge's investigation is also conveyed by his use of the verb "sich versenken" (to lose oneself, to immerse oneself in), as on p. 179: "man muss sich hier in die Bedingnisse jeder einzelnen Schöpfung versenken."

101. Warburg's notes from Lamprecht's course on "Grundzüge der deutschen Kulturentwickelung im Mittelalter" (winter semester 1887–88), esp. pp. 2, 6–7 (notes dated 3 and 5 November 1887), show that Lamprecht referred his students to the writings of Johann Friedrich Herbart (1776–1841) and Hermann Lotze on *Völkerpsychologie* and physiology. Herbart's *Lehrbuch zur Psychologie*, first published in 1816, had been issued in an updated

version that same year (*Lehrbuch zur Psychologie*, 3d ed., ed. G. Hartenstein [Hamburg: L. Voss, 1887]); Lotze's writings included *Geschichte der Aesthetik in Deutschland* (Munich: Cotta, 1868) and his influential *Mikrokosmos. Ideen zur Naturgeschichte und Geschichte der Menschheit. Versuch einer Anthropologie*, 3 vols. (Leipzig: Hirzel, 1856–64), issued in many later editions. (Lamprecht recommended the second volume, which dealt with "Der Mensch, Der Geist, Der Weltlauf.") Lamprecht also referred to the writings of Moritz Lazarus (1824–1903), an ethnopsychologist, who edited the *Zeitschrift für Völkerpsychologie und Sprachwissenschaft* between 1860 and 1890. Lazarus's publications included *Das Leben der Seele in Monographien über seine Erscheinungen und Gesetze* (Berlin: F. Dümmler, 1856), reissued in several later editions.

102. For instance, in letters sent to Clemen from Strasbourg in the late spring of 1890 and later (excerpts cited earlier). The specific handbooks and studies that Vöge read are discussed in my article "Male Bonding" (in preparation).

103. A letter sent to Goldschmidt from Florence on 21 November 1894 reveals that Vöge had been in contact with the Göttingen professor for some time regarding the *Habilitation*. Vöge told Goldschmidt that if Vischer were unable to approve it for the Göttingen faculty (as a letter from Vischer indicated might be the case), Georg Dehio in Strasbourg had asked if Vöge would submit it there: "Von anderen Seiten habe ich ja bereits viel Zustimmung erfahren, auch indirekt. Zum Beispiel Dehio hat geradezu, nach Lektüre meines Buches, geäussert, warum ich mich nicht in Strassburg habilitieren wolle." Vöge's *Habilitation* was in fact approved in Strasbourg in February 1895 (see Chapter 3). An earlier letter sent to Goldschmidt from Rome on 29 July 1894 indicates that Vöge had first made a preliminary inquiry regarding the *Habilitation* to August Schmarsow in Leipzig; a Leipzig *Habilitation* proved impossible, for according to university regulations the manuscript had to be "druckfertig" (ready to print) rather than already published. Vöge's *Die Anfänge* appeared in July 1894.

104. Vöge reported in his letter to Goldschmidt of 21 November that Vischer had another candidate for an *Habilitation* waiting in the wings: "Nun weiss ich allerdings, dass in Göttingen ein anderer, Vischer genehmer Bewerber, vor der Thür steht, er hat sich mir kurioser Weise selbst verraten!" Judging from Weisbach's portrayal of Vischer's personality and his polemical relations with other art historians in Germany (see note 73 to the present chapter for the reference), it seems likely that Vischer would not have welcomed an outside applicant not of his own choosing, for he felt shunned by the "official" practitioners of art history, including some of the professors with whom Vöge had studied.

105. Adolph von Hildebrand, *Das Problem der Form in der bildenden Kunst* (Strasbourg: J. Heitz, 1893). Vöge referred to Hildebrand's treatise in particular in Part II, Chapter 10 ("Technik und Stil in ihren Zusammenhängen," pp. 267–79), and in Part III ("Die Zusammenhänge mit der weiteren Entwicklung und die Bedeutung des Tektonischen in der französischen Plastik des Mittelalters," pp. 295–332). It is well known that Wölfflin too was influenced by the theories of Hildebrand, whom he knew personally. Wölfflin and Vöge appear to have learned quite different things from Hildebrand's treatise, however.

106. Deicher, "Produktionsanalyse und Stilkritik"; Robert Suckale, "Die Bamberger Domskulpturen. Technik, Blockbehandlung, Ansichtigkeit und die Einbeziehung des Betrachters," *Münchner Jahrbuch der bildenden Kunst*, 3d ser., vol. 38 (1987), pp. 27–82, esp. pp. 27–28, for his discussion of Vöge's book. Suckale took several of Vöge's technical observations, such as the mode of *Blockbehandlung* (treatment of the block) at Chartres, as a point of departure for an examination of sculptural technique and practice at Bamberg Cathedral.

107. Deicher, "Produktionsanalyse," esp. pp. 71–74.

108. The notion that artistry resides in the processes of execution had also been explored in

the writings of the art critic and polemicist Conrad Fiedler (1841–95), in essays such as "Über den Ursprung der künstlerischen Tätigkeit" ("On the Origins of Artistic Creativity") of 1887, reprinted in Fiedler, *Schriften zur Kunst*, vol. 1, 2d ed. (Munich: W. Fink, 1991), pp. 111–220. Fiedler's philosophical writings on the intellectual origins, processes and ends of art production arose, in turn, from his close association with contemporary artists such as Hans von Marées and Adolph von Hildebrand.

109. For instance, Vöge, *Die Anfänge*, p. xix: "Ein ausgesprochener Sinn für dekorative Wirkung redet aus diesen Kompositionen der Frühzeit; ein Drang nach Einheitlichkeit und Unterordnung massregelt den Stil des Figürlichen; und diese ciselierende Feinheit der Arbeit zeugt von der grossen Begabung des französischen Volkes für das Kunstgewerbe"; p. 52: "Da sind die Gewänder mit feingemusterten Bordüren gesäumt, die Haare der Frauen kunstvoll wie von weiblicher Hand geflochten, der Schmuck, die Verschnürungen wetteifern in liebevoller Durchbildung mit den Erzeugnissen des Kunstgewerbes selbst." Sauerländer, "Kleider machen Leute," discussed the impact of the arts-and-crafts sensibility upon scholarly investigations of medieval sculpture at the turn of the century with some reference to Vöge. For the contemporary polemics in both France and Germany concerning the role and value of the applied arts (vis-à-vis mechanical processes of production), see Debora Silverman, *Art Nouveau in Fin-de-Siècle France: Politics, Psychology, Style* (Berkeley and Los Angeles: Univ. of California Press, 1989), and Nancy J. Troy, *Modernism and the Decorative Arts in France: Art Nouveau and Le Corbusier* (New Haven: Yale Univ. Press, 1991).

110. Richard Muther, *Geschichte der Malerei im XIX. Jahrhundert*, 3 vols. (Munich: G. Hirth, 1893–94); mentioned in a letter to Goldschmidt written on 2 May 1893 from Hanover. Even a superficial comparison between the turn-of-the-century writings of Muther and Julius Meier-Graefe, among others, and the contemporary discourse on medieval art reveals that the language used to describe medieval and modern masters was often interchangeable. For this subject, see also my article "The Naumburg Master: A Chapter in the Development of Medieval Art History," *Gazette des beaux-arts*, 6th per., 122 (1993), pp. 109–22.

111. Vöge mentioned attending the Salon in a postcard to Goldschmidt mailed on 3 September 1892 from Paris. Manet and the other artists were discussed in a letter of 5 November 1893 from Aix. See Deicher's discussion of this letter, "Produktionsanalyse und Stilkritik," p. 71. In *Die Anfänge*, p. xvii, Vöge lauded the "wealth of French artistic life" in the Middle Ages ("diese Fülle künstlerischen Lebens ... in Frankreich"); this statement was probably influenced by the vitality of French artistic life at the time he was writing.

112. Letter to Goldschmidt written on 27 November 1893 from Paris.

113. Goldschmidt, for instance, was a lifelong friend of the painter Max Liebermann and also of Edvard Munch. There are countless other examples of friendships between medievalists and practicing artists (in Vöge's and Goldschmidt's circle, also Paul Clemen, whose many artist friends included Auguste Rodin) and, especially after ca. 1906 or 1907, of medievalists who became modernists or worked simultaneously on modern art (for example, Wilhelm Worringer, Richard Hamann and Goldschmidt's student Eckhart von Sydow). For links between the study of medieval and contemporary art in the 1920s, see Chapter 5. See also Madeline H. Caviness, "Broadening the Definitions of 'Art': The Reception of Medieval Works in the Context of Post-Impressionist Movements," *Hermeneutics and Medieval Culture*, ed. Patrick J. Gallacher and Helen Damico (Albany: State Univ. of New York Press, 1989), pp. 259–82.

114. See, for instance, p. 47 ("der jugendliche Genius der Ile-de-France"); p. 51 ("das jugendliche Lebensgefühl der Meister"); p. 52 ("Alles vereinigt sich hier, diese Schöpfung mit dem Reize des Jugendlichen und Originalen zu umkleiden! Sprach nicht junger Wagemut

aus der künstlerischen Komposition? und wie jugendfrisch ist nicht die Technik. . . . Ja, wie jugendlich ist nicht der Ernst stilschöpferischer Arbeit").

115. See, for instance, the recollections of Panofsky, "Wilhelm Vöge," esp. pp. x–xi, xx–xxii; Heise, *Wilhelm Vöge zum Gedächtnis*, pp. 6, 8–13, 18; Hans Butzmann, "Erinnerung an Wilhelm Vöge," *Zeitschrift für Kunstwissenschaft* 12 (1958), pp. 211–18. Vöge's creative nature is also evident in his surviving correspondence.

116. This topic is discussed in my article "Male Bonding," where I also consider the communicatory structure of Vöge's language. For the latter, see also Panofsky, "Wilhelm Vöge," pp. x, xvi; and most recently, the remarks of Karen Michels in "Bemerkungen zu Panofskys Sprache," *Erwin Panofsky. Beiträge des Symposions Hamburg 1992*, ed. Bruno Reudenbach (Berlin: Akademie Verlag, 1994), p. 63.

117. For instance, in a postcard to Goldschmidt from Hanover on 8 June 1893: "Die Arbeit rundet sich, ich gehe täglich um dieselbe herum, sie von allen Seiten betrachtend, betastend, Hand an sie legend"; a letter to Goldschmidt from Toulouse, 19 November 1893: "ich strebe mit Macht nach Paris zurück, endlich den Guss zu vollenden."

118. Vöge, like other educated persons of his generation, was steeped in the German literary classics. In his correspondence he made frequent references to the writings of authors such as Goethe, Schiller and Jean Paul (Johann Paul Friedrich Richter).

119. My translation after Vöge, *Die Anfänge*, pp. 51–52:

Und diese Künstler besassen ein persönliches Verhältnis zur Natur! sie führen den Gebilden der Tradition neues Blut zu.

Wo leuchtete das wohl heller auf als in den Köpfen! Die schematisch abgeteilten Haarsträhnen sind zu welligen fliessenden Lockenmassen geworden, Haar und Bart verloren das Klebende, Perrückenhafte, die Gesichter scheinen gleichsam die Maske abzulegen . . . es ist nicht das Porträthafte, das Physiognomische, was hier neu ist, sondern die lebensvolle typische Schönheit, das Verständnis für das Gesetzmässige lebendiger Form; das jugendliche Lebensgefühl der Meister, das gewissermassen auf der Schneide ihres Meissels ist. Wie hat sich nicht der Ausdruck dieser Köpfe unter ihren Händen verändert! An die Stelle des Greisenhaftmürrischen, des Tiefsinnig-zerstreuten, des Gewaltsam-gesammelten, tritt das Kraftvoll-gespannte männlicher Energie, das Untadelhafte männlicher Schönheit, das Lachende der Jugend.

Die Körper bezeugen uns ein Gleiches! Trotz der tektonischen Gebundenheit der Formen ist keine Gestalt auffällig verkrüppelt oder zu kurz gekommen, kein Glied in der Art verzeichnet, wie wir das hier und da in Arles bemerken!

Clearly, much of the rhythm of the original text is lost in translation.

120. See, for instance, ibid., pp. 62–63: "Wir haben eingangs ausgeführt, wie der Künstler durch die perspectivische Gruppierung der Statuen an den Gewänden eine künstliche Hebung des Augenpunktes erreicht. Erst indem er das gleiche auch am Tympanon durchführt, indem er uns den thronenden Christus sozusagen in Obersicht giebt, wird die Illusion eine vollkommene! Sollte diese einheitliche, wie es scheint, so fein berechnete Wirkung vom Künstler nicht vorausgesehen sein, bei dem wir auf so viel künstlerische Weisheit im einzelnen stossen? Wie fein ist hier nicht das Gefühl für die Reinheit des architektonischen Umrisses entwickelt, man sehe, wie sich die Gestalten, die Flügel demselben einfügen, wie sehr erscheint hier das Ganze als das Mass für Anordnung und Grösse der Teile! Der Geist, der den Künstler bei der Schöpfung seiner Statuen leitete, spricht auch aus dieser Reliefgruppe!"

121. Postcard mailed to Goldschmidt from Paris on 24 March 1894: "Ich bin mit den letzten Partien meiner Arbeit gottlob einigermassen zufrieden und nenne sie meinen kleinen Laokoon."

122. It is also clear from the context that Vöge saw himself countering Viollet-le-Duc, just as Lessing had countered Winckelmann. See notes 32 and 35 to this chapter.

123. Vöge, *Die Anfänge*, p. 70, employed this term.

Chapter 3. Thematic and Methodological Range in the Scholarship of Goldschmidt and Vöge to ca. 1905

1. Vöge's trip to Istanbul was occasioned by his research for a catalogue of ivories for the Berlin Museums. Following his premature retirement from the University of Freiburg on 20 June 1916 (from which he had, since his breakdown, been on leave during the summer semester of 1915 and the winter semester of 1915–16; Personalakten, Universitätsarchiv Freiburg im Breisgau, Bestand B24 [Wilhelm Vöge]), he rarely left Ballenstedt, the site of his self-imposed exile (compare Panofsky, "Wilhelm Vöge," pp. xxvii–xxxii). Materials in Vöge's personnel file at the Universitätsarchiv in Freiburg (as in the preceding citation, specifically the "Fragebogen zur Durchführung des Gesetzes zur Wiederherstellung des Berufsbeamtentums vom 7. April 1933") show, however, that there was one lengthy exception. Between 8 May 1933 and 31 August 1936 he embarked on a trip to southern, central and western Germany, where he conducted research for several articles, as well as for his final opus on Jörg Syrlin. He did not return to Ballenstedt during this three-year period.

2. Goldschmidt discussed these and other travels in his memoirs. See Roosen-Runge-Mollwo, *Goldschmidt. Lebenserinnerungen*, esp. pp. 106–110, 345–48 (Scandinavia), 137–58 (Turkey, Greece, Russia), 201–35 (Spain), 226–334, 351–85 (United States).

3. For instance, in a letter written in Rome on 29 July 1894, Vöge advised Goldschmidt to discourage his student Arthur Haseloff (discussed later in this chapter) from a career in art history, since his limited finances would preclude extensive travel, as had been the case with Springer: "Ohne die Möglichkeit, dauernd in Kontakt mit den Kunstwerken zu bleiben, ist ja das Studium völlig aussichtslos. Die Zeit des grünen Tisches, ich meine die Ära Springer, ist ein für alle Mal vorbei, und wehe dem, der noch nach den alten Rezepten verfährt. Wenn der Mann [Haseloff] reisen könnte, so wäre ja in Frankreich genug zu thun – aber ohne das ist alles eitel." Similarly, in a letter to Goldschmidt written on 25 October 1894 in Venice, Vöge criticized Goldschmidt's colleague Herman Grimm (see also the following note): "Für mehrere Artikel habe ich das Material. Aber wer möchte in Venedig über Michelangelo schreiben – geschweige denn hinter dem Berliner Ofen wie Ihr Kollege Grimm!"

4. Roosen-Runge-Mollwo, *Goldschmidt. Lebenserinnerungen*, pp. 93–95, 97–98.

5. Ibid., pp. 78–87, esp. p. 83, for Goldschmidt's report of his travels in Italy and Sicily.

6. Adolph Goldschmidt, "Die Favara des Königs Roger von Sizilien," *Jahrbuch der Königlich Preussischen Kunstsammlungen* 16 (1895), pp. 199–215; "Die normannischen Königspaläste in Palermo," *Zeitschrift für Bauwesen* 48 (1898), pp. 451–590.

7. Wolfgang Krönig, "Anhang V. Zum Sizilien-Aufenthalt 1889–1890," in Roosen-Runge-Mollwo, *Goldschmidt. Lebenserinnerungen*, pp. 445–51, with some reproductions of Goldschmidt's architectural drawings (e.g., plans, elevations).

8. Adolph Goldschmidt, "Der Utrechtpsalter," *Repertorium für Kunstwissenschaft* 15 (1892), pp. 156–69.

9. See Goldschmidt's inaugural address to the Preussische Akademie der Wissenschaften upon his election to membership in 1914: "Antrittsrede des Hrn. Goldschmidt," *Sitzungsberichte der Königlichen Preussischen Akademie der Wissenschaften*, Part II (1914), pp. 753–56, esp. p. 755. Springer was largely responsible for introducing the Utrecht Psalter to the

broader scholarly community in his 1880 *Die Psalter-Illustration im frühen Mittelalter mit besonderer Rücksicht auf den Utrechtpsalter* (see Chapter 1).

10. A lengthy letter dated 5 July 1892 (Paris) shows that Vöge researched the Psalter of Charles the Bald at the Bibliothèque Nationale for Goldschmidt's article.

11. Goldschmidt, "Der Utrechtpsalter," p. 156, notes 1–3, listed the earlier bibliography on the Psalter.

12. See, for instance, ibid., p. 157, where Goldschmidt compared small, dynamic figures in the gables of the canon tables of the Ebbo Gospels with figures in the Utrecht Psalter: "Alle gleichen den mannigfach bewegten Gestalten des Utrechtpsalters. Dieselben vorgestreckten Köpfe mit niedriger Stirn, hochgezogenen Augenbrauen und in der Vorderansicht breitem, im Profil meist spitz vorgestrecktem Kinn, dieselben gespreizten Handbewegungen, dieselben unten sehr spitz zulaufenden Beine mit theilweise übertriebener Musculatur und Waden, dieselbe Lebendigkeit in den Stellungen mit Verkürzungen der Glieder. Die Kleidung ist dieselbe; in der zweiten Kanontafel tragen die Männer den im Utrechtpsalter so beliebten kurzen, unten geschlitzten Rock oder Schurz, dessen drei Theile in Form von spitzen Zipfeln zur Seite und zwischen den Beinen herabfallen."

13. Ibid., pp. 159–65. My purpose here is to outline Goldschmidt's critical procedure rather than to determine the degree to which specific aspects of his hypotheses were correct or incorrect.

14. Ibid., pp. 165–69.

15. Ibid., p. 169.

16. For Goldschmidt's profession of his desire to study the natural sciences, see Roosen-Runge-Mollwo, *Goldschmidt. Lebenserinnerungen*, p. 30, esp. p. 41. However, he was the eldest son, and his family expected him to become a banker like his father. Following his schooling at the *Realgymnasium* in Hamburg, Goldschmidt spent two years in his father's office and was then sent to London for a year of training in international banking (ibid., pp. 41–46). He displayed little aptitude for a banking career, and in 1884 his family permitted him to enroll at the University of Jena with the goal of studying art history. For his visit to Morelli, see Chapter 1, note 46. Goldschmidt, "Antrittsrede," p. 753, drew specific parallels between study of the natural sciences and art history. For an insightful view into the cultured circumstances of Goldschmidt's youth, see Marie Roosen-Runge-Mollwo, "Ein Jugendtagebüchlein des Hamburger Kunsthistorikers Adolph Goldschmidt (1863–1944) verfasst vom 28. März bis 11. Mai 1880," *Hamburgische Geschichts- und Heimatblätter* 12, nos. 8–9 (1991), pp. 177–95.

17. This was also true of his dissertation.

18. Goldschmidt, "Antrittsrede" (see note 9 to this chapter), and the accompanying response, "Erwiderung des Sekretärs Hrn. Diels," *Sitzungsberichte der Königlichen Preussischen Akademie der Wissenschaften*, Part II (1914), pp. 756–58; "Kunstgeschichte," *Aus fünfzig Jahren deutscher Wissenschaft. Die Entwicklung ihrer Fachgebiete in Einzeldarstellungen*, ed. Gustav Abb (Berlin: De Gruyter, 1930), pp. 192–97.

19. Goldschmidt, "Antrittsrede," pp. 754–55. He acknowledged that there were no fixed standards for the kind of critically trained eye he advocated and warned against the dangers of dilettantism. Methodologically, Goldschmidt's approach to the sorting and classification of manuscripts was closely related to the reconstructive scientific-philological method espoused earlier by Springer (see Chapter 1).

20. See esp. Goldschmidt, "Kunstgeschichte," pp. 192–93. In acknowledging various interpretative perspectives from which a work could be approached, he stated: "Hinter all diesen verschiedenen und wechselnden Arten der Behandlung aber liegt eine Konstante. . . . Das ist die Präparierung des Materials, die kritische Sonderung der Objekte, die das Substrat der kunstgeschichtlichen Erörterung bildet. Es ist die Aufspürung der Dinge selbst,

die Feststellung ihrer Personalien, das heisst der Umstände, unter denen sie entstanden, wo und wann sie geschaffen wurden. Erst auf diesen Voraussetzungen können die übrigen Schlussfolgerungen Glaubhaftigkeit gewinnen."

21. Authoritative certitude was not Goldschmidt's primary aim. For instance, in the first volume of his *Die Elfenbeinskulpturen*, published in 1914, he expressed reservations about his interpretations of visual evidence and stressed that his publication would raise more questions than it would solve. See *Die Elfenbeinskulpturen*, vol. 1, pp. 2–3.

22. For Grimm, see Waetzoldt, *Deutsche Kunsthistoriker*, vol. 2, pp. 214–39; Kultermann, *Geschichte der Kunstgeschichte*, pp. 122–24. Grimm's scholarship bore the deep imprint of German Romanticism (his father Wilhelm and his uncle Jakob were the Brothers Grimm), and he was as much a poet or literary figure as an art historian. His writings included *Das Leben Michelangelos*, 2 vols. (Hanover: C. Rümpler, 1860–63), *Das Leben Raphaels* (Berlin: W. Hertz, 1872) and a biography of Goethe, published originally as *Goethe. Vorlesungen gehalten an der Königlichen Universität zu Berlin*, 2 vols. (Berlin: W. Beck, 1877). The publications of Grimm's student Frey included *Die Loggia dei Lanzi zu Florenz. Eine quellenkritische Untersuchung* (Berlin: W. Hertz, 1885) and editions of Michelangelo's letters and poetry, *Die Dichtungen des Michelagniolo Buonarroti* (Berlin: G. Grote, 1897) and *Sammlung ausgewählter Briefe an Michelagniolo Buonarroti. Nach den Originalen des Archivio Buonarroti* (Berlin: K. Sigismund, 1899).

23. Courses in medieval architecture were less unusual. During the 1880s, for instance, the architectural historian Georg Dehio began his career at the University of Königsberg; he succeeded Janitschek in Strasbourg in 1892 (see note 63 to this chapter).

24. For Vöge, see the discussion later in this chapter. Clemen was accepted for the *Habilitation* at the University of Bonn in 1893. He lectured there until his appointment in 1899 to the Kunstakademie in Düsseldorf. In late 1901 he returned to Bonn as Justi's successor; as *Ordinarius* he directed the Bonn Kunsthistorisches Seminar until his retirement in 1935. In his capacity as first Provincial Conservator of the Rhineland (a position he held concurrently with his university appointments between 1893 and 1911), he was responsible for drawing up a series of important inventories of historic monuments in the region (*Die Kunstdenkmäler der Rheinprovinz*), many of which dated from the Middle Ages. His teaching and publications during the 1890s and later tended to concentrate on medieval painting, sculpture and architecture in Germany, though he published on a number of other subjects; he also organized an important exhibition of German art in Düsseldorf in 1902. His work, like Goldschmidt's, displayed a careful balance between visual evidence (i.e., scrutiny of the object) and historical research, reflecting his studies with Springer, Justi and Lamprecht, as well as the nature of the tasks he was charged with in the early years of his career. Inventories of artistic monuments encouraged a factual approach rather than abstract speculation or theorizing. Clemen achieved international prominence; he taught, for instance, at Harvard University during the academic year 1907–08 (see Chapter 4). See *Paul Clemen, 1866–1947. Erster Provinzialkonservator der Rheinprovinz* and *Paul Clemen. Zur 125. Wiederkehr seines Geburtstages*, pp. 423–43, for a complete list of his publications.

25. Roosen-Runge-Mollwo, *Goldschmidt. Lebenserinnerungen*, pp. 93–95.

26. Adolph Goldschmidt, "Michelangelos Malereien in der Sixtinischen Kapelle," *Kunstgeschichtliche Gesellschaft Berlin, Sitzungsberichte* (1897)(2), pp. 7–9; "Die Kunstsprache Michelangelos," *Das Museum* 4 (1899–1900), pp. 33–36.

27. In a letter written to Goldschmidt on 20 November 1892 from Paris (postmarked in Paris on 2 December), Vöge reported that he had learned via his friend Ernst Burmeister that Goldschmidt was doing research on Michelangelo. In a postcard of 16 December he drew Goldschmidt's attention to an article by Eugène Müntz that had just appeared: "Michel-Ange," *Revue des deux mondes* 114, 3d per., 62d yr. (15 December 1892), pp. 875–903.

28. Adolph Goldschmidt, *Der Albanipsalter in Hildesheim und seine Beziehung zur symbolischen Kirchensculptur des XII. Jahrhunderts.* In his memoirs, Goldschmidt portrayed the casual circumstances in which he carried out his study of the twelfth-century manuscript, which belonged to the Church of St. Godehard in Hildesheim. The chaplain, who kept the manuscript in his apartment, allowed Goldschmidt to examine it in his hotel room under the supervision of a subordinate, who made himself at home in Goldschmidt's room and occupied himself by smoking Goldschmidt's cigarettes. Goldschmidt was permitted to trace many of the initials; these tracings later served as the basis for illustrations in his book. See Roosen-Runge-Mollwo, *Goldschmidt. Lebenserinnerungen,* pp. 89–92.

29. Wilhelm Vöge, "Litteraturbericht: *Der Albani-Psalter in Hildesheim* von Adolph Goldschmidt," *Repertorium für Kunstwissenschaft* 19 (1896), pp. 204–11. In his detailed review, he praised Goldschmidt's study, terming it, p. 204, "a small masterpiece of this genre of research" ("ein kleines Meisterstück dieser Art Forschung"). He not only drew attention to the many new observations about the Psalter yielded by Goldschmidt's approach, but also situated the importance of his colleague's contributions within the study of manuscripts generally.

30. Goldschmidt, *Der Albanipsalter,* pp. 68–88, discussed the iconography and meaning of the decorated initials in relation to such large-scale monuments as the sculpted pier in the crypt of Freising Cathedral, capitals at the Cathedral of Basel, and the reliefs on the portal of the Church of St. Jacob in Regensburg. Vöge, "*Der Albani-Psalter* von Adolph Goldschmidt," pp. 209–11, demonstrated that Goldschmidt's arguments could also be extended to twelfth-century sculpture in France.

31. For instance, Adolph Goldschmidt, "Die Gregorsmesse in der Marienkirche zu Lübeck," *Zeitschrift für christliche Kunst* 9 (1896), cols. 225–32; "Anfänge des Genrebildes," *Das Museum* 2 (1898–99), pp. 33–36; "Rode und Notke, zwei Lübecker Maler des 15. Jahrhunderts," *Zeitschrift für bildende Kunst* 36, N.F. 12 (1901), pp. 31–39, 55–60; "Willem Buytewech," *Jahrbuch der Königlich Preussischen Kunstsammlungen* 23 (1902), pp. 100–17. See Goldschmidt's complete bibliography in Roosen-Runge-Mollwo, *Goldschmidt. Lebenserinnerungen,* pp. 465–79.

32. See Roosen-Runge-Mollwo, *Goldschmidt. Lebenserinnerungen,* pp. 465–79.

33. Adolph Goldschmidt, "Die mittelalterlichen Bronzegrabmäler im Magdeburger Dom," *Kunstgeschichtliche Gesellschaft Berlin, Sitzungsberichte* (1897)(8), pp. 33–34; "Französische Einflüsse in der frühgotischen Skulptur Sachsens," *Jahrbuch der Königlich Preussischen Kunstsammlungen* 20 (1899), pp. 285–300; "Die Stilentwickelung der romanischen Skulptur in Sachsen," *Jahrbuch der Königlich Preussischen Kunstsammlungen* 21 (1900), pp. 225–41; "Die Freiberger Goldene Pforte," *Jahrbuch der Königlich Preussischen Kunstsammlungen* 23 (1902), pp. 20–33.

34. Klaus Niehr, "Anhang VI. Adolph Goldschmidts Forschungen zur niedersächsischen Kunst des hohen Mittelalters," in Roosen-Runge-Mollwo, *Goldschmidt. Lebenserinnerungen,* pp. 452–56; in greater detail in Niehr, *Die mitteldeutsche Skulptur der ersten Hälfte des 13. Jahrhunderts* (Weinheim: VCH, Acta Humaniora, 1992), esp. pp. 24–40.

35. As Niehr, "Adolph Goldschmidts Forschungen," p. 455, has pointed out, Goldschmidt's reliance on an impartial stylistic method (rather than on aesthetic judgment) allowed him to recognize the links between Magdeburg and early thirteenth-century French sites, despite the "high" quality of the French models and the "low" quality of the sculpture at Magdeburg. Roosen-Runge-Mollwo, *Goldschmidt. Lebenserinnerungen,* p. 454, has reproduced Goldschmidt's portal reconstruction.

36. Goldschmidt's recognition during the 1890s of the far-reaching impact of Byzantium upon medieval monuments in Germany and in western Europe generally was to have important consequences for his own work and that of his students. By contrast, earlier German-

speaking scholars, including Springer, had tended to minimize the role of Byzantium in their explanations of the iconographic and formal character of western European monuments.

37. Adolph Goldschmidt, *Studien zur Geschichte der sächsischen Skulptur in der Übergangszeit vom romanischen zum gotischen Stil* (Berlin: G. Grote, 1902).

38. Goldschmidt drew attention to the distorted views of medieval sculpture that resulted from patriotic interpretative stances in his review of Max Hasak's *Geschichte der deutschen Bildhauerkunst im 13. Jahrhundert* (Berlin: E. Wasmuth, 1899); this review appeared in *Kunstgeschichtliche Gesellschaft Berlin, Sitzungsberichte* (1900)(6), pp. 28–29. See also my "Gothic Sculpture as a Locus for the Polemics of National Identity" and "The Naumburg Master: A Chapter in the Development of Medieval Art History."

39. Adolph Goldschmidt, *Die Kirchenthür des Heiligen Ambrosius in Mailand. Ein Denkmal frühchristlicher Skulptur* (Strasbourg: J. Heitz, 1902).

40. Adolph Goldschmidt, "Drei Elfenbein-Madonnen." He identified the group of ivories he later termed the "Ada Group" in an article of 1905, "Elfenbeinreliefs aus der Zeit Karls des Grossen," *Jahrbuch der Königlich Preussischen Kunstsammlungen* 26 (1905), pp. 47–67. For his further work on ivory carvings, see my article, "Adolph Goldschmidt, 1863–1944," and Weitzmann, *Adolph Goldschmidt und die Berliner Kunstgeschichte.* Goldschmidt became associate professor (*Extraordinarius*) at the University of Berlin in 1903 and was summoned to Halle as full professor (*Ordinarius*) the following year. See Heinz Mode, "Historiker und Kenner der Kunst, Adolph Goldschmidt (Halle: 1904–1912)," *450 Jahre Martin-Luther-Universität Halle-Wittenberg*, vol. 2 (Halle: Martin-Luther-Universität, 1953), pp. 325–28; Roosen-Runge-Mollwo, *Goldschmidt. Lebenserinnerungen*, pp. 119–24. In 1903, August Schmarsow, *Ordinarius* for art history at the University of Leipzig, proposed Goldschmidt (as well as Vöge) as candidates for an associate professorship at Leipzig; neither received the position. See ibid., p. 120, n. 140. The matter is also mentioned in Vöge's letters to Goldschmidt.

41. The listing of Goldschmidt's courses at the University of Berlin (*Verzeichniss der Vorlesungen, welche auf der Friedrich-Wilhelms-Universität zu Berlin . . . gehalten werden*) between the summer semester of 1893 (his first teaching semester) and the summer semester of 1904 (after which he moved to Halle) shows that in addition to conducting yearly *Kunsthistorische Übungen* (tutorials on unspecified topics, mainly for beginning students), he taught the following seminars, many of which focused on the Berlin collections: "Deutsche Skulptur und Malerei im Mittelalter" (summer 1893); "Geschichte der niederländischen Malerei mit Benutzung des Königlichen Museums" (winter 1893–94); "Geschichte der italienischen Renaissancemalerei mit Demonstrationen im Königlichen Museum" (summer 1894); "Geschichte der Skulptur und Malerei in Deutschland im 15. und 16. Jahrhundert" (winter 1894–95); "Die holländische Malerei des 16. und 17. Jahrhunderts mit Demonstrationen im Königlichen Museum" (summer 1895); "Geschichte der deutschen Plastik im Mittelalter" (winter 1895–96); "Italienische Barockkunst" (summer 1896); "Italienische Barockkunst" (winter 1896–97); "Die deutsche Skulptur im Mittelalter" (summer 1897); "Roms Kunstepochen im Mittelalter und in der Renaissance" [open lecture], "Geschichte der niederländischen Malerei des 17. Jahrhunderts in Übungen im Königlichen Museum" (winter 1897–98); "Dürer und Holbein" (summer 1898); "Geschichte der deutschen Kunst zur Zeit der Gotik" (winter 1898–99); "Geschichte der niederländischen Malerei des 15., 16. und 17. Jahrhunderts mit Demonstrationen im Königlichen Museum" (summer 1899); "Geschichte der italienischen Skulptur von Niccolò Pisano bis Michelangelo" (winter 1899–1900); "Geschichte der bildenden Künste in Deutschland vom 9. bis 13. Jahrhundert" (summer 1900); "Geschichte der belgischen und holländischen Malerei des 17. Jahrhunderts mit Demonstrationen im Museum" (summer 1901); "Kunstentwicklung Italiens

im Mittelalter," "Kunsthistorische Übungen über Ornamentik" [tutorial] (winter 1901–
02); "Die Barockkunst in Italien" (summer 1902); "Die bildenden Künste in Italien wäh-
rend des Mittelalters," "Rembrandt" [lecture] (winter 1902–03); "Niederländische Malerei
des 16. und 17. Jahrhunderts" (summer 1903); "Geschichte der deutschen Kunst von den
Anfängen bis in das 14. Jahrhundert" (winter 1903–04); "Die Bildhauer der italienischen
Renaissance" [open lecture], "Italienische Barockkunst vom 16. bis 18. Jahrhundert" (sum-
mer 1904). I wish to thank Dr. Marie Roosen-Runge-Mollwo, who kindly provided me
with this information during a research trip to the Federal Republic of Germany in the
summer of 1992.

42. Hans Jantzen, "Adolph Goldschmidt," in *Adolph Goldschmidt zum Gedächtnis*, ed. Carl
Georg Heise, pp. 7–13, esp. p. 9. This collection of essays also includes valuable reports on
Goldschmidt's teaching by Otto von Taube and Heise (see notes 44 and 45 to the present
chapter) as well as Panofsky ("Goldschmidts Humor," pp. 25–32). Other accounts of
Goldschmidt's teaching include Alfred Neumeyer, "Four Art Historians Remembered:
Wölfflin, Goldschmidt, Warburg, Berenson," *Art Journal* 31(1) (1971), pp. 33–36, and
Weitzmann, *Adolph Goldschmidt und die Berliner Kunstgeschichte*. See also Weitzmann's re-
cently pubished memoirs *Sailing with Byzantium from Europe to America: The Memoirs of an
Art Historian* (Munich: Editio Maris, 1994), esp. pp. 45–57.

43. Jantzen, "Adolph Goldschmidt," p. 9, cited Goldschmidt as follows: "Denken Sie, sie seien
eine Fliege und kröchen quer über die Figur hinweg. Beschreiben Sie den Weg dieser
Fliege über alle Höhen und Tiefen des Gewandes!"

44. See esp. Otto von Taube, "Erinnerungen an Adolph Goldschmidt," *Adolph Goldschmidt zum
Gedächtnis*, pp. 20–24, esp. pp. 21–22, where he decribed Goldschmidt's frequent hosting of
students for Sunday lunch: "Bei diesen Gelegenheiten gab er sich ganz frei; da legte er
seiner musischen Natur keine Fesseln an, da redete er von Meistern und Meisterwerken
mit einer Wärme, die wir in seinen Vorlesungen manchmal vermissten. Ein Beispiel: ich
hatte ihn einmal bei Tisch ganz wundervoll von der Grösse Rembrandts reden hören. Im
Kolleg aber hörten wir nur, Rembrandt sei Schüler von dem und dem, und Meister von
dem und dem gewesen und habe drei Stilperioden durchgemacht. . . . Nur einmal – nur
einmal – begann Goldschmidt in einem Kolleg zu uns von Rembrandts Einzigkeit und
Grösse zu reden, unterbrach sich aber jählings und sagte: 'Es bleibe jedem überlassen,
sich mit Rembrandt auseinanderzusetzen. Hierher gehört es nicht, das gehört nicht in die
Wissenschaft.'" See also von Taube's descriptions of his teacher in idem, *Stationen auf dem
Wege. Erinnerungen an meine Werdezeit vor 1914* (Heidelberg: Lothar Stiehm, 1969), esp. pp.
150–58, 163, 184.

45. Ibid. See also Heise, "Goldschmidt als Lehrer und Freund," *Adolph Goldschmidt zum Ge-
dächtnis*, pp. 33–37, esp. p. 35–36. In addition to the visual arts (and his own artistic skills),
Goldschmidt had a deeply cultivated interest in music and was an accomplished pianist.
See, for example, Heise, ibid., and Roosen-Runge-Mollwo, "Ein Jugendtagebüchlein des
Hamburger Kunsthistorikers Adolph Goldschmidt." Goldschmidt also made numerous
references to his musical interests in his memoirs.

46. Weisbach, *'Und alles ist zerstorben,'* pp. 209–10: "Mit seiner ganz auf vergleichender stilkrit-
ischer Betrachtung ruhenden Methode, die er zu vollendeter Meisterschaft führte, ver-
stand er es ausgezeichnet, das Auge zu schulen, die feinsten Zusammenhänge, Übergänge
und Unterschiede auf Grund bestimmter Kriterien aufzuweisen und daraus Folgerungen
für entwicklungsgeschichtliche Fragen abzuleiten. War auf eine genetische Geschichtsbe-
trachtung und immanente Kunstentwicklung alles bei ihm eingestellt und hatte ich ihm
für diesen Zweig der Ausbildung viel zu verdanken, so stand doch für mich fest, dass es
eine meiner Veranlagung entsprechende Aufgabe sei, die künstlerischen Phänomene in
einem grösseren Zusammenhang von Kultur und geistigem Leben zu deuten."

47. Roosen-Runge-Mollwo, *Goldschmidt. Lebenserinnerungen,* esp. pp. 95, 132–36 (Liebermann); pp. 104–05 (Munch). Goldschmidt was a regular visitor at Liebermann's home and accompanied the artist on sketching trips; in 1912 Liebermann executed a portrait (etching) of his friend, which is reproduced in Roosen-Runge-Mollwo, ibid., p. 136. Goldschmidt delivered the commemorative speech at Liebermann's funeral in 1935; his address was not published until 1954. See Adolph Goldschmidt, *Gedenkrede auf Max Liebermann 1935,* foreword by Carl Georg Heise (Hamburg: Kunstverein Hamburg und Niedersächsische Landesgalerie Hannover, 1954). During the 1890s Munch frequented Goldschmidt's *Stammtisch* (favorite restaurant) in Berlin. The two men remained on friendly terms in later years. During several trips to Scandinavia, Goldschmidt visited Munch; he also saw the artist on occasions when Munch traveled back to Berlin.

48. Roosen-Runge-Mollwo, *Goldschmidt. Lebenserinnerungen,* pp. 92–124. The poets Rainer Maria Rilke (1875–1926) and Christian Morgenstern (1871–1914) were among Goldschmidt's students in Berlin during the 1890s. See ibid., pp. 101–03.

49. Ibid., pp. 106–10, 346–47, for Goldschmidt's account of his dealings with these and other Scandinavian scholars, including the Finnish art historian J. J. Tikkanen (1857–1930), who shared many of Goldschmidt's manuscript interests. For Tikkanen, see Sixten Ringbom, *Art History in Finland before 1920* (Helsinki: Societas Scientiarum Fennica, 1986), esp. pp. 62–78.

50. Haseloff, *Eine thüringisch-sächsische Malerschule des 13. Jahrhunderts;* Swarzenski, *Die Regensburger Buchmalerei des X. und XI. Jahrhunderts* (see the Introduction to the present volume, note 19). See also Roosen-Runge-Mollwo, *Goldschmidt. Lebenserinnerungen,* pp. 103–04.

51. For full lists of the dissertations supervised by Goldschmidt, see *Festschrift für Adolph Goldschmidt zum 60. Geburtstag am 15. Januar 1923,* pp. 143–48, and *Das siebente Jahrzehnt. Festschrift Adolph Goldschmidt zu seinem 70. Geburtstag am 15. 1. 1933,* pp. 173–74.

52. Gombrich, *Aby Warburg,* pp. 141–44, 346, has published this letter together with an English translation.

53. Ibid., pp. 143–44. In the categories of technique and "the educated man's sense of space," Warburg placed question marks beside his friend's name, as if soliciting response from him. Warburg placed all other scholars in a single category, with the exception of Wölfflin, whom he located in two ("sense of space" and "iconography," along with Goldschmidt). It is interesting in this regard that later in his career Goldschmidt published two theoretical studies, "Das Nachleben der antiken Formen im Mittelalter," *Vorträge der Bibliothek Warburg, 1921–1922* (Leipzig: B. G. Teubner, 1923), pp. 40–50 (a topic that was clearly directed to the interests of the Warburg Library), and "Die Bedeutung der Formenspaltung in der Kunstentwicklung," *Independence, Convergence, and Borrowing in Institutions, Thought, and Art* (Cambridge, Mass.: Harvard Univ. Press, 1937), pp. 167–77.

54. Gombrich, *Aby Warburg,* p. 143. Warburg also included the name of Konrad Lange (1855–1921), professor of art history and aesthetics at the University of Tübingen, in this category.

55. In a postcard mailed from Rome on 12 July 1894, Vöge asserted that Michelangelo was "revealing his secrets" (i.e., the secrets of his artistic production) to him, as if the Renaissance artist were a living, flesh-and-blood equal ("Michel Angelo verrät mir hier seine Geheimnisse"). There are other instances in Vöge's correspondence where he expressed his "encounters" with Renaissance artists in a similar way.

56. Postcard from Rome postmarked 7 July 1894: "Hier arbeite ich an meinem 'Stil Michel Angelos' – überhaupt sind hier zahlreiche Pläne aufgetan." Compare with Panofsky, "Wilhelm Vöge," pp. xvii–xix.

57. Postcard mailed on 12 September 1894 from Siena: "Das neue Buch kommt im Frühjahr. . . . Ich verbringe einen Teil des Winters in Florenz, um alles auszuarbeiten; eine Schar von Artikeln soll ankündigend vorausgehen."

58. Letter of 23 September 1894 posted from Bologna on 24 September: "Vielleicht bringt Bologna noch einzelnes. Dort hoffe ich, mit dem Kapitel 'Michelangelo und Quercia' in's Reine zu kommen. . . . Es wird ein Werkchen!"

59. Letter dated 25 October 1894 written in Venice: "Ich möchte so bald als möglich in Florenz sein. Für mehrere grössere Artikel habe ich das Material. Aber wer möchte in Venedig über Michelangelo schreiben. . . . So etwas gelingt nur entweder in Firenze oder in Rom. . . . Meine Artikel möchte ich gern alle in's Jahrbuch haben." Vöge intended to submit his manuscript on Michelangelo to the publisher of the *Jahrbuch*, G. Grote in Berlin, when it was completed: "Ich möchte Grote . . . einige Clichés in die Hände spielen; er soll dann später auch das 'Werk' verlegen." Vöge's intentions are confirmed by a letter written to his brother-in-law on 17 September 1894.

60. See Chapter 2, note 103, for the citation.

61. Letter sent to his family from San Gimignano on 22 December 1894: "Meine nächste Arbeit, die allerdings nur kleineren Umfangs sein wird, wird Michelangelo gewidmet sein. Ich werde in Strassburg sehen, ob Heitz geneigt ist, mir ein Honorar zu zahlen, tut er das nicht, so werde ich wohl eine Serie von Abhandlungen in eine Zeitschrift geben und das Ganze dann als Separatabzug erscheinen lassen." The Strasbourg publisher Heitz had published *Die Anfänge des monumentalen Stiles;* Vöge announced in the same letter his intention to return to Strasbourg (for the *Habilitation*) in the new year.

62. Postcard of 21 January 1895 from Florence: "Ich habe einiges recht Nettes zu Raffaelo, dem göttlichen Knaben, gefunden und will daraus eine eigene kleine Publication machen."

63. Vöge's *Habilitation* took place on 23 February 1895. In the postcard to Goldschmidt he stated: "Ich habe mich Samstag hier in Strassburg habilitiert; mein Vortrag 'Raffael und Donatello' wurde mit Erregung aufgenommen. . . . Mit Dehio hoffe ich sehr gut auszukommen. Die Antrittsvorlesung findet erst zu Beginn des Sommers statt ('Michelangelo und die Pisani')." Georg Dehio, the *Ordinarius* for art history at Strasbourg, was extremely interested in Vöge's work and wrote a major review of *Die Anfänge des monumentalen Stiles* (see Chapter 4). During the 1890s Dehio conducted research and taught on both medieval art and art of the Italian Renaissance. He supervised, for instance, Oskar Fischel's *Raphaels Zeichnungen. Versuch einer Kritik der bisher veröffentlichten Blätter* (Strasbourg: Trübner, 1898), as a doctoral thesis. See the compilation of Dehio's bibliography by Brigitte Herrbach, "Georg Dehio: Verzeichnis seiner Schriften," *Zeitschrift für Kunstgeschichte* 47 (1984), pp. 392–99.

64. Vöge, *Raffael und Donatello*. In a letter postmarked in Strasbourg on 4 August 1895 he reported to Goldschmidt that his manuscript on Raphael was complete except for the introduction, and that he would send it, together with the photographs, to the publisher before he left Strasbourg for the semester holidays. He mentioned that he planned to return to Paris and Reims during that time.

65. Wilhelm Vöge, "Besprechung von *Raffael-Studien mit besonderer Berücksichtigung der Handzeichnungen des Meisters,* von Dr. W. Koopmann, Marburg, 1895," *Zeitschrift für christliche Kunst* 8 (1895), col. 292.

66. The two manuscripts, which I have been able to examine and identify, have recently entered the possession of the Kunstgeschichtliches Institut at the University of Freiburg. Professor Wilhelm Schlink, *Ordinarius* at the Freiburg Institute, found them among a random group of materials brought to the Federal Republic of Germany from the former German Democratic Republic by Dr. Friedrich (Fritz) Bellmann (1911–93) of the Landesamt für Denkmalpflege Sachsen-Anhalt (Halle) upon his retirement. These two essays are not cited in the list of unpublished manuscripts by Vöge compiled by Bellmann after Vöge's death (compare *Bildhauer des Mittelalters*, p. 248). Bellmann moved from Freiburg to Halle in 1947

and thereafter established a close friendship with Vöge. He regularly transported books from Halle to Ballenstedt so that the elderly scholar could conduct research. For Bellmann's kindnesses to Vöge, see Panofsky, "Wilhelm Vöge," p. xxxi.

The two manuscripts are "Michelangelo und die Pisani" (87 pages; 74 pages of text, plus endnotes) and "Michelangelo's Madonna mit dem Buche und Ihr Vorbild" (13 pages; 11 pages of text, plus endnotes). The relief discussed in the latter essay (Florence, Bargello), referred to by Vöge as the "Madonna with the Book," is known today as the "Madonna of Bartolommeo Pitti." The Pitti Madonna essay is accompanied by a sheet of instructions for the printer ("Bemerkungen für den Setzer"). The latest date of bibliography cited by Vöge in the endnotes for both essays was 1894; moreover, in "Michelangelo und die Pisani," p. 74, he referred to his forthcoming research on Raphael, suggesting that he wrote the essays sometime between late 1894 and early 1896; these and other circumstances suggest a date of 1895. In the "Michelangelo und die Pisani" manuscript, Vöge referred in the endnotes to articles by Bode and Wölfflin "in dieser Zeitschrift." One of these was Wölfflin's "Ein Entwurf Michelangelos zur Sixtinischen Decke," *Jahrbuch der Königlich Preussischen Kunstsammlungen* 13 (1892), pp. 178–82, thereby confirming Vöge's intention to submit the articles to that journal.

67. A twenty-three-page manuscript, labeled by Vöge "Michelangelo und die Pisani (Vortrag)," complete with Vöge's address to the audience and notes for his delivery of the paper. It is among the materials that recently entered the possession of the Kunstgeschichtliches Institut in Freiburg.

68. Hans Kauffmann, for instance, compared Vöge's "lost" work on Michelangelo to Panofsky's lost and never-published *Habilitationsschrift* on the same artist. See Hans Kauffmann, "Erwin Panofsky, 30. März 1892–14. März 1968," *Kunstchronik* 21 (1968), p. 264. For Panofsky's *Habilitation*, see most recently Horst Bredekamp, "Ex nihilo: Panofskys Habilitation," and "Appendix: Gustav Paulis Habilitationsgutachten," *Erwin Panofsky. Beiträge des Symposions Hamburg 1992*, pp. 31–51.

69. Wilhelm Vöge, "Michelangelo's Madonna mit dem Buche und Ihr Vorbild," unpublished ms., pp. 1–2: "In der That hat Michelangelo's Phantasie hier, wie ich glaube, an ein ganz bestimmtes älteres Kunstwerk angeknüpft, die 'Madonna mit dem Buche' hat ihr 'Vorbild'; ich finde es, nicht etwa im Bereiche der älteren Madonnenbilder, sondern auf einem ganz anderen Gebiete, in einer allegorischen Darstellung der Grammatica. Ich meine die an der Sieneser Domkanzel."

70. For instance, in Vöge's inaugural lecture, "Michelangelo und die Pisani," unpublished ms., pp. 4–5 (with Vöge's emphases):

Franz Wickhoff hat auf die Beziehungen Michelangelos zu Jacopo della *Quercia* hingewiesen. Im einzelnen mögen seine Bemerkungen der Berichtigung bedürfen, sicher ist, dass Michelangelo aus dieser Quelle geschöpft hat. Hiermit war ein wichtiger *Fingerzeig* gegeben. Quercia ist seinem Wesen nach noch *Trecentist*. Michelangelo knüpft an einen Meister an, der längst nicht mehr zeitgemäss war. Zu dem Bestreben, den in Kleine und Einzelne sich verlierenden Naturalismus des 15. Jahrhunderts zu überwinden, greift er zurück auf eine ältere Epoche.

Wir fragen, möchte nicht die eigentümlich lose Verbindung mit seinen unmittelbaren Vorgängern, mit seinen Zeitgenossen eben darin ihre Erklärung finden, dass er mit der älteren Kunst nur um so weniger verwachsen war? Hat er nicht in noch weit grösserem Massstabe auf jene älteren, auf die *Primitiven* zurückgegriffen?

In der That reicht der alles überschattende Baum seiner Kunst mit seinen Wurzeln bis an die Anfänge der italienischen Renaissance hinunter. Nicht Giotto, zwar *die Plastiker*, die Schule der Pisani ist es, mit der Michelangelo in unmittelbars-

ter Beziehung steht. In seinem Ehrgeiz, alle anderen zu übertreffen, scheint er gleichsam instinctiv zurückzugreifen auf diese älteste Schule, wie als wollte er die künstlerische Tradition in ihrer ganzen Ausdehnung in sich aufnehmen.

71. Compare Panofsky, "Wilhelm Vöge," p. xviii and notes.

72. Vöge outlined his position vis-à-vis Wölfflin's 1891 study on the first page of his "Michelangelo's Madonna mit dem Buche" essay and in the first few pages of his "Michelangelo und die Pisani" manuscript (beginning with his note 5). In the "Michelangelo's Madonna mit dem Buche" manuscript, p. 1, he stated that he intended to consider the sort of external and internal factors that had conditioned Michelangelo's creative process, asserting bluntly that such issues had not been addressed by Wölfflin ("Bei Wölfflin ist von solchen nicht die Rede; er untersucht das nicht").

73. Vöge referred, for instance, in his inaugural lecture, "Michelangelo und die Pisani," p. 1, to the "lebendiger Zusammenhang einer Entwicklung" when speaking of the relationships linking Michelangelo with the Pisani over a distance of centuries.

74. Donatello's four narrative reliefs showing miracles of Saint Anthony are dated to the years 1446–53. In the foreword to *Raffael und Donatello*, p. 1, Vöge pointed out that scholars had looked for Raphael's models in painting rather than in the medium of sculpture. Continuing, he asserted: "Die Bedeutung, welche die ältere italienische Plastik für die Kunst des klassischen Zeitalters hatte, ist noch nicht gewürdigt. Und doch war sie *ungemein gross*. Die Untersuchung über Raffael's Beziehungen zu Donatello stellt nur ein einzelnes Kapitel dar innerhalb dieses allgemeineren Zusammenhanges."

75. Vöge, ibid., p. 7, acknowledged Vischer's provocative suggestion and quoted in full the relevant paragraph from Vischer's essay "Raphael und der Gegensatz der Style," *Studien zur Kunstgeschichte*, pp. 108–09. Asserting that Vischer had not attempted to prove his point in any great detail, Vöge, p. 8, announced his intention to explore the character of links between the art of Raphael and Donatello.

76. Heinrich Wölfflin, "Litteraturbericht: Wilhelm Vöge, *Raffael und Donatello*," *Repertorium für Kunstwissenschaft* 19 (1896), pp. 134–35.

77. Vöge's studies of Renaissance artists also manifested his desire to reconcile notions of developmental "laws" with the variability of artistic individuality and genius. See Vöge, *Raffael und Donatello*, p. 36: "Die Idee von der 'organischen' Entwicklung der Kunst und unser Wissen vom Genius stehen, meine ich, in keinem Widerspruche miteinander. Sind es doch gerade die Grössten, in den die 'Entwicklung' sich darstellt; die andern zählen kaum. Über die Häupter der übrigen hinweg reichen jene einander in goldenen Schalen den begeisternden Trank."

78. For instance, in the completed article-length manuscript "Michelangelo und die Pisani," note 18.

79. There are numerous verbal and conceptual analogies. In "Michelangelo's Madonna mit dem Buche," for instance, Vöge referred, p. 1, to the Renaissance master's "artistic volition" ("künstlerisches Wollen"). In a manner also reminiscent of *Die Anfänge des monumentalen Stiles*, Vöge in *Raffael und Donatello* did not simply point to links between the two artists' work but instead portrayed these links in "living" terms as helping to explain the nature of Raphael's creative achievement ("schöpferische Leistung"), for instance, p. 13: "Was hier vorliegt, ist keine Herübernahme fertiger Gestalten, es ist eine Überwirkung von Geist zu Geist, das Überspringen eines Funkens, der lebendige That entzündet." In the same book Vöge's language and approach varied from a detached, scientific form of Morellian connoisseurship (pp. 11, 31–33) to a highly evocative empathizing (*Einfühlung*) with the creative presence and personhood of the artist. See, for example, ibid., p. 27, where he depicted Raphael's reaction to Donatello's reliefs: "Dieses eben war es, was Raffael so packte. Staunenden Auges sah er es. Wovon ihm geträumt haben mochte, das fand er hier von

einem genialen Vorgänger bereits geleistet. Er giebt sich ihm hin, er zeichnet, er lernt. Was Donatello ihn lehrte, war die künstlerische Bewältigung der Masse, Donatello erst macht ihn zum grossen Historienmaler."

80. In a letter to Goldschmidt postmarked on 4 August 1895 in Strasbourg Vöge remarked that he had held *Übungen* (tutorials) on Raphael during the summer semester. Vöge's courses from winter semester 1895–96 through winter semester 1897–98 are listed in the academic calendars of the University of Strasbourg (*Verzeichniss der Vorlesungen, welche an der Kaiser-Wilhelms-Universität Strassburg . . . gehalten werden* [Strasbourg: Universitäts-Buchdruckerei von J. Heitz]) as follows: "Geschichte der französischen Plastik seit dem 12. Jahrhundert," "Michelangelos Leben und Werke," "Übungen über französische Kunst des Mittelalters" (winter 1895–96); "Französische Plastik seit dem 11. Jahrhundert" (summer 1896); "Französische Kunst des 19. Jahrhunderts [Malerei und Plastik]," "Kunstgeschichtliche Übungen [Lektüre mittelalterlicher Quellenschriften]" (winter 1896–97); no courses listed: "Dr. Vöge wird später anzeigen" (summer 1897); "Die italienische Plastik vom 13. bis zum Schluss des 15. Jahrhunderts" (winter 1897–98). Because Vöge was ill between at least the fall of 1896 and the summer of 1897 (see note 84), it is unlikely that the courses listed in the academic calendars for that period were taught. A few random notes from Vöge's course on Michelangelo's life and work (winter 1895–96) are among the papers that recently entered the Kunstgeschichtliches Institut in Freiburg. A letter sent from August Schmarsow to Vöge on 7 August 1896 (Landesamt für Denkmalpflege Sachsen-Anhalt) shows that Schmarsow, who had earlier been unable to accept Vöge for the *Habilitation* at Leipzig (see Chapter 2, note 103), attempted to lure Vöge to a post at the Leipzig art history institute, which would have begun in the winter semester of 1897–98. Vöge, however, accepted a position at the Berlin Museums shortly thereafter. In 1903 Schmarsow made a second unsuccessful attempt to attract Vöge to a teaching position at Leipzig (see note 40 to the present chapter).

81. Wilhelm Vöge, "Ein Verwandter des Codex Egberti," *Repertorium für Kunstwissenschaft* 19 (1896), pp. 105–08; "Litteraturbericht: *Beiträge zur Geschichte der Trierer Buchmalerei im frühen Mittelalter,* von Edmund Braun, Trier, 1895," *Repertorium für Kunstwissenschaft* 19 (1896), pp. 125–34.

82. Panofsky, "Wilhelm Vöge," p. xviii.

83. In a letter written to Vöge from Berlin on 15 November 1896 (Landesamt für Denkmalpflege Sachsen-Anhalt), Richard Stettiner apologized for not having responded earlier to Vöge's inquiry and suggested that Vöge should send him a list of articles on Michelangelo that he wished to submit. Stettiner added that it was unlikely he would be able to publish them because the recently founded periodical (*Das Museum,* published by W. Spemann 1896–1911) had already accepted another scholar's proposal for articles on Michelangelo. Vöge may have abandoned his original plan to submit his articles to the *Jahrbuch der Königlich Preussischen Kunstsammlungen* sometime in 1895 or 1896 after learning that the journal was already committed to publishing a series of three documentary articles on Michelangelo by Karl Frey. See Karl Frey, "Studien zu Michelagniolo," *Jahrbuch der Königlich Preussischen Kunstsammlungen* 16 (1895), pp. 91–103; 17 (1896), pp. 5–18, 97–119.

84. In the Vöge–Goldschmidt correspondence at Freiburg there are two letters from Helene Vöge to Goldschmidt (22 November 1896 and 4 April 1897, both sent from Hanover), in which she thanked Goldschmidt for his concern about her son's health, which she described as a nervous condition resulting from exhaustion. As Heise, *Wilhelm Vöge zum Gedächtnis,* p. 25, pointed out, this lengthy illness anticipated Vöge's later, more serious breakdown in 1915–16.

85. Vöge's personnel records at the University of Freiburg im Breisgau (this chapter, note 1) show that Vöge was appointed to the position of "wissenschaftlicher Hilfsbearbeiter" in

the Department of Christian Sculpture on 1 April 1897, though it appears from his correspondence that he did not actually move to Berlin until late 1897 or early 1898. At this time the collection of the Department of Christian Sculpture was distributed between the Altes Museum and the Neues Museum; it was transferred to the Kaiser-Friedrich-Museum (now the Bodemuseum) when that facility opened in October 1904. Vöge's acceptance of a curatorial position in Berlin thus coincided with the planning and building stages (1898–1904) of the Kaiser-Friedrich-Museum. For Wilhelm Bode and the collecting and building activities of the Berlin Museums (including the newly founded Kaiser-Friedrich-Museum) at the time Vöge worked there, see Thomas W. Gaehtgens, *Die Berliner Museumsinsel im Deutschen Kaiserreich. Zur Kulturpolitik der Museen in der wilhelmischen Epoche* (Munich: Deutscher Kunstverlag, 1992), esp. pp. 11–65.

86. Vöge's personnel records (see note 85), specifically, "Ministerium der Justiz, des Kultus und Unterrichts, Karlsruhe, den 30. November 1908, No. B. 14850. Die Errichtung einer ausserordentlichen Professur für Kunstgeschichte an der Universität Freiburg betr." According to these documents, Vöge was named *Extraordinarius* on 30 November 1908 and was to take up the position on 1 April 1909. A letter issued by the same ministry on 31 March 1909 shows that the starting date of Vöge's appointment was in fact postponed until 1 October 1909 (i.e., winter semester 1909–10). He was named *Ordinarius* on 22 March 1910.

87. Wilhelm Vöge et al., *Beschreibung der Bildwerke der christlichen Epochen in den Königlichen Museen zu Berlin. I. Teil: Die Elfenbeinbildwerke.* Vöge wrote the largest section of the catalogue on ivories from the Early Christian through Gothic eras (pp. 1–76), while Werner Weisbach was responsible for a smaller section dealing with Renaissance and Baroque ivories (pp. 76–94). See the foreword, n.p., by Bode. The catalogue was accompanied by a folio of forty-five large-format photographs of selected ivories, issued in 1902 (*Königliche Museen zu Berlin. Beschreibung der Bildwerke der christlichen Epochen. Zweite Auflage. Die Elfenbeinbildwerke, 45 Lichtdrucktafeln* [Berlin: G. Reimer, 1902]).

88. These letters are discussed in my article "Male Bonding" (in preparation). Goldschmidt reviewed Vöge's catalogue of ivories; see Goldschmidt, "Zur Erforschung mittelalterlicher Elfenbeinskulpturen. Arbeiten von Graeven, Vöge, Haseloff," *Kunstgeschichtliche Anzeigen* 1 (1904), pp. 35–40.

89. Weisbach, *'Und alles ist zerstorben,'* p. 300: "Ich wurde später Vöge zugeteilt, der sich gerade der Abfassung des Kataloges der Elfenbeinbildwerke widmete, und hatte, während er das Mittelalter bearbeitete, die späteren Zeiten zu übernehmen. . . . Ein häufiges Zusammensein mit Vöge konnte aber nur gewinnbringend sein. Ein Schüler Janitscheks, genoss er allgemein den Ruf eines der fähigsten jüngeren Kunsthistoriker. Er hatte sich eine ausserordentliche Kennerschaft auf dem Gebiete mittelalterlicher Kunst erworben und besass ein ungemein feines Auge, aber über den Rahmen stilkritischer Betrachtung gingen seine Bemühungen nicht hinaus."

90. Wilhelm Vöge, "Ein deutscher Schnitzer des 10. Jahrhunderts," *Jahrbuch der Königlich Preussischen Kunstsammlungen* 20 (1899), pp. 117–24, reprinted in *Bildhauer des Mittelalters,* pp. 1–10.

91. Vöge assigned five works to this Ottonian master, including the Crucifixion ivory on the book cover of the Golden Gospels of Echternach (Nuremberg, Germanisches Nationalmuseum) and the celebrated "expressionistic" diptych panels in Berlin (Staatliche Museen Preussischer Kulturbesitz), which portray the Doubting Thomas and Moses Receiving the Ten Commandments. Vöge entered intuitively into the personhood of the artist; for instance, *Bildhauer des Mittelalters,* p. 4: "Der Zufall, dass wir mehrere Werke nebeneinander haben, gestattet erst, dem Meister näher zu kommen. . . . Wir folgen den Neigungen und Launen seines Geschmacks. . . . Wir nehmen persönlichen Anteil und gewinnen Interesse

selbst an dem Menschen, was wir von keinem anderen Meister dieser Zeit sagen können," or p. 7: "Scharfäugige Beobachtung des Seelischen ist die starke Seite unseres Meisters."

92. Wilhelm Vöge, "Über die Bamberger Domsculpturen," *Repertorium für Kunstwissenschaft* 22 (1899), pp. 94–104; 24 (1901), pp. 195–229, 255–89, reprinted in *Bildhauer des Mittelalters*, pp. 130–200. He stated in the first essay, note 1 (*Bildhauer des Mittelalters*, p. 130, note 1), that he had written his study during the winter of 1897–98; his investigation was conceived in part as a response to Artur Weese's *Die Bamberger Domsculpturen. Ein Beitrag zur Geschichte der deutschen Plastik des XIII. Jahrhunderts* (Strasbourg: J. Heitz, 1897), a dissertation supervised by Dehio.

93. Georg Dehio, "Zu den Skulpturen des Bamberger Domes," *Jahrbuch der Königlich Preussischen Kunstsammlungen* 11 (1890), pp. 194–99. Dehio's proposal met with vehement opposition from many of his contemporaries who wished to deny the presence of non-German components in the Bamberg enterprise. In 1892 Dehio denounced what he called the "nationalist perspective" (*vaterländische Haltung*) adopted in the writings of his critics; see his "Noch einmal die Skulpturen des Bamberger Domes," *Jahrbuch der Königlich Preussischen Kunstsammlungen* 13 (1892), p. 141.

94. Vöge expressed his desire to explore the sculpture at Reims in a number of letters to Goldschmidt of the second half of the 1890s. His plans appear to have crystallized around 1900; in a letter of 16 May 1901 (no place given) he announced his intention to write a monograph on the site. A series of postcards sent to Goldschmidt from Reims between May and July 1903 documents his progress (see Figs. 24, 25). He related in a postcard of 8 May that he had conferred with the archaeologist Louis Demaison (1852–1937) and archivist Henri Jadart (1847–1921); on 5 July he reported that he had examined the sculpture from scaffolding and had taken hundreds of photographs. In the following years Vöge published a number of articles in which he treated works of sculpture at Reims. In addition, he wrote a book-length manuscript entitled "Die Kathedralen von Reims und Amiens und ihre Bildwerke. Studien zur Plastik der französischen Frühgotik, Bd. II" (evidently *Die Anfänge des monumentalen Stiles* represented the first volume of this sequence). Panofsky, "Wilhelm Vöge," p. xix, note 40, asserted that Vöge wrote the manuscript in 1917–18 shortly after his breakdown. Because the ravaging of Reims Cathedral by the German military during the war years appears to have been a factor contributing to Vöge's illness, it is not surprising that he had little desire to rework the manuscript for publication. In fact Vöge never returned to France following World War I, and his later correspondence with Goldschmidt shows that he associated the manuscript with a time of personal despair.

The manuscript survives; it entered the collection of the Kunstgeschichtliches Institut in Freiburg in 1992. According to the accompanying documentation, a transcription of the manuscript was planned by a group of East and West German scholars (who included Friedrich Bellmann, Ernst Schubert and Theodor Müller) in the years 1960–63, for it was believed that Vöge's prewar observations were potentially of great value. Although Willibald Sauerländer carried out the transcription, it was never published, owing to difficulties that arose as a consequence of political tensions dividing the two Germanys in the early 1960s.

95. See, for instance, Wilhelm Vöge, "Der Visitatiomeister und die Reimser Plastik des 13. Jahrhunderts," *Kunstgeschichtliche Gesellschaft Berlin, Sitzungsberichte* (1904)(3), pp. 13–16, reprinted in *Bildhauer des Mittelalters*, pp. 60–62.

96. Vöge's personnel file at the University of Freiburg shows that he delivered his inaugural address ("Über die Bedeutung der Persönlichkeit in der französischen Kunst des Mittelalters") on 18 May 1911. For Vöge's teaching at Freiburg, see Panofsky, "Wilhelm Vöge," pp. xxii–xxvii (with a list of the dissertations supervised by Vöge); Kurt Bauch, "Emil G. Bührle und sein Lehrer," *Sammlung Emil G. Bührle. Festschrift zu Ehren von Emil G. Bührle*

zur Eröffnung des Kunsthaus-Neubaus und Katalog der Sammlung Emil G. Bührle (Zurich: Kunsthaus, 1958), pp. 16–18. According to Bauch, the art historians Frederick Antal, Carl Georg Heise and Walter Greischel, the philosopher Martin Heidegger, and the Swiss art collector Emil Bührle attended Vöge's lectures in their student days in Freiburg. For other prominent figures who attended Vöge's classes, see the Introduction to the present volume.

97. Wilhelm Vöge, "Die Bahnbrecher des Naturstudiums um 1200," *Zeitschrift für bildende Kunst* N. F. 25 (1914), pp. 193–214, reprinted in *Bildhauer des Mittelalters*, pp. 63–97. This essay has also been published in an English version that does not attempt to reproduce Vöge's literary style. See the translation by Barbara Chabrowe ("Pioneers of the Study of Nature around 1200") appearing in Branner, ed., *Chartres Cathedral*, pp. 207–32.

98. For instance, Vöge, "Die Bahnbrecher," in *Bildhauer des Mittelalters*, p. 65 ("Also es liegt nicht zum wenigsten an den Unzulänglichkeiten der Überlieferung, wenn die einzelnen Künstlerpersönlichkeiten so wenig deutlich heraustreten. Doch es liegt auch – an uns! Wir haben uns zu flüchtig bisher mit diesen Mittelalterlichen abgegeben; wir kennen sie nicht"). On page 67 he claimed: "die stärksten Künstlerindividualitäten, die das mittelalterliche Frankreich hervorgebracht hat, sind noch gar nicht entdeckt worden." See the English translation in Branner, ed., *Chartres Cathedral*, p. 210 ("the most distinct artistic personalities which medieval France produced have not yet been discovered!")

99. Vöge, *Beschreibung der Bildwerke der christlichen Epochen . . . Die deutschen Bildwerke und die der anderen cisalpinen Länder*. This catalogue, completed before Vöge left Berlin, was not published until 1910.

100. See Vöge's complete bibliography in *Bildhauer des Mittelalters*, pp. 245–48. In a letter to Goldschmidt dated 31 December 1911 he declared his interest in working on Jörg Syrlin and suggested that such a project could perhaps be undertaken for the Deutscher Verein für Kunstwissenschaft. Vöge's study on Syrlin did not appear until almost forty years later.

101. Wilhelm Dilthey's *Einleitung in die Geisteswissenschaften. Versuch einer Grundlegung für das Studium der Gesellschaft und der Geschichte* was published in 1883 (Leipzig: Duncker und Humblot); it has been reprinted as the first volume of Wilhelm Dilthey, *Gesammelte Schriften*, vol. 1 (Stuttgart: B. Teubner, 1959). The bibliography on Dilthey is extensive. For an introduction, see Michael Ermath, *Wilhelm Dilthey: The Critique of Historical Reason* (Chicago: Univ. of Chicago Press, 1978), H. P. Rickman, *Wilhelm Dilthey: Pioneer of the Human Sciences* (Berkeley and Los Angeles: Univ. of California Press, 1979), and Ilse N. Bulhof, *Wilhelm Dilthey. A Hermeneutic Approach to the Study of History and Culture* (The Hague: Martinus Nijhoff, 1980). For a valuable account of the development of academic disciplines such as anthropology, human geography and branches of psychology that took culture as their object of study, see Woodruff D. Smith, *Politics and the Sciences of Culture in Germany, 1840–1920* (New York: Oxford Univ. Press, 1991).

102. "Die Natur erklären wir, das Seelenleben verstehen wir." The passage is from Dilthey's "Ideen über eine beschreibende und zergliedernde Psychologie" (1894), reprinted in Wilhelm Dilthey, *Gesammelte Schriften*, vol. 5 (Stuttgart: B. Teubner, 1961), p. 144.

103. Holly, *Panofsky and the Foundations of Art History*, esp. pp. 34–42, has discussed the influence of Dilthey on art history in early twentieth-century Germany in relation to the developing thought of Panofsky. She noted that Panofsky outlined comparable principles of inquiry in his later (1940) essay on "The History of Art as a Humanistic Discipline," reprinted in *Meaning in the Visual Arts*, pp. 1–25. Panofsky would have encountered a similar methodological approach (and model?) in the art historical writings of his teacher Vöge. Vöge, however, was less concerned than either Dilthey or Panofsky with situating manifestations of individual will or intent within a specific cultural or social matrix.

Chapter 4. German and International Responses
at the Turn of the Century

1. For the influence of Berlin catalogues (including those of Vöge) on cataloguing efforts undertaken at the Metropolitan Museum of Art prior to World War I, see Walter Cahn and Linda Seidel, *Romanesque Sculpture in American Collections. Volume I: New England Museums* (New York: Burt Franklin, 1979), pp. 7–8. In 1908, Wilhelm Valentiner, one of Vöge's younger colleagues in Berlin, was appointed curator of decorative arts at the Metropolitan Museum, a position he retained until the outbreak of World War I. A number of catalogues were produced under his direction, including Joseph Breck's *Catalogue of Romanesque, Gothic and Renaissance Sculpture* (New York: Metropolitan Museum of Art, 1913). For Valentiner's prewar sojourn in America, see Sterne, *The Passionate Eye* (Chapter 1, note 73), pp. 86–110. Vöge's catalogue of ivory carvings may also have provided an important model for Goldschmidt's *Die Elfenbeinskulpturen* (see Chapter 3 to the present volume). The British scholar O. M. Dalton was also influenced by Vöge's catalogue; see his *Catalogue of the Ivory Carvings of the Christian Era with Examples of Mohammedan Art and Carvings of Bone in the Department of British and Mediaeval Antiquities and Ethnography of the British Museum* (London: Trustees of the British Museum, 1909). Among Vöge's and Goldschmidt's papers are several letters (in German) from Dalton; he solicited their advice in 1907 and 1908.

2. To cite one example, Goldschmidt's 1902 article "Willem Buytewech" was the first to direct attention to the Dutch artist's importance as a draftsman and etcher. See the comments of Wolfgang Stechow, "Review of E. Haverkamp Begemann, *Willem Buytewech*, Amsterdam, 1959," *Art Bulletin* 43 (1961), pp. 338–39.

3. Georg Dehio, "Litteraturbericht: *Die Anfänge des monumentalen Stiles im Mittelalter* von Dr. Wilhelm Vöge," *Repertorium für Kunstwissenschaft* 18 (1895), pp. 279–82, esp. p. 279: "Wir dürfen uns freuen, dass die deutsche Methode der Stilkritik in der Anwendung auf einen französischen Stoff einen so tüchtigen und verdientes Lob erntenden Vertreter gefunden hat."

4. Ibid., p. 279: "Gleich die Wahl des Stoffes zeugt von einem richtigen Gefühl für das, was unserer Wissenschaft im Augenblick nöthig und was in ihr möglich ist. Offenbar war bis dahin die Bildhauerkunst das Stiefkind der mittelalterlichen Studien . . . weil die Mittel zu eindringender Bearbeitung fehlten."

5. Ibid., p. 280: "Die weitere Forschung wird nun nach festen Richtlinien ausschreiten können, während sie bis jetzt nur tappte."

6. Paul Clemen, "Bücherschau: Wilhelm Vöge, *Die Anfänge des monumentalen Stiles im Mittelalter*," *Kunstchronik* N. F. 6 (1894–95), cols. 169–71.

7. Ibid., col. 170: "Wo aber sind die Ursprünge dieser Schule zu suchen? Zwei Provinzen sind genannt worden: Languedoc und Burgund. Vöge, der dieses Problem zum erstenmal eingehend untersucht und auf wissenschaftliche Basis stellt, weist im Gegensatz hierzu durch sorgfältige, ins einzelne gehende Vergleichungen nach, dass die Chartrerer Kunst ihrem Hauptbestande nach aus der Provence stammt."

8. Ibid., col. 171: "Ich wüsste aus dem letzten Jahrzehnt unserer deutschen Kunstliteratur über das Mittelalter kein Buch zu nennen, das das Problem mit solcher Klarheit erfasst, mit so viel Aufwand von Scharfsinn und Grazie und in so eingehender Analyse der Lösung entgegenführt."

9. Ibid., col. 171: "Die auf der eingehendsten Kenntnis des Materiales mit erstaunlicher Beherrschung der Literatur aufgebauten Resultate . . . eröffnen eine Fülle neuer und wertvoller Gesichtspunkte, die auch für die Nachbarkünste von Bedeutung sind."

10. Alexander Schnütgen, "Bücherschau: *Die Anfänge des monumentalen Stiles im Mittelalter* von Dr. Wilhelm Vöge," *Zeitschrift für christliche Kunst* 7 (1894), cols. 349–50, esp. col. 349: "Und

diese Prüfung ist eine so eingehende und konsequente, eine so vielseitige und objektive, eine so anschauliche und überzeugende, dass dem Ergebnisse das Zeugniss ganz neuer massgebender Geschichtspunkte für den Ursprung und die Entwickelung der französischen Plastik des XI. und namentlich des XII. Jahrhunderts ausgestellt werden darf und muss."

11. Ibid.: "Dieses ganze Beweisverfahren aber ist ein durchaus genetisches" (col. 349); "Neben allen stilistischen Erwägungen und historischen Begründungen kommen auch die ikonographischen Analysen nicht zu kurz, die als die starke Seite des Verfassers längst bekannt sind. Und ein eigenes, sehr lehrreiches Kapitel ist der Technik gewidmet in ihrem Zusammenhange mit dem Stil" (col. 350).

12. Albert Marignan, "Dr. W. Vöge, *Die Anfänge des monumentalen Stiles im Mittelalter. Eine Untersuchung über die erste Blütezeit französischer Plastik*," *Le Moyen Âge* 7 (1894), pp. 253–58.

13. Ibid., p. 253: "C'est la première fois qu'on discute d'une manière sérieuse et méthodique ce que les écoles du midi de la France ont donné, qu'on cherche à analyser leurs oeuvres et leur influence sur l'éclosion du groupe si important du Nord. C'est la première étude scientifique sur la *genèse* de la statuaire monumentale en France."

14. Ibid., pp. 254–55: "L'église de Chartres est, d'après ce qui nous reste des monuments du nord de la France, la première tentative de décorer la façade d'une série ininterrompue de statues en grandeur naturelle. . . . De quelle région ont-ils [the artists] pu trouver sur les façades ou sur les piliers des cloîtres la conception de cette série de figures en grandeur naturelle? En d'autres termes, quels sont donc les ancêtres de ces rois de Juda qui décorent les portails de l'église de Chartres? Pour répondre à cette question si importante, il était nécessaire à M. V. de parcourir les différentes écoles romanes qui florissaient alors en Gaule. . . . L'analyse de l'école de Provence est du plus haut intérêt. . . . Toute cette première partie est à lire avec soin; pour l'érudit, c'est un petit chef-d'oeuvre de méthode et de critique. . . . La généalogie de l'art du Nord donnée par M. V. me paraît excellente."

15. Ibid., for instance, p. 253: "L'auteur n'a pas, comme bien des archéologues l'auraient fait, décrit simplement le portail et son iconographie; il a comparé ces sculptures avec les oeuvres des autres écoles existant alors sur le sol de la France." See also p. 257: "La méthode employée par M. V. est encore nouvelle. Tous ceux qui, en France, s'étaient occupés de l'histoire de la sculpture avaient analysé les oeuvres, sans souci des divers artistes qui avaient pu les créer. L'auteur cherche au contraire à distinguer les artistes différentes auxquels sont dues les oeuvres du portail. Il attribue à plusieurs maîtres les oeuvres de la façade, parmi lesquels un surtout domine tous les autres."

16. Ibid., p. 258: "On le voit, le livre de M. V. est un livre du plus haut intérêt; il décrit l'histoire de la sculpture du XIIe siècle en France, il recule le développement plastique des écoles primitives, il nous prouve l'originalité si profonde et si grande des oeuvres du XIIe."

17. At a meeting of the Société held on 8 December 1894, one of the members (Henry Lehr) volunteered to translate Vöge's text once the German scholar had been contacted for authorization. The project was prompted by the president's presentation of Marignan's 1894 review at the meeting. See the report "Séance du 8 décembre 1894," *Procès-verbaux de la Société Archéologique d'Eure-et-Loir* 9 (1898), pp. 197–99 (with a summary of the contents of Vöge's book). At a later meeting (7 February 1895) the president reported that he had received a letter from Vöge in which the scholar stated that his publisher (J. Heitz) could not yet authorize a translation. It was therefore decided that Lehr would undertake an abridged translation of the 1894 publication, and that these extracts would be published in the society's bulletin. See "Séance du 7 février 1895," *Procès-verbaux de la Société Archéologique d'Eure-et-Loir* 9 (1898), pp. 202–03.

18. Henry Lehr, "L'École chartraine de sculpture au douzième siècle, d'après *Les Origines du*

style monumental au moyen âge; étude sur la première floraison de la plastique française, par le Dr. Wilhelm Vöge: Extraits," *Mémoires de la Société Archéologique d'Eure-et-Loir* 12 (1901), pp. 85–140. Lehr, pp. 134–40, outlined what he considered to be Vöge's most important points.

19. Émile Mâle, "Les Origines de la sculpture française du moyen âge," *La Revue de Paris,* 2d yr., 5 (1895), pp. 198–224, esp. pp. 222–24. He introduced Vöge's book on p. 199, stating that such studies as this "livre d'un Allemand" would ensure that "la sculpture française sera étudiée désormais comme elle mérite de l'être."

20. Ibid., p. 223: "L'art de l'Ile de France est né au portail vieux de la cathédrale de Chartres. . . . Nul archéologue n'avait pu expliquer comment une région, si pauvre jusque-là en oeuvres d'art, avait pu produire soudain un pareil chef-d'oeuvre. M. Vöge, le premier, a réussi à résoudre le problème. Dans son livre si ingénieux sur les origines de l'art monumental du moyen âge, il a montré que l'art de Chartres dérivait de l'art d'Arles."

21. Ibid., pp. 223–24, esp. p. 223: "Le maître de Chartres connut la façade de Saint-Trophime, et il l'imita. Son imitation est, il est vrai, celle d'un homme de génie: elle est libre, originale. . . . Le maître de Chartres a eu ce qui manquait au maître d'Arles, l'amour de la vie. Il fut le premier des sculpteurs gothiques."

22. Adolfo Venturi, "Recensione: *Die Anfänge des monumentalen Stiles im Mittelalter* von Dr. Wilhelm Vöge," *Archivio storico dell'arte* 1 (1895), p. 466. Vöge later published an article dealing specifically with links between Provençal and northern Italian sculpture: "Der provençalische Einfluss in Italien und das Datum des Arler Porticus," *Repertorium für Kunstwissenschaft* 25 (1902), pp. 409–29, reprinted in *Bildhauer des Mittelalters,* pp. 16–35.

23. Venturi, "*Die Anfänge des monumentalen Stiles,*" p. 466: "Questo saggio del giovane studioso d'arte è veramente magistrale per il rigore delle ricerche, e lascia sperare che l'A. vorrà continuarle. . . . Certamente il libro deve incitare gli studiosi a continuare le ricerche con uguale buon metodo, a portare uno spirito d'ordine nelle idee storiche confuse sulla scultura medioevale."

24. See also the notices by Herman Grimm, "Wilhelm Vöge, *Die Anfänge des monumentalen Stiles im Mittelalter,*" *Deutsche Litteraturzeitung* 15 (1894), cols. 1431–32, and Franz Xaver Kraus's comprehensive "Litteraturbericht: Christliche Archäologie, 1895–96," *Repertorium für Kunstwissenschaft* 19 (1896), p. 461.

25. The reviews by Dehio, Clemen and Schnütgen are particularly informative in this regard. Dehio, "*Die Anfänge des monumentalen Stiles,*" for instance, p. 279, highlighted Vöge's command of the German method of style criticism and then mentioned the author's literary style, interpreting it as a form of politeness toward the reader ("eine unerlässliche Pflicht der Höflichkeit gegen den Leser"). Clemen, "*Die Anfänge des monumentalen Stiles,*" col. 171, referred to Vöge's "finely crafted style" ("feinziselirter Stil") and "dialectical sharpness" ("dialektische Schärfe") but did not elaborate. Schnütgen, "*Die Anfänge des monumentalen Stiles,*" cols. 349–50, stressed the "objectivity" of Vöge's study and made passing reference to the "elegant" and "refined" ("vornehm") quality of the young scholar's arguments.

26. For instance, Dehio, "*Die Anfänge des monumentalen Stiles,*" p. 281.

27. Vöge, *Die Anfänge,* pp. 190–91: "Für uns gilt es, soweit angängig, die verbindenden Fäden zwischen Werk und Werk, zwischen Meister und Meister wieder aufzudecken, der einzelnen Schöpfung ihre Stelle im Zusammenhange des Ganzen anzuweisen, die Eigenart des einzelnen Meisters scharf zu erfassen, mit einem Worte, an die Stelle historischen Gerümpels Geschichte zu setzen." This attitude was reminiscent of Vöge's dissertation.

28. Weese, *Die Bamberger Domsculpturen;* Karl Franck-Oberaspach, *Der Meister der Ecclesia und Synagoge am Strassburger Münster. Beiträge zur Geschichte der Bildhauerkunst des dreizehnten Jahrhunderts in Deutschland, mit besonderer Berücksichtigung ihres Verhältnisses zur gleichzeitigen französischen Kunst* (Düsseldorf: L. Schwann, 1903); Kurt Moriz-Eichborn, *Der Skulpturen-*

cyclus in der Vorhalle des Freiburger Münsters und seine Stellung in der Plastik des Oberrheins (Strasbourg: J. Heitz, 1899). Moriz-Eichborn's study, a dissertation supervised by Henry Thode, bore a distinct Wagnerian imprint.

29. See my article "The Naumburg Master: A Chapter in the Development of Medieval Art History."

30. Ibid.

31. Landesamt für Denkmalpflege Sachsen-Anhalt (Halle). The correspondence includes letters from Weese, Franck-Oberaspach and Moriz-Eichborn, as well as from other young scholars, including Georg Swarzenski and Arthur Haseloff.

32. For Mâle's scholarly and teaching career, as well as his publications, see *Émile Mâle et le symbolisme chrétien*, exh. cat., Centre Culturel et Grand Casino de Vichy (Vichy: Wallon, 1983). See also Heinrich Dilly, "Émile Mâle, 1862–1954," *Altmeister moderner Kunstgeschichte*, ed. Heinrich Dilly (Berlin: Dietrich Reimer Verlag, 1990), pp. 133–48.

33. Émile Mâle, "Le Portail Sainte-Anne à Notre-Dame de Paris," *Revue de l'art ancien et moderne* 2 (1897), pp. 231–46, reprinted in idem, *Art et artistes du moyen âge* (Paris: A. Colin, 1927), pp. 188–208. My citations follow the 1897 edition.

34. Ibid., p. 232: "M. Vöge a abordé ces recherches avec le tour d'esprit d'un philologue. . . . Il a analysé le portail de Chartres comme tel érudit décompose les éléments d'un chant d'Homère: il y a reconnu quatre mains différentes, quatre artistes de valeur inégale, et il a réussi à nous faire partager sa conviction. Il lui a suffi d'observer et de comparer. . . . M. Vöge en étudiant nos statues a remarqué la moindre boucle de cheveux, le moindre pli des tuniques. Heureux scrupules. Il a réussi à prouver qu'il y a eu en France, dès le XIIe siècle, plusieurs maîtres d'une personnalité très forte, dont les oeuvres peuvent se reconnaître entre cent autres. Ils ne se ressemblent point entre eux. . . . Ainsi, dans cet art du XIIe siècle, où l'on ne voyait qu'uniformité, M. Vöge a reconnu la variété, la vie. . . . Sans doute, nous ne connaîtrons jamais les noms de ces vieux maîtres, mais dès maintenant nous commençons à savoir discerner leurs oeuvres."

35. Mâle's article spawned much subsequent scholarship centered on arguments for or against the "single master" theory for the Chartres and Paris tympana. See, for instance, Paul Vitry, "Nouvelles observations sur le portail Sainte-Anne de Notre-Dame de Paris. À propos de deux fragments de voussures conservés au Musée du Louvre," *Revue de l'art chrétien* 60 (1910), pp. 70–76.

36. Vöge, *Die Anfänge*, pp. 67–68, note 2. The article in question was Mâle's "Les Chapiteaux romans du musée de Toulouse et l'école toulousaine du XIIe siècle," *Revue archéologique* 20 (1892), pp. 28–35, 176–97.

37. Vöge, *Die Anfänge*, pp. 67–68, note 2: "Die Arbeit Mâle's ist gewiss verdienstlich, aber es ist doch merkwürdig, warum er sich auf das Studium der Kapitäle beschränkt, warum er nicht wenigstens zwischendurch einen Blick wirft auf die zahlreichen figuralen Skulpturen grossen Massstabes, die die Schule von Toulouse uns hinterlassen hat, da er sich doch offenbar ein Urteil über Wesen und Entwicklung dieser Schule bilden wollte. Er hätte hier die Abfolge der verschiedenen Ateliers und Stile mit weit grösserer Sicherheit zu verfolgen vermocht; meine wenigen Bemerkungen werden das ins Licht setzen."

38. Mâle, *L'Art religieux du XIIIe siècle*, pp. 127, 439, 519.

39. Émile Mâle, "Histoire de l'art: Les Travaux sur l'art du moyen âge en France depuis vingt ans," *Revue de synthèse historique* (1901), pp. 81–108.

40. Ibid., p. 93: "Si l'histoire de l'architecture a passionné les archéologues français depuis vingt ans, on n'en saurait dire autant de l'histoire de la sculpture. Chose étrange, le seul livre vraiment riche d'idées qui ait paru sur ce sujet est l'oeuvre d'un Allemand."

41. Ibid., pp. 95–96. After discussing the revisions to Vöge's chronology then being made by French scholars (see note 44 to this chapter), Mâle, p. 96, stated: "Il [Vöge] étudie les

oeuvres avec tant de finesse, il les rapproche et les groupe avec tant de vraisemblance, que plusieurs de ses chapitres resteront comme des modèles de critique archéologique."

42. Ibid., p. 96: "L'exemple qu'il nous donne devra être suivi. La statuaire de nos cathédrales du XIIIe siècle demande l'étude la plus minutieuse. C'est un beau sujet qui n'a encore été abordé par personne. Les problèmes à résoudre sont nombreux. Quelles sont, dans une cathédrale donnée, les oeuvres qui portent la marque du même artiste? Quelles sont, dans la même cathédrale, les statues les plus anciennes? Quelles sont les plus récentes? Peut-on établir une chronologie approximative des oeuvres, et étudier méthodiquement le développement de la sculpture au XIIIe siècle? Y a-t-il eu des écoles de sculpture? Chaque grande ville a-t-elle eu ses sculpteurs indigènes? Ou bien les mêmes artistes sont-ils allés de Chartres à Paris, de Paris à Amiens? Autant de questions sur lesquelles les textes sont muets et qui ne pourront être résolues dans une certaine mesure que par l'étude critique des monuments."

43. Albert Marignan, "Le Portail occidental de Notre-Dame de Chartres," *Le Moyen Âge* 11 (1898), pp. 341–53, esp. pp. 345–46, where he stated that his study was suggested by a conversation with Courajod following the appearance of Vöge's book; Marignan elaborated his theses in "L'École de sculpture en Provence du XIIe au XIIIe siècle," *Le Moyen Âge* 12 (1899), pp. 1–64. See also Maurice Lanore, "Reconstruction de la façade de la cathédrale de Chartres au 12e siècle," *Revue de l'art chrétien* 42 (1899), pp. 328–35; 43 (1900), pp. 32–39, 137–45.

44. Robert de Lasteyrie, *Études sur la sculpture française au moyen âge* (Paris: E. Leroux, 1902). This study was widely acclaimed in France; see, for instance, the review by Eugène Lefèvre-Pontalis, "*Études sur la sculpture française au moyen âge* par Robert de Lasteyrie," *Bulletin monumental* 67 (1903), pp. 591–95. It is important to stress that despite differences in chronology, the French scholar's book helped to disseminate knowledge of Vöge's "system" in France. Vöge also reviewed the book, "Litteraturbericht: *Études sur la sculpture française au moyen âge* von Robert de Lasteyrie," *Repertorium für Kunstwissenschaft* 26 (1903), pp. 512–20, reprinted in *Bildhauer des Mittelalters*, pp. 36–43. Although Vöge agreed in general with the redating, he criticized a number of the methodological precepts guiding de Lasteyrie's inquiry.

45. Louise Pillion, "Les Historiens de la sculpture française," *La Revue de Paris* 15th yr., no. 20 (15 October 1908), pp. 849–68 (Part I); 15th yr., no. 21 (1 November 1908), pp. 109–28 (Part II), esp. pp. 115–116, for her assessment of Vöge's book ("nous devions rattacher à un nom étranger le seul grand travail d'ensemble publié sur la sculpture française de l'époque romane") and the amendments to his arguments made by French scholars. In his 1901 article Mâle also professed admiration for Vöge's investigative strategies, despite his awareness of revisions to Vöge's chronology to be published the next year by de Lasteyrie.

46. Pillion, "Les Historiens," p. 116: "Quelque peu disposé que l'on soit à attribuer une telle importance initiatrice à l'école de Provence . . . c'est un plaisir de suivre, à travers les ingénieuses déductions de M. Vöge, l'itinéraire d'un atelier de sculpteurs français au XIIe siècle, de voir avec lui cet atelier . . . nous savons gré à M. Vöge d'avoir essayé de reconstituer une individualité d'artiste du XIIe siècle, et nous admirons la puissance d'analyse avec laquelle il applique à notre art roman ce que nos voisins appellent la critique 'stylistique.'" The filiational scheme introduced by Vöge for the study of French sculpture is echoed in the sections on "La Sculpture romane: La Sculpture en France" and "Formation et développement de la sculpture gothique du milieu du XIIe à la fin du XIIIe siècle: La Sculpture en France" written by André Michel for his celebrated *Histoire de l'art*. See, for instance, vol. 1, Part II, *Des Débuts de l'art chrétien à la fin de la période romane* (Paris: A. Colin, 1905), pp. 661–66; vol. 2, Part I, *Formation, expansion et évolution de l'art gothique* (Paris: A. Colin, 1906), pp. 130–40. Compare also the interpretative framework of Louise Pillion's

Les Sculpteurs français du XIIIe siècle (Paris: Plon, 1910), republished in many later editions. The notion of itinerant sculptors in medieval France had, of course, certain ideological precedents in nineteenth-century French scholarship on itinerant medieval architects, specifically Villard de Honnecourt. For an historiographical study of the thirteenth-century French architect, see Carl F. Barnes, Jr., *Villard de Honnecourt: The Artist and His Drawings. A Critical Bibliography* (Boston: G. K. Hall, 1982).

47. Landesamt für Denkmalpflege Sachsen-Anhalt (Halle). Most of these materials are thank-you letters to Vöge. Vöge had, for instance, congratulated Enlart upon his assumption of the directorship of the Musée de Sculpture Comparée (letter from Enlart dated 21 August 1903 from Saint-Léonard, Pas de Calais) and frequently sent offprints of his publications to French scholars. In a letter from Paris dated 15 October 1901, for example, Michel thanked Vöge for sending him a copy of his lengthy essay on the Bamberg sculpture; similarly, in a postcard of 7 July 1914 Aubert thanked Vöge for an offprint of "Die Bahnbrecher des Naturstudiums." I have not found evidence of correspondence between Mâle and Vöge.

48. Letter of 8 January, no year given (Landesamt für Denkmalpflege Sachsen-Anhalt). Because Koechlin referred to de Lasteyrie's publication, the letter can be dated to 1903 or later.

49. Vöge's comments pertained specifically to Marignan and his 1894 review of *Die Anfänge des monumentalen Stiles* in *Le Moyen Âge*. In a letter to Goldschmidt from Arezzo dated 4 September 1894 Vöge remarked that the French scholar was working on a lengthy review of his book: "Marignans Besprechung scheint sich der *Buch*form anzunähern. Er hat jetzt alles übersetzt." The following month Vöge reported to his friend in a letter from Venice (dated 25 October) that he had seen the review in manuscript form, and had been obliged to rework it: "Marignans Besprechung meiner Arbeit ging mir vor einiger Zeit im Manuscript durch die Finger. Ich musste sehr stark umschreiben. Es ist merkwürdig, wie schwer den kleinen Franzen das Deutsch ist – und Marignan ist doch einer von den Auserwählten, die es gut lesen." Study of the French scholarship cited here (and later French writings on medieval sculpture) indicates that French scholars interpreted Vöge's arguments largely in black-and-white terms, even though the scholar had repeatedly stressed the tentative nature of his findings. In his 1903 review "Litteraturbericht: *Études sur la sculpture française*" (see note 44 to this chapter), Vöge pointed to discrepancies between statements made in his book and their interpretation by de Lasteyrie.

50. Émile Mâle, *L'Art allemand et l'art français du moyen âge* (Paris: A. Colin, 1917). In this book Mâle constructed a disparaging view of German artistic achievement in the Middle Ages, emphasizing its abject dependency on France. Mâle's "livre vengeur" was inspired in part by the German bombing of Reims Cathedral. For comments on Mâle's nationalist undertaking, see Germain Bazin, *Histoire de l'histoire de l'art de Vasari à nos jours*, p. 271.

51. Margaret Marriage and Ernest Marriage, *The Sculptures of Chartres Cathedral / Les Sculptures de la Cathédrale de Chartres* (Cambridge: Cambridge Univ. Press, 1909).

52. Ibid., for instance, pp. 25–26, 30, 40, 44, 60, 269–70.

53. Edward S. Prior and Arthur Gardner, *An Account of Medieval Figure-Sculpture in England* (Cambridge: Cambridge Univ. Press, 1912). See especially the "Appendix to Book I: Bibliography of English Medieval Sculpture," pp. 105–08, where the authors surveyed the very limited state of research.

54. Arthur Frothingham, *A History of Sculpture* (London: Longmans, Green, 1901). In 1885 he had published an article on medieval sculpture that was influenced by German "histories" as well as the writings of Viollet-le-Duc. See Arthur Frothingham, "The Revival of Sculpture in Europe in the Thirteenth Century," *American Journal of Archaeology and of the History of the Fine Arts* 1 (1885), pp. 34–45, 372–84.

55. See, for instance, David A. Brown, "Giovanni Morelli and Bernard Berenson," *Giovanni*

Morelli e la cultura dei conoscitori, vol. 2, pp. 389–97. Like young European scholars of his day (for example, Wickhoff and Goldschmidt; see Chapter 1, note 46), the young American visited Morelli. Connoisseurship was the subject of Berenson's first major essay on art, written in 1894. See "The Rudiments of Connoisseurship," in Bernard Berenson, *The Study and Criticism of Italian Art,* 2d series (London: George Bell and Sons, 1902), pp. 111–48 (he stated in the preface, pp. vi–viii, that the essay had been written eight years earlier). For a recent account of Berenson, with an extensive bibliography, see Mary Ann Calo, *Bernard Berenson and the Twentieth Century* (Philadelphia: Temple Univ. Press, 1994).

56. Reiner Pommerin, "Paul Clemen in Harvard," *Jahrbuch der Rheinischen Denkmalpflege* 29 (1983), pp. 12–16. For the cultural-political background of the founding of the Germanic Museum at Harvard with the earlier bibliography, see Franziska von Ungern-Sternberg, "Die Gründung des Germanischen Museums in Cambridge, Massachusetts. Kulturpolitische Hintergründe für ihre Realisierung," unpublished M. A. thesis, University of Hamburg, 1990 (copy also deposited at the Busch-Reisinger Museum, Harvard University); idem, *Kulturpolitik zwischen den Kontinenten – Deutschland und Amerika. Das Germanische Museum in Cambridge, Massachusetts* (Cologne: Böhlau Verlag, 1994). Guido Goldman's *A History of the Germanic Museum at Harvard University* (Cambridge, Mass.: Minda de Gunzburg Center for European Studies, Harvard University, 1989) is highly informative but has limited scholarly value due to its lack of critical apparatus.

57. These letters are among those papers of Goldschmidt deposited at the Universitätsbibliothek Basel (Nachlass Goldschmidt 44 444), papers which were brought by Goldschmidt to Switzerland when he was forced to leave Germany in 1939. The fifteen letters from Dvořák in that collection (Briefe von Max Dvořák, Briefe Nos. 28–43) date from 1902 to 1912; most were written between 1902 and 1905.

58. Dvořák discussed the project in a letter from Raudnitz dated 28 December 1903 (Universitätsbibliothek Basel, Nachlass Goldschmidt 44 444, Brief No. 32,) as well as in several letters sent from Vienna (9 January 1904, Brief No. 35; 21 December 1904, Brief No. 38).

59. Ibid. In his letter of 28 December 1903 Dvořák asked Goldschmidt for Vöge's address so that he could also recruit him for the undertaking. In the letter of 21 December 1904 he called for the formation of a "Falanx aller Forscher" whose primary concern was "die exakte Wissenschaftlichkeit der Kunstgeschichte." In his letter of 9 January 1904 Dvořák praised the scientific criticism and method embodied in Goldschmidt's collected essays on Saxon sculpture (1902), terming the publication "das unbedingte Beste . . . was in den letzten Jahrzehnten auf dem Gebiete der mittelalterlichen Kunst geschrieben wurde." See also Dvořák's review, "Adolph Goldschmidt, *Studien zur Geschichte der sächsischen Skulptur,*" *Kunstgeschichtliche Anzeigen* 1 (1904), pp. 32–34, in which he praised the work of Goldschmidt, as well as that of Vöge, Dehio, Swarzenski and others. In a letter of 8 May 1905 (Basel, Universitätsbibliothek, Nachlass Goldschmidt, Brief No. 40), Dvořák stressed the exemplary nature of Goldschmidt's scholarship: "Man sollte *jeden* Aufsatz von Ihnen in den Seminarübungen durchnehmen, um daran zu zeigen, wie eine kunsthistorische Untersuchung gemacht werden muss."

60. Ibid., letter of 28 December 1903.

61. Chickering, *Karl Lamprecht,* pp. 254–83, esp. pp. 263–67.

62. Wilhelm Worringer, whose writings included *Abstraktion und Einfühlung. Ein Beitrag zur Stilpsychologie* (Munich: R. Piper, 1908) and *Formprobleme der Gotik* (Munich: R. Piper, 1911), was highly influential in this regard. In contrast to Vöge, he was primarily interested in evoking collective rather than individualized mental attitudes in the Middle Ages. The extent of Worringer's exposure to Vöge's 1894 book is unclear, for his writings were accompanied by very little scholarly apparatus. Other writers of the Expressionist era referred specifically to Vöge's work. See, for instance, Heinrich Lempertz, *Wesen der Gotik* (Leipzig:

K. Hiersemann, 1926); the author stated in the introduction, p. vi, that the book was completed in 1920. In his exploration of *gotisches Wollen* (p. v), Lempertz repeatedly cited Vöge's *Die Anfänge des monumentalen Stiles*, as well as his 1914 essay "Die Bahnbrecher des Naturstudiums" together with the writings of such scholars as Worringer, Dvořák and Lipps. For a recent study of the nature and impact of the so-called Gothic mentality in the Expressionist era, see Magdalena Bushart, *Der Geist der Gotik und die expressionistische Kunst. Kunstgeschichte und Kunsttheorie, 1911–1925* (Munich: Verlag Silke Schreiber, 1990). See also the essays in *Invisible Cathedrals: The Expressionist Art History of Wilhelm Worringer*, ed. Neil H. Donahue (University Park: Pennsylvania State Univ. Press, 1995), which has appeared just as this book is going to press.

63. Richard Hamann and Felix Rosenfeld, *Der Magdeburger Dom. Beiträge zur Geschichte und Ästhetik mittelalterlicher Architektur, Ornamentik und Skulptur* (Berlin: G. Grote, 1910), pp. v–vii, esp. pp. vi–vii: "Es handelt sich um die Bewährung einer rein ästhetischen kunstgeschichtlichen Methode in architektonischen Untersuchungen. . . . In dieser Methode werden viele einen Gegensatz zu der gerade in architektonischen Monographien fast ausschliesslich geübten technischen erblicken, und sie wird vielleicht die Fachleute zunächst befremden. Aber wenn in dieser Arbeit, schon der methodischen Bedeutung wegen, die stilkritisch-ästhetische Methode allein zu Wort kommt, so soll damit nicht für sie ein ausschliessliches Recht auf wissenschaftliche Bedeutung proklamiert werden. Beide Untersuchungsweisen müssen sich zu gemeinsamer Arbeit verbinden. . . . In der künstlerischen Erfassung mittelalterlicher Kunst sind wir durch Dehios und Bezolds grosses Werk auf Schritt und Tritt bestärkt worden. Vor allem aber fühlen wir uns eins mit der Gesinnung, die in W. Vöges grundlegendem Buch über den 'monumentalen Stil' niedergelegt ist. Ihm, der auch persönlich an dem vorliegenden Werke mit freundlichen Ratschlägen Anteil hat, ist die Widmung in Dankbarkeit dargebracht." Hamann's collaborator Rosenfeld was an archivist.

64. See the preceding note.

65. Hamann's *Der Magdeburger Dom* was approved as an *Habilitationsschrift* by Wölfflin in 1911. For Hamann, see the entry by Frieda Dettweiler, *Neue Deutsche Biographie*, vol. 7 (Berlin: Duncker und Humblot, 1966), pp. 578–79; *Richard Hamann in Memoriam, mit zwei nachgelassenen Aufsätzen und einer Bibliographie der Werke Richard Hamanns* (Berlin: Akademie-Verlag, 1963); Gustav André, "Richard Hamann (1879–1961), Kunsthistoriker," *Marburger Gelehrte in der ersten Hälfte des 20. Jahrhunderts*, ed. Ingeborg Schnack (Marburg: Elwert, 1977), pp. 124–41; Peter H. Feist, "Beiträge Richard Hamanns zur Methodik der Kunstgeschichtsschreibung," *Sitzungsberichte der Akademie der Wissenschaften der DDR. Gesellschaftswissenschaften* (1980, no. 1/G), pp. 3–20. During his long career Hamann undertook major campaigns to photograph works of art (especially works of medieval art and architecture) all over Europe. The large collection of photographs he assembled led him to establish the celebrated photographic archive of the Kunstgeschichtliches Seminar in Marburg, known today as the Bildarchiv Foto Marburg.

66. For instance, Richard Hamann, "Individualismus und Aesthetik," *Zeitschrift für Aesthetik und allgemeine Kunstwissenschaft* 1 (1906), pp. 312–22; "Über die psychologischen Grundlagen des Bewegungsbegriffes," *Zeitschrift für Psychologie* 45 (1907), pp. 231–54, 341–77; "Das Wesen des Plastischen," *Zeitschrift für Aesthetik und allgemeine Kunstwissenschaft* 3 (1908), pp. 1–46.

67. Letter from Dvořák to Vöge dated Vienna, 10 July 1905 (Landesamt für Denkmalpflege Sachsen-Anhalt): "Verärgern Sie mir nicht, wenn ich mich im Namen Wickhoffs und eigenem noch einmal an Sie wende mit der Bitte, an unseren Kunstgeschichtlichen Anzeigen mitzuarbeiten. Sie nehmen unter den wenigen Leuten, die die Kunstgeschichte wissenschaftlich betreiben, eine solche Stelle ein, und wir verehren Sie so, dass uns ungemein

viel daran gelegen ist, dass Sie sich an unserem Unternehmen beteiligen – entschuldigen Sie damit bitte mein so häufiges Anfragen." Vöge agreed to write a book review; see Wilhelm Vöge, "Richard Reiche, *Das Portal des Paradieses am Dom zu Paderborn. Ein Beitrag zur Geschichte der deutschen Bildhauerkunst des 13. Jahrhunderts,* Münster, Regensburg, 1905," *Kunstgeschichtliche Anzeigen* 3 (1906), pp. 1–10.

68. Max Dvořák, "Idealismus und Naturalismus in der gotischen Skulptur und Malerei," *Historische Zeitschrift* 119 (1918), pp. 1–62, 185–246, reprinted in Dvořák, *Kunstgeschichte als Geistesgeschichte* (Munich: R. Piper, 1924), pp. 41–147. See also the English translation of Dvořák's text, *Idealism and Naturalism in Gothic Art,* trans. Randolph J. Klawiter (Notre Dame, Ind.: Univ. of Notre Dame Press, 1967).

69. Letter from Dvořák to Vöge dated Vienna 2 June 1914 (Landesamt für Denkmalpflege Sachsen-Anhalt): "Wollen Sie meinen wärmsten Dank für Ihren Aufsatz entgegennehmen, über den ich mich unendlich freute. Wenn doch das Buch, das Sie über die französische Skulptur des XIII. Jahrhunderts schreiben wollten, doch geschrieben werden könnte! Welch ein Ereignis wäre dies für die Kunstgeschichte! Doch auch die Fragmente sind neue Etappen, und wir müssen Ihnen für jedes Wort dankbar sein."

70. At least five letters from Pinder to Vöge survive among Vöge's papers (Landesamt für Denkmalpflege Sachsen-Anhalt). A letter to Vöge from Würzburg dated 29 December 1907, for instance, shows that the two men were on relatively close terms. After unintentionally creating a rhyme in two successive clauses of his letter to Vöge, Pinder evoked the elder scholar's literary skills: "Der unfreiwillige Reim erinnert mich, dass meine Muse noch vergebens auf eine Vöge'sche Ballade harrt!" After Vöge sent Pinder a copy of his article "Konrad Meits vermeintliche Jugendwerke und ihr Meister," *Jahrbuch für Kunstwissenschaft* (1927), pp. 24–38 (Vöge's first article to be published following his 1915 breakdown), Pinder thanked him in a letter from Munich dated 9 February 1928: "Sie können sich gar nicht vorstellen, welche tiefe Freude die Übersendung Ihres Aufsatzes mir gemacht hat! Das Schicksal – es konnte nicht Zufall sein – fügte, dass ich gerade von Ihnen zu sprechen hatte. Und das Münchner Auditorium maximum hörte meinen Dank und meine tiefe Freude, dass 'diese feinste Stimme unter den deutschen Kunsthistorikern sich wieder hören liess,' und was das alles für uns bedeutet. Was ist das für ein Takt der Sprache, wie biegt sich jeder Satz um seinen Inhalt!" Vöge contributed an essay to a *Festschrift* commemorating Pinder's sixtieth birthday; see Wilhelm Vöge, "Der Meister des Grafen von Kirchberg," *Festschrift Wilhelm Pinder zum 60. Geburtstage* (Leipzig: E. A. Seemann, 1938), pp. 325–47. Pinder later gained notoriety as the most prominent art historian in Germany during the Nazi regime; Vöge's admiration of Pinder's scholarship had, however, taken root long before these events.

71. Wilhelm Pinder, *Der Naumburger Dom und seine Bildwerke* (Berlin: Deutscher Kunstverlag, 1925).

72. For the most recent study of Pinder, with a comprehensive bibliography, see Marlite Halbertsma, *Wilhelm Pinder und die deutsche Kunstgeschichte,* trans. Martin Püschel (Worms: Wernersche Verlagsgesellschaft, 1992). Halbertsma has summarized recent debates in Germany concerning Pinder's activities during the Nazi era. On page 28, she comments on the relationship between Vöge's *Die Anfänge des monumentalen Stiles* and Pinder's early writings, esp. his *Mittelalterliche Plastik Würzburgs. Ein Versuch einer lokalen Entwickelungsgeschichte vom Ende des 13. bis zum Anfang des 15. Jahrhunderts* (Würzburg, 1911; 2d ed. Leipzig: C. Kabitzsch, 1924).

73. As we saw earlier, the reviewers of Goldschmidt's 1889 dissertation (see Chapter 1, note 129) and his 1895 *Habilitationsschrift* on the Albani Psalter (see Chapter 3, note 29) lauded his analytical rigor and "scientific" approach. Most of Goldschmidt's other publications during the 1890s appeared as articles and therefore did not receive extensive treatment in

reviews (most of his major books, as I noted at the beginning of this chapter, postdate 1900). "Scientific" responses to Goldschmidt's *Studien zur Geschichte der sächsischen Skulptur* (1902) included the review by Dvořák (cited in note 59 to this chapter); and Georg Dehio, "Adolph Goldschmidt, *Studien zur Geschichte der sächsischen Skulptur in der Übergangszeit vom romanischen zum gotischen Stil," Repertorium für Kunstwissenschaft* 25 (1902), pp. 460–64. See also Klaus Niehr's comprehensive discussion of the impact of Goldschmidt's work on later scholarship concerning Saxon sculpture (Chapter 3, note 34). Goldschmidt's "objective" and systematic *Stilkritik* was often subject to formulaic imitation by other scholars; see, for example, Kurt Freyer, "Entwicklungslinien in der sächsischen Plastik des 13. Jahrhunderts," *Monatshefte für Kunstwissenschaft* 4 (1911), pp. 261–75. See the related discussion of 1920s scholarship in Chapter 5.

Chapter 5. Implications for Later Discourse in Medieval Art History

1. See the bibliography of Vöge's late works in *Bildhauer des Mittelalters,* pp. 247–48. The exception was an article exploring the artistic sources of Donatello: "Donatello greift ein reimsisches Motiv auf," *Festschrift für Hans Jantzen* (Berlin: Gebr. Mann, 1951), pp. 117–27.

2. Goldschmidt, *Die Elfenbeinskulpturen.*

3. See, for instance, Wolfgang F. Volbach, *Elfenbeinarbeiten der Spätantike und des frühen Mittelalters,* 2d ed. (Mainz: Römisch-Germanisches Zentralmuseum, 1952); the first edition appeared in 1916.

4. Adolph Goldschmidt, *Gotische Madonnenstatuen in Deutschland* (Augsburg: B. Filser, 1923); *Die Skulpturen von Freiberg und Wechselburg* (Berlin: B. Cassirer, 1924).

5. Adolph Goldschmidt, *Die deutschen Bronzetüren des frühen Mittelalters. Die frühmittelalterlichen Bronzetüren I* (Marburg: Verlag des Kunstgeschichtlichen Seminars, 1926); *Die Bronzetüren von Nowgorod und Gnesen. Die frühmittelalterlichen Bronzetüren II* (Marburg: Verlag des Kunstgeschichtlichen Seminars, 1932).

6. Adolph Goldschmidt, *Die deutsche Buchmalerei,* 2 vols. (Munich: K. Wolff, 1928); *German Illumination,* 2 vols. (New York: Harcourt, Brace, 1928).

7. See *Festschrift für Adolph Goldschmidt zum 60. Geburtstag am 15. Januar 1923,* pp. 143–48, and *Das siebente Jahrzehnt. Festschrift Adolph Goldschmidt zu seinem 70. Geburtstag,* pp. 173–74.

8. Some of these materials are preserved among Vöge's papers at the Landesamt für Denkmalpflege Sachsen-Anhalt. I will discuss the epistolary exchange between Vöge and Panofsky in a separate study.

9. Most studies to date, such as the collection of essays in Lorenz Dittmann, ed., *Kategorien und Methoden der deutschen Kunstgeschichte, 1900–1930* (Wiesbaden: F. Steiner, 1985), have been general in scope.

10. For instance, Erwin Panofsky, *Die deutsche Plastik des elften bis dreizehnten Jahrhunderts,* 2 vols. (Munich: K. Wolff, 1924); Wilhelm Pinder, *Der Naumburger Dom und seine Bildwerke;* idem, *Die deutsche Plastik vom ausgehenden Mittelalter bis zum Ende der Renaissance* (Wildpark-Potsdam: Verlagsgesellschaft Athenaion, 1924).

11. Johannes Jahn, ed., *Die Kunstwissenschaft der Gegenwart in Selbstdarstellungen* (Leipzig: Felix Meiner, 1924). For an account of Jahn's career, see Ernst Ullmann, ed., *Kunstwerk, Künstler, Kunstgeschichte. Ausgewählte Schriften von Johannes Jahn* (Leipzig: E. A. Seemann, 1982), esp. pp. 259–66. See Heinrich Dilly's recent comments on Jahn's undertaking in the introduction to Martina Sitt, ed., *Kunsthistoriker in eigener Sache. Zehn autobiographische Skizzen* (Berlin: Dietrich Reimer Verlag, 1990), esp. pp. 11–19. Sitt consciously conceived her compila-

tion of ten autobiographical sketches by prominent art historians of today as an "updated" pendant to Jahn's 1924 publication.

12. Jahn, *Die Kunstwissenschaft der Gegenwart in Selbstdarstellungen*, pp. iii–viii.

13. See Jahn's comments, ibid., p. vii.

14. Ibid., p. iii: "Die letzten dreissig Jahre waren von ausserordentlicher Wichtigkeit für die methodische Weiterbildung des Faches. Den wesentlichsten Anteil daran hat die neue formalistische Einstellung."

15. Ibid., pp. iii–iv, esp. p. iv: "Natürlich hängt die Ausbreitung des Fachgebietes auch mit wichtigen modernen Lebensinteressen zusammen, die sich in der bildenden Kunst unserer Zeit widerspiegeln; der Sinn für das Primitive und das Expressive hat uns manche Gebiete ganz neu gezeigt und andere, schon bekannte, neu gedeutet."

16. Ibid., p. v: "Hand in Hand mit dieser Ausdehnung des Arbeitsgebietes ging eine Vertiefung der Forschungsmethoden. Das wichtigste Fortschrittsmoment war dabei die schon eingangs erwähnte Konzentration auf das Wesen und Entwicklung der Form am historischen Kunstwerk. . . . Und wie wichtig ist die Konzentration auf plastische Formprobleme für die Erkenntnis des Wesens und der Filiation mittelalterlicher Plastik geworden!"

17. Ibid., pp. v–vi.

18. Jahn outlined major intellectual trends in art history; he did not name specific individuals in his account. Jahn's own publications, including *Kompositionsgesetze französischer Reliefplastik im 12. und 13. Jahrhundert* (Leipzig: K. W. Hiersemann, 1922) and *Schmuckformen des Naumburger Domes* (Leipzig: E. A. Seemann, 1944), were largely formalist in orientation.

19. Jahn, *Die Kunstwissenschaft der Gegenwart in Selbstdarstellungen*, pp. v–vi.

20. Ibid.

21. Ibid., pp. vi–vii: "Der Forscher soll versuchen, das Kunstwerk nicht nur als Offenbarung von Formkräften und als Produkt der sozusagen materiellen Bedingungen einer bestimmten Kultur zu sehen, sondern er soll es als Ausdruck einer geistigen Gesamthaltung zu begreifen suchen, die als eigentliche erzeugende Kraft hinter ihm steht und die aus ihren einzelnen Äusserungen in Politik, Religion, Wissenschaft möglichst umfassend zu erschliessen ist."

22. Ibid., p. vii.

23. Ibid.

24. Ibid., p. vii: "Manche Forscher, und unter ihnen einige der besten Förderer ihres Faches . . . halten die Diskussion dieser Fragen kunstwissenschaftlicher Systematik für überflüssig und unfruchtbar und sehen im eifrigen Sammeln, Analysieren und Vergleichen des Materials das einzige Heil. Und doch lässt sich beobachten, dass ihre Arbeitsweise von den allgemeinen Gedanken, die von den anderen systematisch eingestellten Naturen nicht geschaffen, sondern nur formuliert werden, beeinflusst wird, und dass wiederum ihr spezielles Arbeiten den Nährboden systematischer Gedankengänge bildet – ein gleichzeitiges Nehmen und Geben."

25. Hermann Beenken, *Romanische Skulptur in Deutschland, 11. und 12. Jahrhundert* (Leipzig: Klinkhardt und Biermann, 1924).

26. Beenken, ibid., made numerous references to the dialogue between medieval and contemporary art in his book. See, for instance, p. xiv: "Vielmehr hat uns die Kunst unserer eigenen Tage den Sinn geweckt für die Grösse und Wirkungsgehalt mittelalterlicher Form, für die ursprüngliche Stilkraft vor allem der romanischen Kunst, der wir uns selber in keiner Weise gewachsen fühlen." Compare also Pinder, *Die deutsche Plastik vom ausgehenden Mittelalter*, p. viii. Eduard Trier, "Kategorien der Plastik in der deutschen Kunstgeschichte der zwanziger Jahre," *Kategorien und Methoden der deutschen Kunstgeschichte, 1900–1930*, pp. 39–49, has explored some of the ways in which the study of medieval sculpture was often

framed by concepts and terms borrowed from modern (i.e., contemporary) sculptural production during the 1920s.

27. Beenken's study appeared at virtually the same moment as Eugen Lüthgen's *Romanische Plastik in Deutschland* (Bonn: Kurt Schroeder, 1923). Lüthgen, of the University of Bonn, dedicated his monograph to the memory of Alois Riegl; Beenken dedicated his to his teacher, Wölfflin. Both books were concerned with tracing formal laws in Romanesque sculpture.

28. For Beenken's career, see Werner Gross, "Hermann Beenken, + 6. April 1952," *Kunstchronik* 5 (1952), pp. 153–56. His other publications on medieval sculpture included *Bildhauer des vierzehnten Jahrhunderts am Rhein und in Schwaben* (Leipzig: Insel-Verlag, 1927), *Bildwerke des Bamberger Doms aus dem 13. Jahrhundert* (Bonn: F. Cohen, 1925) and *Der Meister von Naumburg* (Berlin: Rembrandt-Verlag, 1939).

29. A number of letters written by Beenken to Vöge during the 1920s are preserved at the Landesamt für Denkmalpflege Sachsen-Anhalt. Beenken is also mentioned in a number of Vöge's letters to Goldschmidt during the same years.

30. Hermann Beenken, "Die Tympana von La Charité sur Loire," *Art Studies* 6 (1928), pp. 145–59.

31. Beenken, *Romanische Skulptur in Deutschland*, p. vii: "Das behandelte Gebiet [Romanesque sculpture] bedingt seiner Natur nach eine Ausführlichkeit der Analyse von stilistischen Phänomenen. . . . Das liegt daran, dass die Analyse zugleich Begründung ist für die historische Einordnung des Materials."

32. Ibid., p. viii.

33. Ibid.: "Dennoch verlangt historischer Ordnungssinn, dass wir Verbindungen und Fixierungen suchen." Throughout his book Beenken discussed individual works of sculpture as representing specific steps or phases (*Stufen*) in the development (*Fortschritt*) of the Romanesque style.

34. For instance, ibid., p. xv: "Es geht nicht an, einfach mit den subjektiven Gedanken und Gefühlen, die zufällig in uns auftauchen, an die Dinge heranzutreten, sondern es gilt zunächst, historische Distanz und historische Perspektive zu gewinnen. Das geschieht durch systematische Vergleichung eines Stils mit anderen Stilen, durch Einordnung in die Entwicklung und die ihr innewohnende Logik."

35. Ibid., pp. xxxvii–xxxviii, where Beenken virtually studied the ground plans and cross sections of drapery folds in order to characterize stylistic currents at different sites: "Die Trierer Falten sind vergleichsweise formlos im Querschnitt wie im Längsverlauf. Zwischen unbestimmt durchschattete Furchen gebettet, quellen und wehen sie auf, schichten sich; aber nicht durchgreifend, so dass es beim Nebeneinander bleibt und kein Übereinander entsteht. In Odilienberg dagegen ist man versucht, den Grundriss der Falten zu zeichnen, so tastbar sind sie in den begrenzenden Flächen, so fest sich gegen ihre Umgebung stellend, so eindeutig und bestimmt in der Schichtung."

36. Panofsky, *Die deutsche Plastik*. See the recent comments on this book by Joan Hart, "Erwin Panofsky and Karl Mannheim: A Dialogue on Interpretation," *Critical Inquiry* 19 (1993), p. 542.

37. Hans Weigert, *Die Stilstufen der deutschen Plastik von 1250 bis 1350* (Marburg: Verlag des Kunstgeschichtlichen Seminars, 1927). Weigert, pp. 1–2, stated that his book was based on his 1924 Leipzig dissertation (supervised by Pinder); Weigert also thanked Hamann for supporting his research.

38. Weigert, for instance, p. 105, compared and contrasted medieval sculpted forms with works of Auguste Rodin (1840–1917) and Aristide Maillol (1861–1944). For comments on Weigert's conceptual and terminological borrowings from twentieth-century art, see Trier, "Kategorien der Plastik," esp. pp. 40–41.

39. Weigert, *Die Stilstufen,* "Die Gründe," pp. 102–08.
40. Beenken, *Romanische Skulptur in Deutschland,* pp. xxxix (Master of Saxon Choir Enclosures), 162 (Gustorf Master).
41. For example, ibid., pp. 156, 160.
42. An overview of the scholarship published on the Samson Master by Karl-August Wirth, "Beiträge zum Problem des 'Samsonmeisters,'" *Zeitschrift für Kunstgeschichte* 20 (1957), pp. 25–51, indicates clearly that the master's "birth" occurred during the 1920s. For the 1920s and 1930s scholarship on the Naumburg Master, including Hermann Beenken's 1939 artistic biography *Der Meister von Naumburg,* see my article "The Naumburg Master: A Chapter in the Development of Medieval Art History."
43. For instance, Panofsky, *Die deutsche Plastik,* vol. 1, pp. 146–58, discussed the stylistic development and artistic career of the Naumburg Master. Hans Jantzen, *Deutsche Bildhauer des dreizehnten Jahrhunderts* (Leipzig: Insel-Verlag, 1925), examined the itineraries and artistic unfolding of thirteenth-century German masters, including the Strasbourg Master, the Naumburg Master and various Bamberg masters.
44. Letter to Goldschmidt dated 2 January 1927 in Ballenstedt: "Es wird so erschrecklich viel verfasst auch über das 13. Jahrhundert, dass man nur in grossen Instituten noch mitkommen kann. All die Scheidungen nach Meistern und Händen, wie Beenken u. a. sie jetzt betreiben, missfallen mir sehr. . . . In wie viele Hände würden sie wohl das Düreroeuvre zerlegen! Wie schade, dass es verhältnismässig so gut gesichert ist; denn da könnten viele dieser Leute Beschäftigung finden."
45. Marcel Aubert, *La Sculpture française du moyen âge et de la renaissance* (Paris: Librairie Nationale d'Art et d'Histoire, 1926); idem, *La Sculpture française au début de l'époque gothique, 1140–1225* (Florence and Paris: Pantheon and Éditions du Pégase, 1929); and Paul Deschamps, *La Sculpture française à l'époque romane, XIe et XIIe siècles* (Florence and Paris: Pantheon and Éditions du Pégase, 1930). Aubert, *La Sculpture française . . . l'époque gothique,* for instance, pp. 58–60, 112, discussed certain hypotheses of Vöge and de Lasteyrie's refutation of them; Deschamps, *La Sculpture française . . . l'époque romane* cited Vöge's *Die Anfänge* in his bibliography.
46. Fred H. Crossley, *English Church Monuments, A.D. 1150–1550: An Introduction to the Study of Tombs and Effigies of the Mediaeval Period* (London: B. T. Batsford, 1921). In addition to describing the tombs and the costume of the effigies, Crossley compiled a chronological list of monuments.
47. Arthur Gardner, *French Sculpture of the Thirteenth Century: Seventy-eight Examples of Masterpieces of Medieval Art Illustrating the Works at Reims and Showing their Place in the History of Sculpture* (London: Philip Lee Warner, 1915); idem, *Medieval Sculpture in France* (Cambridge: Cambridge Univ. Press, 1931); and idem, *A Handbook of English Medieval Sculpture* (Cambridge: Cambridge Univ. Press, 1935). In the introduction to *Medieval Sculpture in France,* pp. xiii–xviv, Gardner stated that his discussion of "local antiquities" in France was intended "for the intelligent tourist as well as the student." He surveyed the scholarship in the field, citing British, French and American publications exclusively.
48. I am currently preparing a series of essays examining the dynamics of exchange between European and American historians of medieval art following World War I. Some of the comments that follow here are based on archival work already conducted for that project.
49. For a recent introduction to this subject, see *The Early Years of Art History in the United States: Notes and Essays on Departments, Teaching, and Scholars,* ed. Craig Hugh Smyth and Peter M. Lukehart (Princeton: Princeton Univ. Press, 1993), hereafter cited as *The Early Years of Art History in the United States.* A survey of American institutions offering art instruction was conducted prior to World War I; see Earl Baldwin Smith, *The Study of the History of Art in the Colleges and Universities of the United States* (Princeton: Princeton Univ. Press, 1912), reprinted in *The Early Years of Art History in the United States,* pp. 12–36.

50. Henry Adams, *Mont-Saint-Michel and Chartres* (Washington, D.C.: private printing, 1904; Boston: Houghton-Mifflin, 1905).

51. See Cahn and Seidel, *Romanesque Sculpture in American Collections*, pp. 1–16, esp. 10–16, and, more recently, Caroline Bruzelius, "Introduction," *The Brummer Collection of Medieval Art, Duke University Museum of Art*, ed. Caroline Bruzelius with Jill Meredith (Durham: Duke Univ. Press, 1991), pp. 1–11.

52. See, for instance, the comments of Erwin Panofsky in a 1926 review: "Literatur: Hans Jantzen, *Deutsche Bildhauer des dreizehnten Jahrhunderts*, Leipzig, 1925," *Repertorium für Kunstwissenschaft* 47 (1926), p. 54: "Die besonderen Bedingungen der Kriegs- und Nach-kriegszeit, deren äussere Notlage die deutsche Forschung zu einer weitgehenden Beschrän-kung auf den einheimischen Denkmälerbestand zwang . . . haben es im Verein mit einer allgemeinen Vorliebe für das Mittelalter zu Wege gebracht, dass in den letzten Jahren kaum ein Gebiet der Kunstgeschichte intensiver bearbeitet worden ist, als das der deutschen mittelalterlichen Plastik."

53. They were the largest in terms of students and faculty during the 1920s. In the years around 1930 a Graduate Department of Fine Arts was established at New York University, where undergraduate instruction in art history had existed since 1923. Under the leadership of Walter W. S. Cook (1888–1962), the Institute of Fine Arts, as it was renamed, acquired pivotal significance during the 1930s with the arrival of German émigré scholars. See Craig Hugh Smyth, "The Department of Fine Arts for Graduate Students at New York University," *The Early Years of Art History in the United States*, pp. 73–78. For the development of instruction in art history in the United States, see Panofsky's 1953 essay, "Three Decades of Art History in the United States," *Meaning in the Visual Arts*, pp. 321–46. For the history of the Princeton Department of Art and Archaeology, see Marilyn Aronberg Lavin, *The Eye of the Tiger: The Founding and Development of the Department of Art and Archaeology, 1883–1923, Princeton University* (Princeton: Department of Art and Archaeology and the Art Museum, Princeton University, 1983), with reference to developments at other American universi-ties. For the Harvard and Princeton departments, see also *The Early Years of Art History in the United States*.

54. See the list of executive members in the *Bulletin of the College Art Association* 1 (1913), as well as the accompanying discussion by Holmes Smith of the "Problems of the College Art Association," pp. 6–10.

55. See Lavin, *The Eye of the Tiger*, p. 23; Smyth, "Concerning Charles Rufus Morey (1877–1955)," *The Early Years of Art History in the United States*, pp. 111–21, with bibliography. For the index, see also Helen Woodruff, *The Index of Christian Art at Princeton University: A Handbook* (Princeton: Princeton Univ. Press, 1942), and Irving Lavin, "Iconography as a Humanistic Discipline ('Iconography at the Crossroads')," *Iconography at the Crossroads*, ed. Brendan Cassidy (Princeton: Princeton Univ. Press, 1993), pp. 33–41, with bibliography.

56. For the scholars at Princeton University, see Lavin, *The Eye of the Tiger*, and the essays in *The Early Years of Art History in the United States*, esp. Smyth, "The Princeton Department in the Time of Morey," pp. 37–42. For an examination of the development of medieval studies generally in America, see Francis G. Gentry and Christopher Kleinhenz, eds., *Me-dieval Studies in North America: Past, Present, and Future* (Kalamazoo, Mich.: Medieval Insti-tute Publications, 1982), esp. William J. Courtenay, "The Virgin and the Dynamo: The Growth of Medieval Studies in America (1870–1930)," pp. 5–22, and Luke Wenger, "The Medieval Academy and Medieval Studies in North America," pp. 23–40. The Medieval Academy of America and its scholarly organ, *Speculum: A Journal of Medieval Studies*, were founded in 1926 in Cambridge, Massachusetts.

57. Lavin, *The Eye of the Tiger*, p. 25, has discussed the Harvard-Princeton Fine Arts Club of the 1920s and the joint endeavors of the graduate students and professors. *Art Studies:*

Medieval, Renaissance and Modern, edited by Frank Jewett Mather of Princeton and Arthur Kingsley Porter of Harvard, appeared between 1923 and 1930 (eight volumes in all). It had a distinguished advisory council of scholars from France, Germany, Italy, Scandinavia and England.

58. Arthur Kingsley Porter, *Medieval Architecture: Its Origins and Development,* 2 vols. (New York: Baker and Taylor, 1909); *Lombard Architecture,* 4 vols. (New Haven: Yale Univ. Press, 1915–17). For an account of Porter's career (written by his wife, Lucy Kingsley Porter) and a bibliography of his writings, see Wilhelm R. W. Koehler, ed., *Medieval Studies in Memory of A. Kingsley Porter,* 2 vols. (Cambridge, Mass.: Harvard Univ. Press, 1939), pp. xi–xxiv. For a recent assessment of Porter's early publications on medieval architecture, see Linda Seidel, "The Scholar and the Studio: A. Kingsley Porter and the Study of Medieval Architecture in the Decade before the War," *The Architectural Historian in America,* Studies in the History of Art, 35; *Center For Advanced Study in the Visual Arts, Symposium Papers, XIX* (Hanover, N.H.: University Press of New England, 1990), pp. 145–58. See Seidel, "Arthur Kingsley Porter: Life, Legend and Legacy," *The Early Years of Art History in the United States,* pp. 97–110, for a recent attempt to contextualize Porter's scholarship in relation to his life, personality and political and social concerns.

59. Porter's first publication devoted exclusively to medieval sculpture was "The Development of Sculpture in Lombardy in the Twelfth Century," *American Journal of Archaeology* 19 (1915), pp. 137–54. For his many later studies, see the complete bibliography in Koehler, ed., *Medieval Studies in Memory of A. Kingsley Porter,* pp. xvii–xxiv.

60. Arthur Kingsley Porter, *Romanesque Sculpture of the Pilgrimage Roads,* 10 vols. (Boston: Marshall Jones, 1923). Like Richard Hamann in Germany (see Chapter 4, note 65), Porter undertook a major campaign to photograph medieval monuments (particularly in France, Spain, Italy and Ireland) in the years following World War I. His collection of photographs now belongs to the Fine Arts Library at Harvard University. On this topic, see most recently Friedrich Kestel, "The Arthur Kingsley Porter Collection of Photography and the European Preservation of Monuments," *Visual Resources* 9 (1994), pp. 361–81.

61. Porter, *Romanesque Sculpture of the Pilgrimage Roads,* vol. 1, Part I, Chapter 1, "The Chronological Problem," pp. 3–17, esp. pp. 12–15, for the arguments sketched here.

62. Ibid., p. 17.

63. Ibid., esp. pp. 171–96. Although novel in the field of art history, Porter's conception of the role of the pilgrimage roads in disseminating artistic influences was based on theories expounded earlier by Joseph Bédier, a French literary scholar who had argued for the importance of the routes in the development of the medieval epic. Bédier's *Les Légendes épiques. Recherches sur la formation des chansons de geste,* 4 vols. (Paris: H. Champion, 1908–13) was cited by Porter in his bibliography, p. 343.

64. Porter considered written documentary evidence (when available), in addition to employing stylistic analysis.

65. See, for instance, Otto Schmitt, "A. Kingsley Porter, *Romanesque Sculpture of the Pilgrimage Roads,*" *Jahrbuch für Kunstwissenschaft* (1927), pp. 266–69. Although Schmitt admired the American scholar's ideas, he was more critical of Porter's use of stylistic analysis, as on p. 267: "Gewiss hat P. mit frischem Sinn oft das Richtige gesehen und Zusammenhänge erkannt, die der früheren Forschung entgangen waren. Aber viel häufiger hat man den Eindruck, dass er Zusammenhänge und Abhängigkeiten sieht, wo sie gar nicht bestehen. Die Schuld daran trägt seine mangelhafte Stilanalyse und Stilkritik, die nicht tief genug schürft; er baut seine Filiation allzuoft auf einzelne und äusserliche Motive auf, gerade als ob Stil nicht mehr als Addition von Motiven sei!" Schmitt went on to cite examples.

66. See Porter's discussion and characterization of masters active at St.-Gilles in *Romanesque Sculpture of the Pilgrimage Roads,* vol. 1, pp. 267–302 (the Master of St.-Gilles, the An-

goulême Master, the Third Master, etc.), or at Santiago, for example, p. 238: "Still another sculptor of Santiago has left us the relief of the Creation of Adam embedded in the east buttress. He is an inferior creature who plods along at a respectful distance behind the master of the south portal of St.-Sernin. He follows him so faithfully that he must have worked about the same time. The hand of the same master may be recognized in the portals of San Isidoro of Léon." Seidel, "Arthur Kingsley Porter: Life, Legend and Legacy," pp. 101–03, has recently commented on Porter's fascination with individual itinerant sculptors.

67. I borrow the term from Porter, *Romanesque Sculpture of the Pilgrimage Roads*, vol. 1, p. 15.

68. Ibid., p. 101. Porter referred to Vöge's work numerous times in his book, for instance, pp. 101–02, 164, 285, 293. He had already referred to it in 1909 in *Medieval Architecture*, vol. 2, pp. 112–13. His comments on it in the bibliography to that work, p. 436 ("An important study of French sculpture of the XII century, containing, however, radical errors of judgment"), show that Porter's early assessment of the 1894 study was colored by his reading of de Lasteyrie's critique of it; later he came to recognize its methodological significance. Porter cited Vöge's 1902 article "Der provençalische Einfluss in Italien und das Datum des Arler Porticus" in another early work, *Lombard Architecture*, vol. 1, p. 482. I wish to thank Janice Mann for directing me to these early references.

69. Arthur Kingsley Porter, "A. Kingsley Porter. Kunst und Wissenschaft," *Die Kunstwissenschaft der Gegenwart in Selbstdarstellungen*, pp. 77–93.

70. Ibid., p. 91: "Meine Erstlingswerke standen unter Einfluss der französischen Schule. In jener Zeit konzentrierte diese ihre Aufmerksamkeit fast ausschliesslich auf die Architektur des Mittelalters, und zwar auf deren äussere, technische Seite. Die Analyse von Gewölben, Gesimsen und Mauerwerken wurde mit der grössten Sorgfalt betrieben."

71. Porter, ibid., p. 91, outlined "die Gefahr, dass die feineren, aber eigentlich lebendigen geistigen Triebkräfte der Kunst durch Überschätzung der technischen in den Schatten gestellt werden."

72. Ibid., pp. 91–92.

73. Ibid., p. 92: "Die Morelli-Methode wurde sehr früh durch deutsche Gelehrte aufgegriffen, und ein Deutscher, Wilhelm Vöge, wandte sie zuerst auf die französischen Kunstdenkmäler des Mittelalters an. Ich weiss nun allerdings nicht, ob es auf politische Umtriebe oder auf die natürliche Blindheit der Menschen zurückzuführen ist, dass die Morelli-Methode bei den französischen Kennern des Mittelalters völlig in Misskredit kam. Dies war jedenfalls im höchsten Grade bedauerlich und hat meiner Meinung nach die Entwicklung der Forschungen über das Mittelalter ausserordentlich verzögert und gehemmt."

74. Ibid.

75. Ibid.

76. The earliest dated letter from Porter to Vöge (Landesamt für Denkmalpflege Sachsen-Anhalt) was written on 4 September 1921. In an undated letter to Vöge (from the context, early 1920s) written in Cambridge, Massachusetts, Porter stated: "You have shown the way to your followers, precisely as did the artists whom you study." It is relevant for the broader context of Porter's remarks that Vöge's 1894 book was one of eight titles on medieval sculpture listed in the College Art Association's first compilation of "Books for the College Art Library." See *Art Bulletin* 3 (1920), p. 26. The list included other publications discussed earlier here, such as the Marriages' *The Sculptures of Chartres Cathedral* (1909), Prior and Gardner's *An Account of Mediaeval Figure-Sculpture in England* (1913) and Max Hasak's *Geschichte der deutschen Bildhauerkunst im XIII. Jahrhundert* (1899). In these same years, Vöge's *Die Anfänge des monumentalen Stiles* was cited by Chandler Rathfon Post in *A History of European and American Sculpture from the Early Christian Period to the Present Day* (Cambridge, Mass.: Harvard Univ. Press, 1921), for instance, vol. 1, p. 58; vol. 2, p. 273.

77. Alan Priest, "The Masters of the West Facade of Chartres," *Art Studies* 1 (1923), pp. 28–44.

78. It is also important in this regard that Porter corresponded during the 1920s with the younger generation of German practitioners of a systematic *Stilkritik,* including Hermann Beenken. Porter published a lengthy and favorable review of Beenken's 1924 study of German Romanesque sculpture; see Porter, "Hermann Beenken, *Romanische Skulptur in Deutschland, 11. und 12. Jahrhundert,*" *Speculum* 1 (1926), pp. 233–42. In 1928 Beenken contributed an essay to *Art Studies,* "Die Tympana von La Charité sur Loire."

79. See, for instance, Charles Rufus Morey, "The Sources of Medieval Style," *Art Bulletin* 7 (1924), pp. 35–50, where he ventured to show "the evolution of style in early medieval art" in chart form. See the recent discussion of Morey's thesis by Per Jonas Nordhagen, "C. R. Morey and His Theory on the Development of Early Medieval Art," *Konsthistorisk Tidskrift* 61 (1992), pp. 1–7.

80. Not all American-born scholars of art history were "pure" style historians, though this was the dominant trend. See, for example, the work of Meyer Schapiro (b. 1904), who wrote on both medieval and modern art during the 1930s and 1940s and later (his 1929 Ph.D. dissertation at Columbia University, "The Romanesque Sculpture of Moissac," appeared in *Art Bulletin* 13 [1931], pp. 248–351, 464–531). Many of Schapiro's celebrated studies of Romanesque sculpture were republished in Meyer Schapiro, *Romanesque Art: Selected Papers* (New York: George Braziller, 1977). Schapiro not only considered issues of form, iconography and technique but also incorporated diverse aspects of psychoanalytic theory as well as social and political issues, often under the influence of contemporary (i.e., modern) art and historical events. Much investigative work into the nature of Schapiro's impact on the shaping of art history in America (and medieval art history specifically) remains to be done. An important step in this direction has been taken recently; see the *Oxford Art Journal* 17 (1994), pp. 3–91, for a series of essays exploring diverse aspects of Schapiro's life and career. For his writings on medieval art, see esp. Michael Camille, "'How New York Stole the Idea of Romanesque Art': Medieval, Modern and Postmodern in Meyer Schapiro," pp. 65–75.

81. Goldschmidt's memoirs contain detailed accounts of his three trips to the United States. See Roosen-Runge-Mollwo, *Adolph Goldschmidt. Lebenserinnerungen,* pp. 226–334; 351–85.

82. See Colin Eisler, "*Kunstgeschichte* American Style: A Study in Migration," *The Intellectual Migration: Europe and America, 1930–1960,* ed. Donald Fleming and Bernard Bailyn (Cambridge, Mass.: Harvard Univ. Press, 1969), pp. 544–629.

83. See Joan Hart's recent comments on the development of Panofsky's interpretative approaches during the 1920s and 1930s in "Erwin Panofsky and Karl Mannheim," esp. pp. 537–61. Hart is currently preparing a book on Panofsky. For the intellectual atmosphere in the Kunsthistorisches Seminar at Hamburg University between 1919 and 1933, see Ulrike Wendland, "Arkadien in Hamburg. Studierende und Lehrende am Kunsthistorischen Seminar der Hamburgischen Universität," *Erwin Panofsky. Beiträge des Symposions Hamburg 1992,* pp. 15–29.

84. See, for instance, Wendland (note 83), and Carl Landauer, "The Survival of Antiquity: The German Years of the Warburg Institute," Ph.D. diss. (Yale University, 1984). I am grateful to Dr. Landauer for informing me about this study.

85. For instance, Hans Sedlmayr, *Die Entstehung der Kathedrale* (Zurich: Atlantis Verlag, 1950); Günter Bandmann, *Mittelalterliche Architektur als Bedeutungsträger* (Berlin: Gebr. Mann, 1951); Otto G. von Simson, *Sacred Fortress: Byzantine Art and Statecraft in Ravenna* (Chicago: Univ. of Chicago Press, 1948), and idem, *The Gothic Cathedral: The Origins of Gothic Architecture and the Medieval Concept of Order* (New York: Pantheon, 1956).

86. Corine Schleif, "How Art History Grew Apart after World War II," paper delivered at the annual meeting of the College Art Association, Seattle, February 1993. I wish to thank Professor Schleif for making a copy of her paper available to me. See also her article

"Kunstchronik," *International Art Periodicals,* ed. Winberta Yao (Westport, Conn.: Greenwood Press, in press). See the related comments in Hart, "Erwin Panofsky and Karl Mannheim," pp. 562–66.

87. Panofsky, "Three Decades of Art History in the United States," p. 329–30. Panofsky painted a rosy picture of art history in America; he extolled the virtues of "American positivism" and the university system in general. In his survey of major directions in American art history Panofsky neglected to mention the prominent French scholar Henri Focillon (1881–1943), who taught as a guest professor at Yale University on a regular basis beginning in 1933; at the outbreak of World War II he took a teaching position at Yale and remained there until his death in 1943. For Focillon generally, see the collection of essays in *Henri Focillon,* ed. Jacques Bonnet (Paris: Éditions du Centre Georges Pompidou, 1986). The nature and extent of Focillon's influence on the development of art history in America has not been adequately studied to date.

88. Willibald Sauerländer, "From Stilus to Style: Reflections on the Fate of a Notion," *Art History* 6 (1983), esp. pp. 263–68; in greater detail in "Kleider machen Leute," esp. pp. 223–26, 235 note 80; most recently (1990) in "Zersplitterte Erinnerung," *Kunsthistoriker in eigener Sache,* pp. 301–23, where he discussed his years of intellectual formation. Sauerländer stated, p. 318, that a review of his *Gotische Skulptur in Frankreich* (discussed later in this chapter) entitled "Comparable Carvings" forced him to reassess his own methodological perspectives: "Hatte ich als Resultat jahrelanger Bemühung nicht mehr als eine Topographie und Chronometrie von verglichenen Motiven, Falten und Haaren in der Hand?"

89. Louis Grodecki, "The Transept Portals of Chartres Cathedral: The Date of Their Construction According to Archaeological Data," *Art Bulletin* 33 (1951), p. 156.

90. Richard Hamann, *Die Abteikirche von St. Gilles und ihre künstlerische Nachfolge,* 3 vols. (Berlin: Akademie-Verlag, 1955). Hamann had frequently corresponded with Vöge, following his retreat to Ballenstedt, and also visited him there. In a letter of 12 January 1923, sent to Goldschmidt from Ballenstedt, Vöge stated that Hamann had attempted (without success) to lure him to a teaching position at the Kunstgeschichtliches Seminar at the University of Marburg, for which an expansion was planned: "Hamann war hier . . . er will mich nach Marburg locken, und dort ein Paradies für mittelalterliche Kunstfreunde zu [sic] schaffen." Hamann had been *Ordinarius* at Marburg since 1913. For a discussion of Hamann's conception of Ernst-von-Hülsen Haus, the large new structure built between 1925 and 1927 to house the Marburg seminar and museum, see Martin Warnke, "Richard Hamann," *Marburger Jahrbuch für Kunstwissenschaft* 20 (1981), pp. 11–20.

91. See, for instance, Willibald Sauerländer, *"Bildhauer des Mittelalters. Gesammelte Studien von Wilhelm Vöge,"* *Zeitschrift für Kunstgeschichte* 22 (1959), pp. 49–53; Adolf Katzenellenbogen, "Wilhelm Vöge, *Bildhauer des Mittelalters. Gesammelte Studien,"* *Art Bulletin* 43 (1961), pp. 337–38; Theodor Müller, "Wilhelm Vöge, *Bildhauer des Mittelalters,"* *Kunstchronik* 12 (1959), pp. 335–41. Earlier in the decade, Vöge's death (1952) had occasioned a number of articles that discussed his work. See, for example, Hans Jantzen, "Wilhelm Vöge, + 30. Dezember 1952," *Kunstchronik* 6 (1953), pp. 104–09; Kurt Bauch, "Wilhelm Vöge," *Freiburger Professoren des 19. und 20. Jahrhunderts,* ed. Johannes Vincke (Freiburg im Breisgau: Verlag Eberhard Albert Universitätsbuchhandlung, 1957), pp. 183–90.

92. Louis Grodecki, "La 'Première Sculpture gothique.' Wilhelm Vöge et l'état actuel des problèmes," *Bulletin monumental* 117 (1959), pp. 265–89. Many of Grodecki's publications followed a similar mode of inquiry. See, for instance, "A Stained-glass *Atelier* of the Thirteenth Century. A Study of the Windows in the Cathedrals of Bourges, Chartres and Poitiers," *Journal of the Warburg and Courtauld Institutes* 11 (1948), pp. 87–111.

93. Willibald Sauerländer, *Von Sens bis Strassburg. Ein Beitrag zur kunstgeschichtlichen Stellung der Strassburger Querhausskulpturen* (Berlin: De Gruyter, 1966); *Gotische Skulptur in Frankreich,*

1140–1270 (Munich: Hirmer Verlag, 1970). His earlier articles are listed in these books. During these years Sauerländer began many of his publications with aphorisms borrowed from Vöge's writings. See, for instance, *Von Sens bis Strassburg,* p. 1, and *Gotische Skulptur in Frankreich,* pp. 5–6. See also Reiner Haussherr's review of Sauerländer's method in "Willibald Sauerländer, *Von Sens bis Strassburg,*" *Kunstchronik* 21 (1968), pp. 302–21. Haussherr's review was very much a product of the style-dominated 1960s. Between 1960 and 1963 a group of German scholars undertook to transcribe and publish a book-length manuscript on the sculpture at Reims and Amiens written by Vöge in 1917–18 (see Chapter 3, note 94, to the present volume); this also indicates the high degree of interest Vöge's work engendered among historians of medieval art during the 1950s and 1960s.

94. The following studies were directly or indirectly affected by the revival of Vöge's writings: Bernhard Kerber, *Burgund und die Entwicklung der französischen Kathedralskulptur im zwölften Jahrhundert* (Recklinghausen: Verlag Aurel Bongers, 1966); Whitney S. Stoddard, *The West Portals of Saint-Denis and Chartres: Sculpture in the Ile-de-France from 1140–1190. Theory of Origins* (Cambridge, Mass.: Harvard Univ. Press, 1952; repr. and expanded, New York: W. W. Norton, 1986); Teresa Frisch, "The Twelve Choir Statues of the Cathedral at Reims: Their Stylistic and Chronological Relations to the Sculpture of the North Transept and of the West Facade," *Art Bulletin* 42 (1960), pp. 1–24; Robert Branner, ed., *Chartres Cathedral* (see the introduction, pp. xi–xiii, for his discussion of Vöge's "valuable demonstration of method"; he included two excerpts from Vöge's writings in his anthology); George Zarnecki and Denis Grivot, *Gislebertus: Sculptor of Autun* (New York: Orion Press, 1961).

95. Willibald Sauerländer, *Gothic Sculpture in France, 1140–1270,* trans. Janet Sondheimer (New York: Abrams, 1972); *La Sculpture gothique en France, 1140–1270,* trans. Jacques Chavy (Paris: Flammarion, 1972).

96. Many current publications in both Europe and America could be cited in this regard, but perhaps the clearest (and thematically most appropriate) illustration of the continuity of Vöge-derived "scientific" trends in the study of medieval sculpture is C. Edson Armi's *The "Headmaster" of Chartres and the Origins of "Gothic" Sculpture* (University Park: Pennsylvania State Univ. Press, 1994). This study examines the west facade sculpture of Chartres, as did Vöge's *Die Anfänge des monumentalen Stiles* exactly one hundred years ago. Though differing from Vöge's book in specific results, Armi's book is indebted in both content and method to 1950s and 1960s interpretations of the pioneering German text. Significantly, Armi's book is dedicated to his teacher Robert Branner. Armi's description of Branner's introduction of Vöge's "connoisseurship" to his graduate students at Columbia University during the 1960s (preface, pp. xvii–xviii), as well as the text and bibliography, reveal the intellectual origins of his approach. Armi's *Masons and Sculptors in Romanesque Burgundy: The New Aesthetic of Cluny III,* 2 vols. (University Park: Pennsylvania State Univ. Press, 1983) also displayed a "scientific," master-centered formalism.

Bibliography

Archival sources

Archives Départementales du Bas-Rhin, Strasbourg
 Matriculation records of the Philosophische Fakultät, Kaiser-Wilhelms-Universität, Strasbourg, 1888–92 (AL 103 7 [1 Mi-W.2]).
Hamburg and Hanover
 Private papers of Wilhelm Vöge.
Historisches Archiv der Stadt Köln
 Herbert Schönebaum, "Karl Lamprecht: Leben und Werk eines Kämpfers um die Geschichtswissenschaft 1856–1915," unpub. ms., typescript, 1956.
Kunstgeschichtliches Institut der Albert-Ludwigs-Universität, Freiburg im Breisgau
 Nachlass Wilhelm Vöge.
Landesamt für Denkmalpflege Sachsen-Anhalt, Halle
 Nachlass Wilhelm Vöge.
Rheinisches Amt für Denkmalpflege, Abtei Brauweiler
 Nachlass Paul Clemen.
Staatsarchiv Hamburg
 Nachlass Familie Adolph Goldschmidt (Bestand 622-1).
Staatsbibliothek Preussischer Kulturbesitz, Berlin
 Nachlass Adolph Goldschmidt (Nachlass 168).
Universitätsarchiv Bonn
 Anmeldebücher: Königlich Preussische Rheinische Friedrich–Wilhelms-Universität zu Bonn, 1885–89 (Ernst Burmeister, Paul Clemen, Hermann Ulmann, Wilhelm Vöge, Aby Warburg).
Universitätsarchiv Freiburg im Breisgau
 Personalakten, Bestand B24 (Wilhelm Vöge).

Universitätsbibliothek Basel, Handschriftenabteilung
 Nachlass Adolph Goldschmidt (44 444).
Universitätsbibliothek Bonn, Handschriftenabteilung
 Nachlass Karl Lamprecht (S 2713).
Warburg Institute, University of London
 Warburg's lecture notes from courses with Karl Lamprecht at the Universität Bonn,
 1887–89: "Ausgewählte Kapitel aus der rheinischen Kunstgeschichte" (summer semester
 1887); "Grundzüge der deutschen Kulturentwickelung im Mittelalter" (winter semester,
 1887–88); "Deutsche Geschichte vom Ausgang der Staufer bis auf Kaiser Max" (summer
 semester 1889).

Secondary literature

Adams, Henry. *Mont-Saint-Michel and Chartres.* Washington, D.C.: private printing, 1904; Boston: Houghton-Mifflin, 1905.
Agosti, Giacomo, Maria Elisabetta Manca, Matteo Panzeri and Marisa Dalai Emiliani, eds. *Giovanni Morelli e la cultura dei conoscitori. Atti del Convegno Internazionale, Bergamo, 4–7 giugno 1987.* 3 vols. Bergamo: P. Lubrina, 1993.
Amtliches Verzeichnis des Personals, der Lehrer, Beamten und Studierenden an der königlich bayerischen Ludwig-Maximilians-Universität zu München. Sommer-Semester 1888; Winter-Semester 1888/ 89; Sommer-Semester 1889. Munich: Kgl. Hof- und Universitäts-Buchdruckerei von Dr. C. Wolf und Sohn, 1888 and 1889.
Anderson, Jaynie. "Giovanni Morelli et sa définition de la 'scienza dell'arte.'" *Revue de l'art* 75 (1987): 49–55.
 "Dietro lo pseudonimo." In Giovanni Morelli, *Della Pittura italiana. Studii storico-critici. Le Gallerie Borghese e Doria-Pamphili in Roma.* Ed. Jaynie Anderson. Milan: Adelphi, 1991, pp. 491–578.
 "Giovanni Morelli's Scientific Method of Attribution – Origins and Interpretations." In *L'Art et les révolutions. Section 5: Révolution et évolution de l'histoire de l'art de Warburg à nos jours. Actes du XXVIIe Congrès International d'Histoire de l'Art, Strasbourg 1–7 septembre, 1989.* Strasbourg: Société Alsacienne pour le Développement de l'Histoire de l'Art, 1992, pp. 135–41.
André, Gustav. "Richard Hamann (1879–1961), Kunsthistoriker." In *Marburger Gelehrte in der ersten Hälfte des 20. Jahrhunderts.* Ed. Ingeborg Schnack. Marburg: Elwert, 1977, pp. 124–41.
Annales archéologiques. Paris: Librairie archéologique, 1844–72.
Armi, C. Edson. *Masons and Sculptors in Romanesque Burgundy: The New Aesthetic of Cluny III.* 2 vols. University Park: Pennsylvania State University Press, 1983.
 The "Headmaster" of Chartres and the Origins of "Gothic" Sculpture. University Park: Pennsylvania State University Press, 1994.
Art Bulletin. New York: College Art Association, 1913–.
Art Studies: Medieval, Renaissance and Modern. Cambridge, Mass.: Harvard University Press, 1923–30.
Aubert, Marcel. *La Sculpture française du moyen âge et de la renaissance.* Paris: Librairie Nationale d'Art et d'Histoire, 1926.
 La Sculpture française au début de l'époque gothique, 1140–1225. Florence and Paris: Pantheon and Éditions du Pégase, 1929.
Bandmann, Günter. *Mittelalterliche Architektur als Bedeutungsträger.* Berlin: Gebr. Mann, 1951.

Barnes, Carl F., Jr. *Villard de Honnecourt: The Artist and His Drawings. A Critical Bibliography.* Boston: G. K. Hall, 1982.

Bauch, Kurt. "Wilhelm Vöge." In *Freiburger Professoren des 19. und 20. Jahrhunderts.* Ed. Johannes Vincke. Freiburg im Breisgau: Verlag Eberhard Albert Universitätsbuchhandlung, 1957, pp. 183–90.

"Emil G. Bührle und sein Lehrer." In *Sammlung Emil G. Bührle. Festschrift zu Ehren von Emil G. Bührle zur Eröffnung des Kunsthaus-Neubaus und Katalog der Sammlung Emil G. Bührle.* Zurich: Kunsthaus, 1958, pp. 16–18.

Bazin, Germain. *Histoire de l'histoire de l'art de Vasari à nos jours.* Paris: Albin Michel, 1986.

Bédier, Joseph. *Les Légendes épiques. Recherches sur la formation des chansons de geste.* 4 vols. Paris: H. Champion, 1908–13.

Beenken, Hermann. *Romanische Skulptur in Deutschland, 11. und 12. Jahrhundert.* Leipzig: Klinkhardt und Biermann, 1924.

Bildwerke des Bamberger Doms aus dem 13. Jahrhundert. Bonn: F. Cohen, 1925.

Bildhauer des vierzehnten Jahrhunderts am Rhein und in Schwaben. Leipzig: Insel-Verlag, 1927.

"Die Tympana von La Charité sur Loire." *Art Studies* 6 (1928): 145–59.

Der Meister von Naumburg. Berlin: Rembrandt-Verlag, 1939.

Berenson, Bernard. "The Rudiments of Connoisseurship." In Bernard Berenson, *The Study and Criticism of Italian Art.* 2d series. London: George Bell and Sons, 1902, pp. 111–48.

Beyrodt, Wolfgang. "Kunstgeschichte als Universitätsfach." In *Kunst und Kunsttheorie 1400–1900.* Wolfenbütteler Forschungen, 48. Ed. Peter Ganz, Martin Gosebruch, Nikolaus Meier and Martin Warnke. Wiesbaden: Otto Harrassowitz, 1991, pp. 313–33.

Bickendorf, Gabriele. *Der Beginn der Kunstgeschichtsschreibung unter dem Paradigma "Geschichte." Gustav Friedrich Waagens Frühschrift "Ueber Hubert und Johann van Eyck."* Worms: Wernersche Verlagsgesellschaft, 1985.

"Die Anfänge der historisch-kritischen Kunstgeschichtsschreibung." In *Kunst und Kunsttheorie, 1400–1900.* Wolfenbütteler Forschungen, 48. Ed. Peter Ganz, Martin Gosebruch, Nikolaus Meier and Martin Warnke. Wiesbaden: Otto Harrassowitz, 1991, pp. 359–74.

"Die Tradition der Kennerschaft: Von Lanzi über Rumohr und Waagen zu Morelli." In *Giovanni Morelli e la cultura dei conoscitori. Atti del Convegno Internazionale, Bergamo, 4–7 giugno 1987.* 3 vols. Ed. Giacomo Agosti, Maria Elisabetta Manca, Matteo Panzeri and Marisa Dalai Emiliani. Bergamo: P. Lubrina, 1993, vol. 1, pp. 25–47.

Bizzarro, Tina Waldeier. *Romanesque Architectural Criticism: A Prehistory.* Cambridge: Cambridge University Press, 1992.

Bloch, Peter. "Kölner Skulpturen des 19. Jahrhunderts." *Wallraf-Richartz-Jahrbuch* 29 (1967): 243–90.

"Sculptures néo-gothiques en Allemagne." *Revue de l'art* 21 (1973): 70–79.

Bode, Wilhelm. *Geschichte der deutschen Plastik.* Geschichte der deutschen Kunst, 2. Berlin: G. Grote, 1885.

"Louis Courajod." *Repertorium für Kunstwissenschaft* 19 (1896): 396–400.

Mein Leben. 2 vols. Berlin: H. Reckendorf, 1930.

Bode, Wilhelm and Hugo von Tschudi. *Beschreibung der Bildwerke der christlichen Epoche.* Berlin: W. Spemann, 1888.

Böhme, Karl. *Der Einfluss der Architektur auf Malerei und Plastik.* Dresden: Gilbers, 1882.

Bonnet, Jacques, ed. *Henri Focillon.* Paris: Éditions du Centre Georges Pompidou, 1986.

"Books for the College Art Library." *Art Bulletin* 3 (1920): 3–60.

Branner, Robert, ed. *Chartres Cathedral.* New York: W. W. Norton, 1969.

Breck, Joseph. *Catalogue of Romanesque, Gothic and Renaissance Sculpture.* New York: Metropolitan Museum of Art, 1913.

Bredekamp, Horst. "Monumentale Theologie: Kunstgeschichte als Geistesgeschichte." In Fer-

dinand Piper, *Einleitung in die Monumentale Theologie* (1867). Repr. Mittenwald: Mäander Verlag, 1978, pp. E2–E47.

"'Du lebst und thust mir nichts.' Anmerkungen zur Aktualität Aby Warburgs." In *Aby Warburg. Akten des internationalen Symposions Hamburg 1990*. Ed. Horst Bredekamp, Michael Diers and Charlotte Schoell-Glass. Weinheim: VCH, Acta Humaniora, 1991, pp. 1–7.

"Ex nihilo: Panofskys Habilitation" and "Appendix: Gustav Paulis Habilitationsgutachten." In *Erwin Panofsky. Beiträge des Symposions Hamburg 1992*. Ed. Bruno Reudenbach. Berlin: Akademie Verlag, 1994, pp. 31–51.

Brown, David A. "Giovanni Morelli and Bernard Berenson." In *Giovanni Morelli e la cultura dei conoscitori. Atti del Convegno Internazionale, Bergamo, 4–7 giugno 1987*. 3 vols. Ed. Giacomo Agosti, Maria Elisabetta Manca, Matteo Panzeri and Marisa Dalai Emiliani. Bergamo: P. Lubrina, 1993, vol. 2, pp. 389–97.

Brush, Kathryn. "The Cultural Historian Karl Lamprecht: Practitioner and Progenitor of Art History." *Central European History* 26 (1993): 139–64.

"The Naumburg Master: A Chapter in the Development of Medieval Art History." *Gazette des beaux-arts*, 6th per., vol. 122 (1993): 109–22.

"Wilhelm Vöge and the Role of Human Agency in the Making of Medieval Sculpture: Reflections on an Art Historical Pioneer." *Konsthistorisk Tidskrift* 62 (1993): 69–83.

"Gothic Sculpture as a Locus for the Polemics of National Identity." In *Concepts of National Identity in the Middle Ages*. Leeds Texts and Monographs, New Series 14. Ed. Simon Forde, Lesley Johnson and Alan V. Murray. Leeds: University of Leeds, 1995, pp. 189–213.

"Integration or Segregation among Disciplines? The Historiography of Gothic Sculpture as Case Study." In *Artistic Integration in Gothic Buildings*. Ed. Virginia Chieffo Raguin, Kathryn Brush and Peter Draper. Toronto: University of Toronto Press, 1995, pp. 19–40.

"Adolph Goldschmidt, 1863–1944." In *Dictionary of Medieval Scholarship*. 3 vols. Ed. Helen Damico. New York: Garland Press, vol. 3 (in press).

Bruzelius, Caroline. "Introduction." In *The Brummer Collection of Medieval Art, Duke University Museum of Art*. Ed. Caroline Bruzelius with Jill Meredith. Durham: Duke University Press, 1991, pp. 1–11.

Bulhof, Ilse N. *Wilhelm Dilthey: A Hermeneutic Approach to the Study of History and Culture*. The Hague: Martinus Nijhoff, 1980.

Bulletin monumental. Paris: Société Française d'Archéologie, 1834–.

Burckhardt, Jacob. *Die Kultur der Renaissance in Italien. Ein Versuch*. Basel: Schweighauser, 1860.

Bushart, Magdalena. *Der Geist der Gotik und die expressionistische Kunst. Kunstgeschichte und Kunsttheorie, 1911–1925*. Munich: Verlag Silke Schreiber, 1990.

Butzmann, Hans. "Erinnerung an Wilhelm Vöge." *Zeitschrift für Kunstwissenschaft* 12 (1958): 211–18.

Cahn, Walter and Linda Seidel. *Romanesque Sculpture in American Collections*. Volume 1: *New England Museums*. New York: Burt Franklin, 1979.

Calo, Mary Ann. *Bernard Berenson and the Twentieth Century*. Philadelphia: Temple University Press, 1994.

Camille, Michael. "The *Très Riches Heures*: An Illuminated Manuscript in the Age of Mechanical Reproduction." *Critical Inquiry* 17 (1990): 72–107.

Image on the Edge: The Margins of Medieval Art. Cambridge, Mass.: Harvard University Press, 1992.

"Mouths and Meanings: Towards an Anti-Iconography of Medieval Art." In *Iconography at the Crossroads*. Ed. Brendan Cassidy. Princeton: Princeton University Press, 1993, pp. 43–57.

"'How New York Stole the Idea of Romanesque Art': Medieval, Modern and Postmodern in Meyer Schapiro." *Oxford Art Journal* 17 (1994): 65–75.

Caviness, Madeline H. "Broadening the Definitions of 'Art': The Reception of Medieval Works in the Context of Post–Impressionist Movements." In *Hermeneutics and Medieval Culture.* Ed. Patrick J. Gallacher and Helen Damico. Albany: State University of New York Press, 1989, pp. 259–82.

Châtelet-Lange, Liliane. "L'Institut d'Histoire de l'Art de Strasbourg." *Formes. Bulletin de l'Institut d'Histoire de l'Art de Strasbourg* 7 (1989): 13–31.

Chickering, Roger. "Young Lamprecht: An Essay in Biography and Historiography." *History and Theory* 28 (1989): 198–214.

"Karl Lamprechts Konzeption einer Weltgeschichte." *Archiv für Kulturgeschichte* 73 (1991): 437–52.

"Karl Lamprecht (1856–1915) und die methodische Grundlegung der Landesgeschichte im Rheinland." *Geschichte in Köln* 31 (1992): 77–90.

Karl Lamprecht. A German Academic Life (1856–1915). Atlantic Highlands, N.J.: Humanities Press International, 1993.

Clemen, Paul. *Die Porträtdarstellungen Karls des Grossen, Erster Theil.* Aachen: Verlag der Cremer'schen Buchhandlung, 1889.

"Die Porträtdarstellungen Karls des Grossen." *Zeitschrift des Aachener Geschichtsvereins* 11 (1889): 185–271; 12 (1890): 1–147.

"Litteratur: Wilhelm Vöge, *Eine deutsche Malerschule um die Wende des ersten Jahrtausends.*" *Jahrbücher des Vereins von Alterthumsfreunden im Rheinlande* 93 (1892): 233–40.

"Anton Springer." In *Allgemeine deutsche Biographie*, vol. 35. Berlin: Duncker und Humblot, 1893, pp. 315–17.

"Bücherschau: Wilhelm Vöge, *Die Anfänge des monumentalen Stiles im Mittelalter.*" *Kunstchronik* N.F. 6 (1894/95): cols. 169–71.

Carl Justi. Gedächtnisrede zur hundertsten Wiederkehr seines Geburtstages. Bonn: F. Cohen, 1933.

Clemen, Paul, ed. *Die Kunstdenkmäler der Rheinprovinz, im Auftrage des Provinzialverbandes.* Düsseldorf: L. Schwann, 1891–1919.

Congrès archéologique de France. Paris: Société Française d'Archéologie, 1834–.

Courajod, Louis. *Alexandre Lenoir, son journal et le Musée des monuments français.* 3 vols. Paris: H. Champion, 1878–87.

Les Origines de l'art gothique. Leçon d'ouverture du cours d'histoire de la sculpture française. Paris: E. Leroux, 1892.

Histoire du département de la sculpture moderne au Musée du Louvre. Paris: E. Leroux, 1894.

Leçons professées à l'École du Louvre (1887–1896). Ed. Henry Lemonnier and André Michel. 3 vols. Paris: A. Picard, 1899–1903.

Courajod, Louis, with P.-Frantz Marcou. *Musée de Sculpture Comparée (moulages), Palais du Trocadéro. Catalogue raisonné publié sous les auspices de la Commission des Monuments Historiques, XIVe et XVe siècles.* Paris: Imprimerie Nationale, 1892.

Courtenay, William J. "The Virgin and the Dynamo: The Growth of Medieval Studies in America (1870–1930)." In *Medieval Studies in North America: Past, Present, and Future.* Ed. Francis G. Gentry and Christopher Kleinhenz. Kalamazoo, Mich.: Medieval Institute Publications, 1982, pp. 5–22.

Crossley, Fred H. *English Church Monuments, A.D. 1150–1550. An Introduction to the Study of Tombs and Effigies of the Mediaeval Period.* London: B. T. Batsford, 1921.

Dalton, O. M. *Catalogue of the Ivory Carvings of the Christian Era with Examples of Mohammedan Art and Carvings of Bone in the Department of British and Mediaeval Antiquities and Ethnography of the British Museum.* London: Trustees of the British Museum, 1909.

Dehio, Georg. "Zu den Skulpturen des Bamberger Domes." *Jahrbuch der Königlich Preussischen Kunstsammlungen* 11 (1890): 194–99.

"Noch einmal die Skulpturen des Bamberger Domes." *Jahrbuch der Königlich Preussischen Kunstsammlungen* 13 (1892): 141.

"Litteraturbericht: *Die Anfänge des monumentalen Stiles im Mittelalter* von Dr. Wilhelm Vöge." *Repertorium für Kunstwissenschaft* 18 (1895): 279–82.

"Adolph Goldschmidt, *Studien zur Geschichte der sächsischen Skulptur in der Übergangszeit vom romanischen zum gotischen Stil*." *Repertorium für Kunstwissenschaft* 25 (1902): 460–64.

Deicher, Susanne. "Produktionsanalyse und Stilkritik. Versuch einer Neubewertung der kunsthistorischen Methode Wilhelm Vöges." *Kritische Berichte* 19(1) (1991): 65–82.

Deschamps, Paul. *La Sculpture française à l'époque romane, XIe et XIIe siècles*. Florence and Paris: Pantheon and Éditions du Pégase, 1930.

Dettweiler, Frieda. "Richard Hamann." In *Neue Deutsche Biographie*, vol. 7. Berlin: Duncker und Humblot, 1966, pp. 578–79.

Didron, Adolphe-Napoléon. *Manuel d'iconographie chrétienne*. Paris: Imprimerie Royale, 1845.

Dilly, Heinrich. "Lichtbildprojektion – Prothese der Kunstbetrachtung." In *Kunstwissenschaft und Kunstvermittlung*. Ed. Irene Below. Giessen: Anabas-Verlag, 1975, pp. 153–72.

Kunstgeschichte als Institution. Studien zur Geschichte einer Disziplin. Frankfurt am Main: Suhrkamp, 1979.

"Einleitung." In *Kunsthistoriker in eigener Sache. Zehn autobiographische Skizzen*. Ed. Martina Sitt. Berlin: Dietrich Reimer Verlag, 1990, pp. 11–22.

"Émile Mâle, 1862–1954." In *Altmeister moderner Kunstgeschichte*. Ed. Heinrich Dilly. Berlin: Dietrich Reimer Verlag, 1990, pp. 133–48.

Dilthey, Wilhelm. *Einleitung in die Geisteswissenschaften. Versuch einer Grundlegung für das Studium der Gesellschaft und der Geschichte*. Leipzig: Duncker und Humblot, 1883. Repr. as Wilhelm Dilthey, *Gesammelte Schriften*, vol. 1. Stuttgart: B. Teubner, 1959.

"Ideen über eine beschreibende und zergliedernde Psychologie" (1894). Repr. in Wilhelm Dilthey, *Gesammelte Schriften*, vol. 5. Stuttgart: B. Teubner, 1961, pp. 139–240.

Dittmann, Lorenz, ed. *Kategorien und Methoden der deutschen Kunstgeschichte, 1900–1930*. Wiesbaden: F. Steiner, 1985.

Dobbert, Eduard. "Henry Thode, *Franz von Assisi und die Anfänge der Kunst der Renaissance in Italien*." *Göttingische gelehrte Anzeigen* (1887): 257–73.

Donahue, Neil H., ed. *Invisible Cathedrals: The Expressionist Art History of Wilhelm Worringer*. University Park: Pennsylvania State University Press, 1995.

Doren, Alfred. "Karl Lamprechts Geschichtstheorie und die Kunstgeschichte." *Zeitschrift für Aesthetik und allgemeine Kunstwissenschaft* 11(4) (1916): 353–89.

Durand, Georges. *Inventaire sommaire des archives communales antérieures à 1790*. Amiens: Piteux, 1891.

Monographie de l'église Notre-Dame, cathédrale d'Amiens. 2 vols. Paris: A. Picard, 1901–03.

Dürr, Sybille. *Zur Geschichte des Faches Kunstgeschichte an der Universität München*. Schriften aus dem Institut für Kunstgeschichte der Universität München, 62. Munich: Tuduv, 1993.

Dvořák, Max. "Adolph Goldschmidt, *Studien zur Geschichte der sächsischen Skulptur*." *Kunstgeschichtliche Anzeigen* 1 (1904): 32–34.

"Idealismus und Naturalismus in der gotischen Skulptur und Malerei." *Historische Zeitschrift* 119 (1918): 1–62, 185–246. Repr. in Max Dvořák, *Kunstgeschichte als Geistesgeschichte*. Munich: R. Piper, 1924, pp. 41–147.

Idealism and Naturalism in Gothic Art. Trans. Randolph J. Klawiter. Notre Dame, Ind.: University of Notre Dame Press, 1967.

The Ecclesiologist. Cambridge: Stevenson and Rivingtons, 1842–68.

Einem, Herbert von. "Bonner Lehrer der Kunstgeschichte von 1818 bis 1935." In *Bonner Gelehrte. Beiträge zur Geschichte der Wissenschaften in Bonn. Geschichtswissenschaften. 150 Jahre Rheinische Friedrich-Wilhelms-Universität zu Bonn*. Bonn: Bouvier, 1968, pp. 410–31.

Eisler, Colin. "*Kunstgeschichte* American Style: A Study in Migration." In *The Intellectual Migration. Europe and America, 1930–1960*. Ed. Donald Fleming and Bernard Bailyn. Cambridge, Mass.: Harvard University Press, 1969, pp. 544–629.

Émile Mâle et le symbolisme chrétien. Exh. cat., Centre Culturel et Grand Casino de Vichy. Vichy: Wallon, 1983.

Empathy, Form, and Space: Problems in German Aesthetics, 1873–1893. Trans. and intro. Harry Francis Mallgrave and Eleftherios Ikonomou. Santa Monica, Calif.: Getty Center for the History of Art and the Humanities, 1994.

Ermath, Michael. *Wilhelm Dilthey: The Critique of Historical Reason*. Chicago: University of Chicago Press, 1978.

Feist, Peter H. "Beiträge Richard Hamanns zur Methodik der Kunstgeschichtsschreibung." *Sitzungsberichte der Akademie der Wissenschaften der DDR. Gesellschaftswissenschaften* (1980, no. 1/G): 3–20.

Festschrift für Adolph Goldschmidt zum 60. Geburtstag am 15. Januar 1923. Leipzig: E. A. Seemann, 1923.

Fiedler, Conrad. "Über den Ursprung der künstlerischen Tätigkeit" (1887). Repr. in Conrad Fiedler, *Schriften zur Kunst*. 2 vols. 2d ed. Munich: W. Fink, 1991, vol. 1, pp. 111–220.

Fischel, Oskar. *Raphaels Zeichnungen. Versuch einer Kritik der bisher veröffentlichten Blätter*. Strasbourg: Trübner, 1898.

Franck-Oberaspach, Karl. *Der Meister der Ecclesia und Synagoge am Strassburger Münster. Beiträge zur Geschichte der Bildhauerkunst des dreizehnten Jahrhunderts in Deutschland, mit besonderer Berücksichtigung ihres Verhältnisses zur gleichzeitigen französischen Kunst*. Düsseldorf: L. Schwann, 1903.

Frankl, Paul. *The Gothic: Literary Sources and Interpretations through Eight Centuries*. Princeton: Princeton University Press, 1960.

Frey, Karl. *Die Loggia dei Lanzi zu Florenz. Eine quellenkritische Untersuchung*. Berlin: W. Hertz, 1885.

———. "Studien zu Michelagniolo." *Jahrbuch der Königlich Preussischen Kunstsammlungen* 16 (1895): 91–103; 17 (1896): 5–18, 97–119.

———. *Die Dichtungen des Michelagniolo Buonarroti*. Berlin: G. Grote, 1897.

———. *Sammlung ausgewählter Briefe an Michelagniolo Buonarroti. Nach den Originalen des Archivio Buonarroti*. Berlin: K. Sigismund, 1899.

Freyer, Kurt. "Entwicklungslinien in der sächsischen Plastik des 13. Jahrhunderts." *Monatshefte für Kunstwissenschaft* 4 (1911): 261–75.

Frisch, Teresa. "The Twelve Choir Statues of the Cathedral at Reims: Their Stylistic and Chronological Relations to the Sculpture of the North Transept and of the West Facade." *Art Bulletin* 42 (1960): 1–24.

Frothingham, Arthur. "The Revival of Sculpture in Europe in the Thirteenth Century." *American Journal of Archaeology and of the History of the Fine Arts* 1 (1885): 34–45, 372–84.

———. *A History of Sculpture*. London: Longmans, Green, 1901.

Gaehtgens, Thomas W. *Die Berliner Museumsinsel im Deutschen Kaiserreich. Zur Kulturpolitik der Museen in der wilhelmischen Epoche*. Munich: Deutscher Kunstverlag, 1992.

Gantner, Joseph, ed. *Jacob Burckhardt und Heinrich Wölfflin. Briefwechsel und andere Dokumente ihrer Begegnung, 1882–1897*. 2d ed. Basel: Schwabe, 1989.

Gardner, Arthur. *French Sculpture of the Thirteenth Century: Seventy-eight Examples of Masterpieces of Medieval Art Illustrating the Works at Reims and Showing Their Place in the History of Sculpture*. London: Philip Lee Warner, 1915.

Medieval Sculpture in France. Cambridge: Cambridge University Press, 1931.

A Handbook of English Medieval Sculpture. Cambridge: Cambridge University Press, 1935.

Gentry, Francis G. and Christopher Kleinhenz, eds. *Medieval Studies in North America. Past, Present, and Future*. Kalamazoo, Mich.: Medieval Institute Publications, 1982.

Germann, Georg. *Gothic Revival in Europe and Britain: Sources, Influences, Ideas*. Trans. Gerald Onn. London: Lund Humphries with the Architectural Association, 1972.

Gesammelte Studien zur Kunstgeschichte. Eine Festgabe zum 4. Mai 1885 für Anton Springer. Leipzig: E. A. Seemann, 1885.

Gesta. New York: International Center of Medieval Art, 1963–.

Glockner, Hermann. "Robert Vischer und die Krisis der Geisteswissenschaften im letzten Drittel des neunzehnten Jahrhunderts. Ein Beitrag zur Geschichte des Irrationalitäts-problems." *Logos. Internationale Zeitschrift für Philosophie der Kultur* 14 (1925): 297–343; 15 (1926): 47–102.

Goethe, Johann Wolfgang von. "On German Architecture" (1772). Trans. John Gage. In *German Essays on Art History*. Ed. Gert Schiff. New York: Continuum, 1988, pp. 33–40.

Goldman, Guido. *A History of the Germanic Museum at Harvard University*. Cambridge, Mass.: Minda de Gunzburg Center for European Studies, Harvard University, 1989.

Goldschmidt, Adolph. *Lübecker Malerei und Plastik bis 1530*. Lübeck: B. Nöhring, 1889.

"Der Utrechtpsalter." *Repertorium für Kunstwissenschaft* 15 (1892): 156–69.

Der Albanipsalter in Hildesheim und seine Beziehung zur symbolischen Kirchensculptur des XII. Jahrhunderts. Berlin: G. Siemens, 1895.

"Die Favara des Königs Roger von Sizilien." *Jahrbuch der Königlich Preussischen Kunstsammlungen* 16 (1895): 199–215.

"Die Gregorsmesse in der Marienkirche zu Lübeck." *Zeitschrift für christliche Kunst* 9 (1896): cols. 225–32.

"Michelangelos Malereien in der Sixtinischen Kapelle." *Kunstgeschichtliche Gesellschaft Berlin, Sitzungsberichte* (1897)(2): 7–9.

"Die mittelalterlichen Bronzegrabmäler im Magdeburger Dom." *Kunstgeschichtliche Gesellschaft Berlin, Sitzungsberichte* (1897)(8): 33–34.

"Die normannischen Königspaläste in Palermo." *Zeitschrift für Bauwesen* 48 (1898): 451–590.

"Anfänge des Genrebildes." *Das Museum* 2 (1898–99): 33–36.

"Französische Einflüsse in der frühgotischen Skulptur Sachsens." *Jahrbuch der Königlich Preussischen Kunstsammlungen* 20 (1899): 285–300.

"Die Kunstsprache Michelangelos." *Das Museum* 4 (1899–1900): 33–36.

"Max Hasak, *Geschichte der deutschen Bildhauerkunst im 13. Jahrhundert*." *Kunstgeschichtliche Gesellschaft Berlin, Sitzungsberichte* 1900(6): 28–29.

"Die Stilentwickelung der romanischen Skulptur in Sachsen." *Jahrbuch der Königlich Preussischen Kunstsammlungen* 21 (1900): 225–41.

"Rode und Notke, zwei Lübecker Maler des 15. Jahrhunderts." *Zeitschrift für bildende Kunst* 36, N. F. 12 (1901): 31–39, 55–60.

"Drei Elfenbein-Madonnen." In *Das Hamburgische Museum für Kunst und Gewerbe dargestellt zur Feier des 25jährigen Bestehens von Freunden und Schülern Justus Brinckmanns*. Hamburg: Verlagsanstalt und Druckerei A.-G., 1902, pp. 277–81.

"Die Freiberger Goldene Pforte." *Jahrbuch der Königlich Preussischen Kunstsammlungen* 23 (1902): 20–33.

Die Kirchenthür des Heiligen Ambrosius in Mailand. Ein Denkmal frühchristlicher Skulptur. Strasbourg: J. Heitz, 1902.

Studien zur Geschichte der sächsischen Skulptur in der Übergangszeit vom romanischen zum gotischen Stil. Berlin: G. Grote, 1902.

"Willem Buytewech." *Jahrbuch der Königlich Preussischen Kunstsammlungen* 23 (1902): 100–17.

"Zur Erforschung mittelalterlicher Elfenbeinskulpturen. Arbeiten von Graeven, Vöge, Haseloff." *Kunstgeschichtliche Anzeigen* 1 (1904): 35–40.

"Elfenbeinreliefs aus der Zeit Karls des Grossen." *Jahrbuch der Königlich Preussischen Kunstsammlungen* 26 (1905): 47–67.

"Antrittsrede des Hrn. Goldschmidt" and "Erwiderung des Sekretärs Hrn. Diels." *Sitzungsberichte der Königlichen Preussischen Akademie der Wissenschaften*, Part II (1914): 753–58.

Die Elfenbeinskulpturen aus der Zeit der karolingischen und sächsischen Kaiser VIII.–XI. Jahrhundert. 2 vols. Berlin: B. Cassirer, 1914 and 1918.

Die Elfenbeinskulpturen aus der romanischen Zeit XI.–XIII. Jahrhundert. 2 vols. Berlin: B. Cassirer, 1923 and 1926.

Gotische Madonnenstatuen in Deutschland. Augsburg: B. Filser, 1923.

"Das Nachleben der antiken Formen im Mittelalter." In *Vorträge der Bibliothek Warburg, 1921–1922.* Leipzig: B. G. Teubner, 1923, pp. 40–50.

Die Skulpturen von Freiberg und Wechselburg. Berlin: B. Cassirer, 1924.

Die deutschen Bronzetüren des frühen Mittelalters. Die frühmittelalterlichen Bronzetüren I. Marburg: Verlag des Kunstgeschichtlichen Seminars, 1926.

Die deutsche Buchmalerei. 2 vols. Munich: K. Wolff, 1928.

German Illumination. 2 vols. New York: Harcourt, Brace, 1928.

"Kunstgeschichte." In *Aus fünfzig Jahren deutscher Wissenschaft. Die Entwicklung ihrer Fachgebiete in Einzeldarstellungen.* Ed. Gustav Abb. Berlin: De Gruyter, 1930, pp. 192–97.

Die Bronzetüren von Nowgorod und Gnesen. Die frühmittelalterlichen Bronzetüren II. Marburg: Verlag des Kunstgeschichtlichen Seminars, 1932.

"Die Bedeutung der Formenspaltung in der Kunstentwicklung." In *Independence, Convergence, and Borrowing in Institutions, Thought and Art.* Cambridge, Mass.: Harvard University Press, 1937, pp. 167–77.

Gedenkrede auf Max Liebermann 1935. Foreword by Carl Georg Heise. Hamburg: Kunstverein Hamburg und Niedersächsische Landesgalerie Hannover, 1954.

Goldschmidt, Adolph, with Kurt Weitzmann. *Die byzantinischen Elfenbeinskulpturen des X.–XIII. Jahrhunderts.* 2 vols. Berlin: B. Cassirer, 1930 and 1934.

Gombrich, Ernst. *Aby Warburg: An Intellectual Biography.* Rev. ed. Chicago: University of Chicago Press, 1986.

Gonse, Louis. *L'Art gothique: L'architecture–la peinture–la sculpture–le décor.* Paris: Quantin, 1890.

Graul, Richard. "Kunstlitteratur: Adolph Goldschmidt, *Lübecker Malerei und Plastik bis 1530.*" *Kunstchronik* N.F. 2 (1891), cols. 22–23.

Grimm, Herman. *Das Leben Michelangelos.* 2 vols. Hanover: C. Rümpler, 1860–63.

Das Leben Raphaels. Berlin: W. Hertz, 1872.

Goethe. Vorlesungen gehalten an der Königlichen Universität zu Berlin. 2 vols. Berlin: W. Beck, 1877.

"Wilhelm Vöge, *Die Anfänge des monumentalen Stiles im Mittelalter.*" *Deutsche Litteraturzeitung* 15 (1894): cols. 1431–32.

Grodecki, Louis. "A Stained-glass *Atelier* of the Thirteenth Century. A Study of the Windows in the Cathedrals of Bourges, Chartres and Poitiers." *Journal of the Warburg and Courtauld Institutes* 11 (1948): 87–111.

"The Transept Portals of Chartres Cathedral: The Date of Their Construction According to Archaeological Data." *Art Bulletin* 33 (1951): 156–64.

"La 'Première Sculpture gothique.' Wilhelm Vöge et l'état actuel des problèmes." *Bulletin monumental* 117 (1959): 265–89.

Gross, Werner. "Hermann Beenken, + 6. April 1952." *Kunstchronik* 5 (1952): 153–56.

Halbertsma, Marlite. *Wilhelm Pinder und die deutsche Kunstgeschichte*. Trans. Martin Püschel. Worms: Wernersche Verlagsgesellschaft, 1992.

Hamann, Richard. "Individualismus und Aesthetik." *Zeitschrift für Aesthetik und allgemeine Kunstwissenschaft* 1 (1906): 312–22.

"Über die psychologischen Grundlagen des Bewegungsbegriffes." *Zeitschrift für Psychologie* 45 (1907): 231–54, 341–77.

"Das Wesen des Plastischen." *Zeitschrift für Aesthetik und allgemeine Kunstwissenschaft* 3 (1908): 1–46.

Die Abteikirche von St. Gilles und ihre künstlerische Nachfolge. 3 vols. Berlin: Akademie-Verlag, 1955.

Hamann, Richard and Felix Rosenfeld. *Der Magdeburger Dom. Beiträge zur Geschichte und Ästhetik mittelalterlicher Architektur, Ornamentik und Skulptur*. Berlin: G. Grote, 1910.

Hart, Joan. "Reinterpreting Wölfflin: Neo-Kantianism and Hermeneutics." *Art Journal* 42 (4) (1982): 292–300.

"Erwin Panofsky and Karl Mannheim: A Dialogue on Interpretation." *Critical Inquiry* 19 (1993): 534–66.

Hasak, Max. *Geschichte der deutschen Bildhauerkunst im 13. Jahrhundert*. Berlin: E. Wasmuth, 1899.

Haseloff, Arthur. *Eine thüringisch-sächsische Malerschule des 13. Jahrhunderts*. Strasbourg: J. Heitz, 1897.

Haussherr, Reiner. "Willibald Sauerländer, *Von Sens bis Strassburg*." *Kunstchronik* 21 (1968): 302–21.

Heise, Carl Georg. *Persönliche Erinnerungen an Aby Warburg*. New York: Eric M. Warburg, 1947; repr. Hamburg: Gesellschaft der Bücherfreunde, 1959.

"Goldschmidt als Lehrer und Freund." In *Adolph Goldschmidt zum Gedächtnis, 1863–1944*. Ed. Carl Georg Heise. Hamburg: Hauswedel, 1963, pp. 33–37.

Wilhelm Vöge zum Gedächtnis. Freiburger Universitätsreden, N.F. 43. Freiburg im Breisgau: Hans Ferdinand Schulz Verlag, 1968.

Heise, Carl Georg, ed. *Adolph Goldschmidt zum Gedächtnis, 1863–1944*. Hamburg: Hauswedel, 1963.

Herbart, Johann Friedrich. *Lehrbuch zur Psychologie*. 3d ed. Ed. G. Hartenstein. Hamburg: L. Voss, 1887.

Herrbach, Brigitte. "Georg Dehio: Verzeichnis seiner Schriften." *Zeitschrift für Kunstgeschichte* 47 (1984): 392–99.

Hildebrand, Adolf von. *Das Problem der Form in der bildenden Kunst*. Strasbourg: J. Heitz, 1893.

Histoire de l'art: Bulletin d'information de l'Institut National d'Histoire de l'Art. Paris: Centre d'Histoire, 1988–.

Holly, Michael Ann. *Panofsky and the Foundations of Art History*. Ithaca: Cornell University Press, 1984.

Iggers, Georg. *The German Conception of History: The National Tradition of Historical Thought from Herder to the Present*. Rev. ed. Middletown, Conn.: Wesleyan University Press, 1983.

Iggers, Georg and James M. Powell, eds. *Leopold von Ranke and the Shaping of the Historical Discipline*. Syracuse: Syracuse University Press, 1990.

Iversen, Margaret. "Aby Warburg and the New Art History." In *Aby Warburg. Akten des internationalen Symposions Hamburg 1990*. Ed. Horst Bredekamp, Michael Diers and Charlotte Schoell-Glass. Weinheim: VCH, Acta Humaniora, 1991, pp. 281–87.

Alois Riegl: Art History and Theory. Cambridge, Mass.: MIT Press, 1993.

Jahn, Johannes. *Kompositionsgesetze französischer Reliefplastik im 12. und 13. Jahrhundert*. Leipzig: K. W. Hiersemann, 1922.

Schmuckformen des Naumburger Domes. Leipzig: E. A. Seemann, 1944.

Jahn, Johannes, ed. *Die Kunstwissenschaft der Gegenwart in Selbstdarstellungen.* Leipzig: Felix Meiner, 1924.

Jahrbuch für Kunstwissenschaft. Leipzig: Klinkhardt und Biermann, 1923–30.

Janitschek, Hubert. *Leone Battista Albertis kleinere kunsttheoretische Schriften.* Vienna: W. Braumüller, 1877.

Die Gesellschaft der Renaissance in Italien und die Kunst. Stuttgart: W. Spemann, 1879.

"Zwei Studien zur Geschichte der carolingischen Malerei." In *Strassburger Festgruss an Anton Springer zum 4. Mai 1885.* Berlin and Stuttgart: W. Spemann, 1885, pp. 1–30.

"Die künstlerische Ausstattung." In *Die Trierer Ada–Handschrift.* Publikationen der Gesellschaft für Rheinische Geschichtskunde, 6. Ed. Karl Lamprecht. Leipzig: Alphons Dürr, 1889, pp. 63–111.

Geschichte der deutschen Malerei. Geschichte der deutschen Kunst, 3. Berlin: G. Grote, 1890.

"Anton Springer als Kunsthistoriker." In Anton Springer, *Aus meinem Leben.* Berlin: G. Grote, 1892, pp. 358–82.

Jantzen, Hans. *Deutsche Bildhauer des dreizehnten Jahrhunderts.* Leipzig: Insel-Verlag, 1925.

"Wilhelm Vöge, + 30. Dezember 1952." *Kunstchronik* 6 (1953): 104–09.

"Adolph Goldschmidt." In *Adolph Goldschmidt zum Gedächtnis, 1863–1944.* Ed. Carl Georg Heise. Hamburg: Hauswedell, 1963, pp. 7–13.

Justi, Carl. *Winckelmann. Sein Leben, seine Werke und seine Zeitgenossen.* 3 vols. in 2. Leipzig: F. C. W. Vogel, 1866–72.

Diego Velazquez und sein Jahrhundert. 2 vols. Bonn: Cohen, 1888.

Michelangelo. Beiträge zur Erklärung der Werke und des Menschen. Leipzig: Breitkopf und Härtel, 1900.

Michelangelo. Neue Beiträge zur Erklärung seiner Werke. Berlin: G. Grote, 1909.

K. (unidentified reviewer). "Bücherschau: Wilhelm Vöge, *Eine deutsche Malerschule um die Wende des ersten Jahrtausends.*" *Zeitschrift für christliche Kunst* 6 (1892): cols. 190–91.

Katzenellenbogen, Adolf. "Wilhelm Vöge, *Bildhauer des Mittelalters. Gesammelte Studien.*" *Art Bulletin* 43 (1961): 337–38.

Kauffmann, Georg. *Die Entstehung der Kunstgeschichte im 19. Jahrhundert.* Opladen: Westdeutscher Verlag, 1993.

Kauffmann, Hans. "Erwin Panofsky, 30. März 1892–14. März 1968." *Kunstchronik* 21 (1968): 260–66.

Kerber, Bernhard. *Burgund und die Entwicklung der französischen Kathedralskulptur im zwölften Jahrhundert.* Recklinghausen: Verlag Aurel Bongers, 1966.

Kessler, Harry Graf. *Gesichter und Zeiten. Erinnerungen.* Berlin: S. Fischer, 1935.

Kestel, Friedrich. "The Arthur Kingsley Porter Collection of Photography and the European Preservation of Monuments." *Visual Resources* 9 (1994): 361–81.

Koehler, Wilhelm R. W., ed. *Medieval Studies in Memory of A. Kingsley Porter.* 2 vols. Cambridge, Mass.: Harvard University Press, 1939.

Kölner Domblatt: Amtliche Mittheilungen des Central-Dombau–Vereins. Cologne: DuMont-Schauberg, 1845–1885/92.

Königliche Museen zu Berlin. Beschreibung der Bildwerke der christlichen Epochen. Zweite Auflage. Die Elfenbeinbildwerke, 45 Lichtdrucktafeln. Berlin: G. Reimer, 1902.

Kraus, Franz Xaver. "Litteraturbericht: Christliche Archäologie, 1890–91." *Repertorium für Kunstwissenschaft* 15 (1892): 395–410.

"Litteraturbericht: Christliche Archäologie, 1895–96." *Repertorium für Kunstwissenschaft* 19 (1896): 439–71.

Krönig, Wolfgang. "Anhang V. Zum Sizilien-Aufenthalt 1889–1890." In *Adolph Goldschmidt, 1863–1944. Lebenserinnerungen.* Ed. Marie Roosen-Runge-Mollwo. Berlin: Deutscher Verlag für Kunstwissenschaft, 1989, pp. 445–51.

Kugler, Franz. *Handbuch der Geschichte der Malerei*. Berlin: Duncker und Humblot, 1837; 2d ed., 1847.

——. *Pommersche Kunstgeschichte nach den erhaltenen Monumenten dargestellt*. Stettin: Gesellschaft für pommersche Geschichte und Alterthumskunde, 1840.

——. *Handbuch der Kunstgeschichte*. Stuttgart: Ebner und Seubert, 1842.

——. "Bilderhandschriften des Mittelalters." In Franz Kugler, *Kleine Schriften und Studien zur Kunstgeschichte. 1. Teil*. Stuttgart: Ebner und Seubert, 1853, pp. 1–95.

Kultermann, Udo. *Geschichte der Kunstgeschichte. Der Weg einer Wissenschaft*. Düsseldorf: Econ-Verlag, 1966; 2d ed., Munich: Prestel-Verlag, 1990.

——. *The History of Art History*. Pleasantville, N.Y.: Abaris Press, 1993.

Kunstchronik: Beiblatt zur Zeitschrift für bildende Kunst. Leipzig: E. A. Seemann, 1866–1926.

Kunstchronik: Monatsschrift für Kunstwissenschaft, Museumswesen und Denkmalpflege. Nuremberg: H. Carl, 1948–.

"Kunstlitteratur: Wilhelm Vöge, *Eine deutsche Malerschule um die Wende des ersten Jahrtausends*." *Kunstchronik* N. F. 4 (1893): col. 11.

Lamprecht, Karl. *Beiträge zur Geschichte des französischen Wirthschaftslebens im elften Jahrhundert*. Leipzig: Duncker und Humblot, 1878.

——. "Der Bilderschmuck des Cod. Egberti zu Trier und des Cod. Epternacensis zu Gotha." *Jahrbücher des Vereins von Alterthumsfreunden im Rheinlande* 70 (1881): 56–112.

——. *Initial-Ornamentik des VIII. bis XIII. Jahrhunderts*. Leipzig: Alphons Dürr, 1882.

——. "Bildercyclen und Illustrationstechnik im späteren Mittelalter." *Repertorium für Kunstwissenschaft* 7 (1884): 405–15.

——. *Deutsches Wirtschaftsleben im Mittelalter. Untersuchungen über die Entwicklung der materiellen Kultur des platten Landes auf Grund der Quellen zunächst des Mosellandes*. 3 vols. Leipzig: Alphons Dürr, 1885–86.

——. *Études sur l'état économique de la France pendant la première partie du moyen-âge*. Trans. Albert Marignan. Paris: A. Picard, 1889.

——. *Deutsche Geschichte*. 12 vols. Berlin: R. Gaertner, 1891–1909.

Lamprecht, Karl, ed. *Die Trierer Ada-Handschrift*. Publikationen der Gesellschaft für Rheinische Geschichtskunde, 6. Leipzig: Alphons Dürr, 1889.

Landauer, Carl. "The Survival of Antiquity: The German Years of the Warburg Institute." Ph.D. dissertation, Yale University, 1984.

Lane, Barbara Miller. "National Romanticism in Modern German Architecture." In *Nationalism in the Visual Arts*. Studies in the History of Art, 29; *Center for Advanced Study in the Visual Arts, Symposium Papers XIII*. Ed. Richard A. Etlin. Hanover, N.H.: University Press of New England, 1991, pp. 111–47.

Lanore, Maurice. "Reconstruction de la façade de la cathédrale de Chartres au 12e siècle." *Revue de l'art chrétien* 42 (1899): 328–35; 43 (1900): 32–39, 137–45.

Lasteyrie, Robert de. *Études sur la sculpture française au moyen âge*. Paris: E. Leroux, 1902.

Lavin, Irving. "Iconography as a Humanistic Discipline ('Iconography at the Crossroads')." In *Iconography at the Crossroads*. Ed. Brendan Cassidy. Princeton: Princeton University Press, 1993, pp. 33–41.

Lavin, Marilyn Aronberg. *The Eye of the Tiger: The Founding and Development of the Department of Art and Archaeology, 1883–1923, Princeton University*. Princeton: Department of Art and Archaeology and the Art Museum, Princeton University, 1983.

Lazarus, Moritz. *Das Leben der Seele in Monographien über seine Erscheinung und Gesetze*. Berlin: F. Dümmler, 1856.

Lefèvre-Pontalis, Eugène. "*Études sur la sculpture française au moyen âge* par Robert de Lasteyrie." *Bulletin monumental* 67 (1903): 591–95.

Lehr, Henry. "L'École chartraine de sculpture au douzième siècle, d'après *Les Origines du style*

monumental au moyen âge; étude sur la première floraison de la plastique française, par le Dr. Wilhelm Vöge: Extraits." *Mémoires de la Société Archéologique d'Eure-et-Loir* 12 (1901): 85–140.

Leitschuh, Friedrich (F. L.). "Bücherschau: Adolph Goldschmidt, *Lübecker Malerei und Plastik bis 1530."* *Zeitschrift für christliche Kunst* 3 (1890): cols. 101–03.

Lempertz, Heinrich. *Wesen der Gotik.* Leipzig: K. Hiersemann, 1926.

Lewald, Ursula. "Karl Lamprecht und die Rheinische Geschichtsforschung." *Rheinische Vierteljahrsblätter* 21 (1956): 279–304.

Lewis, Michael J. *The Politics of the German Gothic Revival: August Reichensperger.* Cambridge, Mass.: MIT Press with the Architectural History Foundation, 1993.

Lotze, Hermann. *Mikrokosmos. Ideen zur Naturgeschichte und Geschichte der Menschheit. Versuch einer Anthropologie.* 3 vols. Leipzig: Hirzel, 1856–64.

———. *Geschichte der Aesthetik in Deutschland.* Munich: Cotta, 1868.

Lübke, Wilhelm. *Die mittelalterliche Kunst in Westfalen nach den vorhandenen Denkmälern dargestellt.* Leipzig: T. O. Weigel, 1853.

———. *Geschichte der Plastik von den ältesten Zeiten bis auf die Gegenwart.* Leipzig: E. A. Seemann, 1863; 2d ed., 1871.

———. "Die heutige Kunst und die Kunstwissenschaft." *Zeitschrift für bildende Kunst* 1 (1866): 3–13.

———. "Kunstlitteratur: *Studien zur Kunstgeschichte* von Robert Vischer." *Kunstchronik* 22 (1887): cols. 241–46.

Lurz, Meinhold. *Heinrich Wölfflin. Biographie einer Kunsttheorie.* Worms: Wernersche Verlagsgesellschaft, 1981.

Lüthgen, Eugen. *Romanische Plastik in Deutschland.* Bonn: Kurt Schroeder, 1923.

Lützow, Carl von. "Neue Michelangelo-Litteratur." *Zeitschrift für bildende Kunst* N.F. 3 (1892): 267–70.

Maginnis, Hayden. "The Role of Perceptual Learning in Connoisseurship: Morelli, Berenson and Beyond." *Art History* 13 (1990): 104–17.

Mai, Ekkehard and Stephan Waetzoldt, eds. *Kunst, Kultur und Politik im Deutschen Kaiserreich, Vol. 1: Kunstverwaltung, Bau- und Denkmal-Politik im Kaiserreich.* Berlin: Gebr. Mann, 1981.

Mâle, Émile. "Les Chapiteaux romans du musée de Toulouse et l'école toulousaine du XIIe siècle." *Revue archéologique* 20 (1892): 28–35, 176–97.

———. *L'Art religieux du XIIIe siècle en France. Étude sur l'iconographie du moyen âge et sur ses sources d'inspiration.* Paris: E. Leroux, 1898.

———. "Les Origines de la sculpture française du moyen âge." *La Revue de Paris* 2d yr., 5 (1895): 198–224.

———. "Le Portail Sainte-Anne à Notre-Dame de Paris." *Revue de l'art ancien et moderne* 2 (1897): 231–46. Repr. in Émile Mâle, *Art et artistes du moyen âge.* Paris: A. Colin, 1927, pp. 188–208.

———. "Histoire de l'art: Les Travaux sur l'art du moyen âge en France depuis vingt ans." *Revue de synthèse historique* (1901): 81–108.

———. *L'Art allemand et l'art français du moyen âge.* Paris: A. Colin, 1917.

Marignan, Albert. *La Foi chrétienne au quatrième siècle.* Paris: A. Picard, 1887.

———. "M. Vöge, *Eine deutsche Malerschule um die Wende des ersten Jahrtausends."* *Le Moyen Âge* 6 (1893): 263–64.

———. "Dr. W. Vöge, *Die Anfänge des monumentalen Stiles im Mittelalter. Eine Untersuchung über die erste Blütezeit französischer Plastik."* *Le Moyen Âge* 7 (1894): 253–58.

———. "Le Portail occidental de Notre-Dame de Chartres." *Le Moyen Âge* 11 (1898): 341–53.

———. "L'École de sculpture en Provence du XIIe au XIIIe siècle." *Le Moyen Âge* 12 (1899): 1–64.

———. *Histoire de la sculpture en Languedoc du XIIe au XIIIe siècle.* Paris: Bouillon, 1902.

———. *Étude sur le manuscrit de l'Hortus deliciarum.* Strasbourg: J. Heitz, 1910.

———. *Les Fresques des églises de Reichenau. Les Bronzes de la cathédrale d'Hildesheim.* Strasbourg: J. Heitz, 1914.

Marriage, Margaret and Ernest Marriage. *The Sculptures of Chartres Cathedral / Les Sculptures de la Cathédrale de Chartres.* Cambridge: Cambridge University Press, 1909.

Mayr-Harting, Henry. *Ottonian Book Illumination: An Historical Study.* 2 vols. London: Harvey Miller, 1991.

Michel, André. "Louis Courajod." *Gazette des beaux-arts,* 38th yr., 3d per., vol. 16 (1896): 203–17.

——— "La Sculpture romane: La Sculpture en France." In *Histoire de l'art,* vol. 1, Part II: *Des Débuts de l'art chrétien à la fin de la période romane.* Ed. André Michel. Paris: A. Colin, 1905, pp. 589–669.

——— "Formation et développement de la sculpture gothique du milieu du XIIe à la fin du XIIIe siècle: La Sculpture en France." In *Histoire de l'art,* vol. 2, Part I, *Formation, expansion et évolution de l'art gothique.* Ed. André Michel. Paris: A. Colin, 1906, pp. 125–98.

——— "Louis Gonse." *Gazette des beaux-arts,* 64th yr., 1st part (1922): 85–88.

Michels, Karin. "Bemerkungen zu Panofskys Sprache." In *Erwin Panofsky. Beiträge des Symposions Hamburg 1992.* Ed. Bruno Reudenbach. Berlin: Akademie Verlag, 1994, pp. 59–69.

Mode, Heinz. "Historiker und Kenner der Kunst, Adolph Goldschmidt (Halle: 1904–1912)." In *450 Jahre Martin-Luther-Universität Halle-Wittenberg.* 3 vols. Halle: Martin-Luther-Universität, 1953, vol. 2, pp. 325–28.

Morelli, Giovanni. *Balvi magnus und Das Miasma diabolicum.* Ed. and intro. Jaynie Anderson. Würzburg: Königshausen und Neumann, 1991.

——— *Della Pittura italiana. Studii storico-critici. Le Gallerie Borghese e Doria-Pamphili in Roma* (Milan: Adelphi, 1991).

Morelli, Giovanni [Lermolieff, Ivan]. "Die Galerien Roms. Ein kritischer Versuch." *Zeitschrift für bildende Kunst* 9 (1874): 1–11, 73–81, 171–78, 249–53; 10 (1875): 97–106, 207–11, 264–73; 11 (1876): 132–37, 168–73.

——— *Kunstkritische Studien über italienische Malerei.* 3 vols. Leipzig: F. A. Brockhaus, 1890–93.

Morey, Charles Rufus. "The Sources of Medieval Style." *Art Bulletin* 7 (1924): 35–50.

Moriz-Eichborn, Kurt. *Der Skulpturencyclus in der Vorhalle des Freiburger Münsters und seine Stellung in der Plastik des Oberrheins.* Strasbourg: J. Heitz, 1899.

Le Moyen Âge. Revue d'histoire et de philologie. Paris: A. Picard, 1888–.

Müller, Theodor. "Wilhelm Vöge, *Bildhauer des Mittelalters.*" *Kunstchronik* 12 (1959): 335–41.

Müntz, Eugène. "Michel-Ange." *Revue des deux mondes* 114, 3d per., 62d yr. (15 December 1892): 875–903.

Das Museum. Berlin: W. Spemann, 1896–1911.

Muther, Richard. *Geschichte der Malerei im XIX. Jahrhundert.* 3 vols. Munich: G. Hirth, 1893–94.

Neumeyer, Alfred. "Four Art Historians Remembered: Wölfflin, Goldschmidt, Warburg, Berenson." *Art Journal* 31(1) (1971): 33–36.

Neuwirth, Joseph. "Litteraturbericht: Die Trierer Ada-Handschrift. Bearbeitet und herausgegeben von Karl Lamprecht." *Repertorium für Kunstwissenschaft* 13 (1890): 196–210.

Niehr, Klaus. "Anhang VI. Adolph Goldschmidts Forschungen zur niedersächsischen Kunst des hohen Mittelalters." In *Adolph Goldschmidt, 1863–1944. Lebenserinnerungen.* Ed. Marie Roosen-Runge-Mollwo. Berlin: Deutscher Verlag für Kunstwissenschaft, 1989, pp. 452–56.

——— *Die mitteldeutsche Skulptur der ersten Hälfte des 13. Jahrhunderts.* Weinheim: VCH, Acta Humaniora, 1992.

Nietzsche, Friedrich. *Jenseits von Gut und Böse. Vorspiel einer Philosophie der Zukunft.* Leipzig: C. G. Naumann, 1886.

——— *Zur Genealogie der Moral. Eine Streitschrift.* Leipzig: C. G. Naumann, 1887.

Nordhagen, Per Jonas. "C. R. Morey and His Theory on the Development of Early Medieval Art." *Konsthistorisk Tidskrift* 61 (1992): 1–7.

Offizieller Bericht über die Verhandlungen des Kunsthistorischen Kongresses zu Köln 1.–3. Oktober 1894. Repr. in *International Congress on the History of Art: 2nd–9th Congress, 1893–1909.* Nendeln, Liechtenstein: Kraus Reprint, 1978, pp. 1–102.

Offizieller Bericht über die Verhandlungen des Kunsthistorischen Kongresses zu Nürnberg 25.–27. September 1893. Repr. in *International Congress on the History of Art: 2nd–9th Congress, 1893–1909.* Nendeln, Liechtenstein: Kraus Reprint, 1978, pp. 1–85.

Olin, Margaret. *Forms of Representation in Alois Riegl's Theory of Art.* University Park: Pennsylvania State University Press, 1992.

Organ für christliche Kunst. Organ des christlichen Kunstvereins für Deutschland. Cologne: 1851–73.

Otte, Heinrich. *Grundzüge der kirchlichen Kunst-Archäologie des deutschen Mittelalters.* Leipzig: T. O. Weigel, 1855.

Pagden, Silvia Ferino. "Raffaello come *test-case* della validità del metodo morelliano." In *Giovanni Morelli e la cultura dei conoscitori. Atti del Convegno Internazionale, Bergamo, 4–7 giugno 1987.* 3 vols. Ed. Giacomo Agosti, Maria Elisabetta Manca, Matteo Panzeri and Marisa Dalai Emiliani. Bergamo: P. Lubrina, vol. 2, pp. 331–49.

Panofsky, Erwin. *Die theoretische Kunstlehre Albrecht Dürers (Dürers Ästhetik).* Berlin: G. Reimer, 1914.

Dürers Kunsttheorie, vornehmlich in ihrem Verhältnis zur Kunsttheorie der Italiener. Berlin: G. Reimer, 1915.

Die deutsche Plastik des elften bis dreizehnten Jahrhunderts. 2 vols. Munich: K. Wolff, 1924.

"Literatur: Hans Jantzen, *Deutsche Bildhauer des dreizehnten Jahrhunderts*, Leipzig, 1925." *Repertorium für Kunstwissenschaft* 47 (1926): 54–62.

"The History of Art as a Humanistic Discipline" (1940). Repr. in *Meaning in the Visual Arts: Papers in and on Art History by Erwin Panofsky.* Garden City, N.Y.: Doubleday [Anchor], 1955, pp. 1–25.

"Three Decades of Art History in the United States. Impressions of a Transplanted European" (1953). Repr. in *Meaning in the Visual Arts: Papers in and on Art History by Erwin Panofsky.* Garden City, N.Y.: Doubleday [Anchor], 1955, pp. 321–46.

"Wilhelm Vöge: 16. Februar 1868–30. Dezember 1952." In *Bildhauer des Mittelalters. Gesammelte Studien von Wilhelm Vöge.* Berlin: Gebr. Mann, 1958, pp. ix–xxxii.

"Goldschmidts Humor." In *Adolph Goldschmidt zum Gedächtnis, 1863–1944.* Ed. Carl Georg Heise. Hamburg: Hauswedell, 1963, pp. 25–32.

"Wilhelm Vöge: A Biographical Memoir." Trans. Ernest Hassold. *Art Journal* 28(1) (1968): 27–37.

Paret, Peter. *Art as History: Episodes in the Culture and Politics of Nineteenth-Century Germany.* Princeton: Princeton University Press, 1988.

Paul Clemen, 1866–1947. Erster Provinzialkonservator der Rheinprovinz. Exh. cat., Rheinisches Landesmuseum, Bonn. Cologne: Rheinland-Verlag, 1991.

Paul Clemen. Zur 125. Wiederkehr seines Geburtstages. Jahrbuch der Rheinischen Denkmalpflege, 35. Cologne: Rheinland-Verlag, 1991.

Pauli, Gustav. *Erinnerungen aus sieben Jahrzehnten.* Tübingen: Rainer Wunderlich, 1936.

Pillion, Louise. "Les Historiens de la sculpture française." *La Revue de Paris* 15th yr., no. 20 (15 October 1908): 849–68; 15th yr., no. 21 (1 November 1908): 109–28.

Les Sculpteurs français du XIIIe siècle. Paris: Plon, 1910.

Pinder, Wilhelm. *Mittelalterliche Plastik Würzburgs. Ein Versuch einer lokalen Entwickelungsgeschichte vom Ende des 13. bis zum Anfang des 15. Jahrhunderts.* Würzburg, 1911; 2d ed. Leipzig: C. Kabitzsch, 1924.

Die deutsche Plastik vom ausgehenden Mittelalter bis zum Ende der Renaissance. Wildpark-Potsdam: Verlagsgesellschaft Athenaion, 1924.

Der Naumburger Dom und seine Bildwerke. Berlin: Deutscher Kunstverlag, 1925.

Piper, Ferdinand. *Einleitung in die Monumentale Theologie.* Gotha: Rud. Besser, 1867; repr. Mittenwald: Mäander Verlag, 1978.

Podro, Michael. *The Critical Historians of Art.* New Haven: Yale University Press, 1982.

Pommerin, Reiner. "Paul Clemen in Harvard." *Jahrbuch der Rheinischen Denkmalpflege* 29 (1983): 12–16.

Porter, Arthur Kingsley. *Medieval Architecture: Its Origins and Development.* 2 vols. New York: Baker and Taylor, 1909.

"The Development of Sculpture in Lombardy in the Twelfth Century." *American Journal of Archaeology* 19 (1915): 137–54.

Lombard Architecture. 4 vols. New Haven: Yale University Press, 1915–17.

Romanesque Sculpture of the Pilgrimage Roads. 10 vols. Boston: Marshall Jones, 1923.

"A. Kingsley Porter. Kunst und Wissenschaft." In *Die Kunstwissenschaft der Gegenwart in Selbstdarstellungen.* Ed. Johannes Jahn. Leipzig: Felix Meiner, 1924, pp. 77–93.

"Hermann Beenken, *Romanische Skulptur in Deutschland, 11. und 12. Jahrhundert.*" *Speculum* 1 (1926): 233–42.

Post, Chandler Rathfon. *A History of European and American Sculpture from the Early Christian Period to the Present Day.* 2 vols. Cambridge, Mass.: Harvard University Press, 1921.

Potts, Alex. *Flesh and the Ideal: Winckelmann and the Origins of Art History.* New Haven: Yale University Press, 1994.

Preziosi, Donald. *Rethinking Art History: Meditations on a Coy Science.* New Haven: Yale University Press, 1989.

Priest, Alan. "The Masters of the West Facade of Chartres." *Art Studies* 1 (1923): 28–44.

Prior, Edward S. and Arthur Gardner. *An Account of Medieval Figure-Sculpture in England.* Cambridge: Cambridge University Press, 1912.

Rave, Paul Ortwin. *Kunstgeschichte in Festschriften. Allgemeine Bibliographie kunstwissenschaftlicher Abhandlungen in den bis 1960 erschienenen Festschriften.* Berlin: Gebr. Mann, 1962.

Reber, Franz von. *Kunstgeschichte des Mittelalters.* Leipzig: T. O. Weigel, 1886.

Rees, A. L. and Frances Borzello, eds. *The New Art History.* London: Camden Press, 1986.

Repertorium für Kunstwissenschaft. Vienna, Stuttgart and Berlin, 1876–1931.

Richard Hamann in Memoriam, mit zwei nachgelassenen Aufsätzen und einer Bibliographie der Werke Richard Hamanns. Berlin: Akademie-Verlag, 1963.

Richter, Irma and Gisela Richter, eds. *Italienische Malerei der Renaissance im Briefwechsel von Giovanni Morelli und Jean Paul Richter, 1876–1891.* Baden-Baden: Grimm, 1960.

Rickman, H. P. *Wilhelm Dilthey: Pioneer of the Human Sciences.* Berkeley and Los Angeles: University of California Press, 1979.

Riegl, Alois. *Stilfragen. Grundlegungen zu einer Geschichte der Ornamentik.* Berlin: G. Siemens, 1893.

Spätrömische Kunstindustrie. Vienna: K. K. Hof- und Staatsdruckerei, 1901.

Problems of Style: Foundations for a History of Ornament. Trans. Evelyn Kain; annotations and intro. David Castriota; pref. Henri Zerner. Princeton: Princeton University Press, 1992.

Ringbom, Sixten. *Art History in Finland before 1920.* Helsinki: Societas Scientiarum Fennica, 1986.

Ringer, Fritz. *The Decline of the German Mandarins: The German Academic Community, 1890–1933.* Cambridge, Mass.: Harvard University Press, 1969; repr. Middletown, Conn.: Wesleyan University Press, 1990.

Robson-Scott, W. D. *The Literary Background of the Gothic Revival in Germany: A Chapter in the History of Taste.* Oxford: Clarendon Press, 1965.

Roosen-Runge-Mollwo, Marie. "Ein Jugendtagebüchlein des Hamburger Kunsthistorikers Adolph Goldschmidt (1863–1944) verfasst vom 28. März bis 11. Mai 1880." *Hamburgische Geschichts- und Heimatblätter* 12(8–9) (1991): 177–95.

Roosen-Runge-Mollwo, Marie, ed. *Adolph Goldschmidt, 1863–1944. Lebenserinnerungen.* Berlin: Deutscher Verlag für Kunstwissenschaft, 1989.

Sauerländer, Willibald. "*Bildhauer des Mittelalters. Gesammelte Studien von Wilhelm Vöge.*" *Zeitschrift für Kunstgeschichte* 22 (1959): 49–53.

Von Sens bis Strassburg. Ein Beitrag zur kunstgeschichtlichen Stellung der Strassburger Querhausskulpturen. Berlin: De Gruyter, 1966.

Gotische Skulptur in Frankreich, 1140–1270. Munich: Hirmer Verlag, 1970.

Gothic Sculpture in France, 1140–1270. Trans. Janet Sondheimer. New York: Abrams, 1972.

La Sculpture gothique en France, 1140–1270. Trans. Jacques Chavy. Paris: Flammarion, 1972.

"From Stilus to Style: Reflections on the Fate of a Notion." *Art History* 6 (1983): 253–70.

"Kleider machen Leute: Vergessenes aus Viollet-le-Ducs 'Dictionnaire du mobilier français.'" *Arte medievale* 1 (1983): 221–40.

"Zersplitterte Erinnerung." In *Kunsthistoriker in eigener Sache. Zehn autobiographische Skizzen.* Ed. Martina Sitt. Berlin: Dietrich Reimer Verlag, 1990, pp. 301–23.

Schapiro, Meyer. "The Romanesque Sculpture of Moissac." *Art Bulletin* 13 (1931): 248–351, 464–531.

Romanesque Art: Selected Papers. New York: George Braziller, 1977.

Schleif, Corine. "*Kunstchronik.*" In *International Art Periodicals.* Ed. Winberta Yao. Westport, Conn.: Greenwood Press (in press).

Schlie, Friedrich. "Litteraturbericht: Adolph Goldschmidt, *Lübecker Malerei und Plastik bis 1530.*" *Repertorium für Kunstwissenschaft* 13 (1890): 402–12.

Schlink, Wilhelm. "Giovanni Morelli und Jacob Burckhardt." In *Giovanni Morelli e la cultura dei conoscitori. Atti del Convegno Internazionale, Bergamo, 4–7 giugno 1987.* 3 vols. Ed. Giacomo Agosti, Maria Elisabetta Manca, Matteo Panzeri and Marisa Dalai Emiliani. Bergamo: P. Lubrina, 1993, vol. 1, pp. 69–81.

Schlosser, Julius von. *Die Wiener Schule der Kunstgeschichte.* Innsbruck: Universitäts-Verlag Wagner, 1934.

Schmidt, Gerhard. "Die internationalen Kongresse für Kunstgeschichte." *Wiener Jahrbuch für Kunstgeschichte* 36 (1983): 7–22.

Schmitt, Otto. "A. Kingsley Porter, *Romanesque Sculpture of the Pilgrimage Roads.*" *Jahrbuch für Kunstwissenschaft* (1927): 266–69.

Schnaase, Carl. *Geschichte der bildenden Künste.* 7 vols. Düsseldorf: J. Buddeus, 1843–64; 2d ed., 1866–79.

Schnütgen, Alexander. "Zur Eröffnung der Zeitschrift." *Zeitschrift für christliche Kunst* 1 (1888): cols. 1–6.

"Bücherschau: *Die Anfänge des monumentalen Stiles im Mittelalter* von Dr. Wilhelm Vöge." *Zeitschrift für christliche Kunst* 7 (1894): cols. 349–50.

Schönebaum, Herbert. "Vom Werden der deutschen Geschichte Karl Lamprechts." *Deutsche Vierteljahrsschrift für Literaturwissenschaft und Geistesgeschichte* 25 (1951): 94–111.

"Zum hundertsten Geburtstag Karl Lamprechts am 25. Februar 1956." *Wissenschaftliche Zeitschrift der Karl-Marx–Universität Leipzig,* Gesellschafts- und sprachwissenschaftliche Reihe, 5 (1955–56): 7–16.

Schorn-Schütte, Luise. *Karl Lamprecht. Kulturgeschichtsschreibung zwischen Wissenschaft und Politik.* Schriftenreihe der Historischen Kommission bei der Bayerischen Akademie der Wissenschaften, 22. Göttingen: Vandenhoeck und Ruprecht, 1984.

"Séance du 8 décembre 1894." *Procès-verbaux de la Société Archéologique d'Eure-et-Loir* 9 (1898): 197–99.

"Séance du 7 février 1895." *Procès-verbaux de la Société Archéologique d'Eure-et-Loir* 9 (1898): 202–03.

Sedlmayr, Hans. *Die Entstehung der Kathedrale.* Zurich: Atlantis Verlag, 1950.

Seidel, Linda. "The Scholar and the Studio: A. Kingsley Porter and the Study of Medieval Architecture in the Decade before the War." In *The Architectural Historian in America.* Studies in the History of Art, 35; *Center for Advanced Study in the Visual Arts Symposium Papers, XIX.* Hanover, N.H.: University Press of New England, 1990, pp. 145–58.

"Arthur Kingsley Porter: Life, Legend and Legacy." In *The Early Years of Art History in the United States: Notes and Essays on Departments, Teaching, and Scholars.* Ed. Craig Hugh Smyth and Peter M. Lukehart. Princeton: Princeton University Press, 1993, pp. 97–110.

Seidlitz, Woldemar von. "Litteraturbericht: Robert Vischer, *Studien zur Kunstgeschichte.*" *Repertorium für Kunstwissenschaft* 11 (1888): 179–83.

Das siebente Jahrzehnt. Festschrift Adolph Goldschmidt zu seinem 70. Geburtstag am 15. 1. 1933 dargebracht von allen seinen Schülern, die in den Jahren 1922–1933 bei ihm gehört und promoviert haben. Berlin: Würfel Verlag, 1935.

Silverman, Debora. *Art Nouveau in Fin-de-Siècle France: Politics, Psychology, Style.* Berkeley and Los Angeles: University of California Press, 1989.

Simson, Otto von. *Sacred Fortress: Byzantine Art and Statecraft in Ravenna.* Chicago: University of Chicago Press, 1948.

The Gothic Cathedral: The Origins of Gothic Architecture and the Medieval Concept of Order. New York: Pantheon, 1956.

Sitt, Martina, ed. *Kunsthistoriker in eigener Sache. Zehn autobiographische Skizzen.* Berlin: Dietrich Reimer Verlag, 1990.

Smith, Earl Baldwin. *The Study of the History of Art in the Colleges and Universities of the United States.* Princeton: Princeton University Press, 1912. Repr. in *The Early Years of Art History in the United States: Notes and Essays on Departments, Teaching, and Scholars.* Ed. Craig Hugh Smyth and Peter M. Lukehart. Princeton: Princeton University Press, 1993, pp. 12–36.

Smith, Holmes. "Problems of the College Art Association." *Bulletin of the College Art Association* 1 (1913): 6–10.

Smith, Woodruff D. *Politics and the Sciences of Culture in Germany, 1840–1920.* New York: Oxford University Press, 1991.

Smyth, Craig Hugh. "Concerning Charles Rufus Morey (1877–1955)." In *The Early Years of Art History in the United States. Notes and Essays on Departments, Teaching, and Scholars.* Ed. Craig Hugh Smyth and Peter M. Lukehart. Princeton: Princeton University Press, 1993, pp. 111–21.

"The Department of Fine Arts for Graduate Students at New York University." In *The Early Years of Art History in the United States: Notes and Essays on Departments, Teaching, and Scholars.* Ed. Craig Hugh Smyth and Peter M. Lukehart. Princeton: Princeton University Press, 1993, pp. 73–78.

"The Princeton Department in the Time of Morey." In *The Early Years of Art History in the United States: Notes and Essays on Departments, Teaching, and Scholars.* Ed. Craig Hugh Smyth and Peter M. Lukehart. Princeton: Princeton University Press, 1993, pp. 37–42.

Smyth, Craig Hugh and Peter M. Lukehart, eds. *The Early Years of Art History in the United States. Notes and Essays on Departments, Teaching, and Scholars.* Princeton: Princeton University Press, 1993.

Speculum: A Journal of Medieval Studies. Cambridge, Mass.: Medieval Academy of America, 1926–.

Springer, Anton. *Die Hegel'sche Geschichtsanschauung. Eine historische Denkschrift.* Tübingen: L. F. Fues, 1848.

Die Baukunst des christlichen Mittelalters. Ein Leitfaden. Bonn: H. Cohen, 1854.

Handbuch der Kunstgeschichte. Zum Gebrauche für Künstler und Studirende und als Führer auf der Reise. Stuttgart: Rieger, 1855.

Kunsthistorische Briefe. Die bildenden Künste in ihrer weltgeschichtlichen Entwicklung. Prague: F. Ehrlich, 1857.

"Das Nachleben der Antike im Mittelalter" (1850s–60s). Repr. in Anton Springer, *Bilder aus der neueren Kunstgeschichte.* 2 vols. 2d ed. Bonn: Adolph Marcus, 1886, vol. 1, pp. 1–40.

"Über das Gesetzmässige in der Entwicklung der bildenden Künste." *Im neuen Reich* 3(1) (1873): 761–72.

Raffael und Michelangelo. Leipzig: E. A. Seemann, 1878.

"Die Miniaturmalerei im frühen Mittelalter." *Zeitschrift für bildende Kunst* 15 (1880): 345–53.

Die Psalter-Illustrationen im frühen Mittelalter mit besonderer Rücksicht auf den Utrechtpsalter. Leipzig: Hirzel, 1880.

"Kunstkenner und Kunsthistoriker." *Im neuen Reich* 11(2) (1881): 737–58. Repr. in Anton Springer, *Bilder aus der neueren Kunstgeschichte.* 2 vols. 2d ed. Bonn: Adolph Marcus, 1886, vol. 2, pp. 379–404.

"Karl Lamprecht, *Initial-Ornamentik des VIII. bis XIII. Jahrhunderts.*" *Göttingische gelehrte Anzeigen* (1883): 769–84.

Die Genesisbilder in der Kunst des Mittelalters mit besonderer Rücksicht auf den Ashburnham-Pentateuch. Leipzig: Hirzel, 1884.

"Robert Vischer, *Studien zur Kunstgeschichte.*" *Göttingische gelehrte Anzeigen* (1887): 241–56.

Der Bilderschmuck in den Sakramentarien des frühen Mittelalters. Leipzig: Hirzel, 1889.

"Karl Lamprecht, hrsg., *Die Trierer Ada-Handschrift.*" *Göttingische gelehrte Anzeigen* (1890): 633–51.

Aus meinem Leben. Berlin: G. Grote, 1892.

Stechow, Wolfgang. "Review of E. Haverkamp Begemann, *Willem Buytewech,* Amsterdam, 1959." *Art Bulletin* 43 (1961): 338–41.

Sterne, Margaret. *The Passionate Eye: The Life of William R. Valentiner.* Detroit: Wayne State University Press, 1980.

Stoddard, Whitney S. *The West Portals of Saint-Denis and Chartres: Sculpture in the Ile-de-France from 1140–1190. Theory of Origins.* Cambridge, Mass.: Harvard University Press, 1952; repr. and expanded, New York: W. W. Norton, 1986.

Suckale, Robert. "Die Bamberger Domskulpturen. Technik, Blockbehandlung, Ansichtigkeit und die Einbeziehung des Betrachters." *Münchner Jahrbuch der bildenden Kunst,* 3d ser., vol. 38 (1987): 27–82.

Swarzenski, Georg. *Die Regensburger Buchmalerei des X. und XI. Jahrhunderts. Studien zur Geschichte der deutschen Malerei des frühen Mittelalters.* Leipzig: K. W. Hiersemann, 1901.

Taube, Otto von. "Erinnerungen an Adolph Goldschmidt." In *Adolph Goldschmidt zum Gedächtnis, 1863–1944.* Ed. Carl Georg Heise. Hamburg: Hauswedell, 1963, pp. 20–24.

Stationen auf dem Wege. Erinnerungen an meine Werdezeit vor 1914. Heidelberg: Lothar Stiehm, 1969.

Thausing, Moriz. *Dürer. Geschichte seines Lebens und seiner Kunst.* Leipzig: E. A. Seemann, 1876; 2d ed., 2 vols., 1884.

"Die Stellung der Kunstgeschichte als Wissenschaft." In Moriz Thausing, *Wiener Kunstbriefe.* Leipzig: E. A. Seemann, 1884, pp. 1–20. Repr. *Wiener Jahrbuch für Kunstgeschichte* 36 (1983): 140–50.

Thode, Henry. *Franz von Assisi und die Anfänge der Kunst der Renaissance in Italien.* Berlin: G. Grote, 1885.

"Hermann Ulmann." *Repertorium für Kunstwissenschaft* 19 (1896): 247–48.

Träger, Jörg. "Carl Georg Heise." *Zeitschrift für Kunstgeschichte* 43 (1980): 113–15.

Trier, Eduard. "Kategorien der Plastik in der deutschen Kunstgeschichte der zwanziger Jahre."

In *Kategorien und Methoden der deutschen Kunstgeschichte, 1900–1930.* Ed. Lorenz Dittmann. Wiesbaden: F. Steiner, 1985, pp. 39–49.

Troy, Nancy J. *Modernism and the Decorative Arts in France: Art Nouveau and Le Corbusier.* New Haven: Yale University Press, 1991.

Tschudi, Hugo von. "Hubert Janitschek." *Repertorium für Kunstwissenschaft* 17 (1894): 1–7.

Ullmann, Ernst, ed. *Kunstwerk, Künstler, Kunstgeschichte. Ausgewählte Schriften von Johannes Jahn.* Leipzig: E. A. Seemann, 1982.

Ungern-Sternberg, Franziska von. "Die Gründung des Germanischen Museums in Cambridge, Massachusetts. Kulturpolitische Hintergründe für ihre Realisierung." M. A. thesis, University of Hamburg, 1990.

Kulturpolitik zwischen den Kontinenten – Deutschland und Amerika. Das Germanische Museum in Cambridge, Massachusetts. Cologne: Böhlau Verlag, 1994.

Venturi, Adolfo. "Recensione: *Die Anfänge des monumentalen Stiles im Mittelalter* von Dr. Wilhelm Vöge." *Archivio storico dell'arte* 1 (1895): 466.

Verzeichnis der Vorlesungen an der Rheinischen Friedrich-Wilhelms-Universität zu Bonn. Winter-Semester 1885–86-Sommer-Semester 1889. Bonn: Universitäts-Buchdruckerei von Carl Georgi, 1885–89.

Verzeichniss der Vorlesungen, welche auf der Friedrich-Wilhelms-Universität zu Berlin . . . gehalten werden. Sommer-Semester 1893–Sommer-Semester 1904. Berlin, 1893–1904.

Verzeichniss der Vorlesungen, welche an der Kaiser-Wilhelms-Universität Strasbourg . . . gehalten werden. Winter-Semester 1895–96-Winter-Semester 1897–98. Strasbourg: Universitäts-Buchdruckerei von J. Heitz, 1895–98.

Viollet-le-Duc, Eugène Emmanuel. "Sculpture." In Eugène Emmanuel Viollet-le-Duc, *Dictionnaire raisonné de l'architecture française du XIe au XVIe siècle*, vol. 8. Paris: Morel, 1888, pp. 97–279.

"Viollet-le-Duc et la sculpture." In *Viollet-le-Duc.* Exh. cat., Galeries Nationales du Grand Palais. Ed. Bruno Foucart. Paris: Éditions de la Réunion des musées nationaux, 1980, pp. 144–73.

Vischer, Robert. *Über das optische Formgefühl. Ein Beitrag zur Aesthetik.* Leipzig: H. Credner, 1873.

Luca Signorelli und die italienische Renaissance. Eine kunsthistorische Monographie. Leipzig: Veit, 1879.

Kunstgeschichte und Humanismus. Beiträge zur Klärung. Stuttgart: G. J. Göschen, 1880.

Studien zur Kunstgeschichte. Stuttgart: A. Bonz, 1886.

Vitry, Paul. "Nouvelles observations sur le portail Sainte-Anne de Notre-Dame de Paris. À propos de deux fragments de voussures conservés au Musée du Louvre." *Revue de l'art chrétien* 60 (1910): 70–76.

Vöge, Wilhelm. *Eine deutsche Malerschule um die Wende des ersten Jahrtausends. Kritische Studien zur Geschichte der Malerei in Deutschland im 10. und 11. Jahrhundert.* Westdeutsche Zeitschrift für Geschichte und Kunst, Ergänzungsheft VII. Trier: Fr. Lintz, 1891.

"Die Mindener Bilderhandschriftengruppe." *Repertorium für Kunstwissenschaft* 16 (1893): 198–213.

Die Anfänge des monumentalen Stiles im Mittelalter. Eine Untersuchung über die erste Blütezeit der französischen Plastik. Strasbourg: J. Heitz, 1894; repr. Munich: Mäander Verlag, 1988.

"Besprechung von *Raffael-Studien mit besonderer Berücksichtigung der Handzeichnungen des Meisters,* von Dr. W. Koopmann, Marburg, 1895." *Zeitschrift für christliche Kunst* 8 (1895): col. 292.

"Litteraturbericht: *Der Albani-Psalter in Hildesheim* von Adolph Goldschmidt." *Repertorium für Kunstwissenschaft* 19 (1896): 204–11.

"Litteraturbericht: *Beiträge zur Geschichte der Trierer Buchmalerei im frühen Mittelalter,* von Edmund Braun." *Repertorium für Kunstwissenschaft* 19 (1896): 125–34.

Raffael und Donatello. Ein Beitrag zur Entwicklungsgeschichte der italienischen Kunst. Strasbourg: J. Heitz, 1896.

"Ein Verwandter des Codex Egberti." *Repertorium für Kunstwissenschaft* 19 (1896): 105–08.

"Ein deutscher Schnitzer des 10. Jahrhunderts." *Jahrbuch der Königlich Preussischen Kunstsammlungen* 20 (1899): 117–24. Repr. in Wilhelm Vöge, *Bildhauer des Mittelalters. Gesammelte Studien von Wilhelm Vöge.* Berlin: Gebr. Mann, 1958, pp. 1–10.

"Über die Bamberger Domsculpturen." *Repertorium für Kunstwissenschaft* 22 (1899): 94–104; 24 (1901): 195–229, 255–89. Repr. in Wilhelm Vöge, *Bildhauer des Mittelalters. Gesammelte Studien von Wilhelm Vöge.* Berlin: Gebr. Mann, 1958, pp. 130–200.

Beschreibung der Bildwerke der christlichen Epochen in den Königlichen Museen zu Berlin. I. Teil: Die Elfenbeinbildwerke. Berlin: W. Spemann, 1900.

"Albert Marignan, *Un Historien de l'art français: Louis Courajod. I. Les Temps francs,* Paris, 1899." *Repertorium für Kunstwissenschaft* 25 (1902): 101–06. Repr. in Wilhelm Vöge, *Bildhauer des Mittelalters. Gesammelte Studien von Wilhelm Vöge.* Berlin: Gebr. Mann, 1958, pp. 11–15.

"Die Kathedrale von Amiens. Besprechung von Georges Durand, *Monographie de l'église Notre Dame, cathédrale d'Amiens."* *Allgemeine Zeitung,* Munich, supplement to no. 172 (30 July 1902): 201–04. Repr. in Wilhelm Vöge, *Bildhauer des Mittelalters. Gesammelte Studien von Wilhelm Vöge.* Berlin: Gebr. Mann, 1958, pp. 110–18.

"Der provençalische Einfluss in Italien und das Datum des Arler Porticus." *Repertorium für Kunstwissenschaft* 25 (1902): 409–29. Repr. in Wilhelm Vöge, *Bildhauer des Mittelalters. Gesammelte Studien von Wilhelm Vöge.* Berlin: Gebr. Mann, 1958, pp. 16–35.

"Litteraturbericht: *Études sur la sculpture française au moyen âge* von Robert de Lasteyrie." *Repertorium für Kunstwissenschaft* 26 (1903): 512–20. Repr. in Wilhelm Vöge, *Bildhauer des Mittelalters. Gesammelte Studien von Wilhelm Vöge.* Berlin: Gebr. Mann, 1958, pp. 36–43.

"Der Visitatiomeister und die Reimser Plastik des 13. Jahrhunderts." *Kunstgeschichtliche Gesellschaft Berlin, Sitzungsberichte* 1904(3): 13–16. Repr. in Wilhelm Vöge, *Bildhauer des Mittelalters. Gesammelte Studien von Wilhelm Vöge.* Berlin: Gebr. Mann, 1958, pp. 60–62.

"Richard Reiche, *Das Portal des Paradieses am Dom zu Paderborn. Ein Beitrag zur Geschichte der deutschen Bildhauerkunst des 13. Jahrhunderts,* Münster, Regensburg, 1905." *Kunstgeschichtliche Anzeigen* 3 (1906): 1–10.

Beschreibung der Bildwerke der christlichen Epochen in den Königlichen Museen zu Berlin. IV. Teil: Die deutschen Bildwerke und die der anderen cisalpinen Länder. Berlin: G. Reimer, 1910.

"Die Bahnbrecher des Naturstudiums um 1200." *Zeitschrift für bildende Kunst* N.F. 25 (1914): 193–214. Repr. in Wilhelm Vöge, *Bildhauer des Mittelalters. Gesammelte Studien von Wilhelm Vöge.* Berlin: Gebr. Mann, 1958, pp. 63–97.

"Konrad Meits vermeintliche Jugendwerke und ihr Meister." *Jahrbuch für Kunstwissenschaft* (1927): 24–38.

Niclas Hagnower. Der Meister des Isenheimer Hochaltars und seine Frühwerke. Freiburg im Breisgau: Urban-Verlag, 1931.

"Der Meister des Grafen von Kirchberg." In *Festschrift Wilhelm Pinder zum 60. Geburtstage.* Leipzig: E. A. Seemann, 1938, pp. 325–47.

Jörg Syrlin der Ältere und seine Bildwerke, II. Band: Stoffkreis und Gestaltung. Berlin: Deutscher Verein für Kunstwissenschaft, 1950.

"Donatello greift ein reimsisches Motiv auf." In *Festschrift für Hans Jantzen.* Berlin: Gebr. Mann, 1951, pp. 117–27.

Bildhauer des Mittelalters. Gesammelte Studien von Wilhelm Vöge. Berlin: Gebr. Mann, 1958.

"The Beginnings of the Monumental Style in the Middle Ages" (1894) [excerpts]. Trans. Alice Fischer and Gertrude Steuer. In *Chartres Cathedral*. Ed. Robert Branner. New York: W. W. Norton, 1969, pp. 126–49.

"Pioneers of the Study of Nature around 1200" (1914). Trans. Barbara Chabrowe. In *Chartres Cathedral*. Ed. Robert Branner. New York: W. W. Norton, 1969, pp. 207–32.

Volbach, Wolfgang F. *Elfenbeinarbeiten der Spätantike und des frühen Mittelalters*. 2d ed. Mainz: Römisch-Germanisches Zentralmuseum, 1952.

Vybíral, Jindřich. "Hubert Janitschek. Zum 100. Todesjahr des Kunsthistorikers." *Kunstchronik* 47 (1994): 237–44.

Waagen, Gustav Friedrich. *Handbuch der Geschichte der Malerei. Die deutschen und niederländischen Malerschulen*. Stuttgart: Ebner und Seubert, 1862.

Waetzoldt, Wilhelm. "Die Stellung der Kunstgeschichte an den deutschen Hochschulen." *Atti del X Congresso Internazionale di Storia dell'Arte in Roma (1912). L'Italia e l'arte straniera*. Rome, 1922; repr. Nendeln, Liechtenstein: Kraus Reprint, 1978, pp. 24–32.

Deutsche Kunsthistoriker. 2 vols. Leipzig: E. A. Seemann, 1924.

Warburg, Aby. *Sandro Botticellis 'Geburt der Venus' und 'Frühling.' Eine Untersuchung über die Vorstellungen von der Antike in der italienischen Frührenaissance*. Hamburg and Leipzig: Leopold Voss, 1893.

Warnke, Martin. "Richard Hamann." *Marburger Jahrbuch für Kunstwissenschaft* 20 (1981): 11–20.

Weese, Artur. *Die Bamberger Domsculpturen. Ein Beitrag zur Geschichte der deutschen Plastik des XIII. Jahrhunderts*. Strasbourg: J. Heitz, 1897.

Weigert, Hans. *Die Stilstufen der deutschen Plastik von 1250 bis 1350*. Marburg: Verlag des Kunstgeschichtlichen Seminars, 1927.

Weisbach, Werner. *'Und alles ist zerstorben.' Erinnerungen aus der Jahrhundertwende*. Vienna: H. Reichner, 1937.

Weitzmann, Kurt. *Adolph Goldschmidt und die Berliner Kunstgeschichte*. Berlin: Kunsthistorisches Institut der Freien Universität, 1985.

Sailing with Byzantium from Europe to America: The Memoirs of an Art Historian. Munich: Editio Maris, 1994.

Wendland, Ulrike. "Arkadien in Hamburg. Studierende und Lehrende am Kunsthistorischen Seminar der Hamburgischen Universität." In *Erwin Panofsky. Beiträge des Symposions Hamburg 1992*. Ed. Bruno Reudenbach. Berlin: Akademie Verlag, 1994, pp. 15–29.

Wenger, Luke. "The Medieval Academy and Medieval Studies in North America." In *Medieval Studies in North America: Past, Present, and Future*. Kalamazoo, Mich.: Medieval Institute Publications, 1982, pp. 23–40.

Westwood, John Obadiah. *Palaeographica sacra pictoria: Being a series of illustrations of the ancient versions of the Bible copied from illuminated manuscripts, executed between the fourth and sixteenth centuries*. London: Bohn, 1849.

White, Hayden. *Metahistory: The Historical Imagination in Nineteenth-Century Europe*. Baltimore: Johns Hopkins University Press, 1973.

The Content of the Form: Narrative Discourse and Historical Representation. Baltimore: Johns Hopkins University Press, 1987.

Wickhoff, Franz. *Die Wiener Genesis*. Vienna: F. Tempsky, 1895.

Wilmotte, Maurice. "Albert Marignan." *Le Moyen Âge* 46 (October–December 1936): 241–43.

Wirth, Karl-August. "Beiträge zum Problem des 'Samsonmeisters.'" *Zeitschrift für Kunstgeschichte* 20 (1957): 25–51.

Wölfflin, Heinrich. *Prolegomena zu einer Psychologie der Architektur*. Munich: Dr. C. Wolf und Sohn, 1886.

Renaissance und Barock. Eine Untersuchung über Wesen und Entstehung des Barockstils in Italien. Munich: T. Ackermann, 1888.

Die Jugendwerke des Michelangelo. Munich: T. Ackermann, 1891.

"Ein Entwurf Michelangelos zur Sixtinischen Decke." *Jahrbuch der Königlich Preussischen Kunstsammlungen* 13 (1892): 178–82.

"Litteraturbericht: Wilhelm Vöge, *Raffael und Donatello.*" *Repertorium für Kunstwissenschaft* 19 (1896): 134–35.

Kleine Schriften (1886–1933). Ed. Joseph Gantner. Basel: Schwabe, 1946.

Renaissance and Baroque (1888). Trans. Kathrin Simon. Ithaca: Cornell University Press, 1964.

Prolegomena to a Psychology of Architecture (1886). Trans. Harry Francis Mallgrave and Eleftherios Ikonomou. In *Empathy, Form, and Space: Problems in German Aesthetics, 1873–1893.* Santa Monica, Calif.: Getty Center for the History of Art and the Humanities, 1994, pp. 149–90.

Woodruff, Helen. *The Index of Christian Art at Princeton University: A Handbook.* Princeton: Princeton University Press, 1942.

Worringer, Wilhelm. *Abstraktion und Einfühlung. Ein Beitrag zur Stilpsychologie.* Munich: R. Piper, 1908.

Formprobleme der Gotik. Munich: R. Piper, 1911.

Wuttke, Dieter. "Aby M. Warburgs Kulturwissenschaft." *Historische Zeitschrift* 256 (1993): 1–30.

Zarnecki, George and Denis Grivot. *Gislebertus: Sculptor of Autun.* New York: Orion Press, 1961.

Zeitschrift für bildende Kunst. Leipzig: E. A. Seemann, 1866–1931/32.

Zeitschrift für christliche Archäologie und Kunst. Leipzig: T. O. Weigel, 1856–58.

Zeitschrift für christliche Kunst. Düsseldorf: L. Schwann, 1888–1921.

Zeitschrift für Kunstgeschichte. Munich: Deutscher Kunstverlag, 1932–42; 1949–.

Zeitschrift für Völkerpsychologie und Sprachwissenschaft. Berlin: F. Dümmler, 1860–90.

Index

NOTE: Page numbers in italics refer to illustrations